The Trees of North America

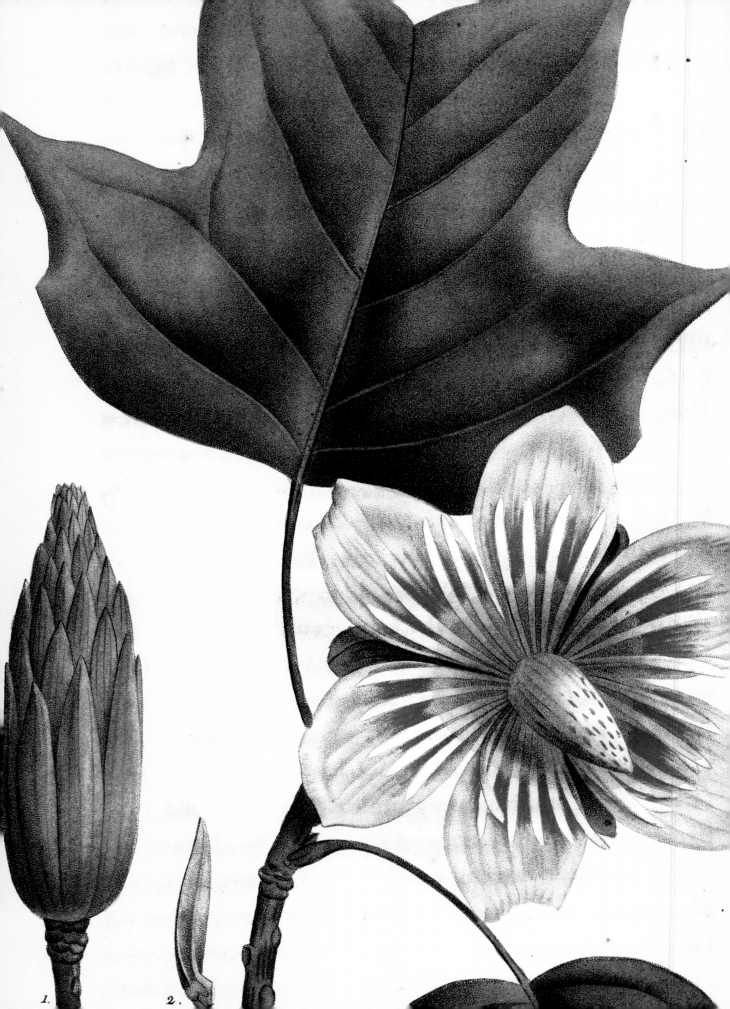

1. 2.

NEW YORK BOTANICAL GARDEN

The Trees of North America

Michaux and Redouté's American Masterpiece

VOLUME EDITORS Susan M. Fraser and Sally Armstrong Leone

FOREWORD Gregory Long

PREFACE Susan M. Fraser

INTRODUCTION Marta McDowell

AFTERWORD AND ADDITIONAL ILLUSTRATIONS
David Allen Sibley

ABBEVILLE PRESS PUBLISHERS

NEW YORK LONDON

About The New York Botanical Garden

The New York Botanical Garden is an iconic living museum, a major educational institution, and a renowned plant research and conservation organization. Founded in 1891 and now a National Historic Landmark, it is one of the greatest botanical gardens in the world and the largest in any city in the United States, distinguished by the beauty of its diverse landscape and extensive collections and gardens, as well as by the scope and excellence of its multidisciplinary exhibitions and programs. The LuEsther T. Mertz Library counts among its holdings many of the most extraordinary and pioneering botanical and horticultural works ever created. Ten centuries of knowledge, from the 12th century to the present, are represented in the Library Collection, with particular strength in systematic, floristic, and economic botany and horticulture, gardening, and landscape design. These subjects are reflected not only in the large collection of books and journals but also in electronic databases, nursery catalogs, manuscripts, prints and drawings, and scientific reprints.

JACKET FRONT: Detail of pl. 80, White Oak, see p. 100.
SPINE: Detail of pl. 96, Bur Oak, see p. 116.
JACKET BACK AND PAGE 2: Details of pl. 129, Tulip Tree, see p. 149.
COVER FRONT: Detail of pl. 55, Common Persimmon, see p. 75.
COVER BACK: Detail of pl. 42, Pacific Dogwood, see p. 62.
PAGE 6: Detail of pl. 243, Silver Maple, see p. 263.
PAGE 18: Detail of pl. 24, Catawba Tree, see p. 44.
PAGE 298: Detail of pl. 8, American Holly, see p. 28.
PAGE 384: Detail of pl. 258, Ohio Buckeye, see p. 278.

EDITOR: Will Lach
DESIGNERS: Misha Beletsky, Patricia Fabricant
PRODUCTION MANAGER: Louise Kurtz

First edition
2 4 6 8 10 9 7 5 3

Library of Congress Cataloging-in-Publication Data
Names: Sibley, David Allen, writer of afterword. | Long, Gregory (Gregory R.), writer of foreword. | Fraser, Susan M., writer of preface. | McDowell, Marta, writer of introduction.
Title: The trees of North America: Michaux and Redouté's American masterpiece / afterword by David Allen Sibley; foreword by Gregory Long; preface by Susan M. Fraser; introduction by Marta McDowell.
Description: New York: Abbeville Press Publishers, [2017]
Includes bibliographical references and index.
Identifiers: LCCN 2016036494 | ISBN 9780789212764 (hardcover: alk. paper)
Subjects: LCSH: Trees—North America—Identification.
Redouté, Pierre-Joseph, 1759–1840. | Michaux, François-André, 1770–1855.
Classification: LCC QK115 .T73 2017 | DDC 582.16097–dc23
LC record available at https://lccn.loc.gov/2016036494

ISBN 978-0-7892-1276-4

For bulk and premium sales and for text adoption procedures, write to Customer Service Manager, Abbeville Press, 116 West 23rd Street, New York, NY 10011, or call 1-800-ARTBOOK. Visit Abbeville Press online at www.abbeville.com.

Contents

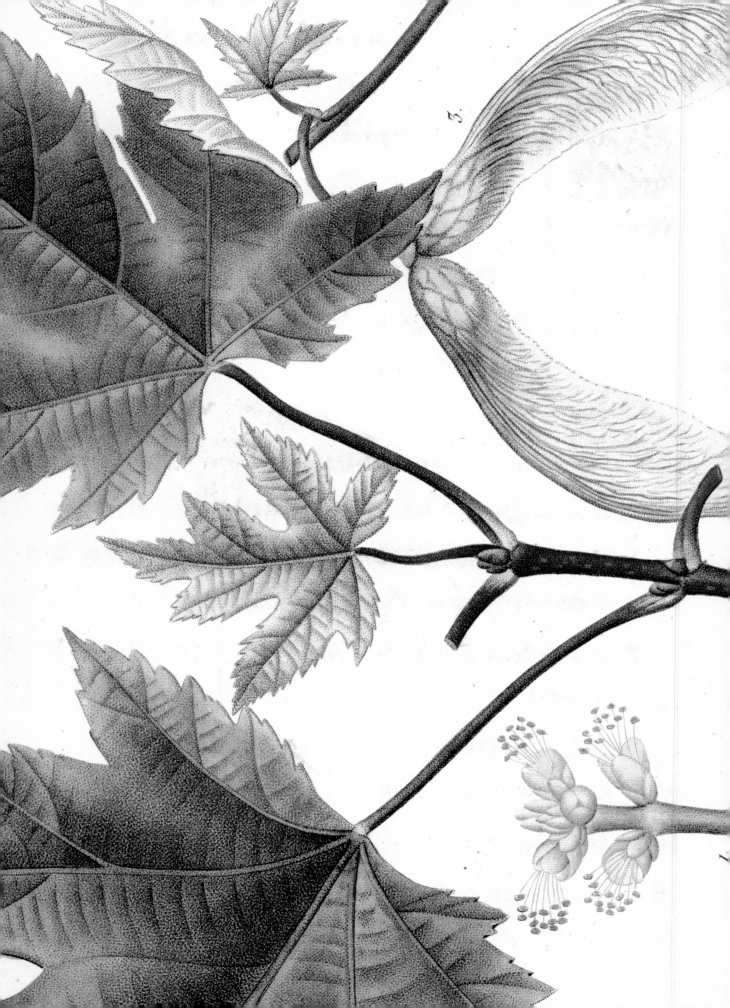

The North American Sylva
and
The New York Botanical Garden

Gregory Long

THE IMPORTANCE OF THE SEMINAL WORKS of father-son team André (1746–1802) and François-André (1770–1855) Michaux and Thomas Nuttall (1786–1859) to the study of American forestry as well to the foundation of The New York Botanical Garden's LuEsther T. Mertz Library Collection cannot be overstated.

André's *Flora Boreali-Americana* (1803) was the first American flora, and François-André's *The North American Sylva* (1817), with supplementary volumes by Nuttall in the 1840s, was the first silva, a descriptive flora of forest trees. The latter remained a standard work for the study of North American woody plants throughout the 19th century. NYBG was founded in 1891 (its 250-acre site selected primarily because of stands of centuries-old trees and great diversity of woodland plants), and trees of this continent were an early area of research by its scientists. Shortly thereafter, the Garden's library was formed with high ambitions to become a comprehensive repository about the plants of the world. The Michaux work, in all of its many editions in French and English was—and continues to be—one of its most important acquisitions. We are delighted to present these important illustrations in a book that commemorates the 125th year of The New York Botanical Garden.

In the 1890s, the Garden's founding Board established the Special Book Fund to acquire the antiquarian and rare materials that would form the base of our now world-renowned library. Philanthropists such as Andrew Carnegie and J. P. Morgan were among the principal donors to the Fund. Founding Director Nathaniel Lord Britton and his colleagues used this support to acquire thousands of rare books and illustrated folios for the new library. The first editions of *The North American Sylva* and other volumes by Michaux were acquired at this time. We have continued to add to the Michaux collection, including through an ongoing gift of works, starting in 2002, from the library of David L. Andrews, M.D. (1930–2016).

Some of our original editions of Michaux came from the collection of David Hosack, M.D. (1769–1835), who not coincidentally founded our predecessor institution, the Elgin Botanic Garden (1801–1812), the first botanical garden in New York City. Notably, among the volumes that Dr. Andrews donated was also a signed and numbered edition from the personal library of John Torrey, M.D., the father of American botany.

It is natural that much of our collection has come from the libraries of physicians. There has always been a close connection between the medical profession and plant science, and many early botanists were themselves physicians. Both Hosack and Torrey held the position of chair of the botany department at Columbia College, and were instrumental in fostering the expansion of *materia medica* and botanical knowledge, which was vital to medical practice. This interest propelled New York City to become the center of American botanical scholarship in the early 19th century.

New York City's continued prominence in plant science coincided with public interest in American natural history, ornamental horticulture, and Romantic garden design, as well as the growth of the nursery and seed industries—of which the Michaux, father and son, were involved through the nursery they ran for many years in New Jersey. The final push was the reform-minded City Beautiful Movement, which spurred the creation of the City's great cultural institutions at the end of the 19th century, including NYBG.

Since then, the Mertz Library has become the premier library of botanical works in the world. Each year, thousands of researchers from a variety of science and humanities disciplines, including molecular systematics, plant genomics, the history of science, new world exploration, garden and landscape history, botanical illustration, the book arts, and urban ecology, consult these wonderful collections.

The Mertz Library has been generously funded over many years by the LuEsther T. Mertz Charitable Trust as well as The Andrew W. Mellon Foundation, the National Endowment for the Humanities, and many others. The Library currently holds more than 1.3 million physical and digital items, including more than 18,000 rare volumes dated before 1850 and comprehensive, pre-Linnean collections of medieval and Renaissance herbals, and large and small folios, alongside the latest botanical and horticultural publications. We also have one of the most active digitization programs of any botanical garden in the world, and are a founding member of the Biodiversity Heritage Library.

I would like to thank Susan M. Fraser, NYBG Vice President and Director of the Mertz Library, for engendering this project and contributing an essay on the publication history of *The North American Sylva*. She also organized a group of Garden staff to verify plant names and write the species treatments. They are acknowledged individually on page 392. We are also indebted to garden historian Marta McDowell and artist-naturalist David Allen Sibley whose own essays establish the context for this remarkable work.

The North American Sylva: A Landmark of American Botanical History

Susan M. Fraser

THE BOTANICAL CONTRIBUTIONS of the father-son team André and François-André Michaux will be forever entwined. When François-André was 15 years old (in 1785) he traveled to New York with his father and their gardener, Paul Saulnier. They established a nursery near Hackensack, New Jersey, where they proposed to grow American trees for export to France. Their exploration took the Michaux to Charleston, South Carolina, where they purchased land for a second nursery where trees of southern origin would be grown and exported. Exploring expeditions were made to Florida and the Bahamas and then up the Savannah River, over the Appalachian Mountains and into the Tennessee Valley.

François-André returned to France in 1790 only to find the trees secured from their nurseries had either been neglected or given away by Marie-Antoinette, then Queen of France. In 1796 the elder Michaux also returned to France after his financial resources were exhausted and the French Government declined to fund future explorations in the New World. Reunited, father and son would set out to prepare for publication *Histoire des Chênes de l'Amérique* (1801), the beautifully illustrated work on the North American oaks, which formed the basis of their more complete work on the trees of North America, *Histoire des Arbres Forestiers de l'Amerique Septentrionale*, published in Paris in 1810 and later translated into English by François-André Michaux and published as *The North American Sylva*.

The 156 engraved plates first produced in Paris were masterfully executed from the drawings by Pierre-Joseph Redouté (1759–1840), Pancrace Bessa (1772–1846), Adèle Riché (1791–1887) and Henri-Joseph (1766–1852) and Antoine-Ferdinand (1756–1809) Redouté, and were printed in color and finished by hand. The first translated edition of *The North American Sylva* was printed in 1817 in Paris by C. d'Hautel and sold by Thomas Dobson of Philadelphia. The work was published in parts and originally planned to be six half volumes, but a seventh half volume and six additional plates were added to the subsequent printings, which also included a revised translation by Augustus L. Hillhouse (1791–1859). Despite its success, Michaux continued to hold out hope that a true American edition would be published. Eager to return to the New World, the younger Michaux solicited a commission

from the Minister of Agriculture in France, to resume work there. In 1801 he was dispatched to America where he traveled through seaboard cities and backwoods regions.

In 1808, the very year François-André Michaux left the U.S. for the final time, young English naturalist Thomas Nuttall (1786–1859) traveled to North America to study its natural history. In Philadelphia, Nuttall met Benjamin Smith Barton, who was serving as Vice President of the American Philosophical Society, and under whose sponsorship Nuttall made collecting trips to Delaware, the Upper Peninsula in Michigan, and the upper Missouri River. Nuttall identified several species new to him with the help of André Michaux's *Flora Boreali-Americana* (1803). His work with Barton and subsequent collecting trips and his 1818 publication, *Genera of North American Plants, and a Catalogue of the Species to the Year 1817,* established Nuttall as America's premier botanist. In 1834 Nuttall participated in the Wyeth expedition to Oregon and the Columbia River where he traversed the Rocky Mountains and explored the territory of Oregon and Upper California. Nuttall, who often lacked financial means, was grateful to philanthropist William Maclure (1763–1840) for providing support for his scientific endeavors. Maclure made his fortune as a textile merchant and was able to retire at a young age to pursue a career in geology. President of the Academy of Natural Sciences in Philadelphia for 22 years, he is famed for creating the first geological map of the U.S. in 1808. During a visit to Paris, Maclure had purchased the engraved copper plates for *The North American Sylva*, which he intended to republish in the U.S. He had acquired land in New Harmony, Indiana, on which he hoped to establish an agricultural school. Other like-minded intellectuals followed Maclure to Indiana to the area developed into a utopian community, including William Amphlett, the expert printer, who in 1841 printed *The North American Sylva*, the first truly American edition (see page 11). This New Harmony edition was a reprint of an 1819 Paris edition that included the first translation into English by Hillhouse and was the first edition to mention the additional compendium volumes by Nuttall on the title page.

In 1839, after traveling around the South, Nuttall returned to Philadelphia where he began work on a revision of Michaux's *The North American Sylva*. His work, which would also include the trees from his Trans-Mississippi explorations and those discovered in the Rocky Mountains, Oregon, and California, took seven years to complete and resulted in the three-volume supplement. Volume 1 parts 1 & 2 were published by Judah Dobson in 1842 and 1843, respectively. Volume 2 was published by T. Ward in 1846 and Volume 3 by Smith and Wistar in 1849. Nuttall compiled the text and supervised the drawings. The work was printed in Philadelphia and Nuttall arranged for artists specializing in lithography to complete the plates. William Gambel (1823–49) collected many of the plants in the Rocky Mountains and Upper California in addition to making the drawings, and E. D. Long, G. Worley, G. West, J. T. French, and J. B. Butler prepared and executed the 120 plates in the supplement. The original drawings with Nuttall's notes and directions to the printer are held at the Harvard Botany Libraries.

Michaux and Nuttall's landmark work has a complicated bibliographic and printing history. There are at least 28 copies of 16 known editions and

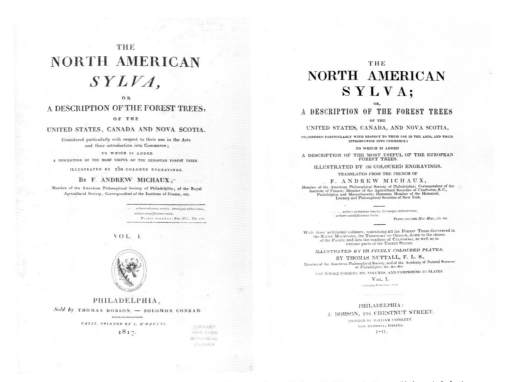

Title pages of *The North American Sylva*, 1817 edition (left) and 1841 edition (right)

various printings in different formats, and in different states or varia-
tions within an edition. Using the bibliographies published by the Morton
Arboretum and compiled by Ian MacPhail (b. 1923) in *André & François-
André Michaux* (1981), and in *Thomas Nuttall* (1983), it appears the LuEsther
T. Mertz Library has an almost complete collection of all the variant states of
the work, including the rare first American edition printed in New Harmony.
Most of these volumes came to the Garden by NYBG Board Member and
avid collector David L. Andrews, M.D. (1930–2016), whose own library of
botanical and horticultural Americana supplements many of the early works
by Michaux and Nuttall that were acquired by the Mertz Library from early
purchases and donations.

In 1785 Humphry Marshall (1722–1801), cousin of naturalist John Bartram
(1699–1777), published *Arbustrum Americanum: the American Grove*, a small
work on trees without illustrations, but it was Michaux and Nuttall's beauti-
fully illustrated *The North American Sylva* that became the standard work on
trees of North America until renowned American botanist Charles Sprague
Sargent (1841–1927), the first Director of Harvard's Arnold Arboretum, pub-
lished his *Silva of North America* (1891–1902).

INTRODUCTION

François-André Michaux and Thomas Nuttall: The Forest and the Trees

Marta McDowell

AT THE HEART OF THE NEW YORK BOTANICAL GARDEN lies the 50-acre Thain Family Forest, the largest remaining tract of the mixed hardwood forest that once covered much of New York City. Mammoth tulip poplars, American beeches, oaks, and maples, among many other remarkable specimens, inhabit this 50-acre urban oasis that hugs the Bronx River. One wonders what two intrepid botanists, namely François-André Michaux (1770–1855) and Thomas Nuttall (1786–1859), would have found and recorded in their journals if they had traversed this woodland, for in the early decades of the 19th century, they authored the six-volume *The North American Sylva*. It was the first illustrated compendium of the trees that populated the forests from Atlantic to Pacific and from Canada to Mexico.

Both men were expats, Michaux from France and Nuttall from England, who disembarked at ports in the new United States as botanical neophytes. They returned to their respective countries as field-trained scientists. Neither became American citizens, but each left a legacy to their temporary country in printed form, *The North American Sylva* the most prominent among their publications.

While a colonial cohort of botanists—Mark Catesby (1682/3–1749), Pehr Kalm (1716–79), and John Bartram (1699–1777), to name a few—had made progress in the run-up to the American Revolution, the continent still held riches for naturalists of the next generation. For those like François-André Michaux and Thomas Nuttall, North America remained a new world. It offered a diversity of habitats, from tropical to boreal, which were unexplored or little explored, at least from a Eurocentric perspective. For finding specimens new to science, it was the place to be.

Both Michaux and Nuttall seemed to get to know everyone who was anyone in science. Both men also had a useful way of bumping into other botanists when they were out in the field, although strangely enough they may never have met one another. And yet while the 19th century knew their names, today both are largely forgotten outside the botanical sphere. They are overshadowed on two sides by their predecessors who got there first, and by the next group of botanists, such as Asa Gray and John Torrey, who were Americans writing for an American audience.

François-André Michaux

 François-André Michaux also stands in the shadow of his father, André Michaux (1746–1802), with whom he first traveled in America and from whom, one assumes, he learned the ropes of plant hunting, classification, and publication. Like other father-son teams over the course of American landscape history—the Bartrams and the Olmsteds come to mind—the fact that there were two Michaux, *père et fils,* with similar first names, adds to the confusion.

 For much of his childhood, François-André Michaux was a near orphan. Born on August 16, 1770, near the great palace of Versailles, his mother died at or shortly after his birth. He had the benefit of tutors and the attention of uncles and aunts who continued to farm the family property, but his absentee father was often off to distant climes on plant collecting forays. Things changed in 1785 when André Michaux, as the newly appointed Royal Botanist to Louis XVI, decided to take his 15-year-old son along to America. A royal commission furnished letters of introduction and a comfortable stipend. Parent and child arrived aboard *Le Courrier de New York* in mid-November, along with a manservant and an experienced horticulturist from the Jardin du Roi. Their plan was straightforward: to collect and ship back unique plants for the king's gardens and to find species of American trees useful to the monarchy.

Motivations for the expedition included the geopolitical. Europe was confronting an energy crisis. Before fossil fuels, it was forests that the human race consumed at alarming rates. To fuel early manufacturing—especially charcoal for iron smelters and glassworks—timber was the thing. The military had also claimed its share of arboreal resources. France, along with the other European global powers, had engaged in a centuries-long naval arms race, and their armadas were wood. As a result, it had been a steady disappearing act for the ancient woodlands across the continent and the British Isles, and a scientific approach to reforestation was a priority. In addition to military-industrial drivers, there was also retail demand for American trees. An arboretum of exotic ornamentals was an expected improvement for any property of substance, up to and including the king's.

Over their first year in America, the father-son Michaux team set up two nursery gardens, one in New Jersey and the other in Charleston, South Carolina. André Michaux, perhaps with son in tow, also networked with American luminaries of plants and politics: Benjamin Franklin; John Bartram's plantsmen sons, John and William; General George Washington at Mount Vernon; and Henry Middleton at Middleton Place, one of the oldest landscaped gardens in America, in Charleston, South Carolina.

Then it was into the wild, collecting in Georgia and the Carolinas, and crisscrossing Spanish Florida. It was not easy going. They covered up to 30 miles a day by foot, stage, horseback, and birchbark canoe, stopping to dig plants and collect seeds. In between expeditions, it was back to their nurseries to clean and cultivate, pack chests, and arrange cargo for ships bound for France. One of their consignments included some "2,500 trees, shrubs, and plants, seven chests in all." On occasion François-André was left to manage the Charleston garden while his father went to collect solo.

The year 1789 brought events that changed their lives. On July 14, a mob stormed the Bastille, the first domino to fall in the run up to the Revolution that eventually toppled the monarchy, and with it financial support for their work. Then, on September 20, on the way back from a trip to the Appalachian Mountains, François-André was accidently wounded in the left eye with stray shot from a hunter. Later that year or early in 1790, he sailed back to France while his father stayed on in America. Sources vary as to why he returned—procuring medical treatment for his eye, monitoring the family finances, and furthering his formal education are mentioned. Likely it was all three.

Michaux earned his medical degree in Paris and continued his study of botany at the former Jardin du Roi—by then rechristened Jardin des Plantes. When his father returned to France in 1796, it is likely that the two worked together on preparations for the elder Michaux's *Histoire des Chênes de l'Amérique* —The Oaks of North America—published in Paris in 1801. François-André became devoted to trees and scientific forestry. He returned twice more to America, in 1801–1803 and 1806–1808, with commissions from the new French republic to continue the work that he and his father had begun.

During his first trip, he collected in the Carolinas and across the old Northwest—Ohio, Kentucky, and Tennessee. But while the son was in America, the father set off in the opposite direction on a scientific voyage to New Holland (Australia). En route, André Michaux died of a fever while exploring

Thomas Nuttall

Madagascar in November 1802. Undeterred, François-André went on to collect more American plants and meet with the scientific establishment. He returned to France and promoted his father's posthumous *Flora Boreali-Americana*— The Flora of North America—in 1803. Two years later he published his own journal of travels west of the Alleghenies. But it was his next work, three illustrated volumes on the trees of eastern North America, which cemented François-André Michaux's place in the botanical pantheon, the *Histoire des Arbres Forestiers de l'Amérique Septentrionale*, published in 1810. Its readable prose is packed with details: description, provenance, history, and commercial potential. Botanical artists, including the Redouté brothers, supplied its splendid illustrations of leaves and seeds. Colleagues at the American Philosophical Society helped arrange an English translation, *The North American Sylva*, published in Philadelphia in 1817, with plates printed in Paris.

Unlike Michaux, Thomas Nuttall did not inherit a botanical career. Born on January 5, 1786, in the Yorkshire village of Long Preston, he was apprenticed to his uncle, a printer, in Liverpool. His formal education seems sparse, limited to the parish school, but he was clearly precocious. Scholars speculate that he taught himself Latin, then the lingua franca of the scholarly world, as

well as Greek, French, and the rudiments of scientific theory then coalescing in the late years of the Enlightenment. Natural history was first a hobby then a passion, his interest stimulated by a boyhood friend, John Windsor, with forays in the West Riding and the Ribble Valley. In 1808 he turned his back on the certainty of a position in the family printing business to follow his star. With little money but great enthusiasm, he boarded a ship bound for America and landed in Philadelphia, that hotbed of science, in October. He was 22 years old.

Nuttall had an unusual entry into the city's scientific circle. Finding a plant he thought to be a species of *Passiflora,* he sought out an authoritative identification. All roads led to Benjamin Smith Barton, professor of medicine and botany at the University of Pennsylvania. The timing was perfect. Barton was in dire need of an assistant in the herbarium and in the field. So Nuttall was launched, collecting for Barton around New Jersey, Delaware, and surrounds, and meeting other plant enthusiasts in places such as Barton's home and lecture hall, seed merchant Bernard McMahon's Philadelphia shop, and William Bartram's home and nursery outside town along the Schuylkill River.

The next year, Barton sent Nuttall west, to collect "animals, vegetables, minerals, Indian curiosities, etc." He intended Nuttall to retrace much of the trail blazed by Meriwether Lewis and William Clark, building on their discoveries. Barton outfitted his assistant with supplies and equipment and offered a meager monthly salary, payable on his return—if he returned.

For the rigors of western travels, Nuttall seemed wildly unsuited, possessing no frontier skills and suffering from malaria contracted in the swamps of the Mid-Atlantic states the year before. What he had were luck and exceptional focus. He worked his way mostly by foot, along the shores of the Great Lakes up to Lake Winnipeg, collecting, always collecting. He linked up with a group of explorers and trappers funded by John Jacob Astor for his Pacific Fur Company and accompanied them up the Missouri River. Their French-Canadian boatmen thought him *fou*—crazy—wandering off in search of plant finds, oblivious to danger, using his rifle as a makeshift spade to dig plants and its barrel as handy storage for seeds. The trip ignited Nuttall's love of the wild reaches of America's West.

During the War of 1812, Nuttall returned to England, working with a friend of Michaux, John Fraser, to introduce his new American plants through Fraser's Chelsea Nursery. The Linnean Society of London elected Thomas Nuttall to its rolls in 1813. After the war, he promptly returned to America and resumed collecting up and down the East Coast. He published his first book, the two-volume *Genera of North American Plants,* at his own expense in 1818. That it was written in English, perhaps because of his lack of Latin proficiency, was unique among botany books of the day and proved popular. In completeness, it superseded André Michaux's 1803 *Flora* and another published by Frederick Pursh in 1814.

The West beckoned. Nuttall resumed his natural history travels "for the investigation of the natural history of a region hitherto unexplored," up the Arkansas and Red Rivers. In 1821 a Philadelphia printer published his *A Journal of Travels into the Arkansas Territory.* Thomas Jefferson suggested Nuttall to James Madison as a professor for their newly established University of Virginia, but it was Harvard that hired him. In 1823 he moved

to Cambridge to curate the college's seven-acre botanic garden and lecture in natural history.

While at Harvard, Nuttall wrote an introductory botany textbook, took collecting excursions, and befriended Massachusetts nurserymen, students, and scholars, including John James Audubon. Like many, then and now, smitten with trees, he also loved birds, and wrote a general field guide, a modestly-priced and readable two-volume set entitled *A Manual of Ornithology of the United States and of Canada* in 1832.

Nuttall became restless "vegetating," as he put it, in the groves of academe. In 1834 he left Harvard for "an exploratory tour across the continent." He collected plants and birds, minerals and mollusks, across the Pacific Northwest, California, and the Sandwich Isles (Hawaii). On the voyage back to Boston around Cape Horn in 1836, he had a chance encounter with a former Harvard student, Richard Henry Dana. The young man had signed aboard *The Pilgrim* as a regular seaman and wrote the best-selling *Two Years Before the Mast* based on his experiences. Dana wrote that the *Pilgrim*'s crew dubbed Nuttall "Old Curious" for the time he spent "picking up flowers and shells and such truck."

Upon his return to the East Coast, Thomas Nuttall took on the task of updating Michaux's *North American Sylva* for a new edition. He added a three-volume supplement, principally of western trees, writing the text and supervising the drawings for the additional plates. Its dedication appropriately acknowledged "F. Andrew Michaux, Member of the American Philosophical Society, Correspondent of the Institute of France, &c. &c whose name is identified with the history and importance of the productions of the North American forest."

The scientific establishment recognized the contributions of both authors of *The North American Sylva* during their lifetimes. Both men were comfortably well off in later life, though neither ever retired completely. François-André Michaux died on the night of October 23, 1855, on his estate in Vauréal. That day he had been directing his gardeners in planting more American trees. He left a legacy to the American Philosophical Society in Philadelphia to advance the study and practice of forestry in the United States. Thomas Nuttall came into money and property when his printer uncle's Lancashire estate devolved on him, with the requirement that he reside there nine months of each year. He returned to England in 1842 to continue less ambitious horticultural pursuits as master of Nutgrove Hall. He died on September 10, 1859.

From the heart of The New York Botanical Garden's native forest, the city's sounds yield to wind, water, and birdsong. I am reminded that Henry David Thoreau studied *The North American Sylva* to learn about the trees encountered in his own surrounds. Whether he read the revised edition is unknown, but Thoreau would have concurred with Thomas Nuttall, who wrote in its preface, "My chief converse has been in the wilderness with the spontaneous productions of Nature and the study of these objects and their contemplation have been to me a source of constant delight." Trees define the character of a place. They anchor us, at a scale larger than the human in both size and time. *The North American Sylva* continues to provide an entrée to the study and appreciation of trees, the majestic denizens of the world we share.

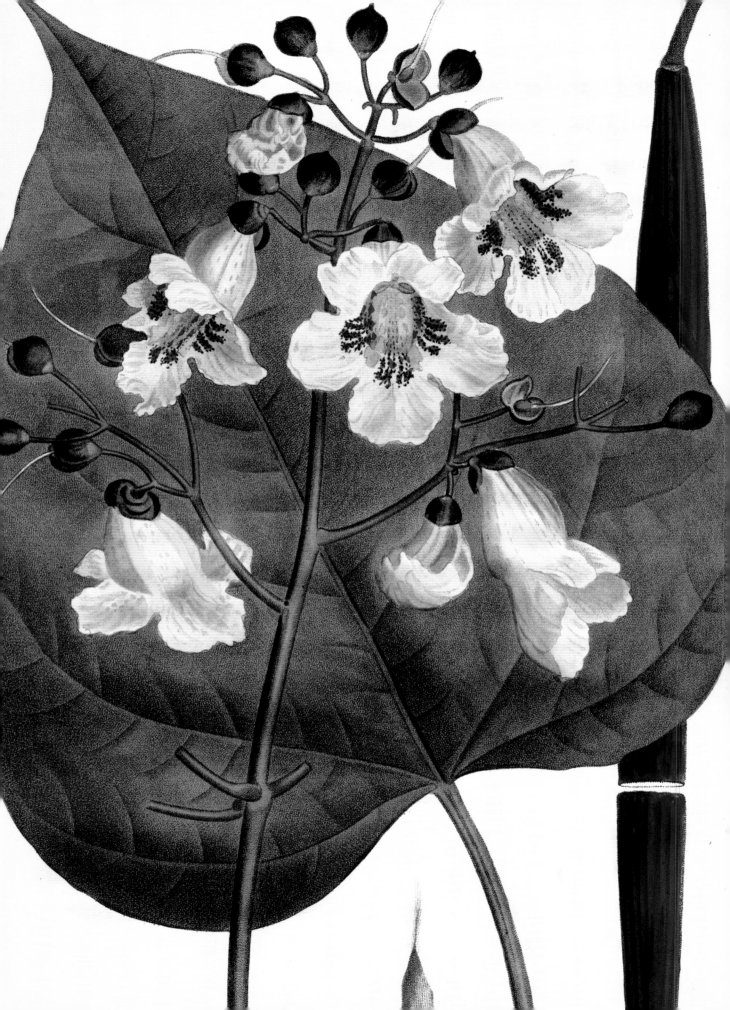

The Plates

A Note About the Plates

The plates in this book are not ordered according to the volumes of *The North American Sylva* by François-André Michaux and Thomas Nuttall. They are arranged alphabetically by family and then by the genus and species as identified by Michaux or Nuttall. A few exceptions occur when variant species assigned by Michaux or Nuttall are now single species or when multiple species on a single plate are identified in number order.

A two-way concordance is provided on pages 378–381, which relates the order of the plates as they appear in this book to the plates as they are numbered in the volumes of *The North American Sylva*.

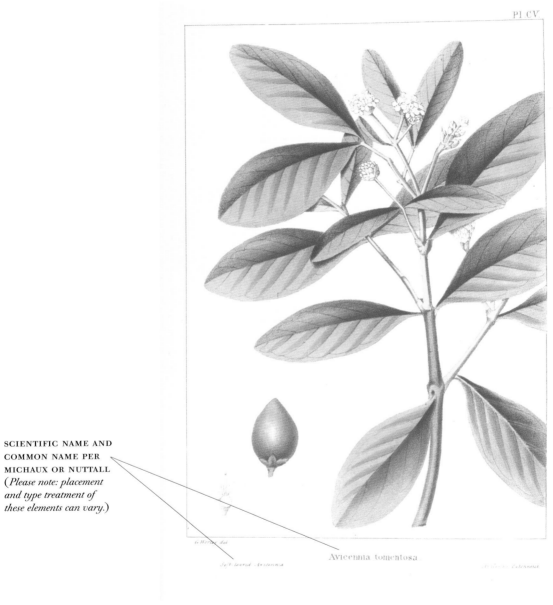

Pl. CV.

Avicennia tomentosa

SCIENTIFIC NAME AND
COMMON NAME PER
MICHAUX OR NUTTALL
(*Please note: placement
and type treatment of
these elements can vary.*)

PLATE NUMBER AS IT
APPEARS IN THIS BOOK

Pl. 1. Black Mangrove (*Avicennia germinans* (L.) L.)

COMMON NAME(S)
PER MODERN USAGE

SCIENTIFIC NAME
PER CURRENT
CLASSIFICATION

AUTHOR(S) OF SCIENTIFIC
NAME—PERSON(S) WHO NAMED
AND/OR REVISED THE SPECIES

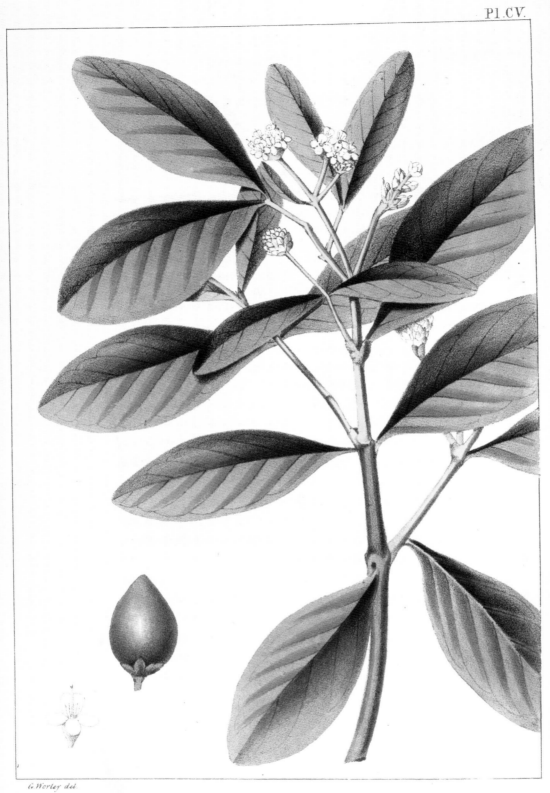

G.Worley del.

Avicennia tomentosa.

Soft-leaved Avicennia Avicennia Cotonneux

Pl. 1. Black Mangrove (*Avicennia germinans* (L.) L.)

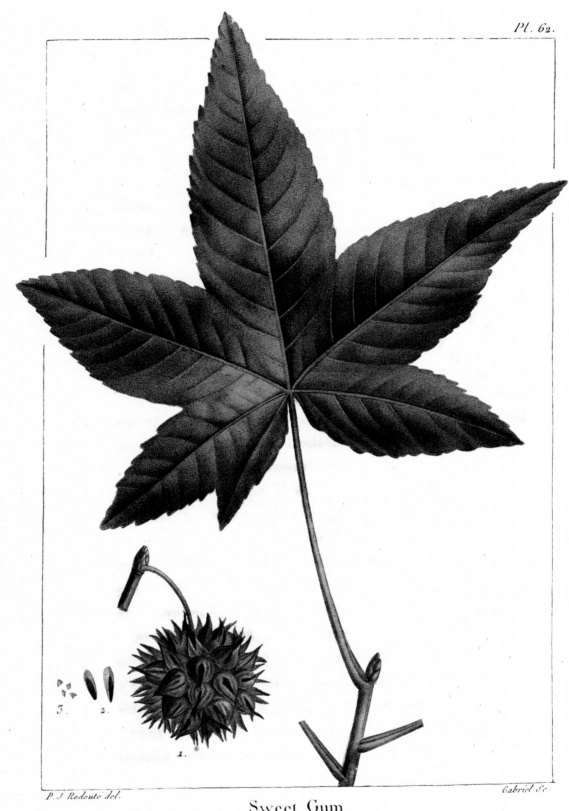

Pl. 62.

P. J. Redouté del.

Gabriel Sc.

Sweet Gum
Liquidambar styraciflua

22] Pl. 2. Sweetgum, Redgum, Sapgum (*Liquidambar styraciflua* L.)

Pl. LXXXI.

Cotinus Americanus.

Large Leaved Cotinus. Sumac Fustet d' Amérique.

G. Werley del.

Pl. 3. American Smokebush (*Cotinus obovatus* Raf.) [23

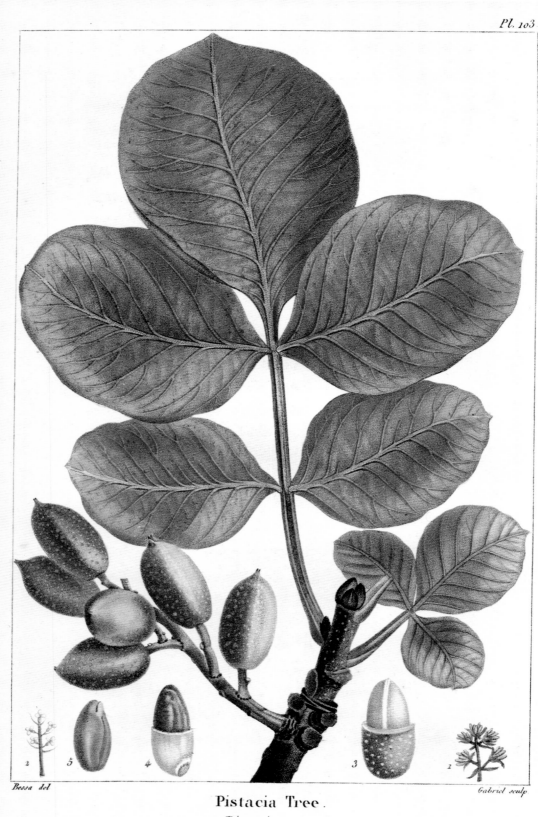

Pl. 103

Bessa del

Gabriel sculp

Pistacia Tree.
Pistacia vera.

Pl. 4. Pistacia Tree, Pistachio (*Pistacia vera* L.)

Pl. 101

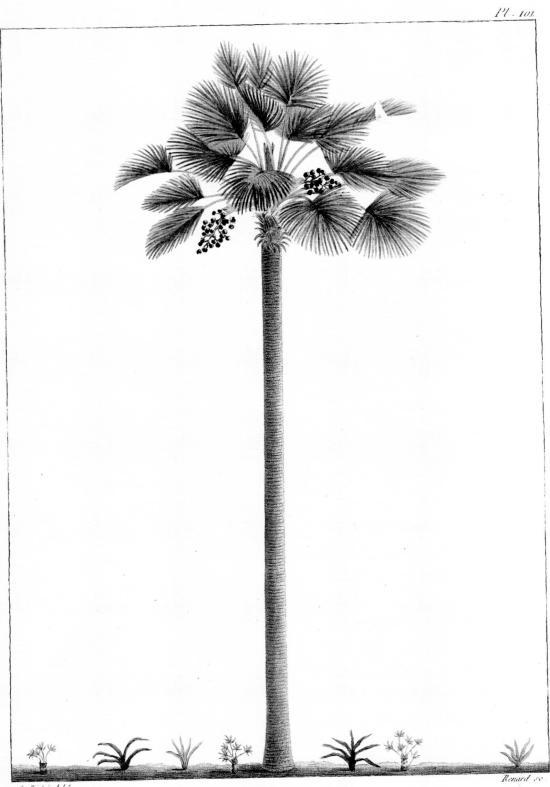

A. Riché del.

Renard sc.

Cabbage Tree.
Chamærops palmetto.

Pl. 9. Cabbage Palmetto (*Sabal palmetto* (Walter) Lodd. ex Schult. & Schult. f.)

Pl. 75.

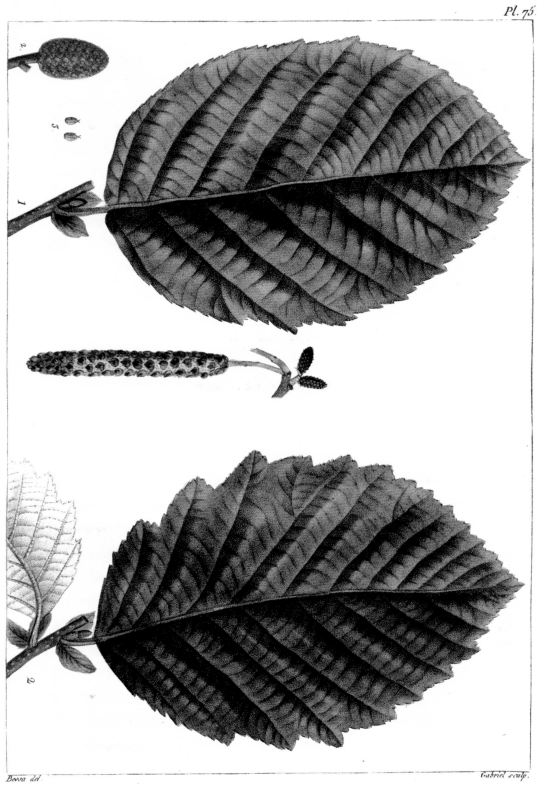

Bessa del.

Gabriel sculp.

1. Common Alder
Alnus surrulata.

2. Black Alder.
Alnus glauca.

Pl. 10 (1). Smooth Alder (*Alnus serrulata* (Aiton) Willd.),
(2). Speckled Alder (*Alnus incana* (L.) Moench subsp. *rugosa* (Du Roi) R. T. Clausen)

Pl. X.(bis)

J.T.French del.

Sinclair's Lith Phil*.

Sea-side Alder. **Alnus maritima.** *Aune maritime*

Pl. 11. Seaside Alder (*Alnus maritima* (Marshall) Muhl. ex Nutt.)

Pl. IX.

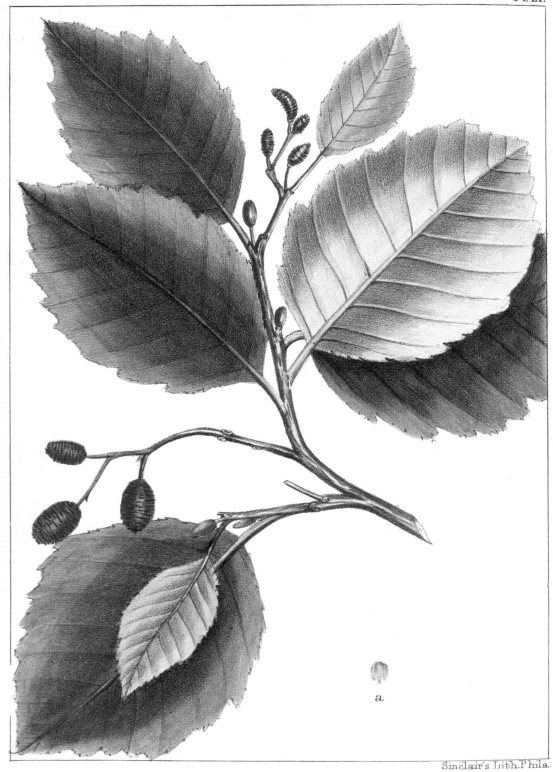

Sinclair's Lith. Phila.

Oregon Alder **Alnus Oregona.** *Aune de l'Oregon.*

a

Pl. 12. Red Alder (*Alnus rubra* Bong.)

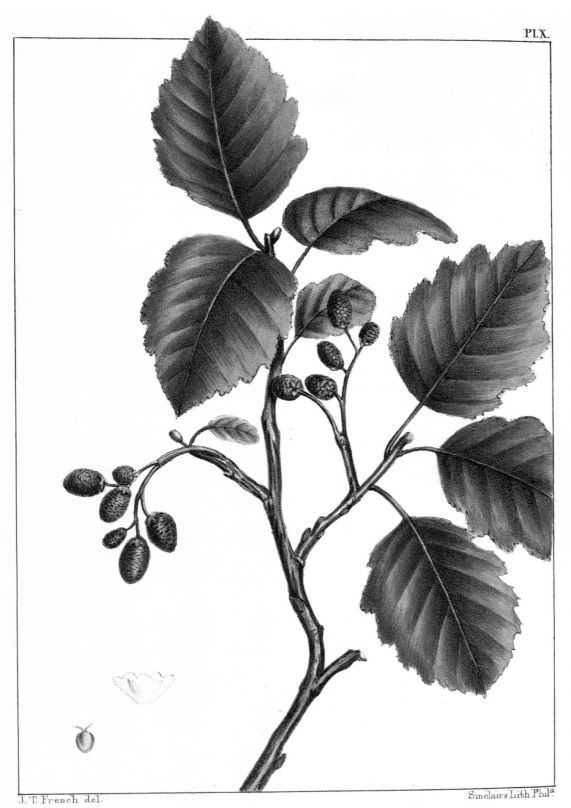

J.T. French del. Sinclairs Lith Phila

Alnus tenuifolia
Thinleaved Alder. *Aune menu feuille.*

Pl. 13. Mountain Alder, Thinleaf Alder
(*Alnus incana* (L.) Moench subsp. *tenuifolia* (Nutt.) Breitung)

Pl. 70.

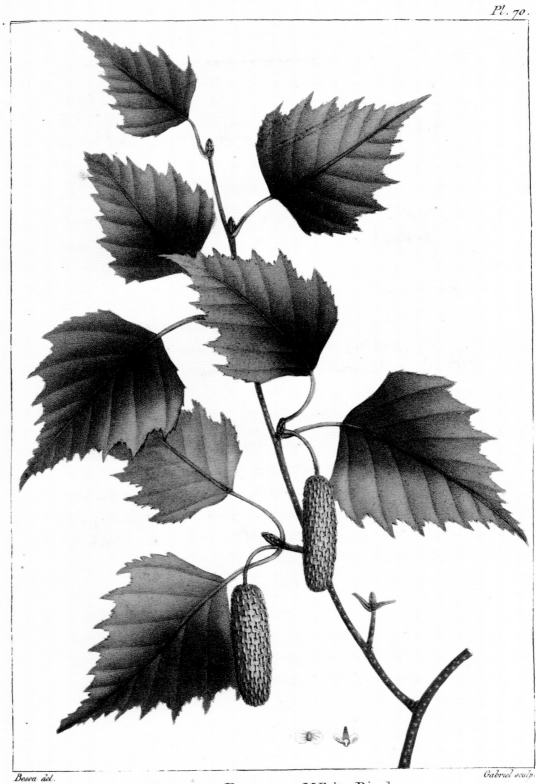

Bessa del.

Gabriel sculp.

Common European White Birch.
Betula alba.

Pl. 14. Downy Birch, European White Birch (*Betula pubescens* Ehrh.)

Pl. 74.

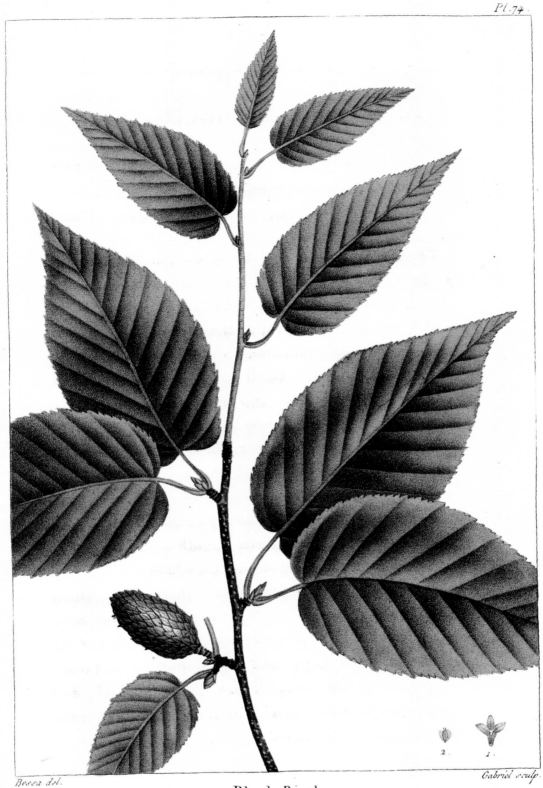

Bessa del.

Gabriel sculp.

Black Birch.

Betula lenta.

Pl. 15. Sweet Birch, Cherry Birch (*Betula lenta* L.) [35

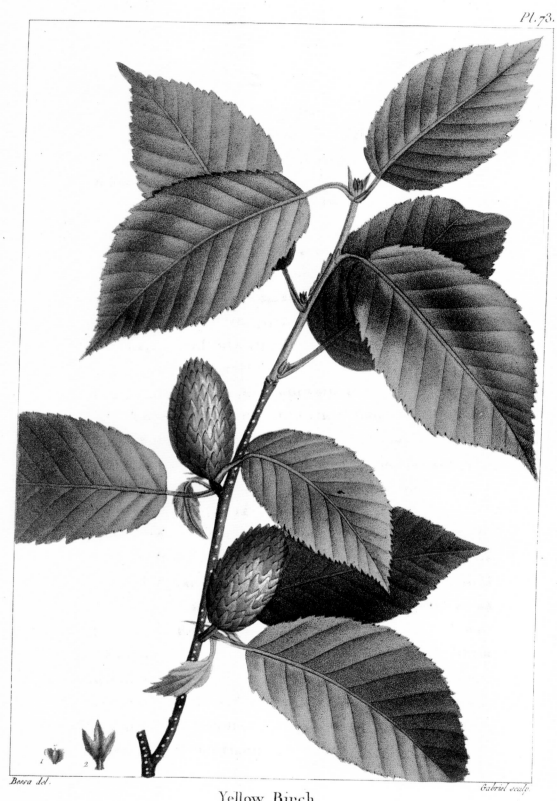

Pl.73.

Bessa del.

Gabriel sculp.

Yellow Birch.

Betula lutea.

36] Pl. 16. Silver Birch, Swamp Birch (*Betula alleghaniensis* Britton)

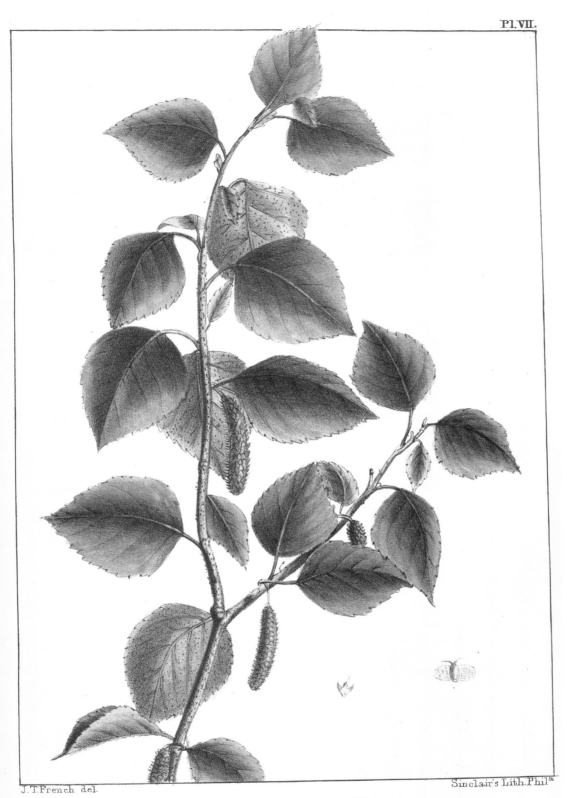

J.T.French. del.

Sinclair's Lith.Phil^a

Betula occidentalis.

Western Birch. *Bouleau occidental.*

Pl. 17. Water Birch (*Betula occidentalis* Hook.)

[37

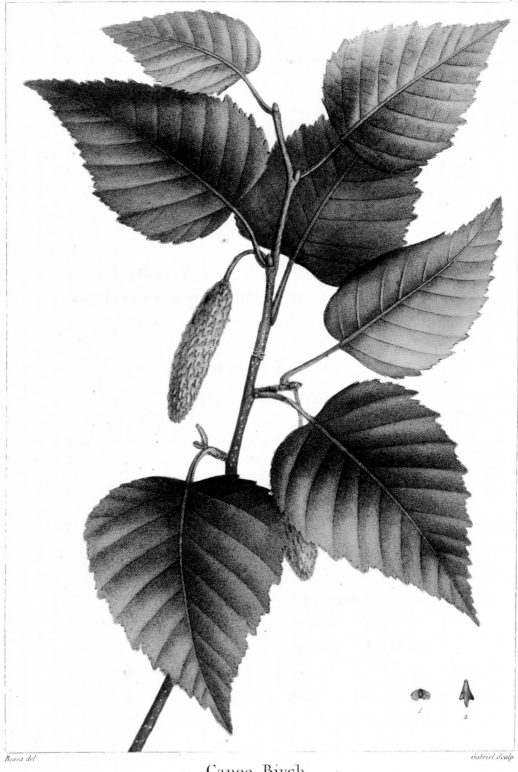

Canoe Birch.
Betula papyracea.

Pl. 18. White Birch, Paper Birch, Canoe Birch (*Betula papyrifera* Marshall)

Pl.72.

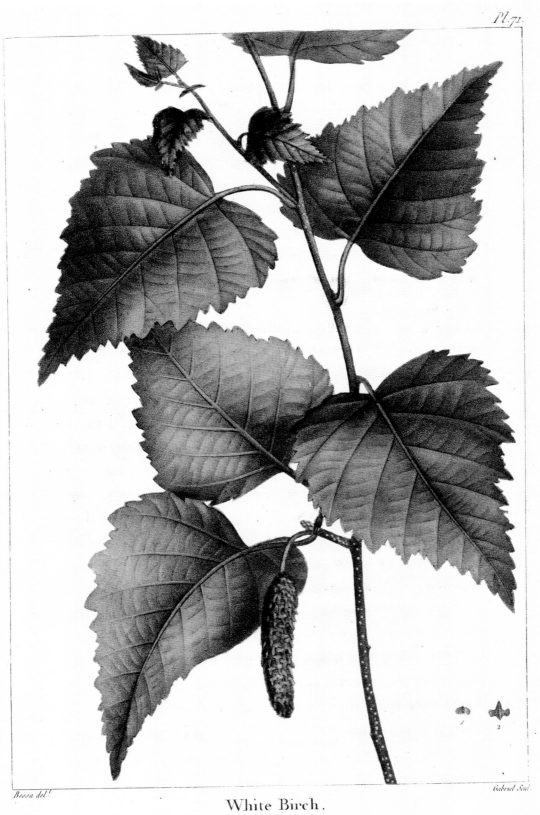

Bessa del. Gabriel Sculp.

White Birch.

Betula populifólia.

Pl. 19. Gray Birch, Poplar Birch (*Betula populifolia* Marshall) [39

Pl. VIII.

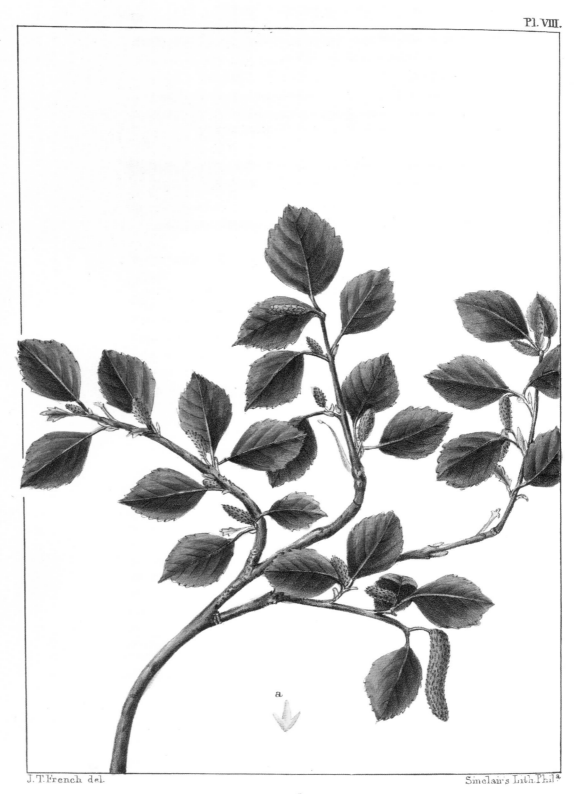

a

J.T.French del.

Sinclair's Lith.Phila

Betula rhombifolia.

Oval-leaved Birch. *Bouleau à feuilles ovales.*

Pl. 20. Water Birch (*Betula occidentalis* Hook.)

*Pl.*72.

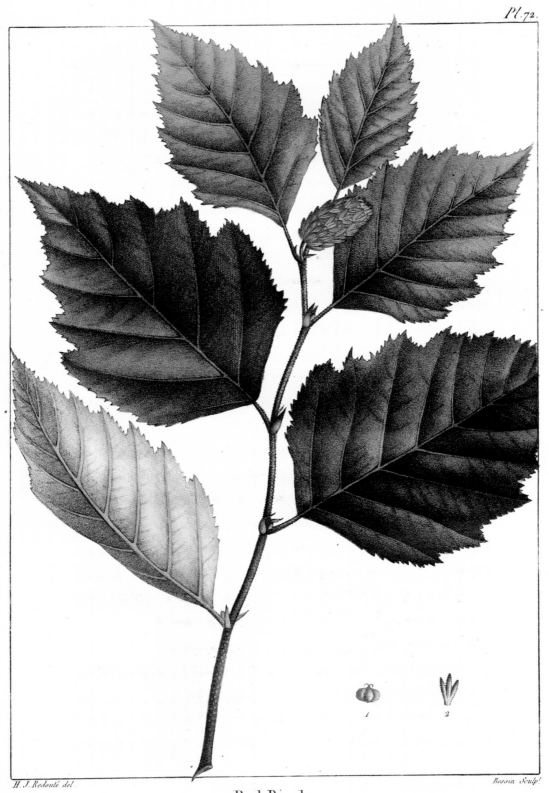

H.J. Redouté del.

Bossin Sculp.

1 *2*

Red Birch.

Betula rubra.

Pl. 21. River Birch, Black Birch (*Betula nigra* L.) [41

Pl. 109.

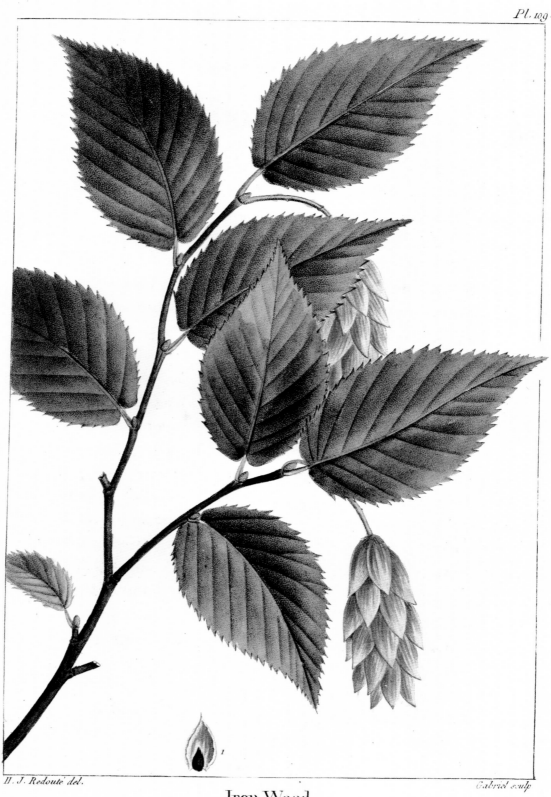

II. J. Redouté del. _Gabriel sculp_

Iron Wood.

Carpinus ostrya.

Pl. 22. Ironwood, Hophornbeam (_Ostrya virginiana_ (Mill.) K. Koch)

Pl.108.

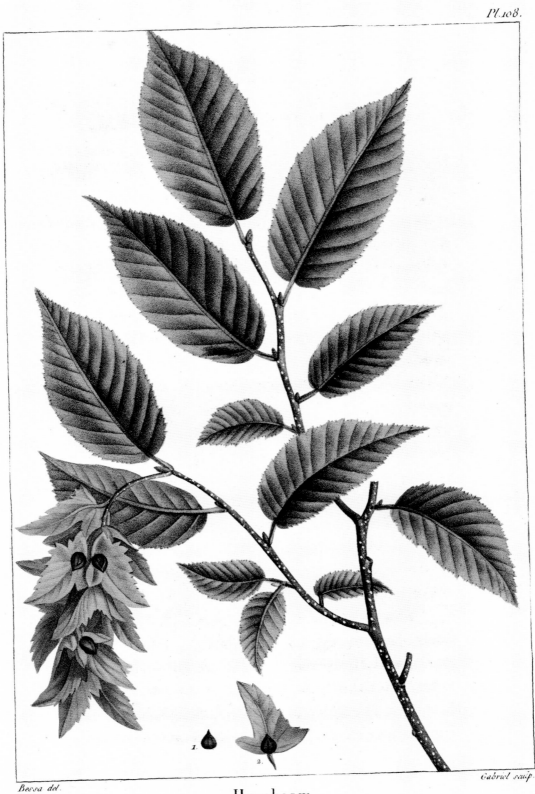

Bessa del. *Gabriel sculp.*

Hornbeam .
Carpinus virginiana .

Pl. 23. American Hornbean, Ironwood (*Carpinus caroliniana* Walter) [43

Pl. 64

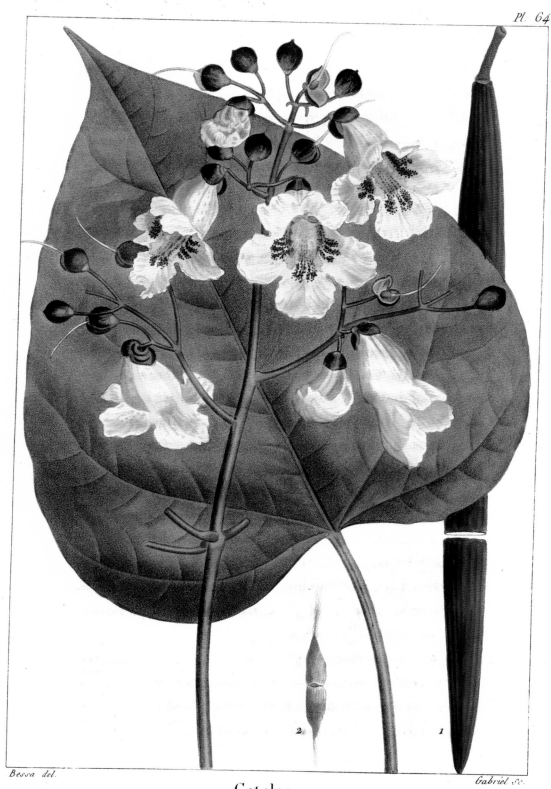

Bessa del.

Gabriel sc.

2

1

Catalpa

Bignonia catalpa

Pl. 24. Catawba Tree, Indian Bean, Cigar Tree
(*Catalpa bignonioides* Walter)

Pl. C III.

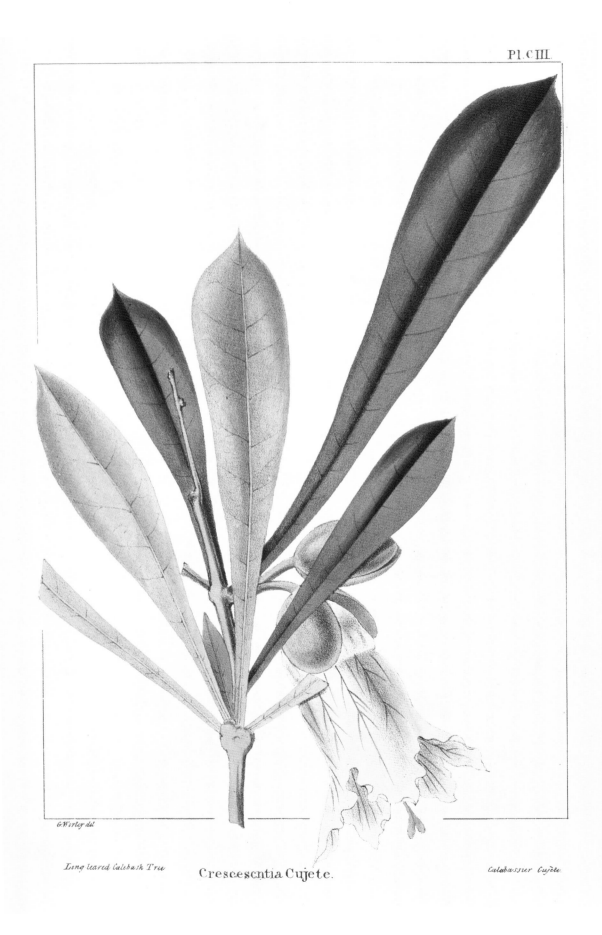

G. Worley del.

Long leared Calabash Tree

Crescescntia Cujete.

Calabassier Cujete.

Pl. 25. Calabash Tree (*Crescentia cujete* L.)

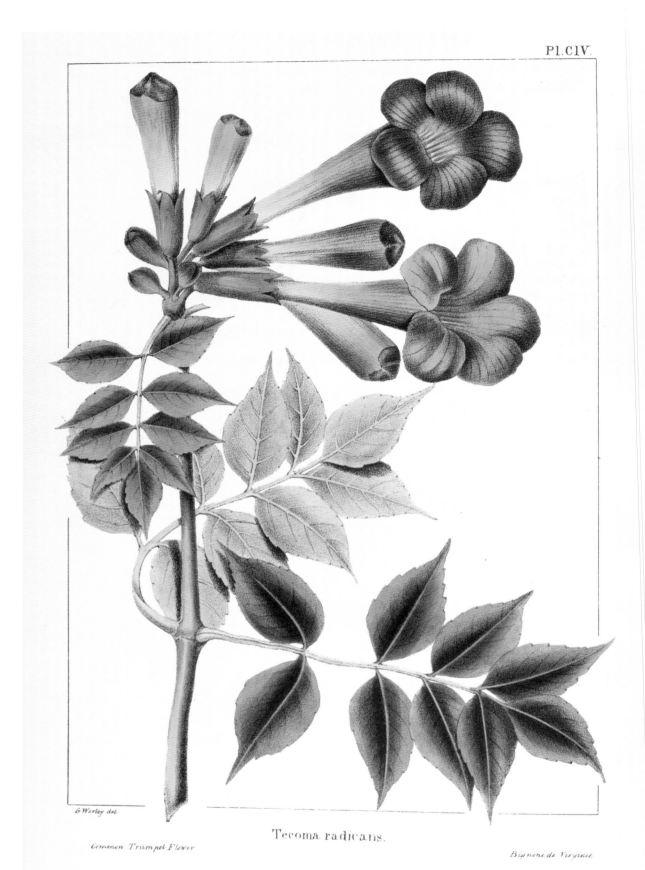

G Werley del.

Tecoma radicans.

Common Trumpet Flower

Bignone de Virginie

46] Pl. 26. Trumpet Flower (*Campsis radicans* (L.) Bureau)

Pl. C VII.

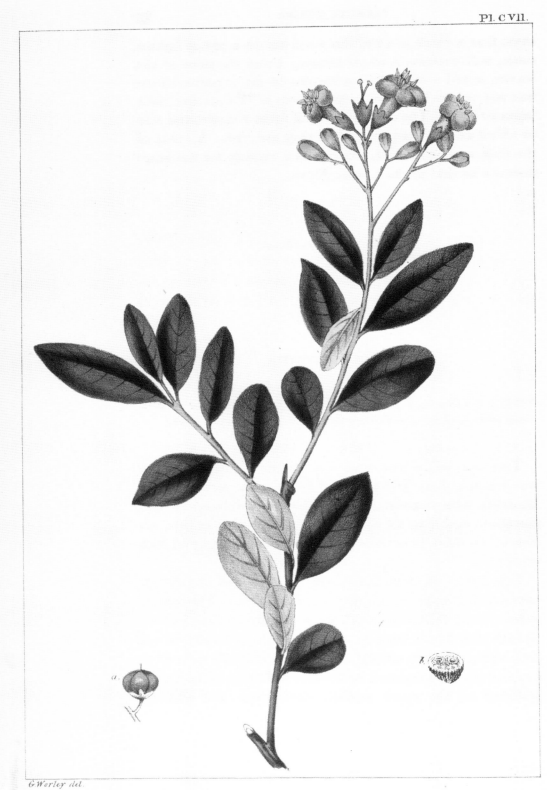

G. Worley del.

Cordia Floridana.

Florida Cordia.

Sebestier des Florides.

Pl. 27. Rough Strongback (*Bourreria radula* (Poir.) G. Don)

Pl. CVI.

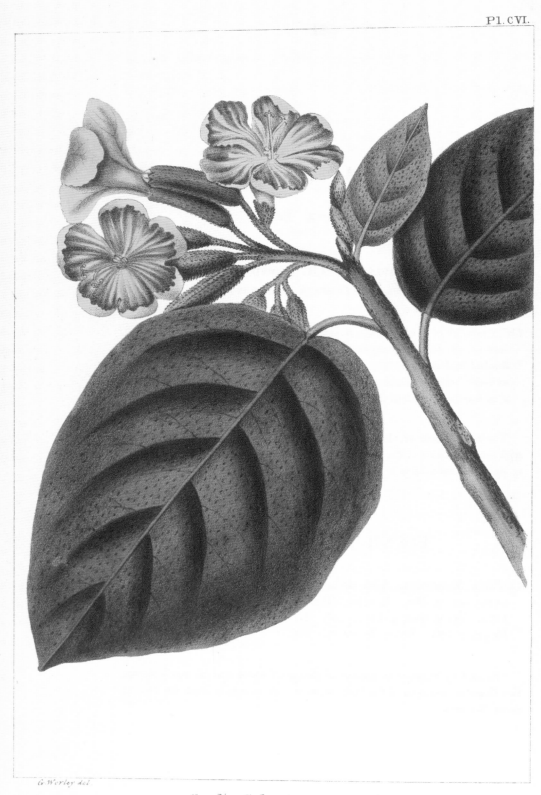

G. Worley del.

Cordia Sebestena

Rough-leaved Cordia.

Sebestier domestique

Pl. 28. Orange Geiger Tree (*Cordia sebestena* L.)

Pl. LXXIX.

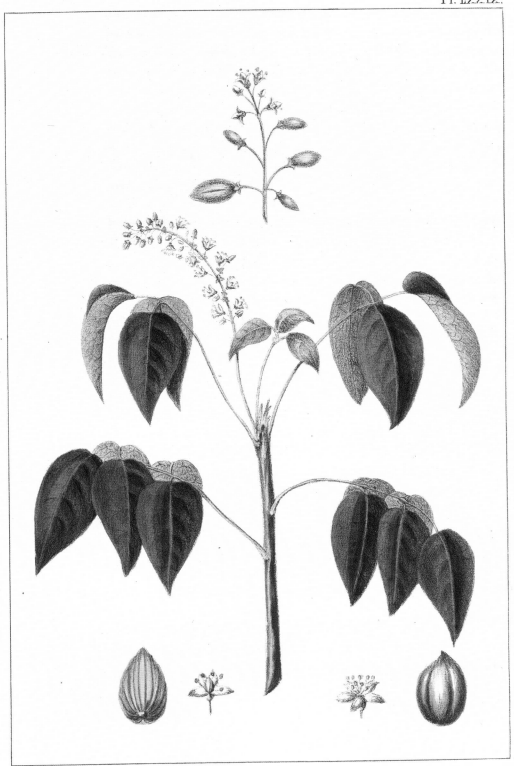

Bursera Gummifera.

West Indian Birch tree.　　　　　Gomart d'Amerique.

Pl. 29. Gumbo Limbo (*Bursera simaruba* (L.) Sarg.)　　[49

Pl. 115.

H. J. Redouté del.

Gabriel Sc.

Hack Berry.

Celtis crassifolia.

Pl. 30. Northern Hackberry, Nettle Tree (*Celtis occidentalis* L.)

Pl. XL.

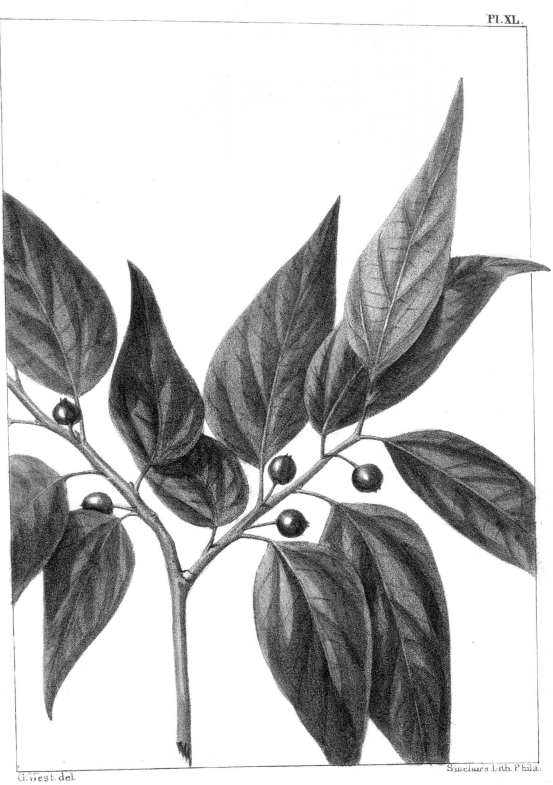

G.West.del.

Sinclairs Lith.Phila.

Celtis longifolia.

Long-leaved Nettle-tree *Micocoulier a'longues feuilles.*

Pl. 31. Sugarberry, Southern Hackberry (*Celtis laevigata* Willd.) [51

Pl. 114.

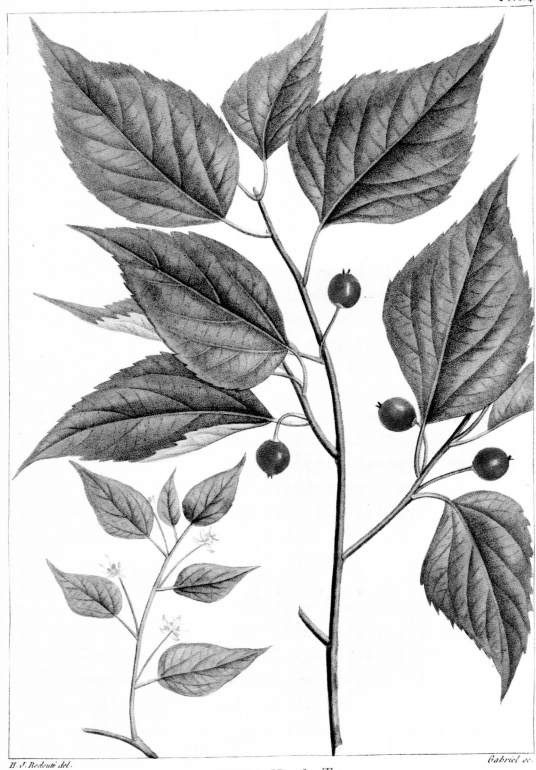

H. J. Redouté del.

Gabriel sc.

American Nettle Tree.

Celtis occidentalis.

Pl. 32. Northern Hackberry, Nettle Tree (*Celtis occidentalis* L.)

Pl. **XXXIX**.

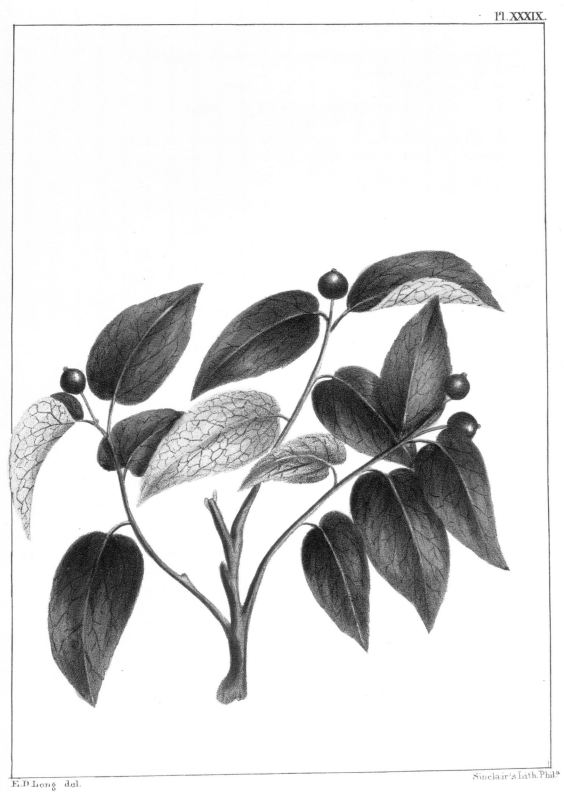

E.D.Long del.

Sinclair's Lith.Phil

Celtis reticulata.

Small leaved Nettle tree *Micocoulier reticule.*

Pl. 33. Netleaf Hackberry (*Celtis reticulata* Torr.) [53

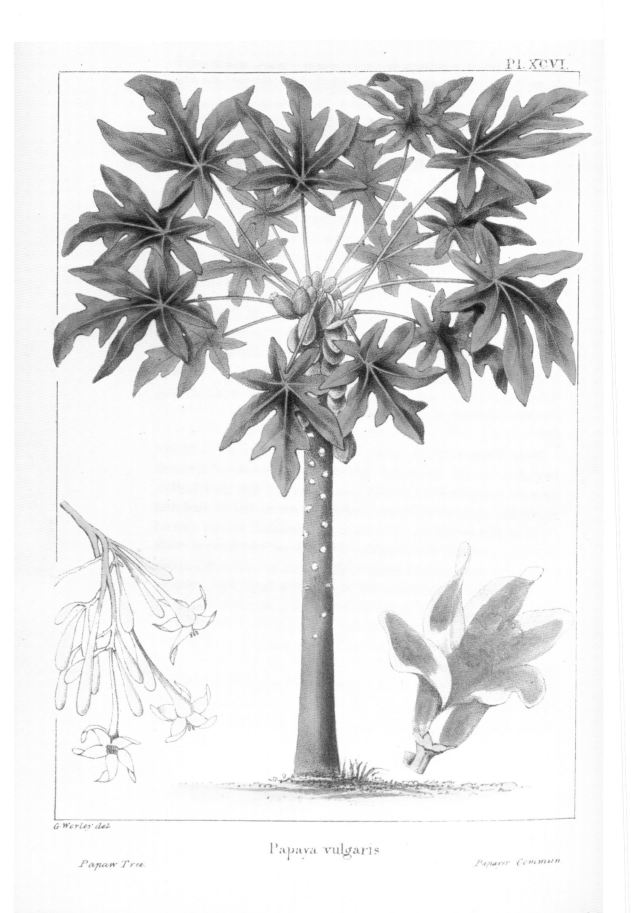

G. Worley del.

Papaya vulgaris

Papaw Tree.

Papayer Commun

Pl. 34. Papaya (*Carica papaya* L.)

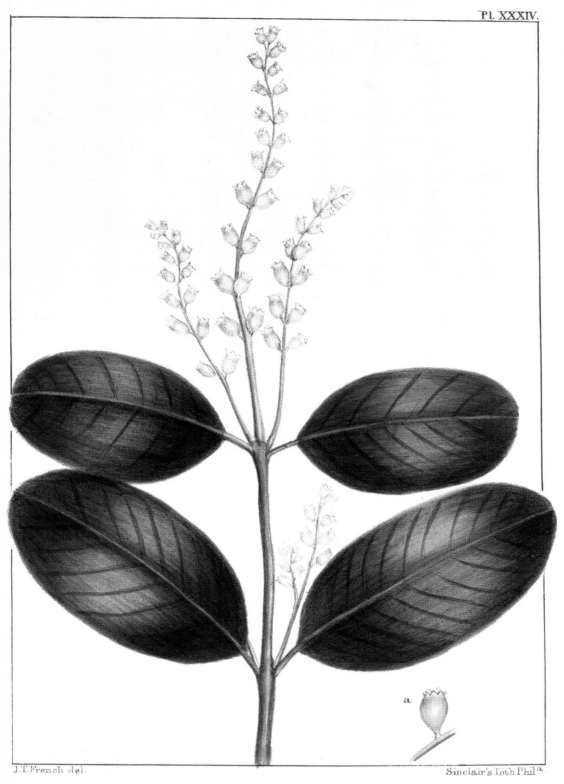

Pl. XXXIV.

J.T.French del.

Sinclair's Lith.Phil&.

White Mangrove. Laguncularia racemosa. Manglier à grappes.

Pl. 39. White Mangrove (*Laguncularia racemosa* (L.) C. F. Gaertn.) [59

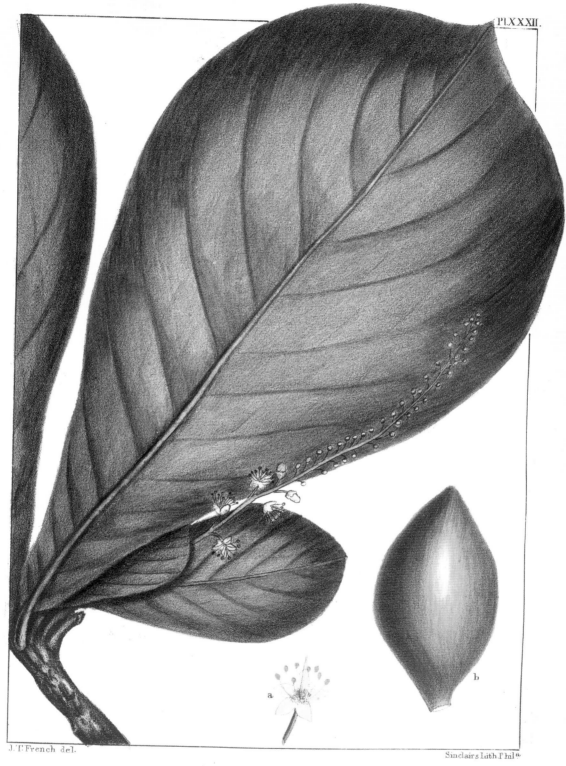

J.T.French del.

Sinclairs Lith.Phil.a

Indian Almond. Terminalia catappa. Badamier de Malabar.

Pl. 40. Indian-almond (*Terminalia catappa* L.)

Pl. 48.

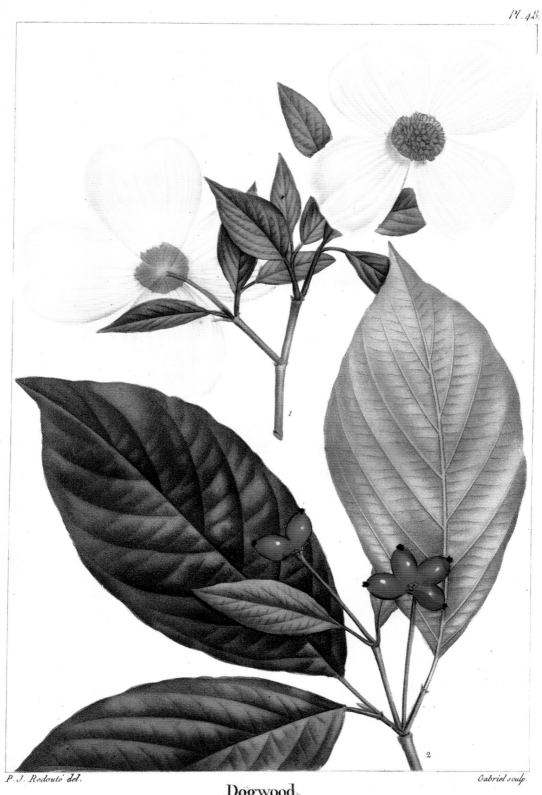

P. J. Redouté del. *Gabriel sculp.*

Dogwood.
Cornus florida.

Pl. 41. Flowering Dogwood (*Cornus florida* L.) [61

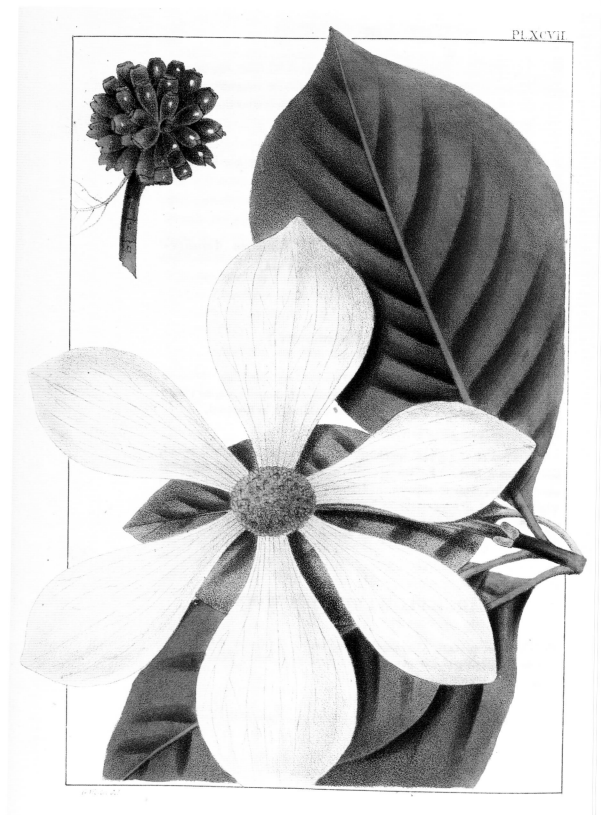

Large-flowered Dogwood Cornus Nuttallii. *Cornouiller de Nuttall*

62] Pl. 42. Pacific Dogwood (*Cornus nuttallii* Audubon ex Torr. & A. Gray)

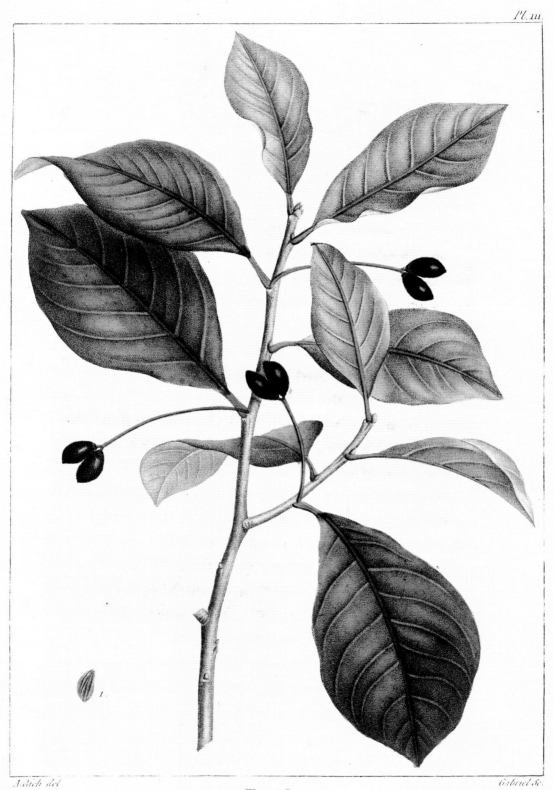

Pl. III.

Tupclo.

Nyssa aquatica.

Pl. 43. Swamp Blackgum
(*Nyssa sylvatica* Marshall var. *biflora* (Walter) Sarg.)

[63

Pl. 113.

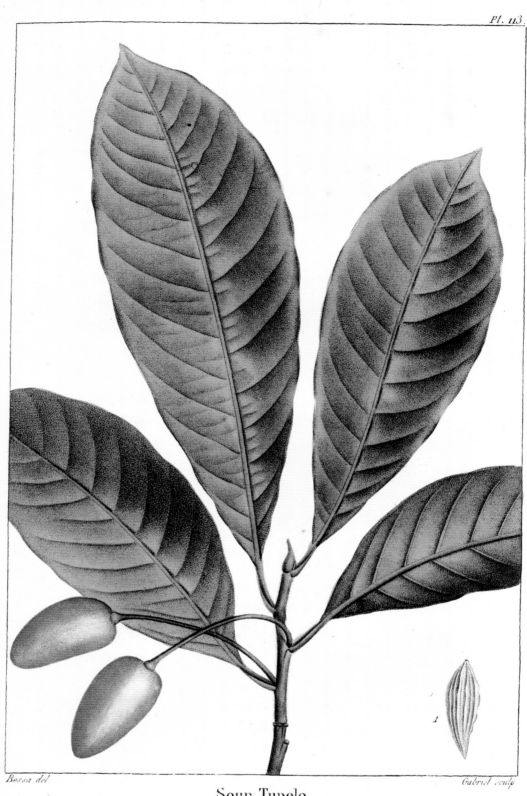

Bessa del.

Gabriel sculp.

Sour Tupelo.
Nyssa capitata.

Pl. 44. Ogeechee Tupelo, Ogeechee-lime, Sour Tupelo
(*Nyssa ogeche* Bartram ex Marshall)

Pl. 112

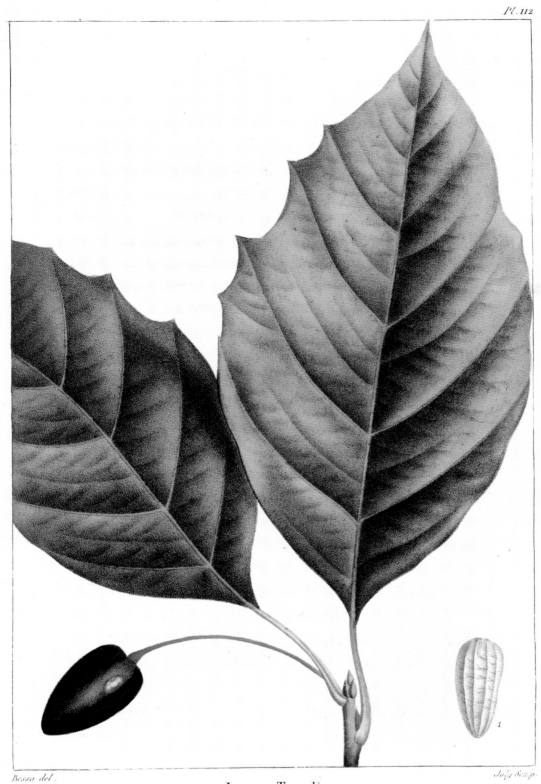

Bessa del.

Joly Sculp.

Large Tupelo.

Nyssa grandidentata.

Pl. 45. Water Tupelo (*Nyssa aquatica* L.) [65

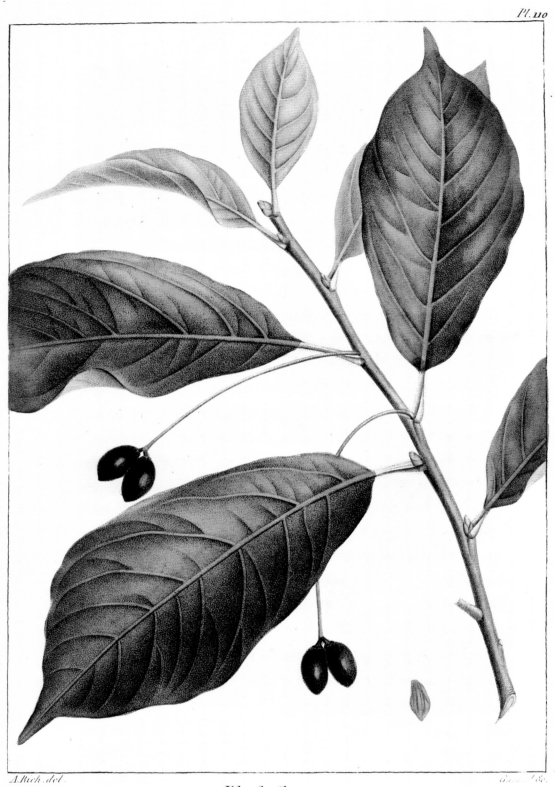

Pl. 110

Black Gum.

Nyssa sylvatica.

A.Rich.del.

Pl. 46. Black Tupelo, Blackgum, Sourgum (*Nyssa sylvatica* Marshall)

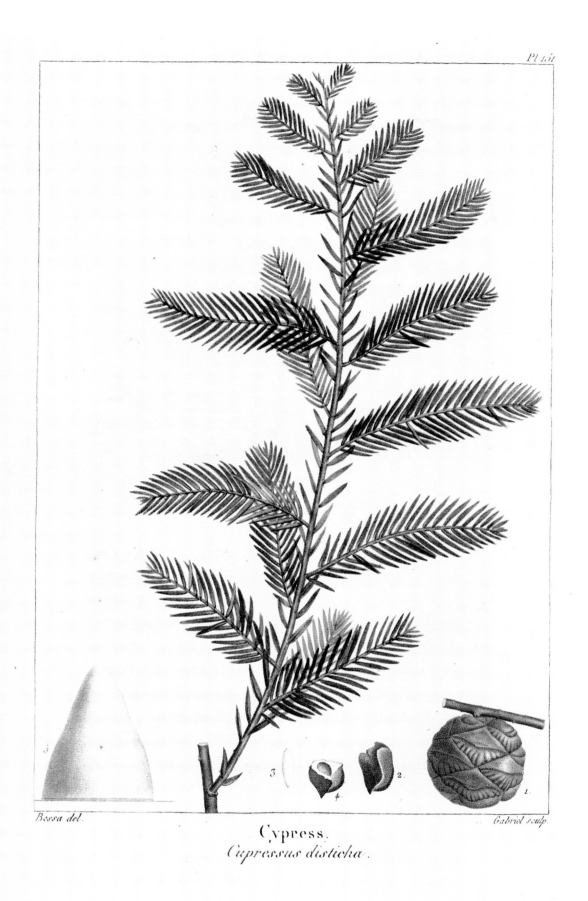

Pl. 151

Bessa del.

Gabriel sculp.

Cypress.
Cupressus disticha.

Pl. 47. Bald-cypress (*Taxodium distichum* (L.) Rich.) [67

Pl. 152.

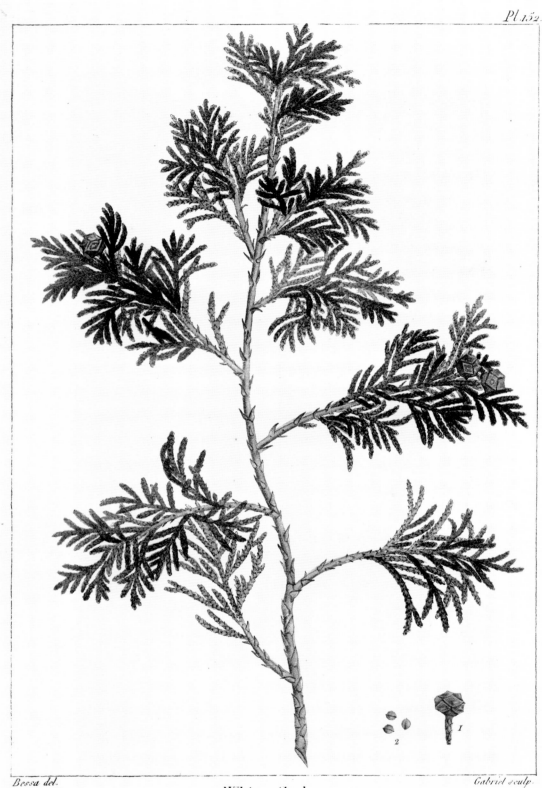

Bessa del. *Gabriel sculp.*

White Cedar.

Cupressus thyoïdes.

Pl. 48. Atlantic White Cedar
68] (*Chamaecyparis thyoides* (L.) Britton, Sterns & Poggenb.)

Pl. CX.

G.Werner del

Juniperus Andina.

Rocky Mountain Juniper. Genévrier des Andes

Pl. 49. Western Juniper (*Juniperus occidentalis* Hook.) [69

Pl.155.

Bessa del.

Gabriel sculp.

Red Cedar.
Juniperus virginiana.

Pl. 50. Eastern Red-cedar (*Juniperus virginiana* L.)

Pl. XCI

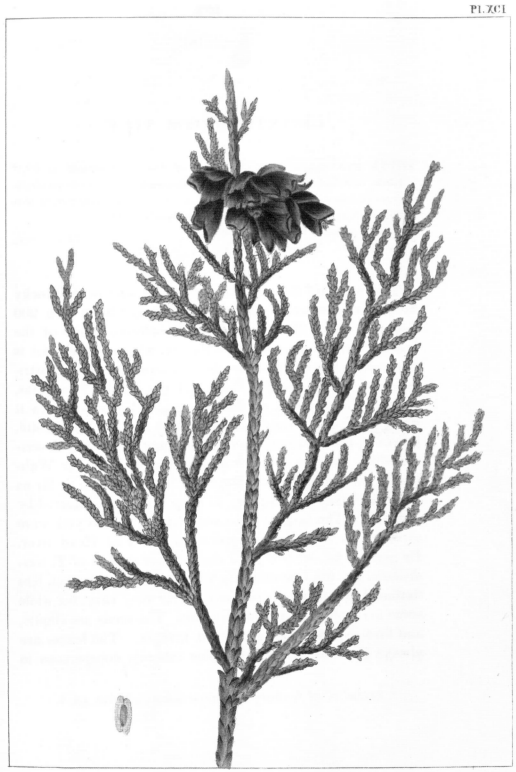

Thuja Gigantea.

Gigantic Arbor Vitae.
Thuia gigantesque.

Pl. 51. Western Red-cedar (*Thuja plicata* Donn ex D. Don)

Pl. 156.

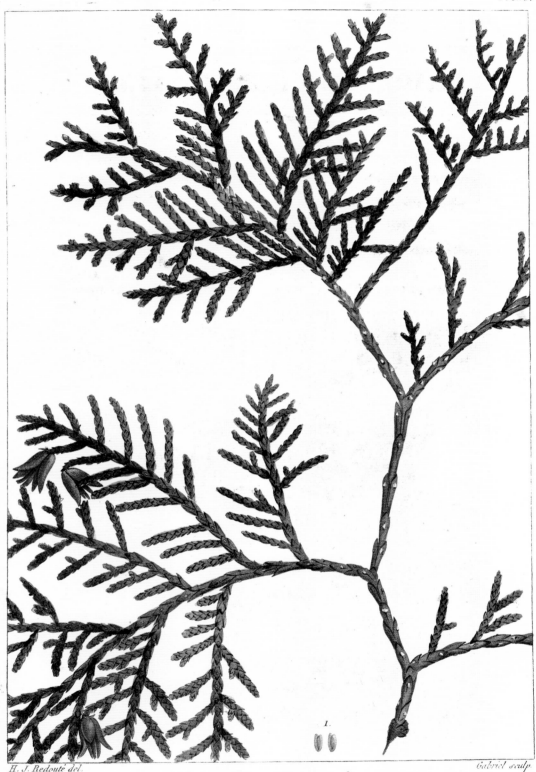

H. J. Redouté del. Gabriel sculp.

Arbor vitæ or White cedar.
Thuya occidentalis.

Pl. 52. American Arborvitae (*Thuja occidentalis* L.)

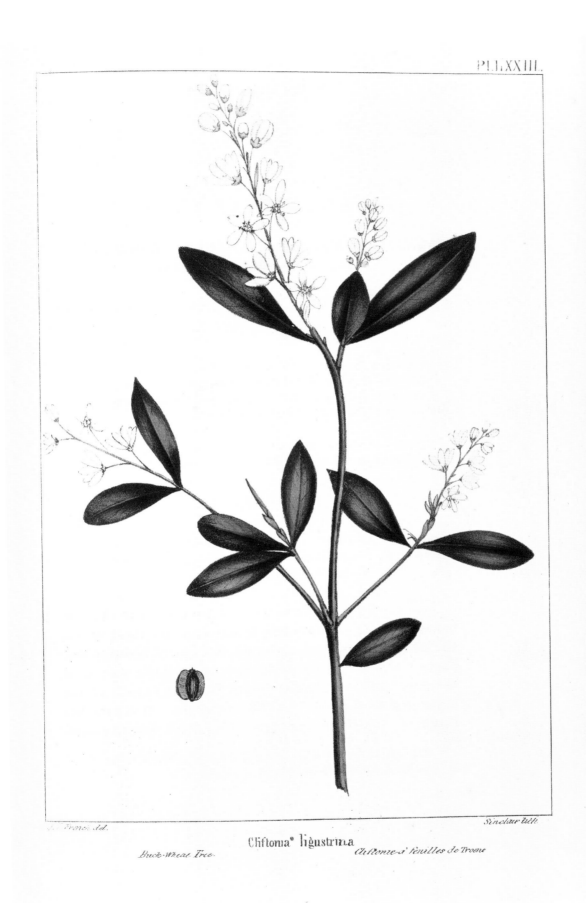

PLLXXIII.

Cliftonia ligustrina
Buck-Wheat Tree. Cliftonie-à-Feuilles de Troene

Pl. 53. Buckwheat Tree (*Cliftonia monophylla* (Lam.) Britton ex Sarg.) [73

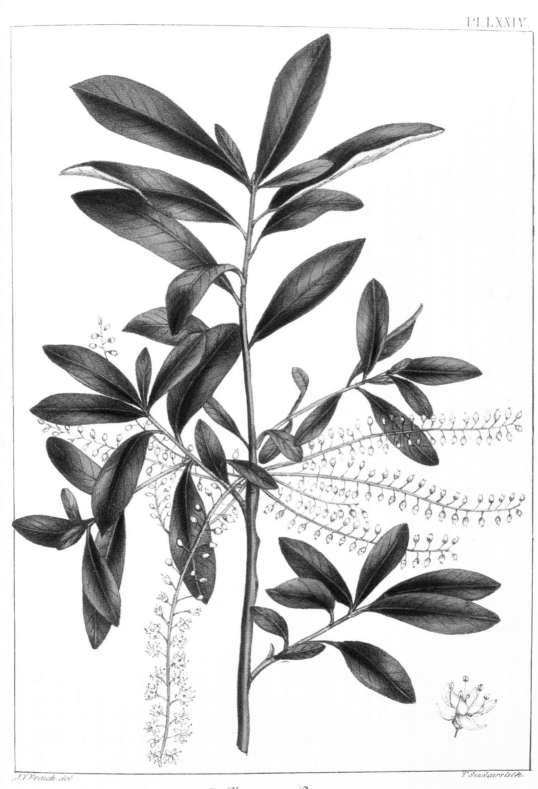

J.T.French del.

T.Sinclairs lith.

Cyrilla racemiflora

Carolina Cyrilla Cyrille de Cardine

Pl. 54. White Titi (*Cyrilla racemiflora* L.)

Pl. 93.

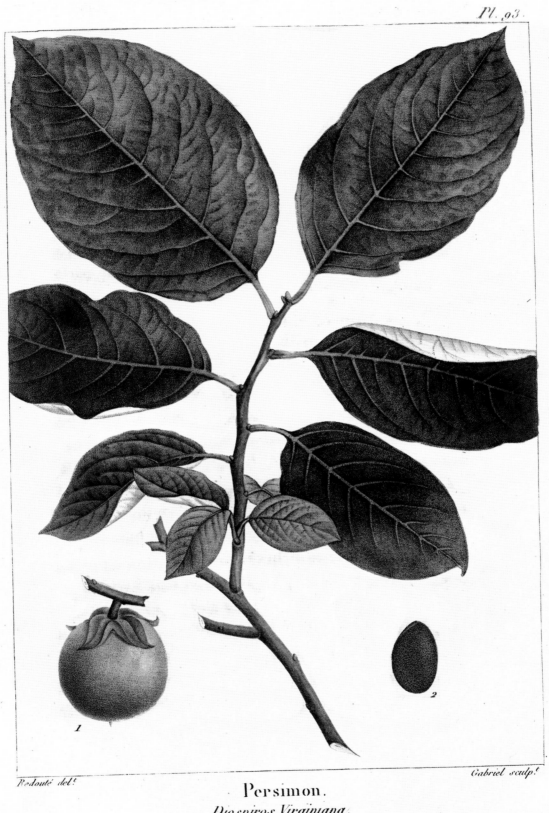

Redouté del. Gabriel sculp.

Persimon.
Diospiros Virginiana.

Pl. 55. Common Persimmon, Possumwood (*Diospyros virginiana* L.) [75

Pl. XXXV.

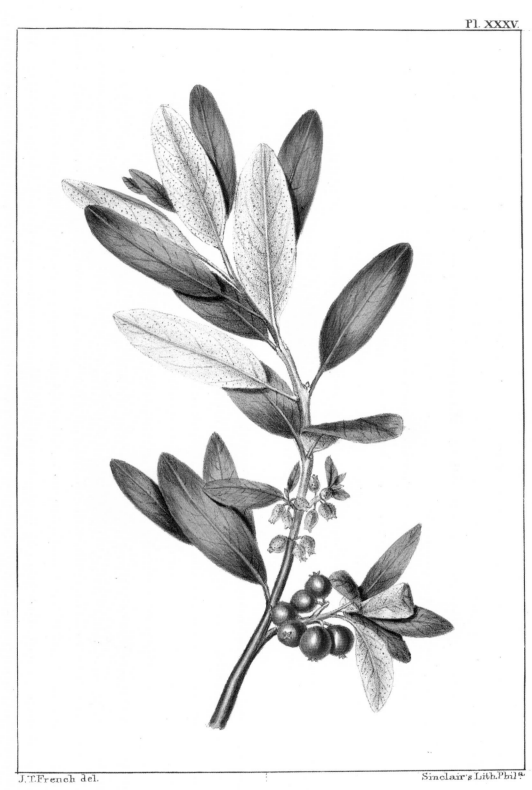

J.T.French del. Sinclair's Lith.Phila

Rabbit Berry. Shepherdia argentea. *Argonsier argente.*

Pl. 56. Silver Buffaloberry (*Shepherdia argentea* (Pursh) Nutt.)

Pl.85.

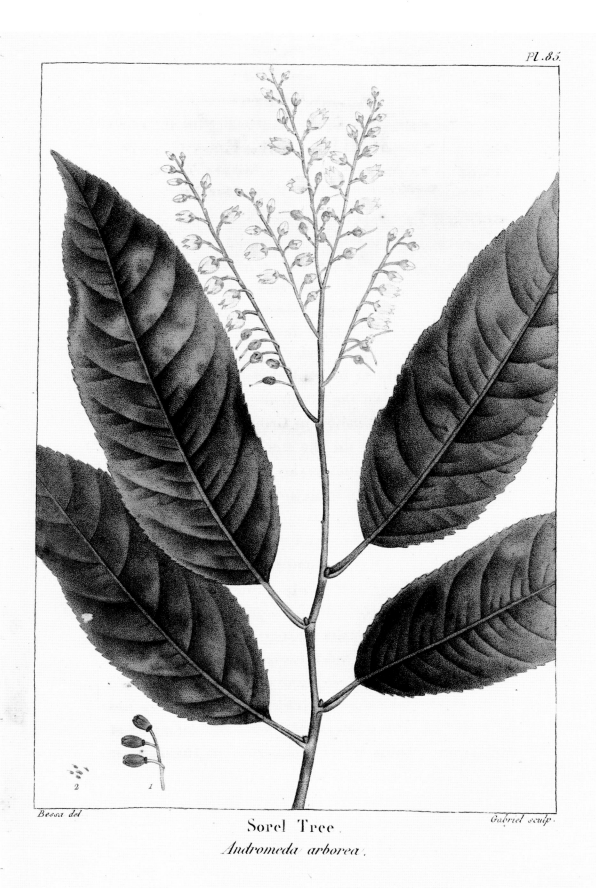

Bessa del

Gabriel sculp.

2 1

Sorel Tree.
Andromeda arborea.

Pl. 57. Sourwood, Sorreltree (*Oxydendrum arboreum* (L.) DC.) [77

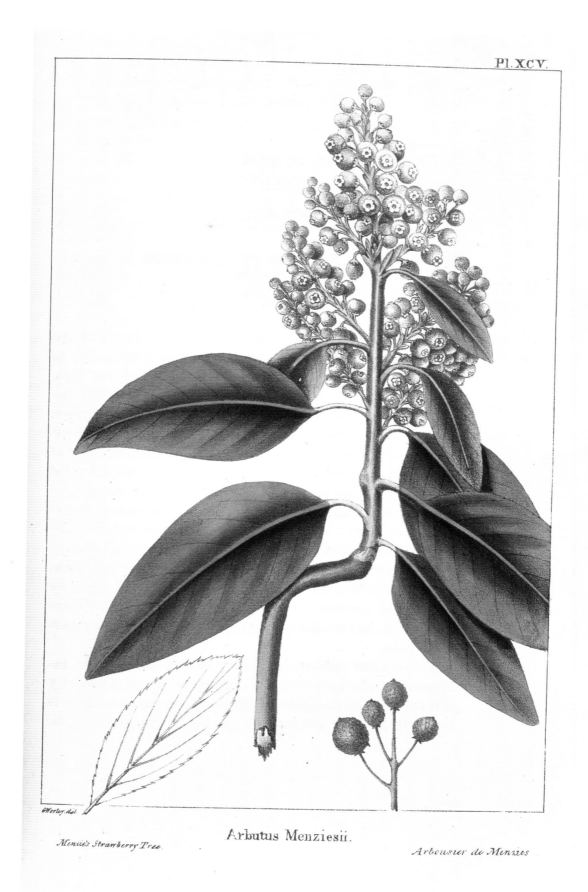

Pl. XCV.

Arbutus Menziesii.

Menzies's Strawberry Tree.

Arbousier de Menzies

78] Pl. 58. Menzies's Strawberry Tree, Madroño (*Arbutus menziesii* Pursh)

Pl. 68.

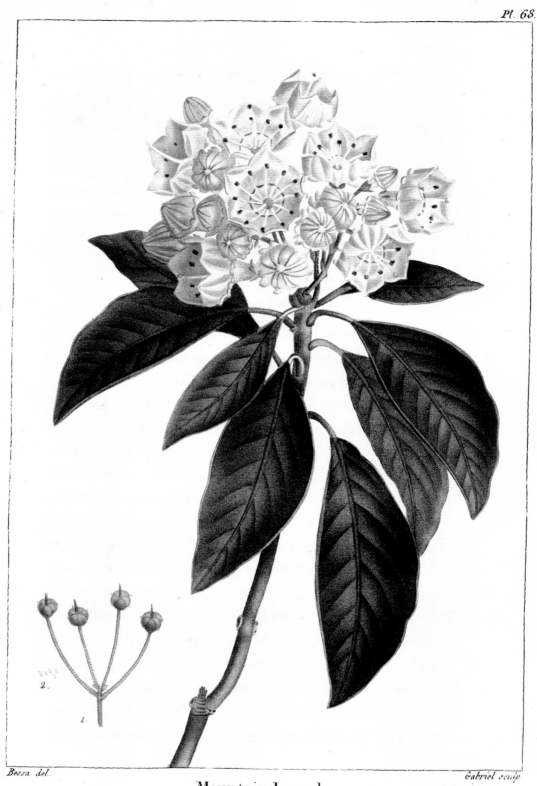

Bessa del.

Gabriel sculp

Mountain Laurel.
Kalmia latifolia

Pl. 59. Mountain-laurel (*Kalmia latifolia* L.)

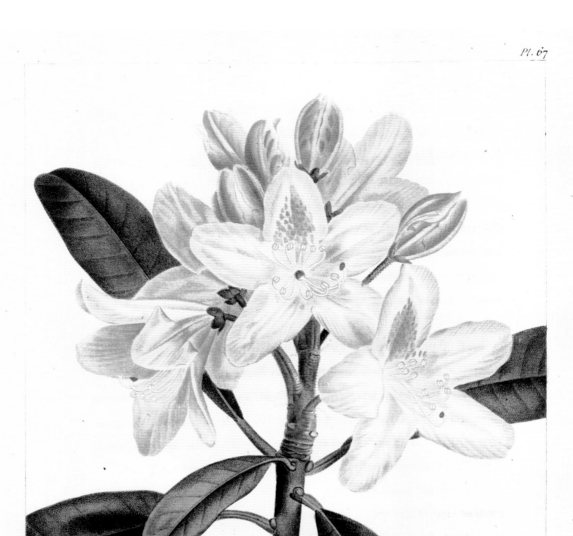

Pl. 67

Bessa del.

Gabriel sc.

Dwarf Rose Bay.
Rhododendrum maximum.

Pl. 60. Great Laurel, Great Rhododendron, Rosebay Rhododendron
(*Rhododendron maximum* L.)

Pl. LXI.

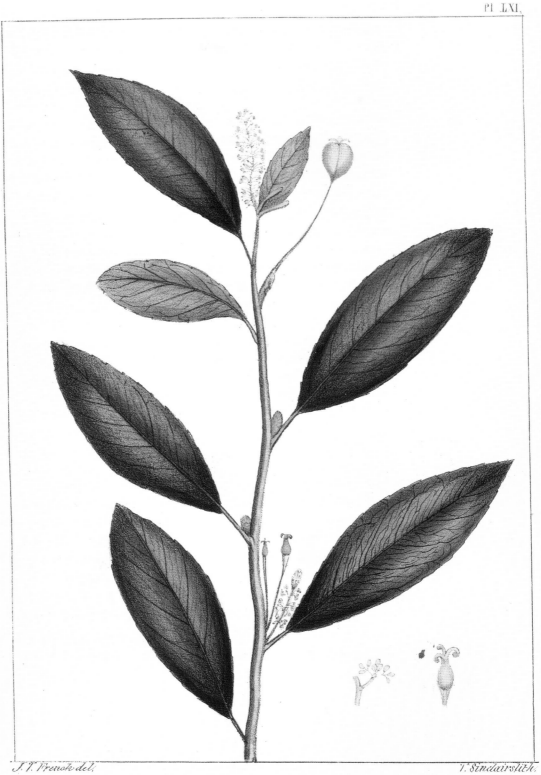

J. T. French del.

T. Sinclair's lith.

Excœcaria lucida

Shining leaved Poison-Wood

Agalloche luisant

Pl. 61. Oysterwood (*Gymnanthes lucida* Sw.)

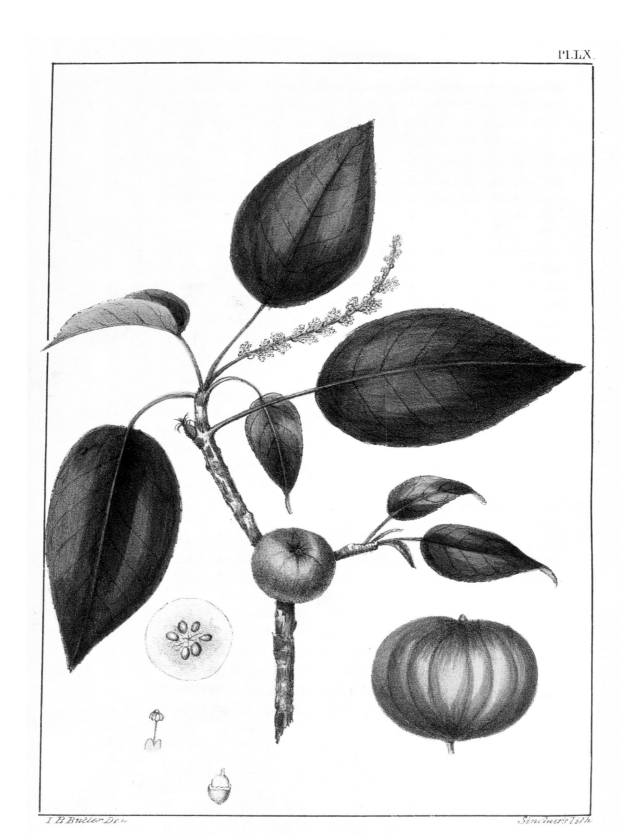

I.B.Butler Del. Sinclair's Lith.

Manchineel

Hippomane Mancinella *Mancenillier*

Pl. 62. Manchineel (*Hippomane mancinella* L.)

Stillingia sebifera

Tallow-tree Stillingia porte-suif.

J.French del. T.Sinclair's lith.

Pl. 63. Chinese Tallowtree (*Triadica sebifera* (L.) Small) [83

J.B. Butler del.

Lith. of Thos Sinclair

Broad-podded Acacia.

Acacia latisiliqua.

Acacia à large silique.

84]

Pl. 64. False-tamarind (*Lysiloma latisiliquum* (L.) Benth.)

Pl. 80.

Bessa del.

Gabriel sculp.

Water locust.

Gleditsia monosperma.

Pl. 65. Water Locust (*Gleditsia aquatica* Marshall)

[85

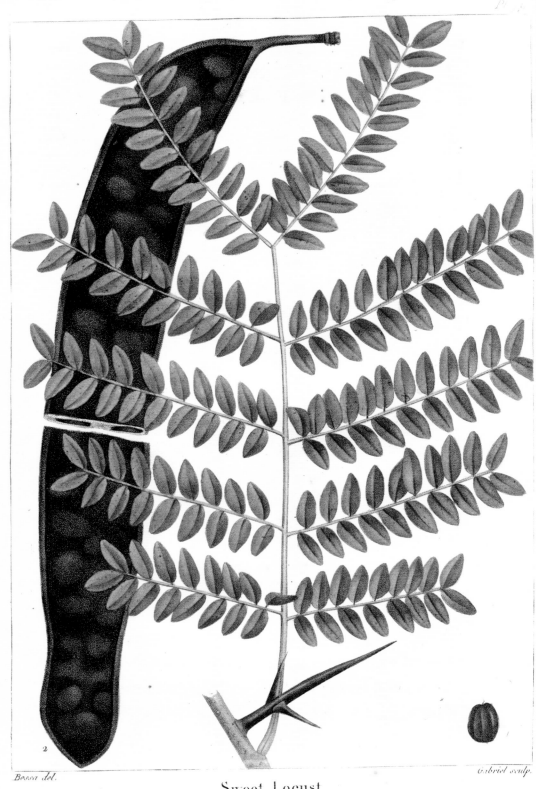

Bessa del.

Gabriel sculp.

Sweet Locust.
Gleditsia triacanthos.

Pl. 66. Honey Locust (*Gleditsia triacanthos* L.)

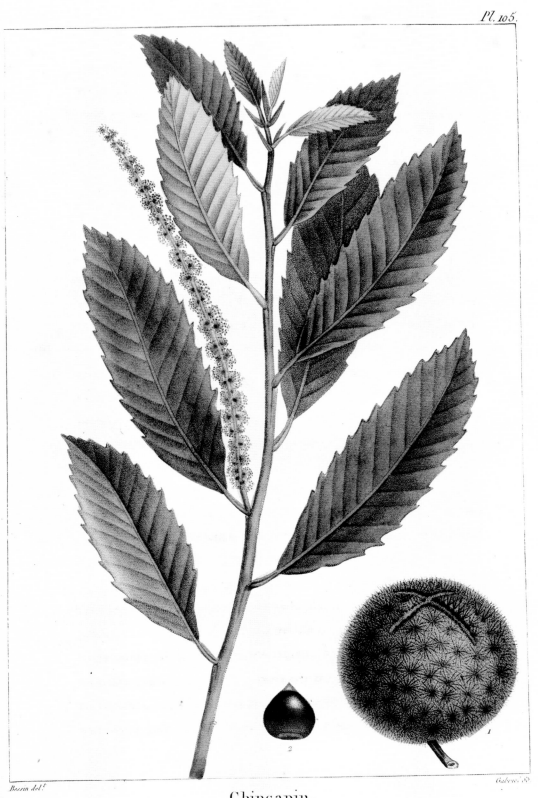

Pl. 105.

Bessin delt.

Gabriel Sc.

Chincapin.

Castanea pumila.

Pl. 75. Chinquapin, Allegheny Chinquapin, Dwarf Chestnut
(*Castanea pumila* (L.) Mill.)

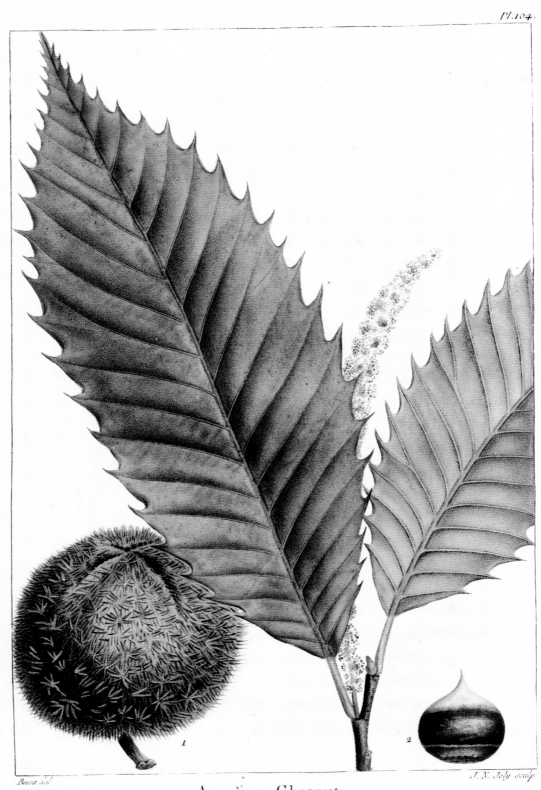

Pl.104.

Boosa del

1

2

J. N. Joly sculp

American Chesnut.

Castanea vesca.

Pl. 76. American Chestnut (*Castanea dentata* (Marshall) Borkh.)

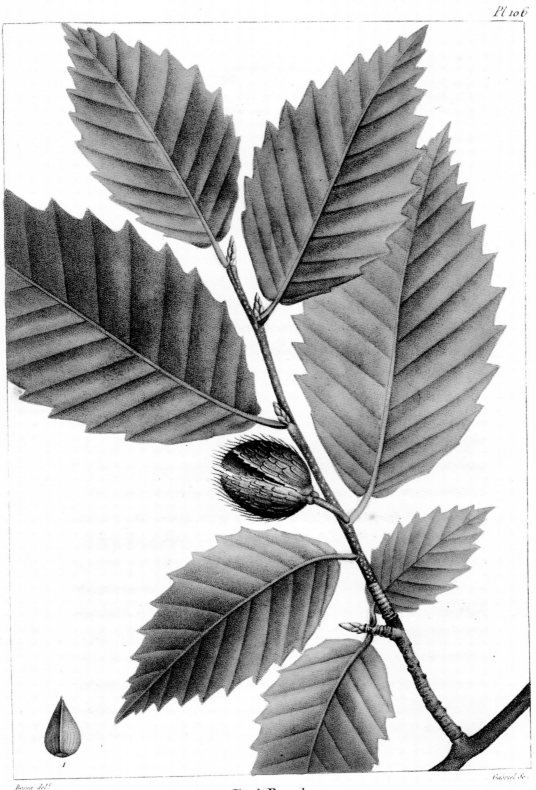

Pl. 106

Red Beech.

Fagus ferrugina.

Pl. 77. American Beech (*Fagus grandifolia* Ehrh.)

[97

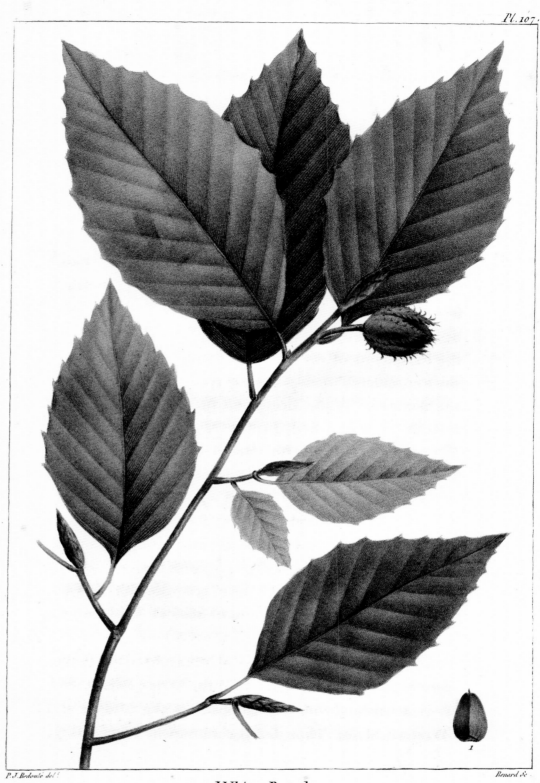

Pl. 107.

P.J.Bedoulé del.

Renard Sc.

1

White Beech.

Fagus sylvestris.

Pl. 78. American Beech (*Fagus grandifolia* Ehrh.)

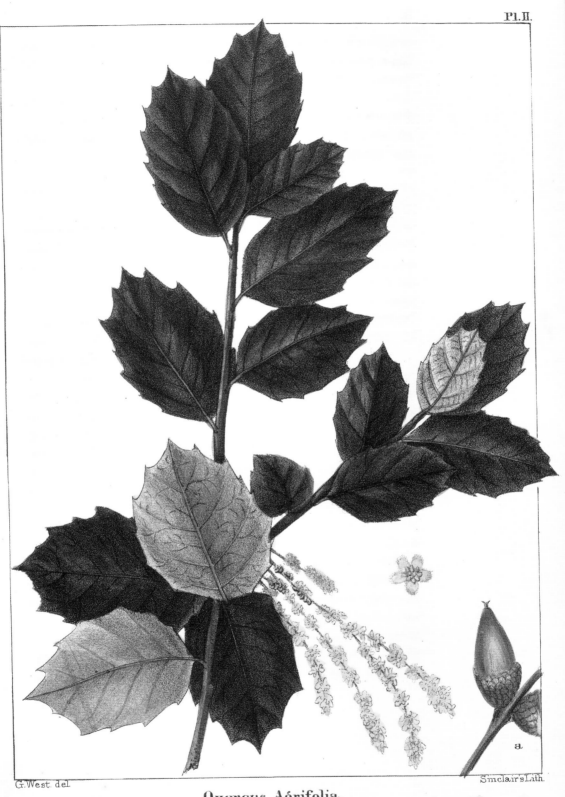

Pl. II.

G.West. del.

Sinclair's Lith.

Quercus Agrifolia.

Holly Leaved Oak *Chêne à feuilles de Houx.*

a

Pl. 79. California Live Oak, Coast Live Oak (*Quercus agrifolia* Née)

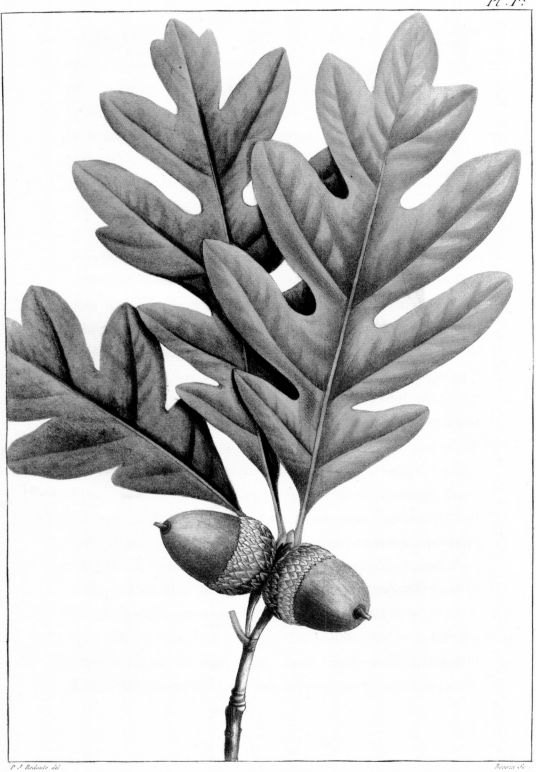

White Oak.

Quercus alba.

Pl. 80. White Oak (*Quercus alba* L.)

Pl. 26.

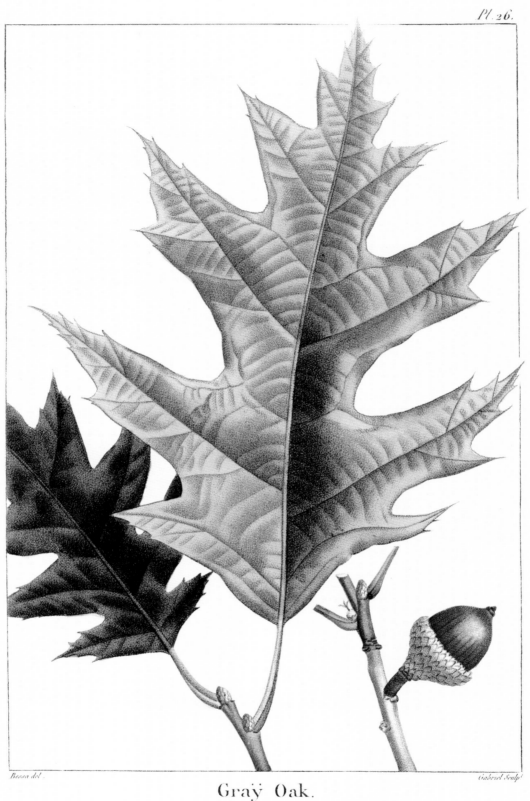

Bessa del.

Gabriel Sculp.

Graÿ Oak.
Quercus ambigua.

Pl. 81. Northern Red Oak (*Quercus rubra* L.)

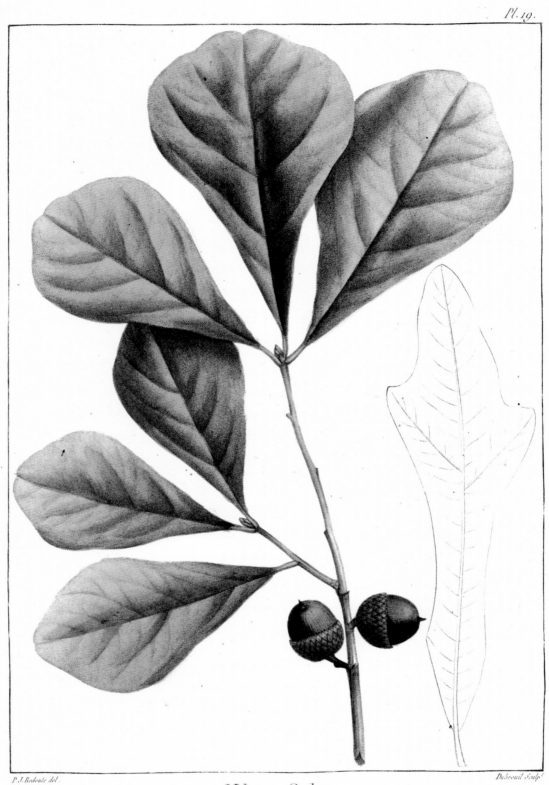

Pl. 19.

P. J. Redouté del.

Dubreuil Sculp.

Water Oak
Quercus aquatica.

Pl. 82. Water Oak (*Quercus nigra* L.)

Pl. 21.

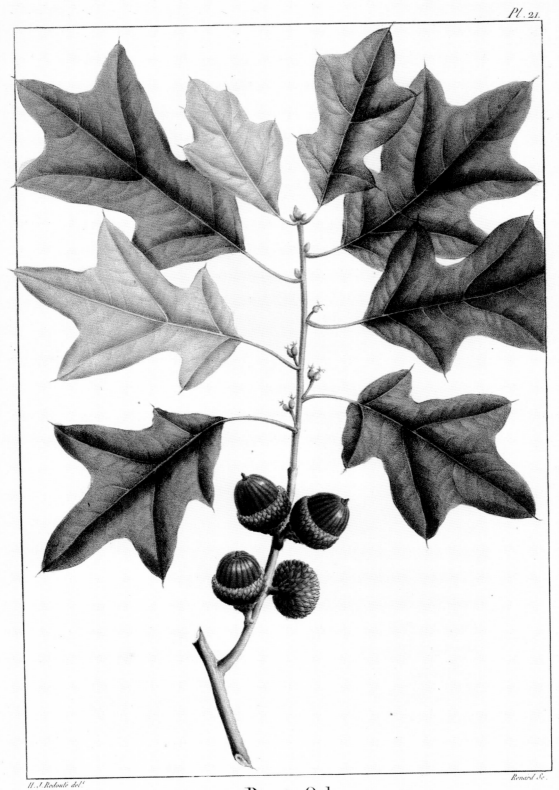

Bear's Oak.

Quercus banisteri.

Pl. 83. Bear Oak (*Quercus ilicifolia* Wangenh.)

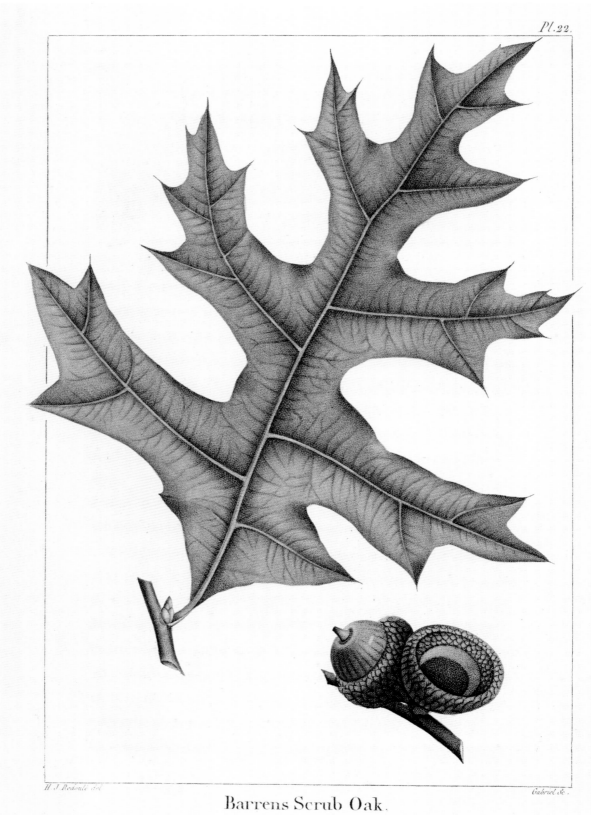

Pl. 22.

H. J. Redouté del.

Gabriel Sc.

Barrens Scrub Oak.

Quercus catesbæi.

Pl. 84. American Turkey Oak (*Quercus laevis* Walter)

Pl. 16.

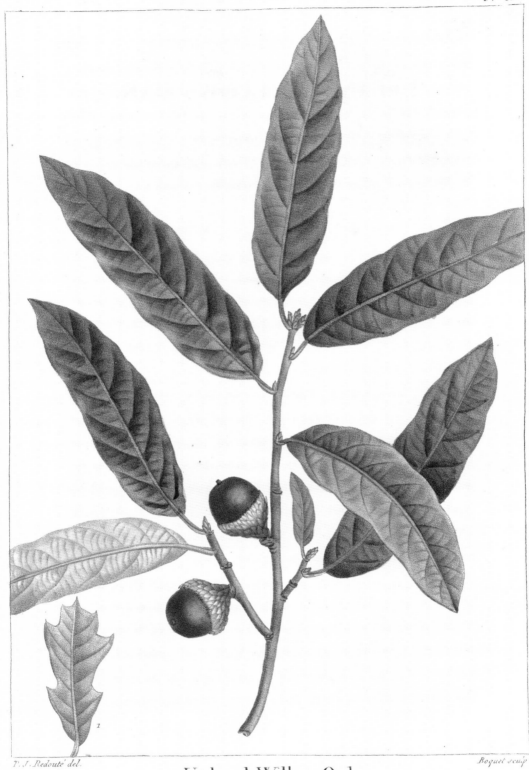

P. J. Redouté del.

Roquet sculp.

Upland Willow Oak
Quercus cinerea.

Pl. 85. Bluejack Oak (*Quercus incana* W. Bartram)

[105

Pl. 25.

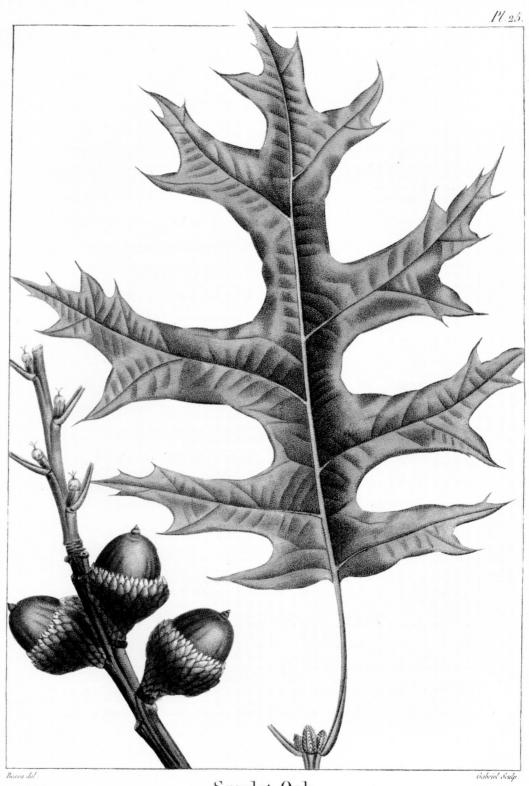

Bessa del.

Gabriel Sculp.

Scarlet Oak.

Quercus coccinea.

Pl. 86. Scarlet Oak (*Quercus coccinea* Münchh.)

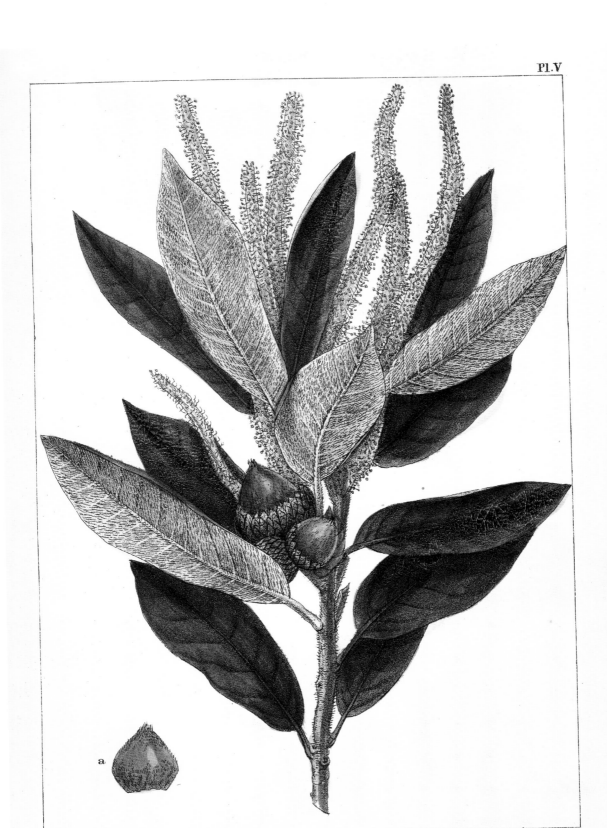

G.West del.

Sinclair's Lith.

Quercus Densiflora.

Dense Flowered Oak. *Chêne a'fleurs denses.*

Pl. 87. Tan Oak, Tanbark-oak
(*Notholithocarpus densiflorus* (Hook. & Arn.) P. S. Manos, C. H. Cannon, & S. H. Oh) [107

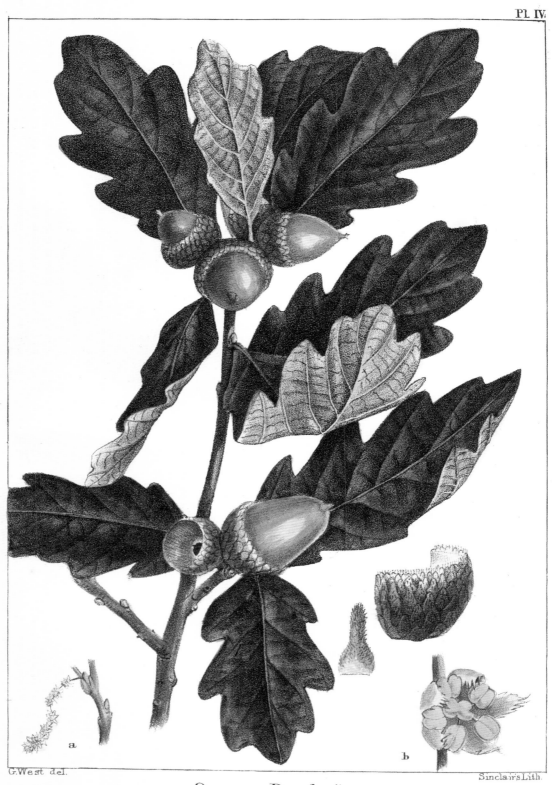

PL. IV

G.West del.

Sinclair's Lith.

Quercus Douglasii.

Douglas's Oak.

Chêne de Douglas.

108] Pl. 88. Blue Oak (*Quercus douglasii* Hook. & Arn.)

Pl. 23.

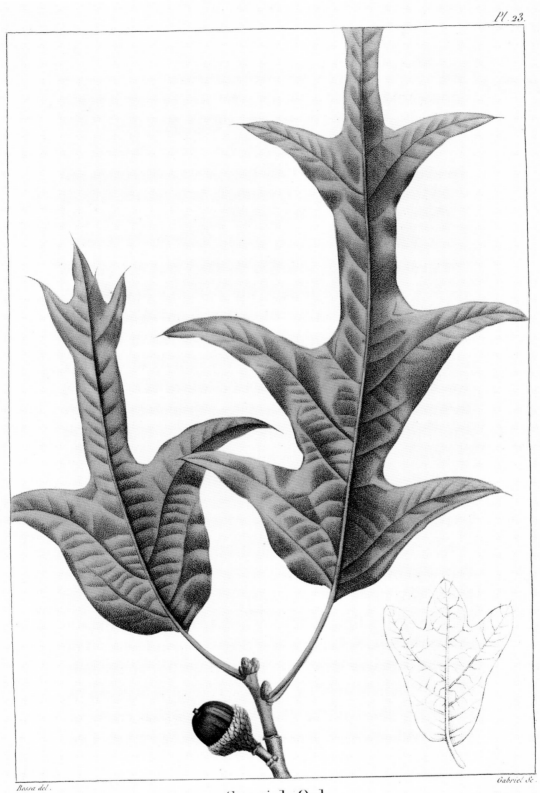

Bossca del.

Gabriel Sc.

Spanish Oak.
Quercus falcata.

Pl. 89. Southern Red Oak (*Quercus falcata* Michx.) [109

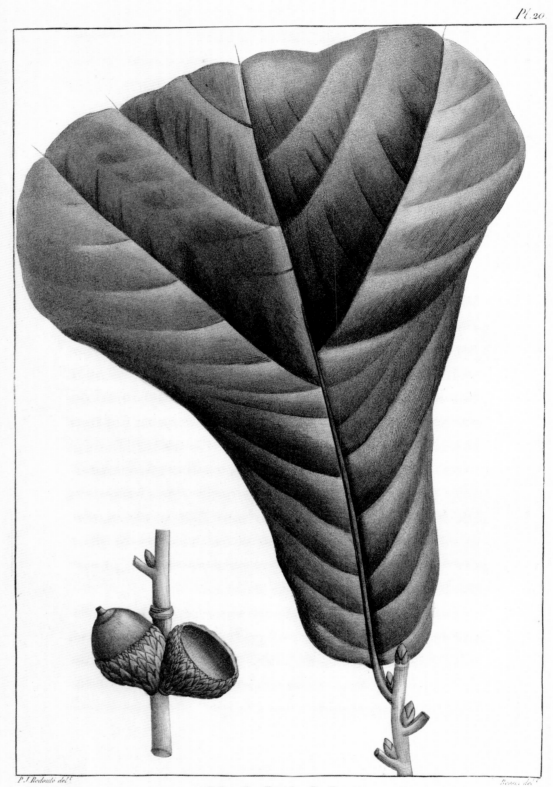

Black Jack Oak.

Quercus ferruginea.

110] Pl. 90. Blackjack Oak (*Quercus marilandica* Münchh.)

Pl. I.

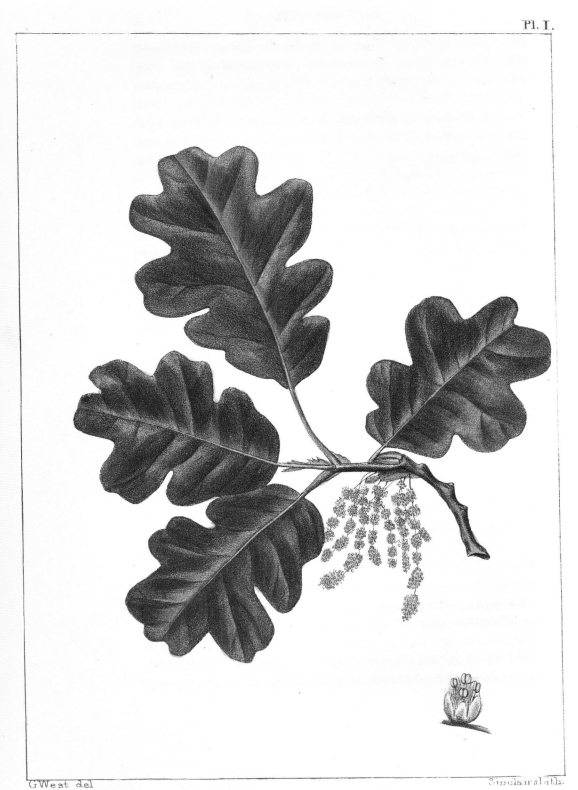

G.West del Sinclair lith.

Quercus Garryana.

Western Oak *Chêne occidental.*

Pl. 91. Oregon White Oak, Garry's Oak (*Quercus garryana* Douglas ex Hook.) [111

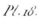

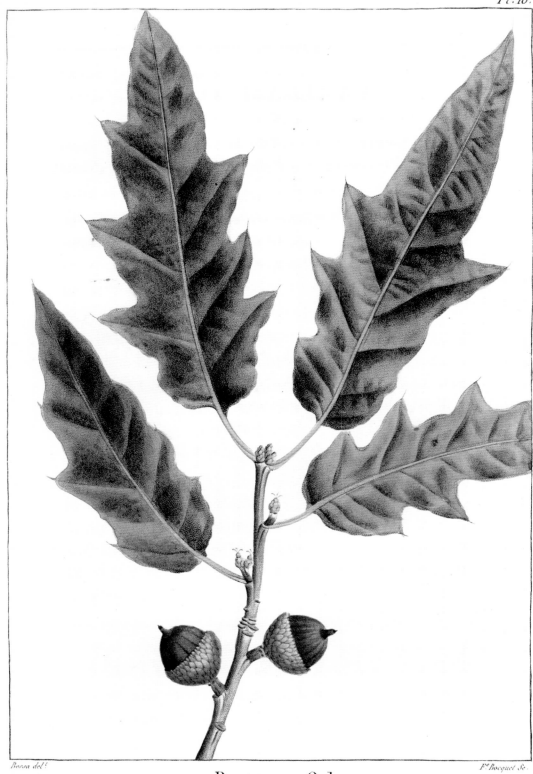

Bartram's Oak.

Quercus heterophilla.

112] Pl. 92. Bartram's Hybrid Oak (*Quercus × heterophylla* F. Michx.)

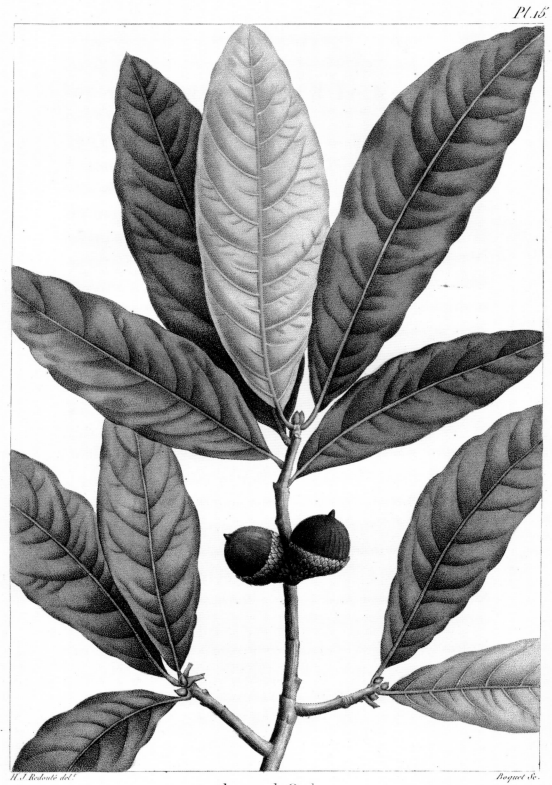

Pl.15.

Laurel Oak
Quercus imbricaria.

H.J. Redouté del.

Boquet Sc.

Pl. 93. Shingle Oak (*Quercus imbricaria* Michx.) [113

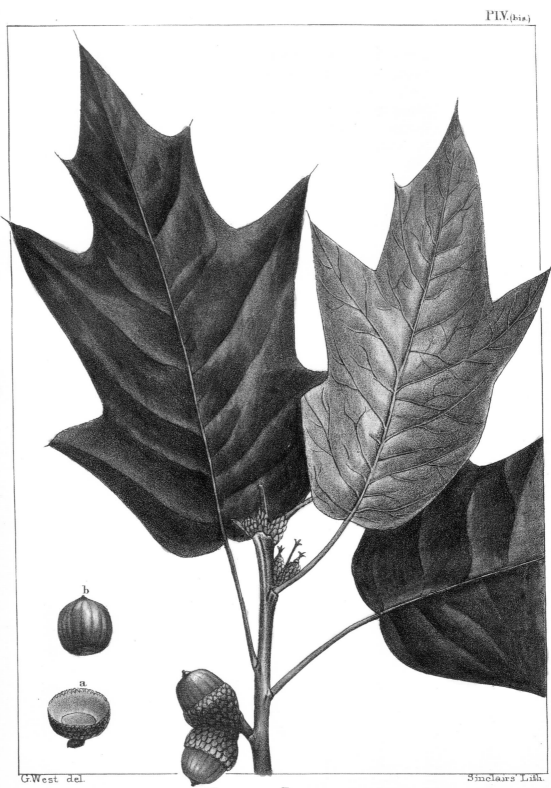

G.West del. Sinclairs' Lith.

Quercus Leana.

Lea's Oak *Chêne de Lea.*

Pl. 94. Lea Oak (*Quercus × leana* Nutt.)

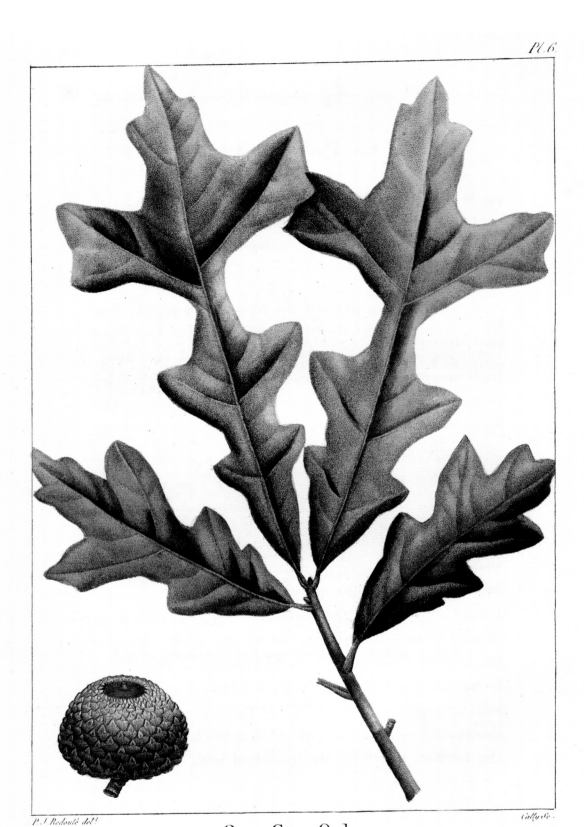

Pl.6.

P.J Redouté del. *Cally Sc.*

Over Cup Oak.
Quercus lyrata.

Plate wrongly placed

Pl. 95. Overcup Oak, Swamp Post Oak (*Quercus lyrata* Walter) [115

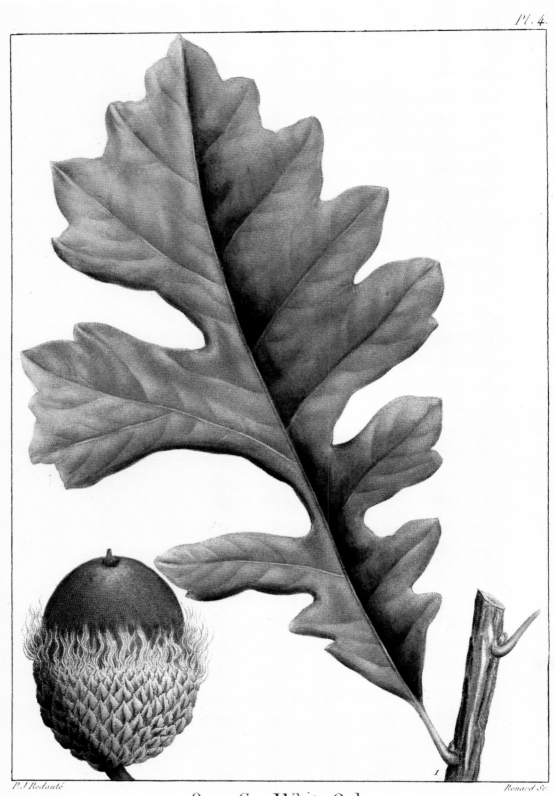

Pl. 4.

P.J Redouté

Renard Sc.

1

Over Cup White Oak.

Quercus macrocarpa.

Pl. 96. Bur Oak (*Quercus macrocarpa* Michx.)

Pl. 5.

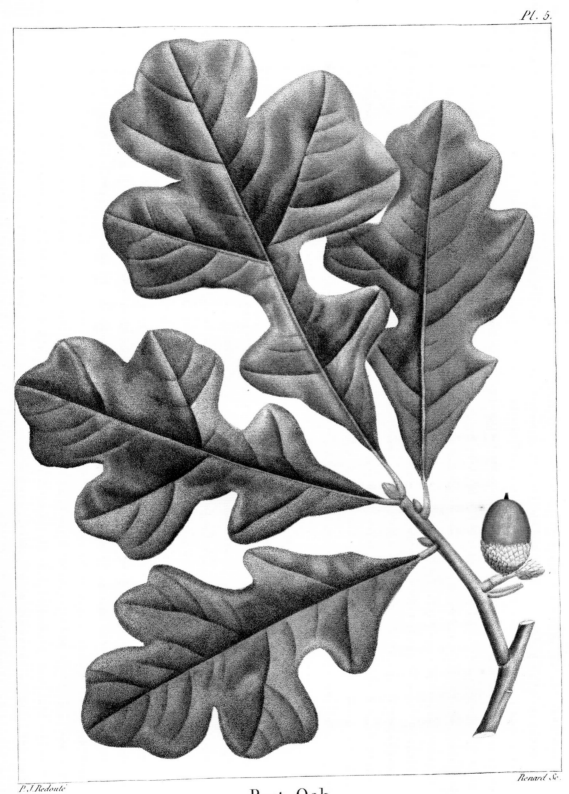

P.J.Redouté

Renard Sc.

Post Oak.

Quercus obtusiloba.

Pl. 97. Post Oak, Turkey Oak (*Quercus stellata* Wangenh.)

[117

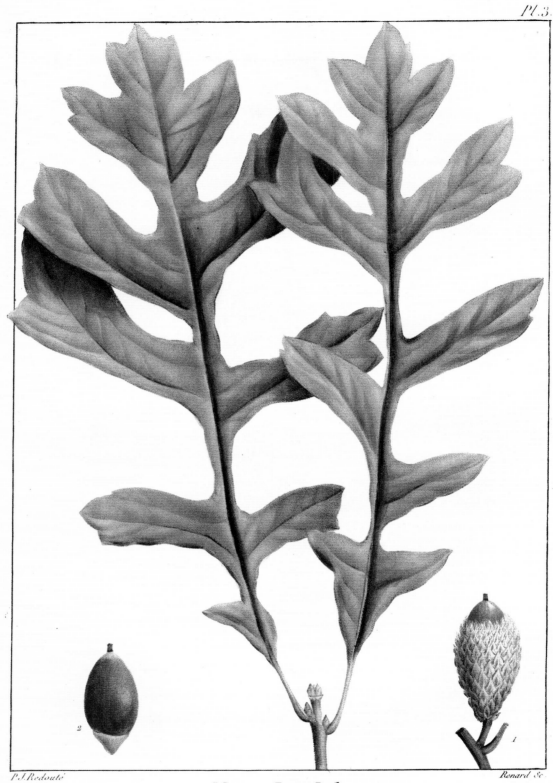

Pl.3.

P.J.Redouté

Renard Sc.

Mossy Cup Oak.

Quercus olivæformis.

Pl. 98. Bur Oak (*Quercus macrocarpa* Michx.)

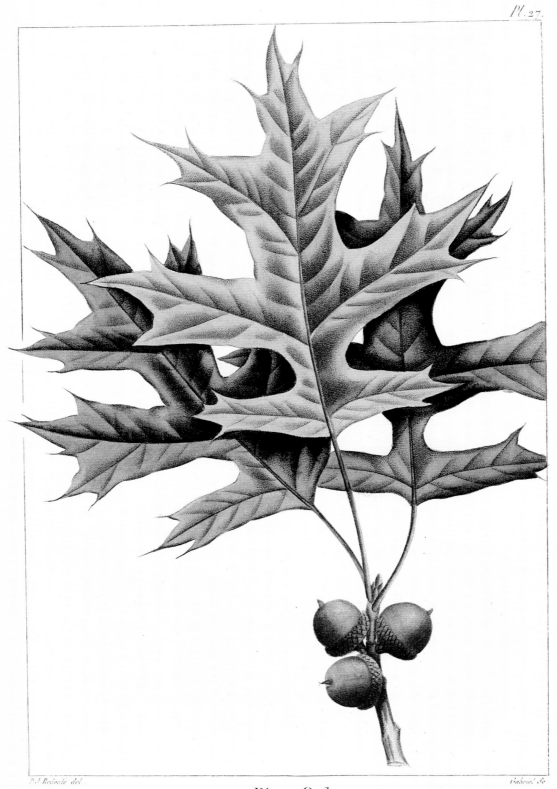

Pl. 27.

Pine Oak.

Quercus palustris.

Pl. 99. Pin Oak, Swamp Oak (*Quercus palustris* Münchh.)

Pl. 14

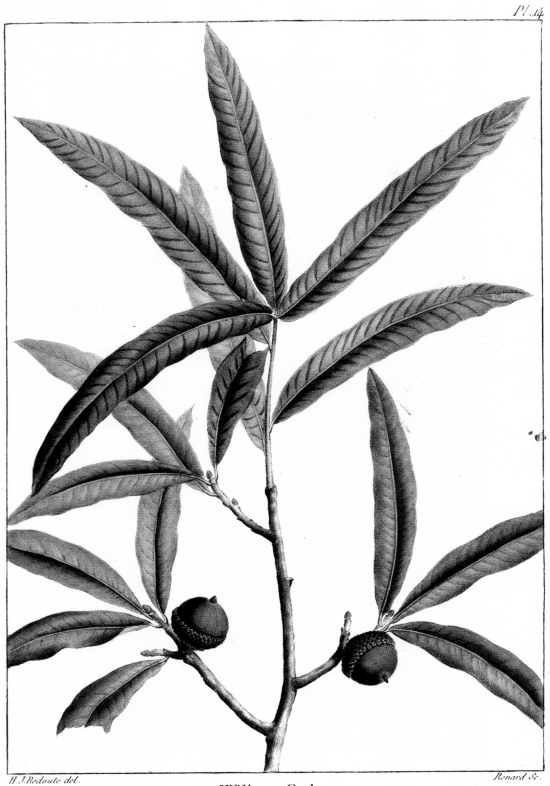

H.J.Redouté del.

Renard Sc.

Willow Oak.
Quercus phellos.

Pl. 100. Willow Oak (*Quercus phellos* L.)

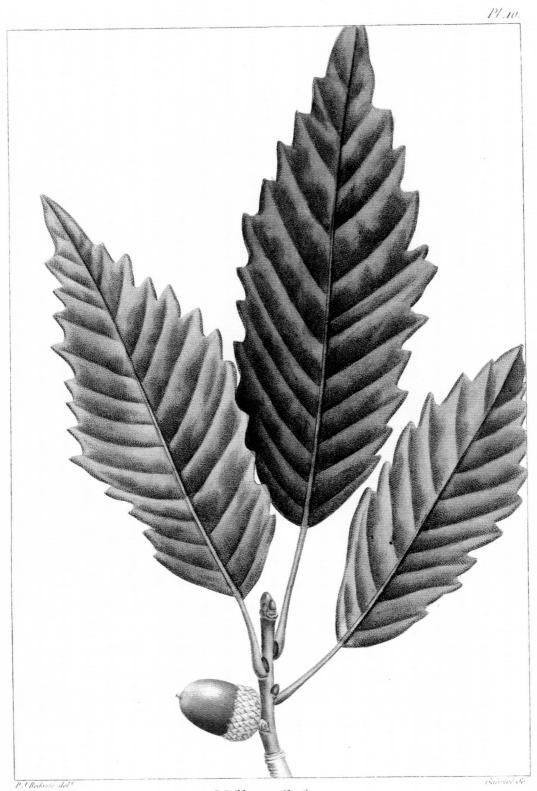

Pl. 10.

Yellow Oak.

Quercus P.ᵘˢ acuminata.

Pl. 101. Chinkapin Oak (*Quercus muehlenbergii* Engelm.) 　　[121

Pl. 11.

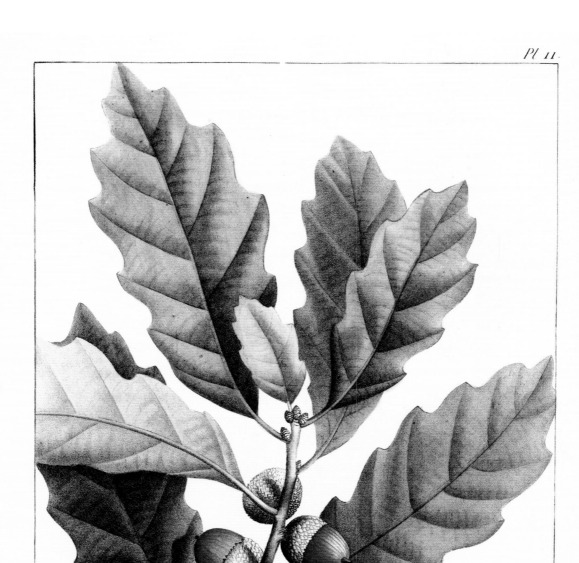

Bessa del. Bessin sculp.

Small Chesnut Oak.

Quercus P.^{llo} chincapin.

122] Pl. 102. Dwarf Chinkapin Oak (*Quercus prinoides* Willd.)

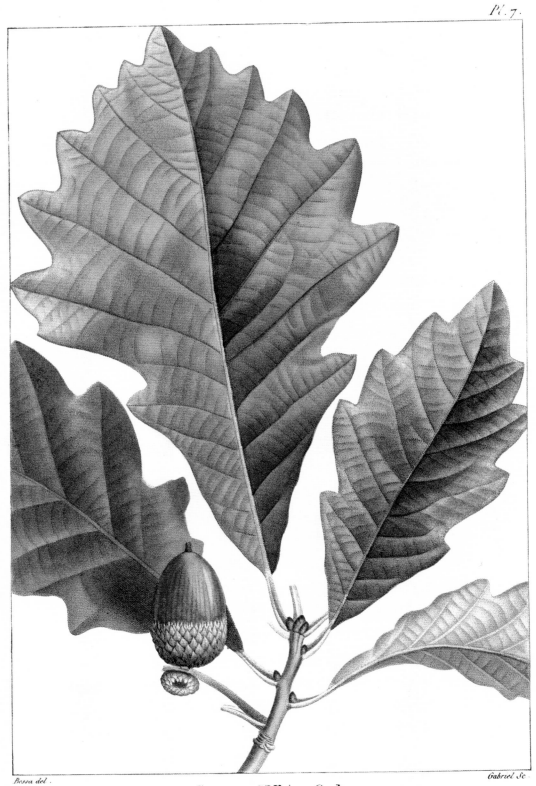

Pl. 7.

Bessa del.

Gabriel Sc.

Swamp White Oak

Quercus P.us discolor.

Pl. 103. Swamp White Oak, Swamp Oak (*Quercus bicolor* Willd.) [123

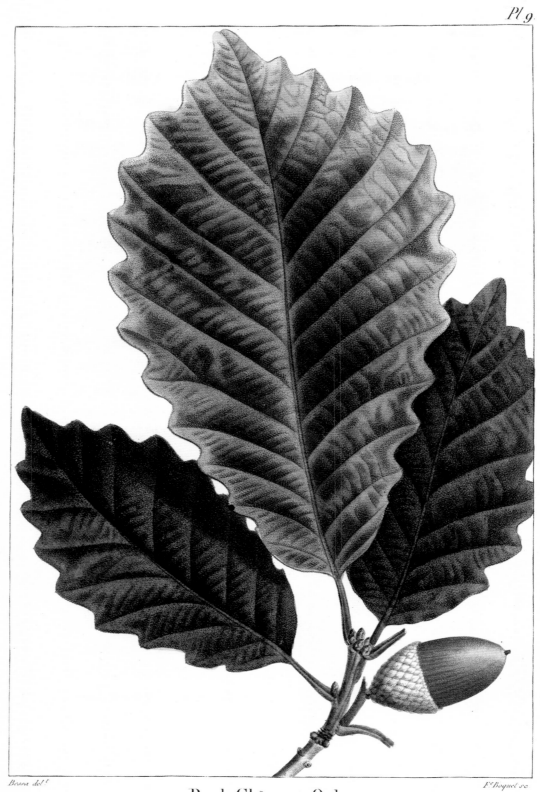

Pl 9.

Bessa del.^t F.^s Boquet sc.

Rock Chesnut Oak.

Quercus P.^{us} monticola .

Pl. 104. Chestnut Oak, Mountain Chestnut Oak, Rock Oak
(*Quercus montana* Willd.)

Pl.8.

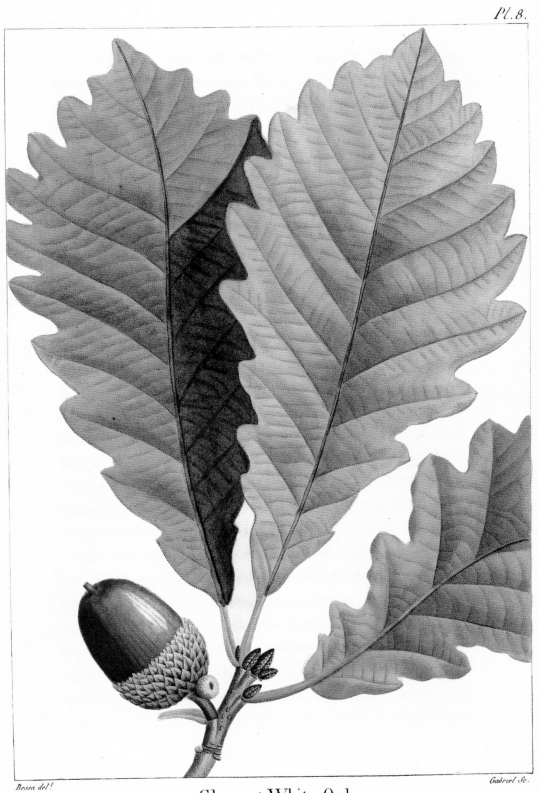

Bessa del.

Gabriel Sc.

Chesnut White Oak.
*Quercus P.*ᵘˢ *palustris.*

Pl. 105. Chestnut Oak, Mountain Chestnut Oak, Rock Oak
(*Quercus montana* Willd.)

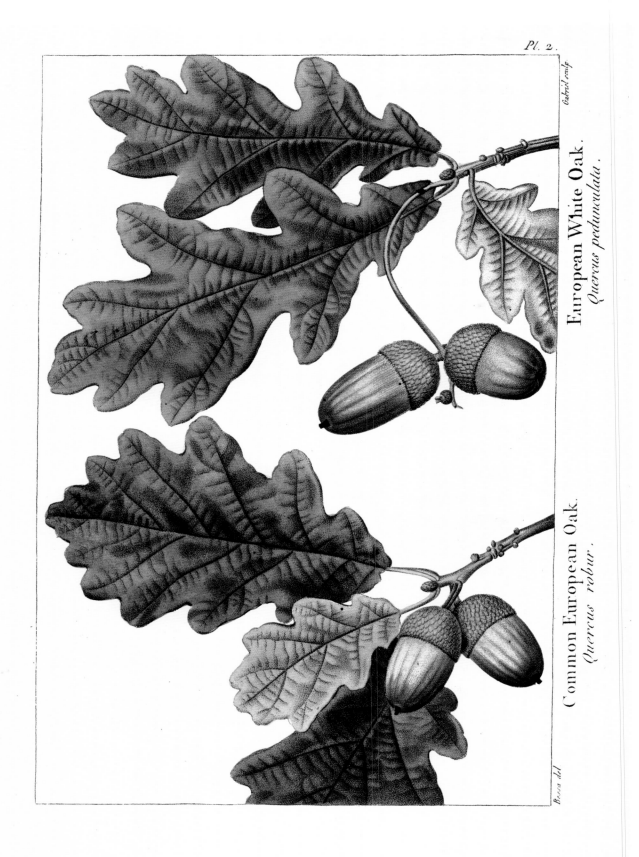

Pl. 2.

Gabriel sculp.

European White Oak.
Quercus pedunculata.

Common European Oak.
Quercus robur.

Becca del.

Plate 106. English Oak, Common Oak (*Quercus robur* L.),
Sessile Oak (*Quercus petraea* (Matt.) Liebl.)

Pl. 17.

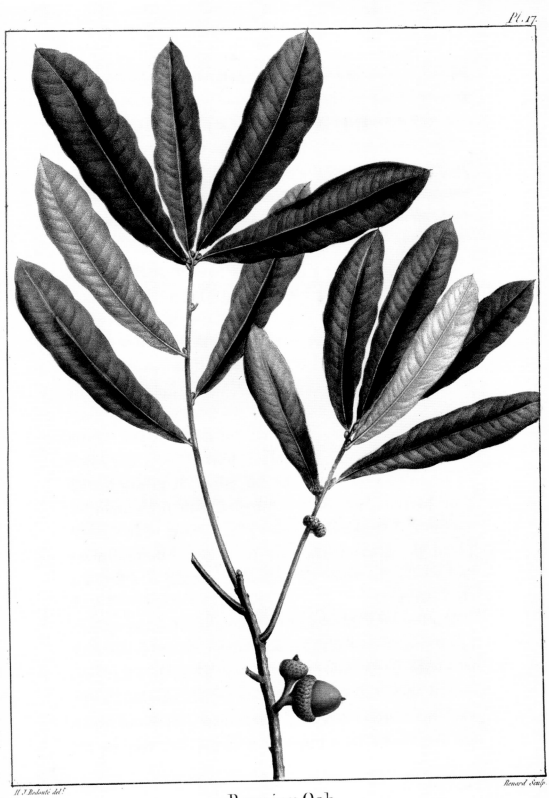

Running Oak.
Quercus pumila

Pl. 107. Runner Oak (*Quercus pumila* Walter)

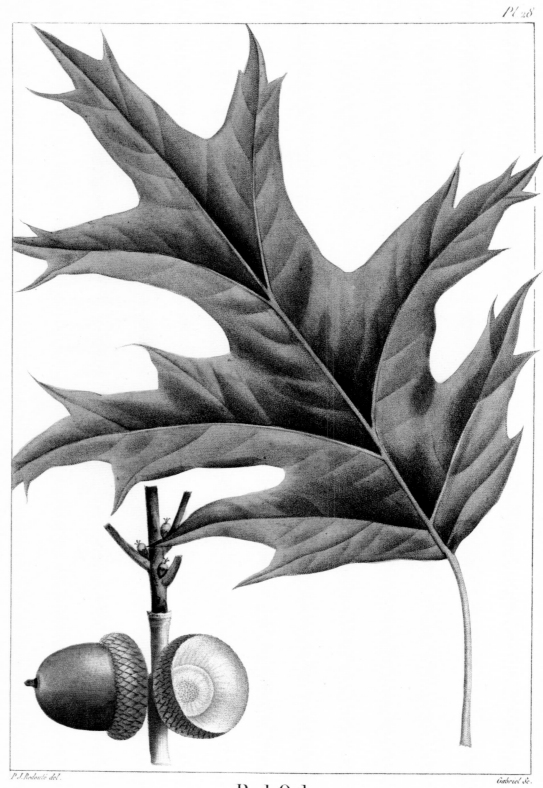

Pl.28

P.J.Redouté del.

Gabriel Sc.

Red Oak.

Quercus rubra.

128]

Pl. 108. Northern Red Oak (*Quercus rubra* L.)

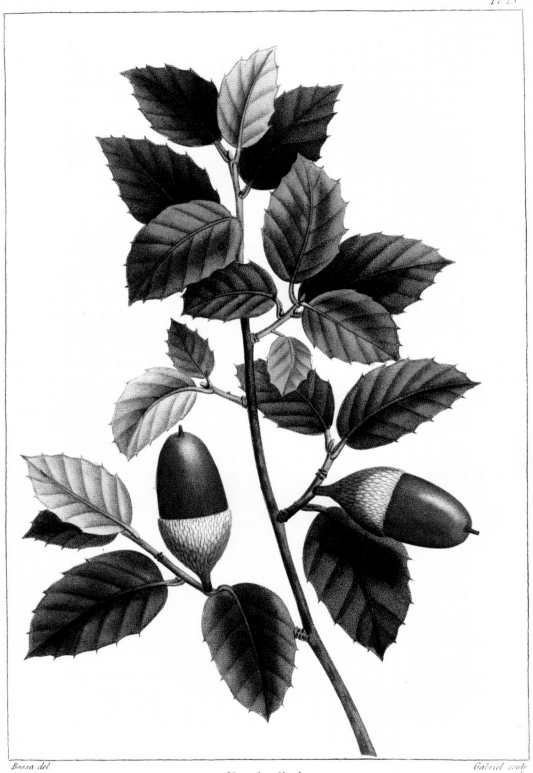

Bessa del. Gabriel sculp.

C o r k O a k.
Quercus suber.

Pl. 109. Cork Oak, Cork Tree (*Quercus suber* L.) [129

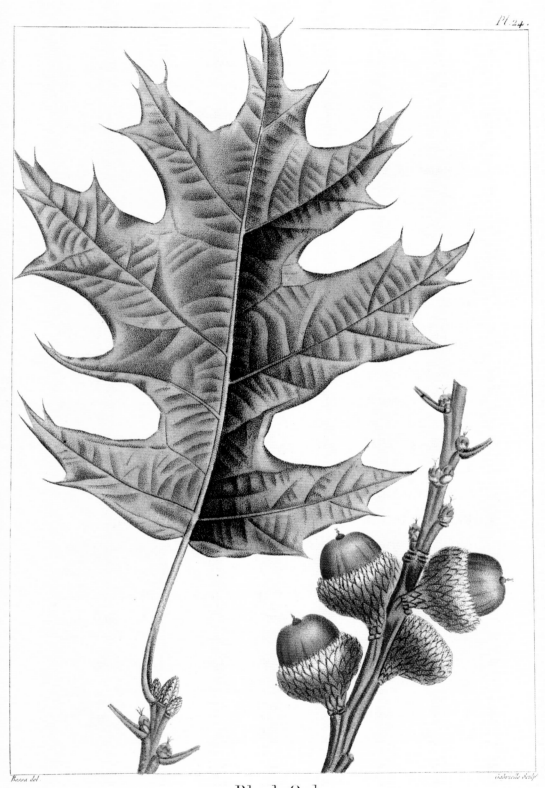

Pl. 24.

Bessa del.

Gabrielle Sculp.

Black Oak

Quercus tinctoria.

Pl. 110. Black Oak (*Quercus velutina* Lam.)

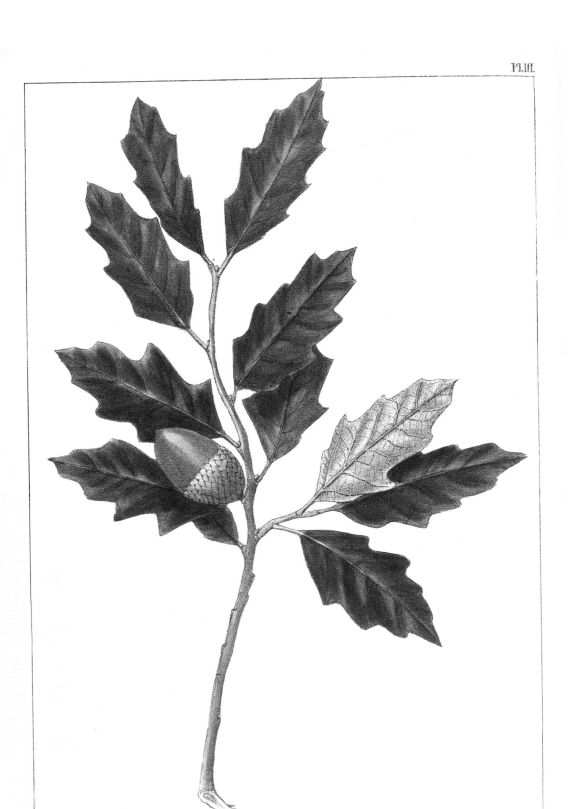

W.Gambel del. from Nature. G.West del. on stone. Sinclairs Lith.

Quercus Undulata.

Rocky Mountain Oak Chêne ondule.

Pl. III. Gambel Oak (*Quercus gambelii* Nutt.)

Pl. 12.

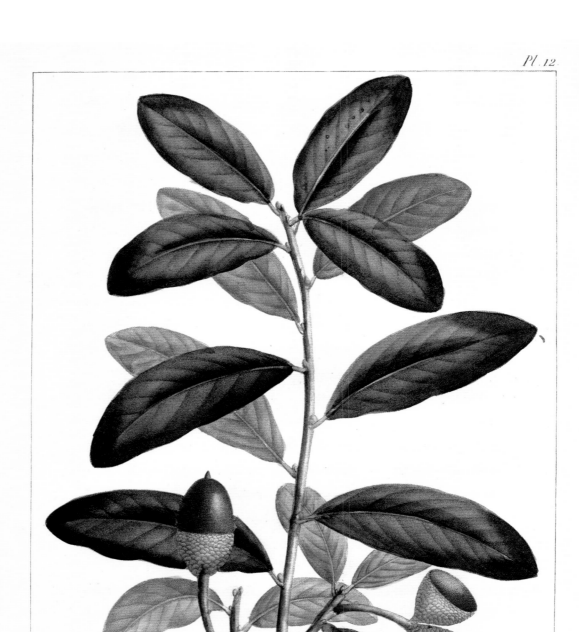

H.J.Redouté del. Gabriel Sc.

Live Oak.

Quercus virens.

Pl. 112. Live Oak (*Quercus virginiana* Mill.)

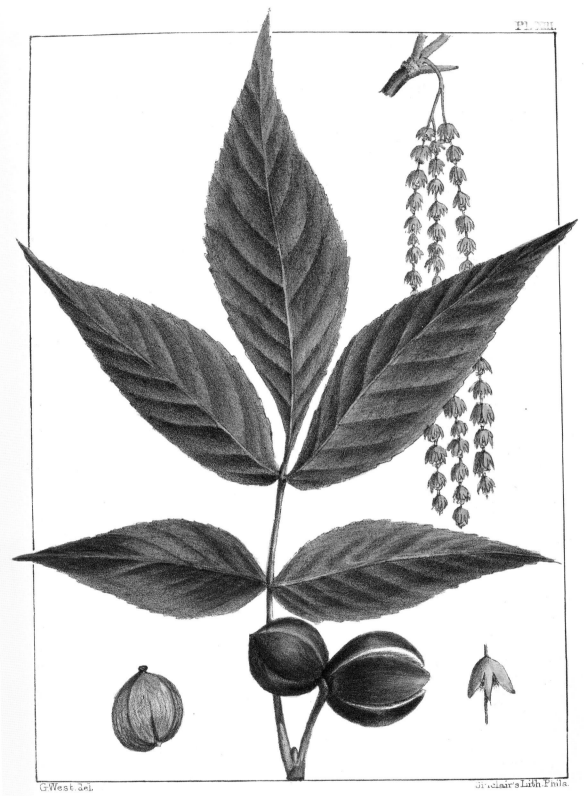

Sinclair's Lith.Phila.

Carya Microcarpa.

Small-fruited Hickory. *Noyer a'petit fruit.*

Pl. 113. Broom Hickory, Pignut Hickory (*Carya glabra* (Mill.) Sweet) [133

Pl. 114. Bitternut Hickory (*Carya cordiformis* (Wangenh.) K. Koch)

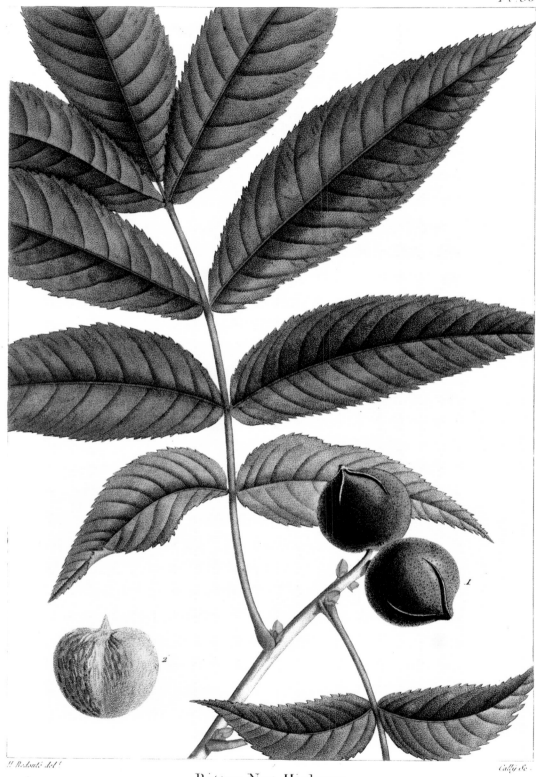

Pl.33.

Bitter Nut Hickory.

Juglans amara.

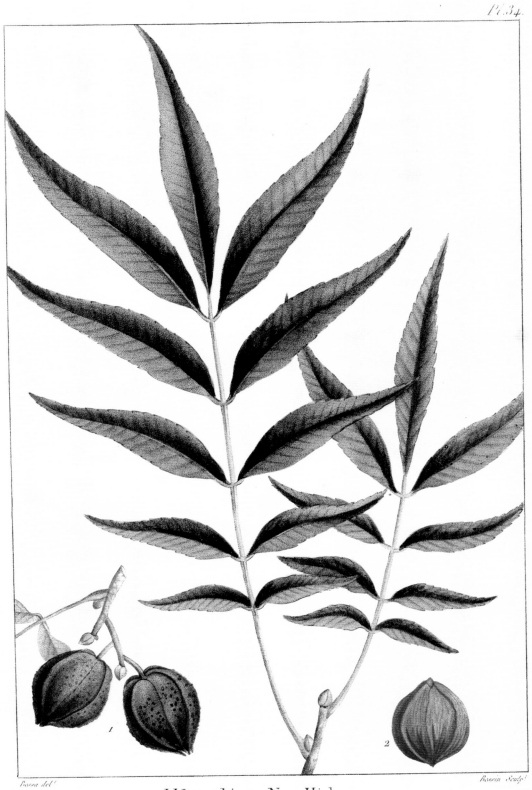

Bessa del. Bessin Sculp.

Water bitter Nut Hickory.

Juglans aquatica.

Pl. 115. Water Hickory, Bitter Pecan (*Carya aquatica* (F. Michx.) Nutt.) [135

Pl. 31.

P.J Redouté del.

Renard Sc.

Butter Nut.

Juglans cathartica.

Pl. 116. Butternut (*Juglans cinerea* L.)

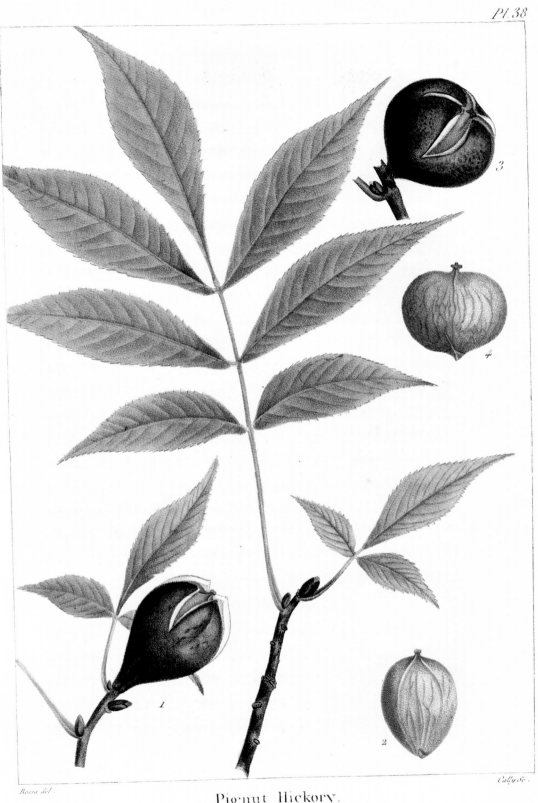

Pl. 38

Bessa del.

Cally Sc.

Pignut Hickory.
Juglans porcina.

Pl. 121. Broom Hickory, Pignut Hickory (*Carya glabra* (Mill.) Sweet) [141

Pl. 29

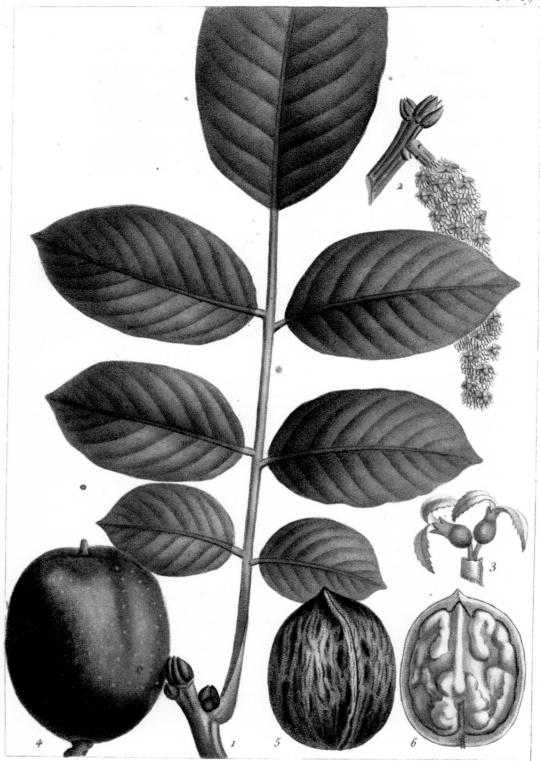

Common European Walnut.

Juglans regia

Pl. 122. Persian Walnut, English Walnut (*Juglans regia* L.)

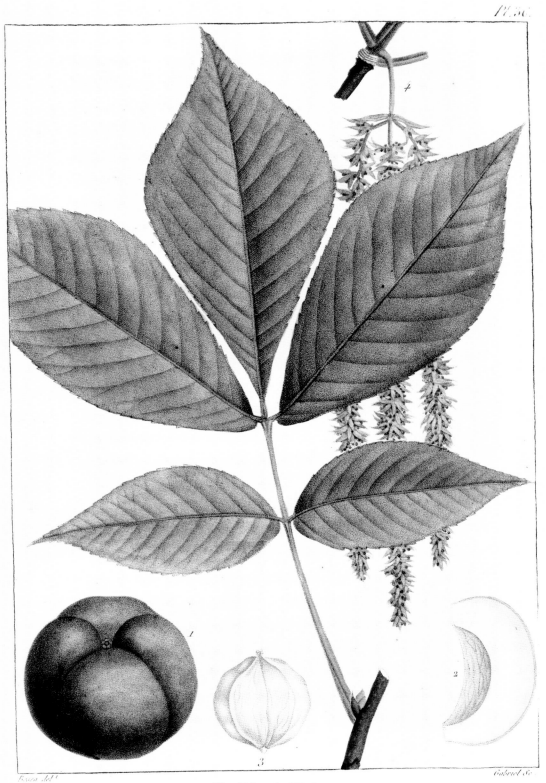

Shell bark Hickory

Juglans squamosa.

Pl. 123. Shagbark Hickory (*Carya ovata* (Mill.) K. Koch) [143

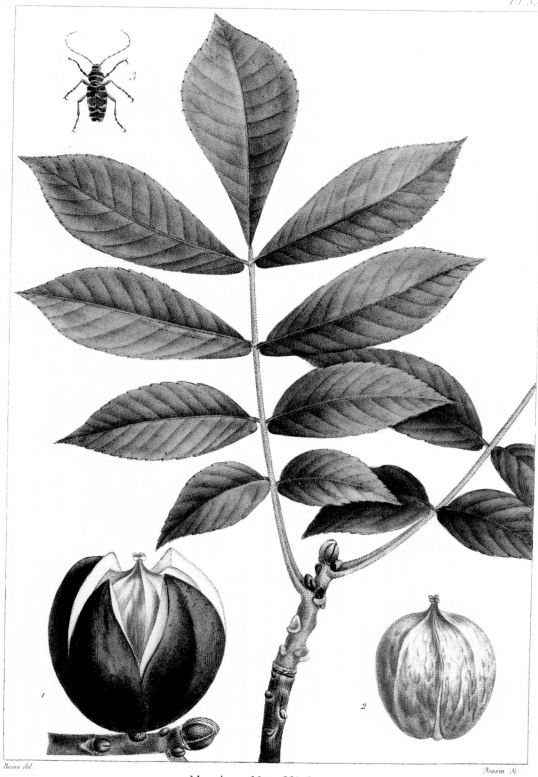

Pl. 33.

Mocker Nut Hickory.

Juglans tomentosa.

Bessa del.

Bessin Sc.

Pl. 124. Mockernut Hickory, White Hickory
(*Carya tomentosa* (Poir.) Nutt.)

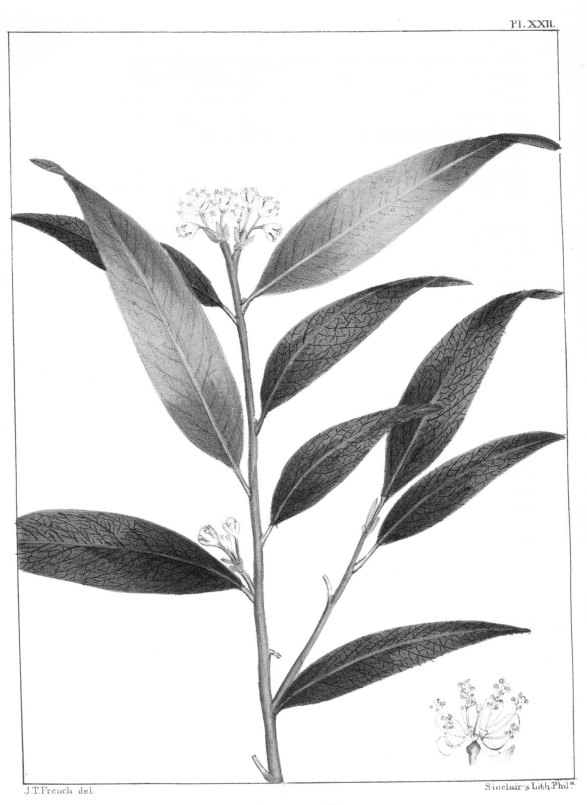

Pl. XXII.

J.T.French del.

Sinclair's Lith.Phil.ª

Drimophylle pauciflore. Drimophyllum pauciflorum. *Californian Bay tree.*

Pl. 125. California Bay, California Laurel
(*Umbellularia californica* (Hook. & Arn.) Nutt.)

Pl. 83.

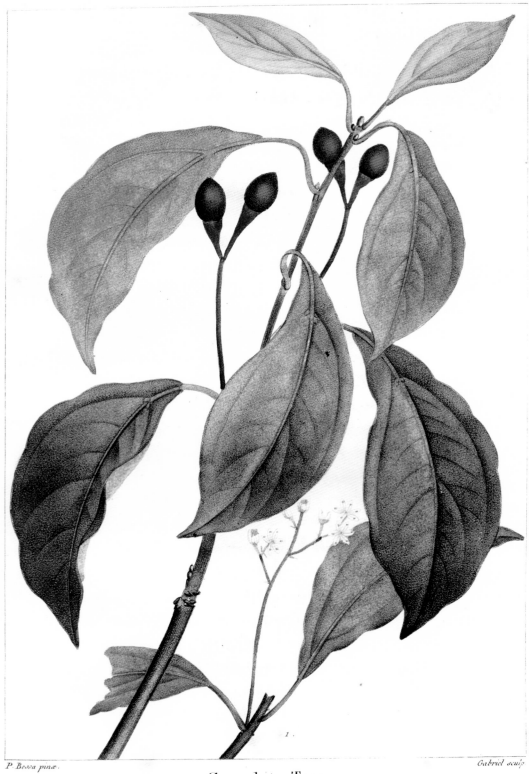

P. Bessa pinx.

Gabriel sculp.

Camphire Tree.
Laurus camphora.

Pl. 126. Camphortree, Camphor-laurel
(*Cinnamomum camphora* (L.) J. Presl.)

Pl. 82.

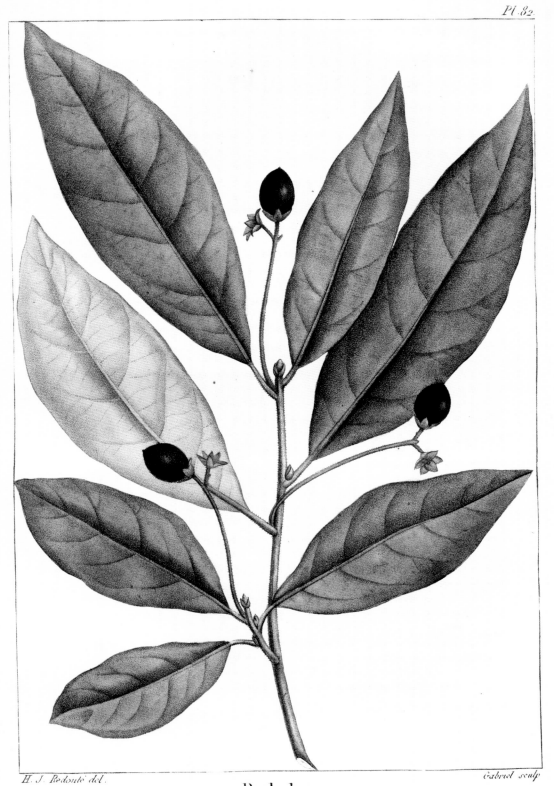

H. J. Redouté del. Gabriel sculp

Red bay.
Laurus caroliniensis.

Pl. 127. Redbay (*Persea borbonia* (L.) Spreng.) [147

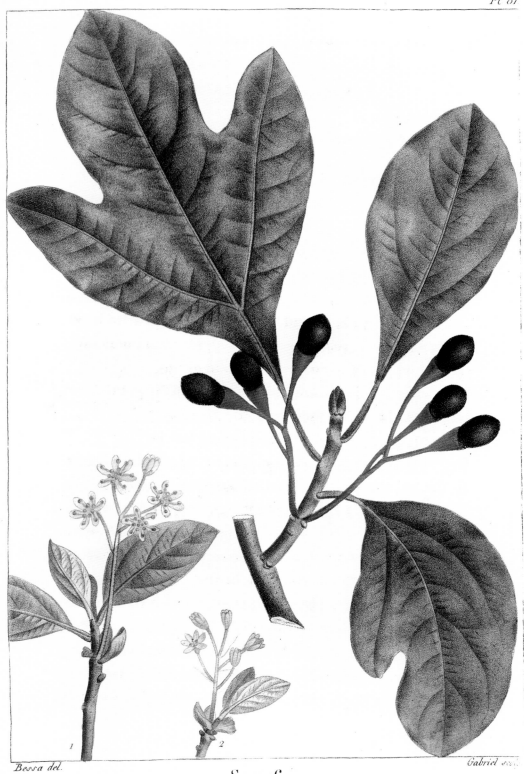

Pl 81

Bessa del.

Gabriel sc.

Sassafras.

Laurus sassafras.

Pl. 128. Sassafras, Cinnamon Wood, Ague Tree (*Sassafras albidum* (Nutt.) Nees)

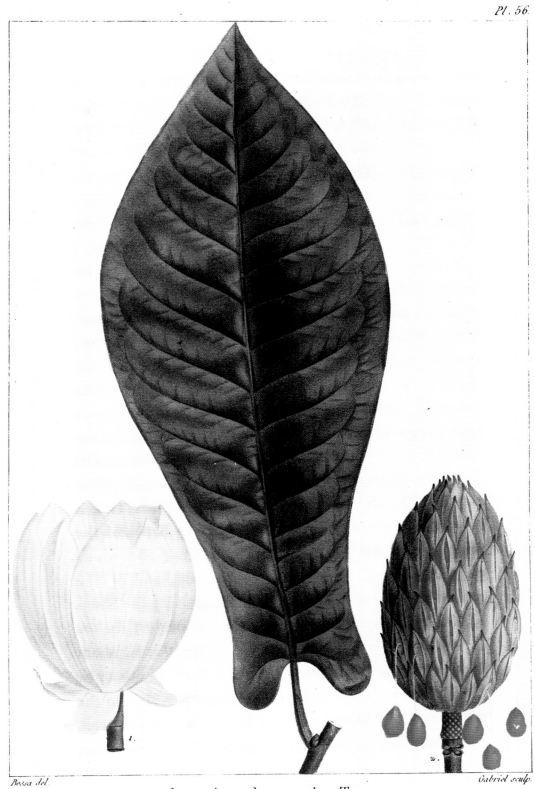

Long leaved cucumber Tree
Magnolia auriculata

Pl. 131. Mountain Magnolia, Fraser Magnolia (*Magnolia fraseri* Walter)

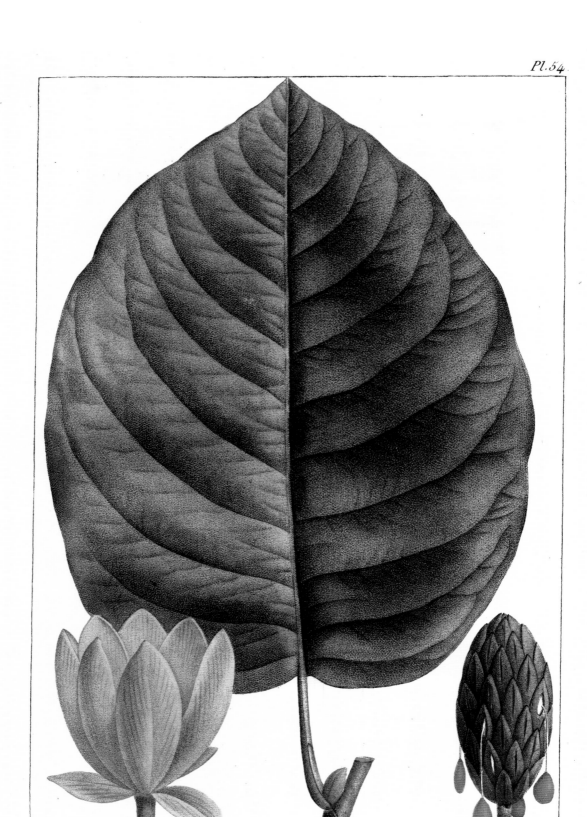

Pl.54.

Bessa del.

Gabriel sculp.

Heart leaved cucumber Tree.
Magnolia cordata.

Pl. 132. Cucumber Tree, Mountain Magnolia
(*Magnolia acuminata* var. *subcordata* (Spach) Dandy)

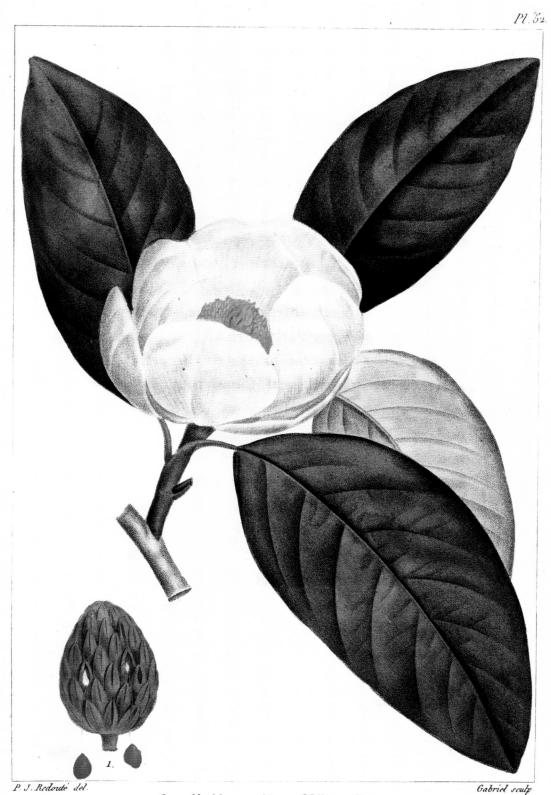

Pl. 52.

P. J. Redouté del.

Gabriel sculp.

Small Magnolia *or* White Bay.
Magnolia glauca.

Pl. 133. Sweetbay, Swamp Magnolia
(*Magnolia virginiana* L.)

Pl.51.

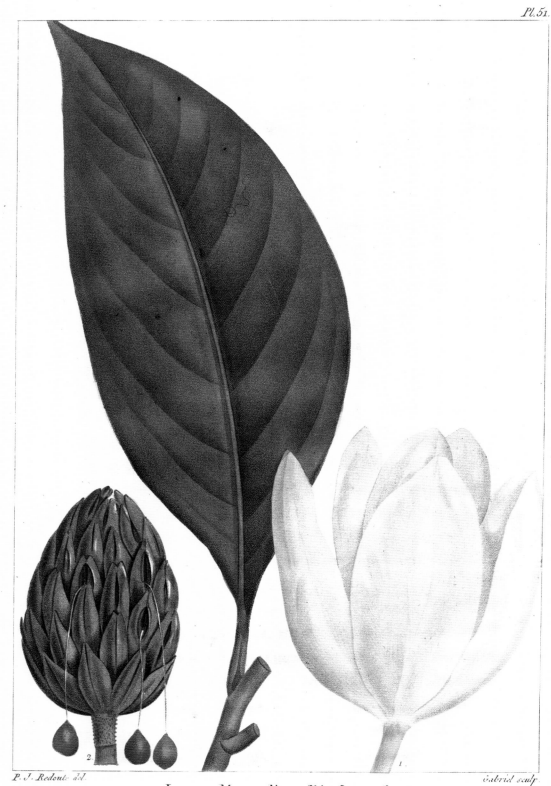

Large Magnolia *or* Big Laurel.

Magnolia Grandiflora.

Pl. 134. Southern Magnolia (*Magnolia grandiflora* L.)

Pl. 57.

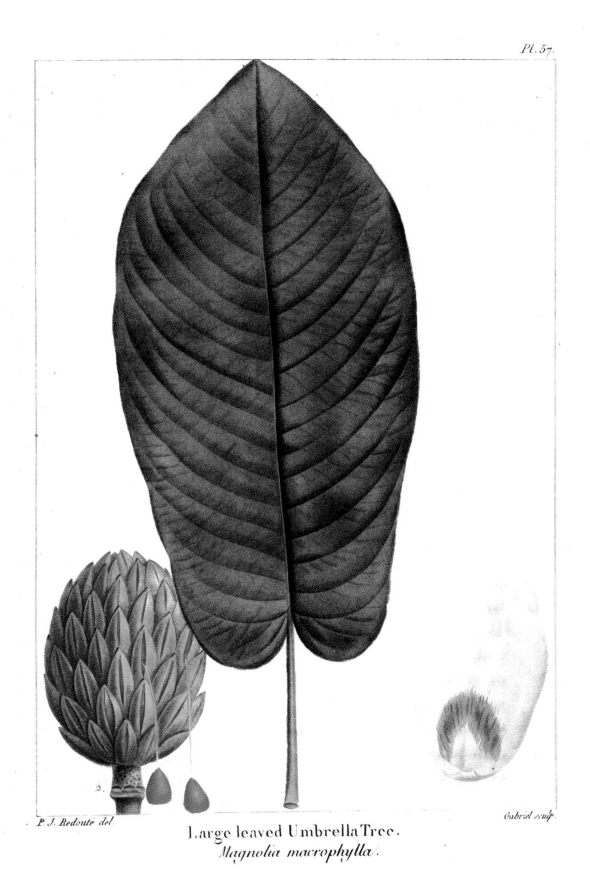

P. J. Redouté del.

Gabriel sculp.

Large leaved Umbrella Tree.
Magnolia macrophylla.

Pl. 135. Bigleaf Magnolia (*Magnolia macrophylla* Michx.)

Pl.55.

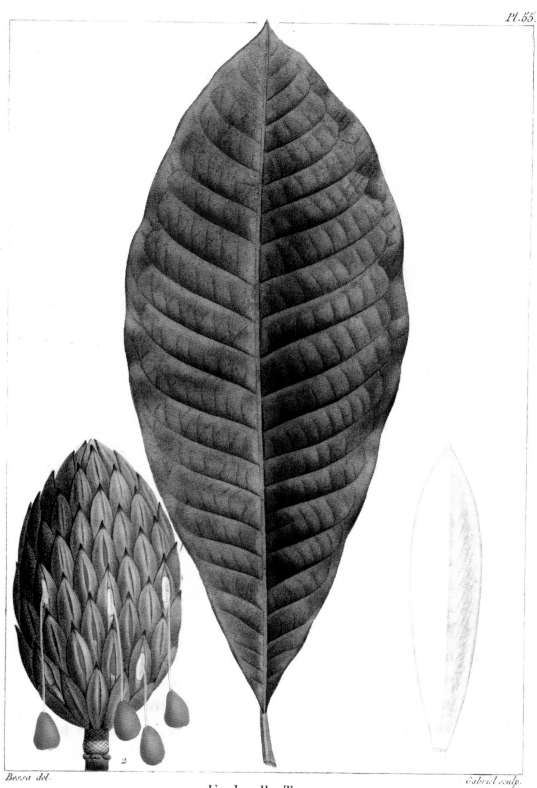

Bessa del.

Gabriel sculp.

Umbrella Tree.

Magnolia tripetala.

Pl. 136. Umbrella Tree, Elkwood (*Magnolia tripetala* (L.) L.)

Pl. 132

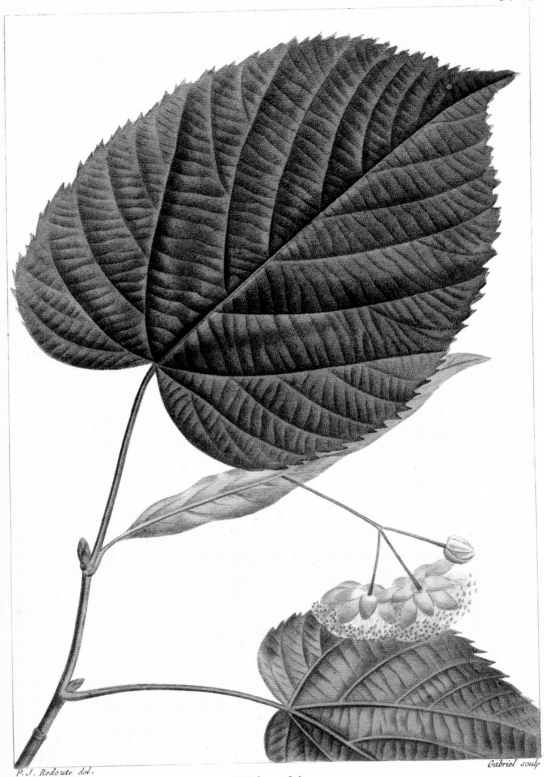

P. J. Redouté del.

Gabriel sculp.

White Lime.

Tilia Alba.

Pl. 137. White Basswood
(*Tilia americana* L. var. *heterophylla* (Vent.) Loudon)

Pl. 131.

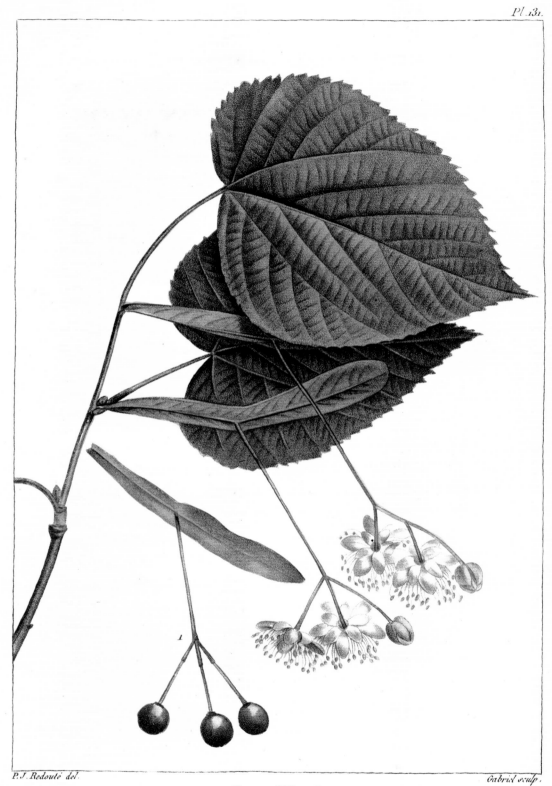

P.J. Redouté del.

Gabriel sculp.

Bass Wood

Tilia Americana

Pl. 138. American Basswood (*Tilia americana* L. var. *americana*)

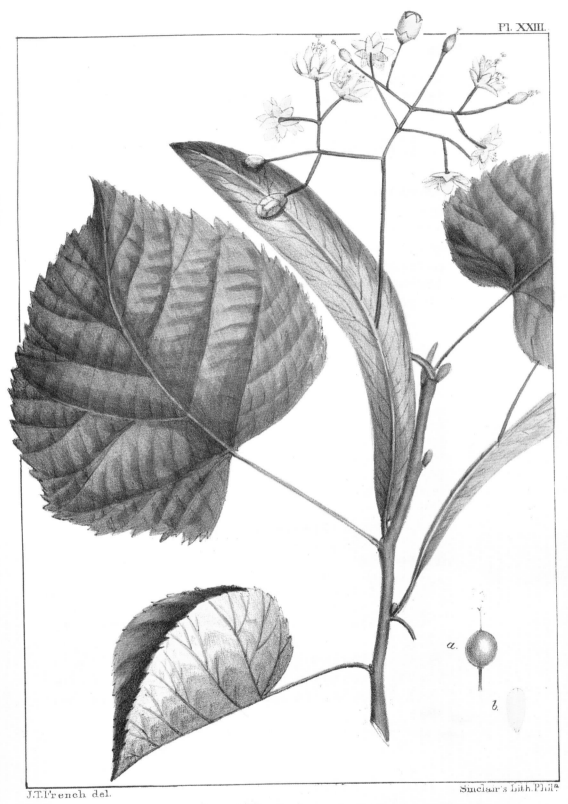

J.T.French del.

Sinclair's Lith.Phil&super;a

Tilleul heterophylle. Tilia heterophylla. *Large-leaved Linden.*

Pl. 139. White Basswood
(*Tilia americana* L. var. *heterophylla* (Vent.) Loudon)

[159

Pl. 133

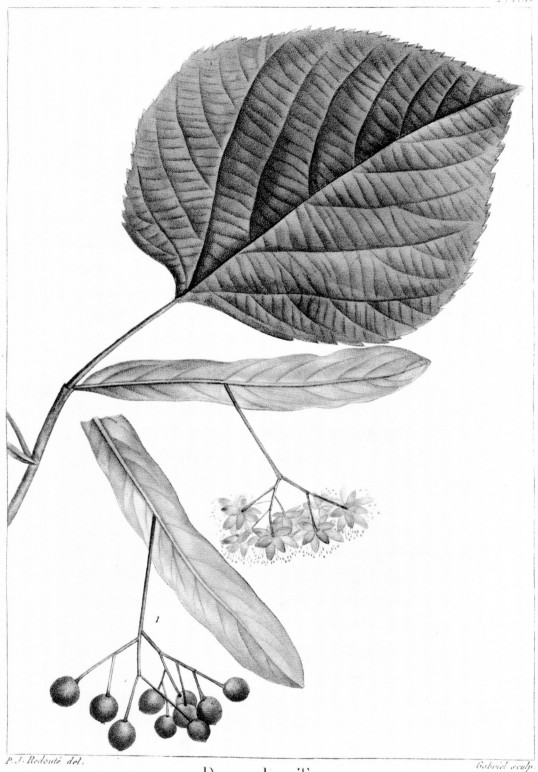

P.J. Redouté del.

Gabriel sculp.

Downy Lime Tree
Tilia pubescens.

Pl. 140. Carolina Basswood
(*Tilia americana* L. var. *caroliniana* (Mill.) Castigl.)

Pl. 102

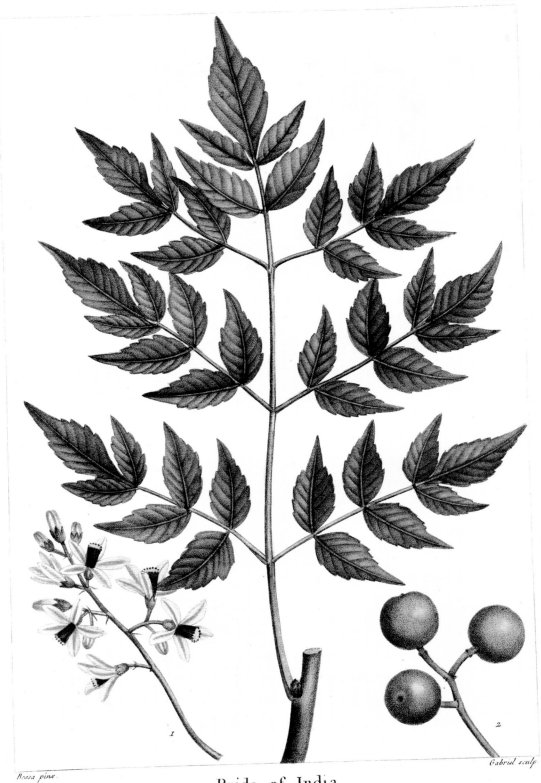

Bessa pinx.

Gabriel sculp.

Pride of India.
Melia azedarach.

Pl. 141. Chinaberry, Bead Tree, Pride of India (*Melia azedarach* L.)

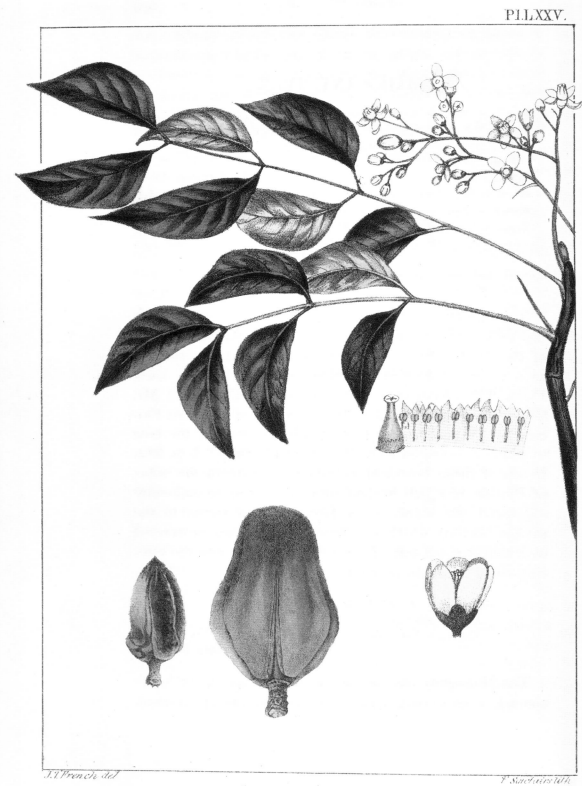

J.T.French del. F.Sinclairs lith.

Swietenia Mahogoni

Mahogany Tree Mahogani d. Amérique

Pl. 142. Mahogany Tree (*Swietenia mahagoni* (L.) Jacq.)

Pl 143.

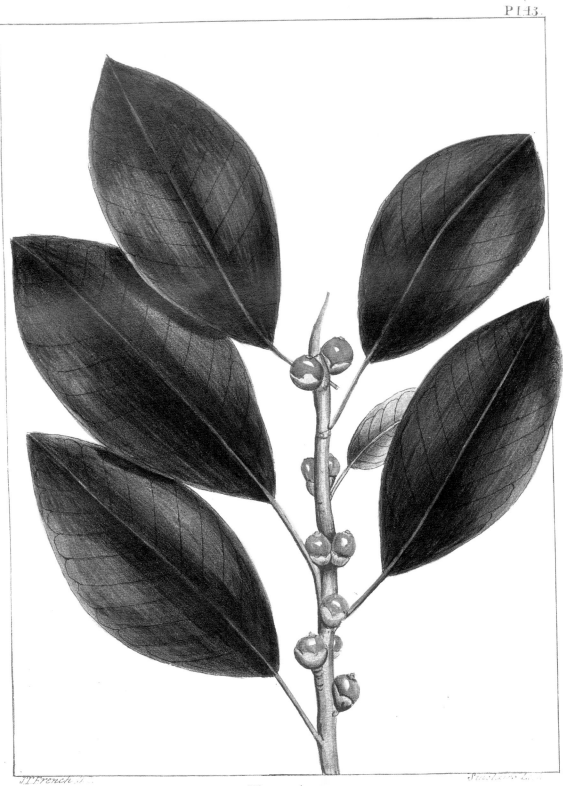

J.T.French

Ficus Aurea

Small fruited Fig Tree.

Figuier doré.

Pl. 143. Strangler Fig (*Ficus aurea* Nutt.)

Pl.42.

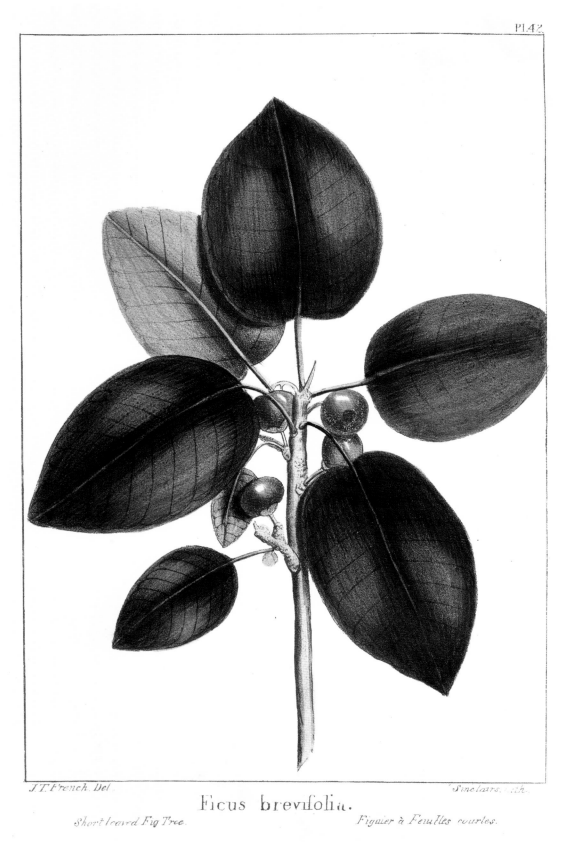

Ficus brevifolia.

Short leaved Fig Tree.　　　　　Figuier à Feuilles courtes.

J.T.French. Del.　　　　　Sinclairs. lith.

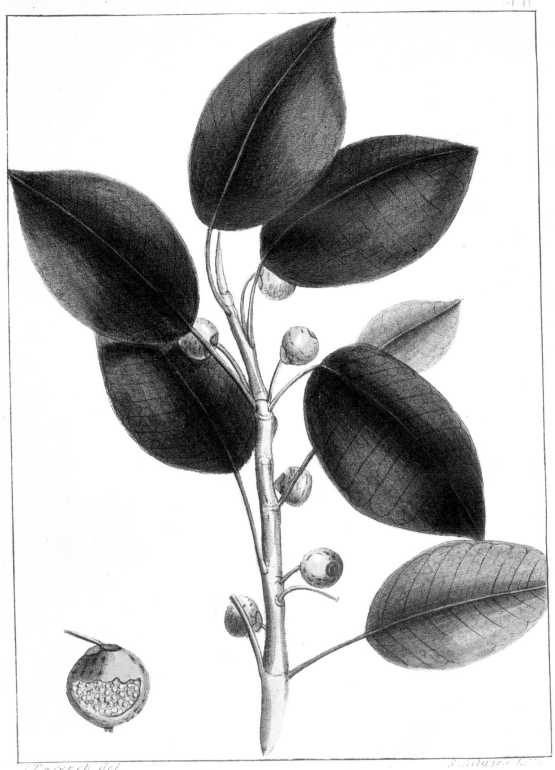

Ficus pedunculata.

Cherry fig-tree Figuier pédoncule

Pl. 145. Shortleaf Fig (*Ficus citrifolia* Mill.) [165

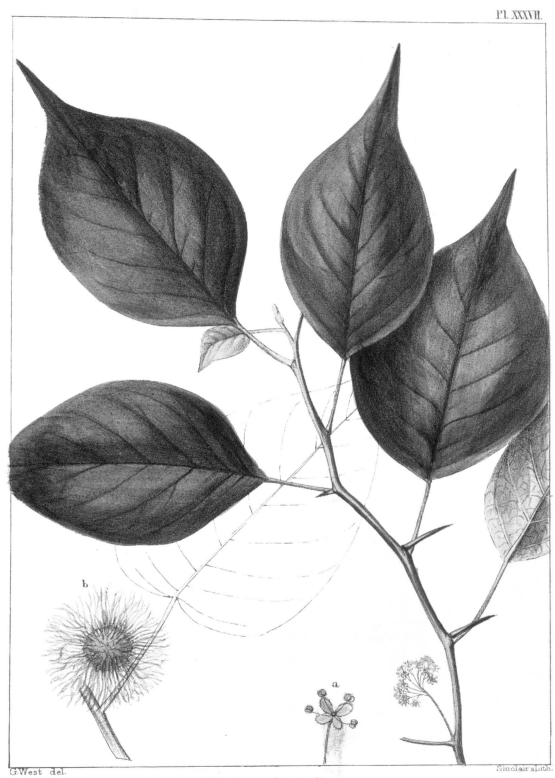

Pl. XXXVII.

G.West del.

Sinclair lith.

Maclura Aurantiaca.

Osage Orange.　　　　　*Bois d'Arc.*

Pl. 146. Osage-orange (*Maclura pomifera* (Raf.) C. K. Schneid.)

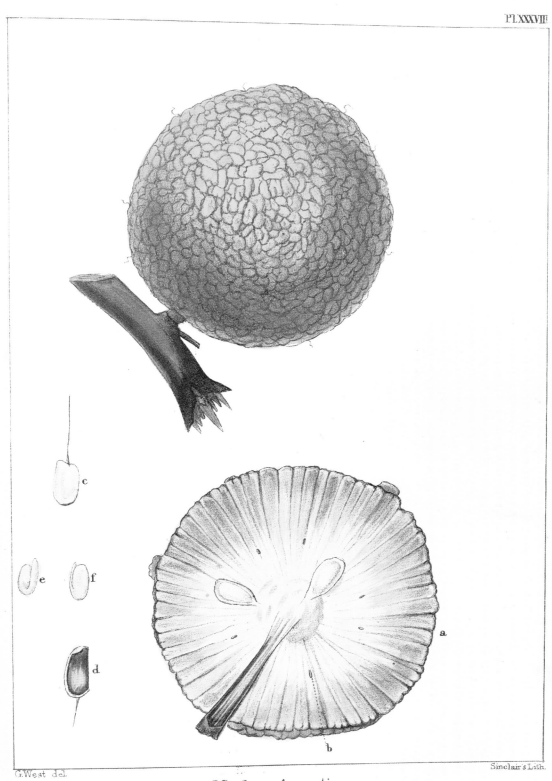

G.West del.

Sinclair's Lith.

Maclura Aurantiaca.

Osage Orange.

Bois d'Arc.

Pl. 147. Osage-orange (*Maclura pomifera* (Raf.) C. K. Schneid.)

[167

Pl.110

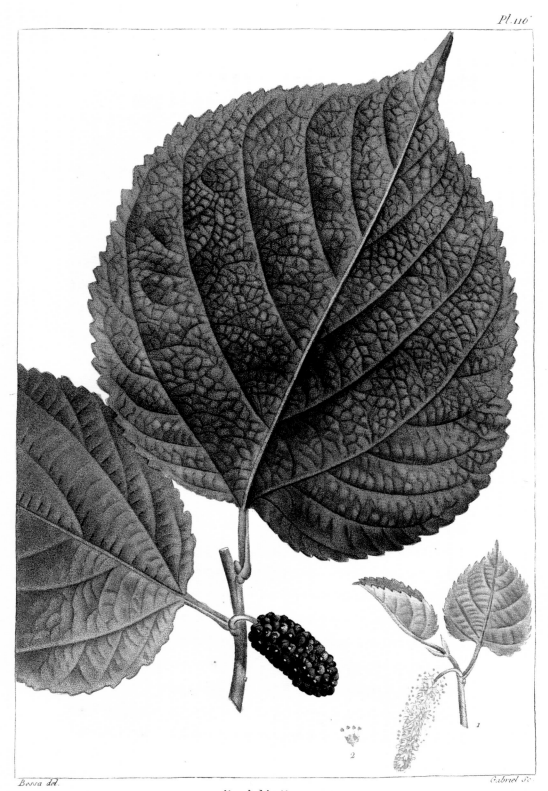

Bessa del.

Gabriel Sc.

2

1

Red Mulberry.
Morus rubra.

Pl. 148. Red Mulberry (*Morus rubra* L.)

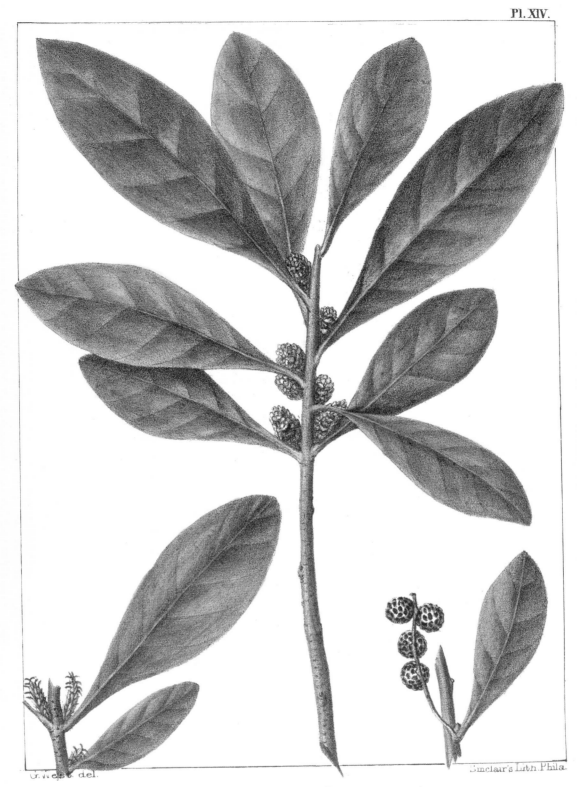

Pl. XIV.

G. West del.

Sinclair's Lith. Phila.

Myrica inodora.

Inodorous Candle-tree. *Cirier inodore.*

Pl. 149. Wax Tree (*Myrica inodora* W. Bartram) [169

Pl. XXVI

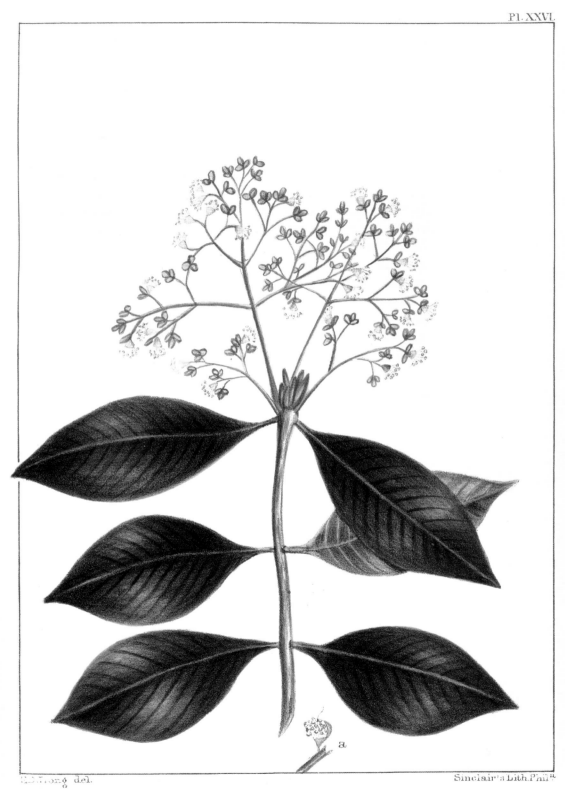

C.C.long del.

Sinclair's Lith. Phil^a

Calyptranthes chytraculia.

Forked Calyptranthes. *Calyptranthe chytraculie.*

Pl. 150. Forked Calyptranthes (*Calyptranthes chytraculia* (L.) Sw.)

Pl. XXIX.

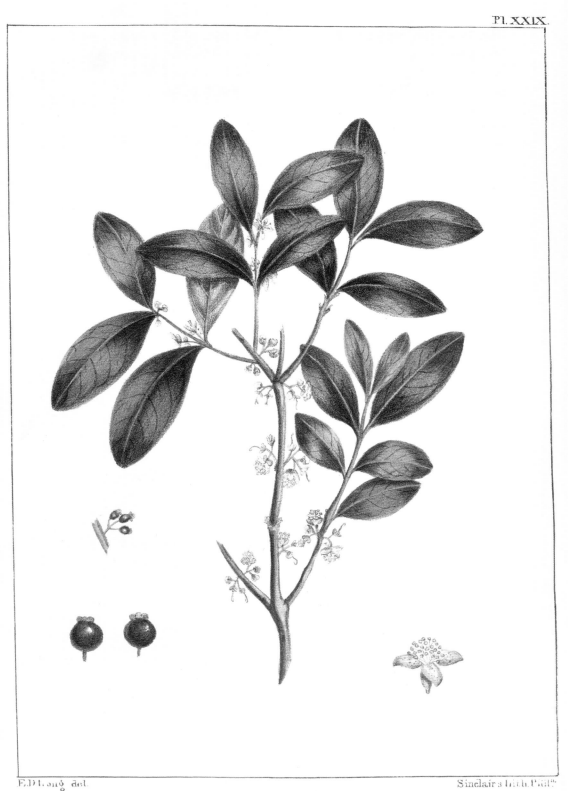

E.D Long del. Sinclair's lith. Phila.

Box-leaved Eugenia. Eugenia buxifolia. *Jambosier à feuilles de buis.*

Pl. 151. Spanish Stopper (*Eugenia foetida* Pers.)

Pl. XXVII.

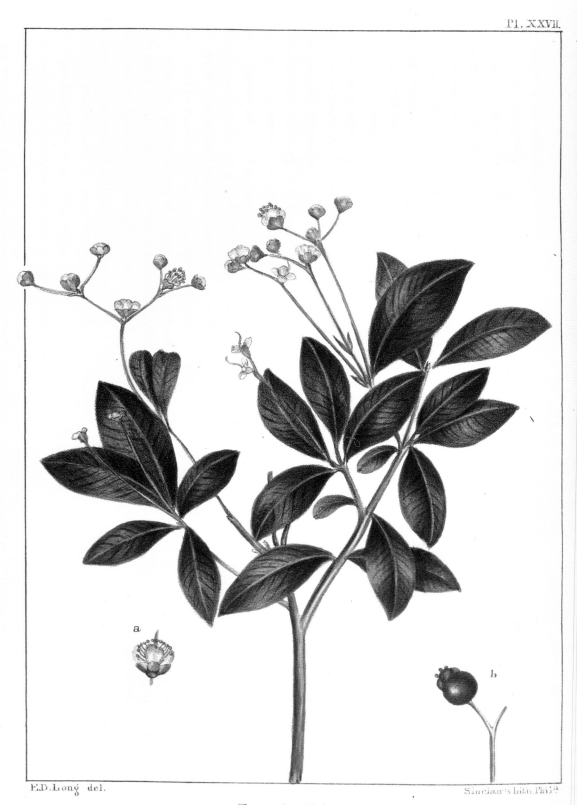

F.D.Long del.

Sinclair's lith Phil?

Small-leaved Eugenia.

Eugenia dichotoma.

Jambosier dichotome.

Pl. 152. Twinberry (*Myrcianthes fragrans* (Sw.) McVaugh)

Pl. XXVIII.

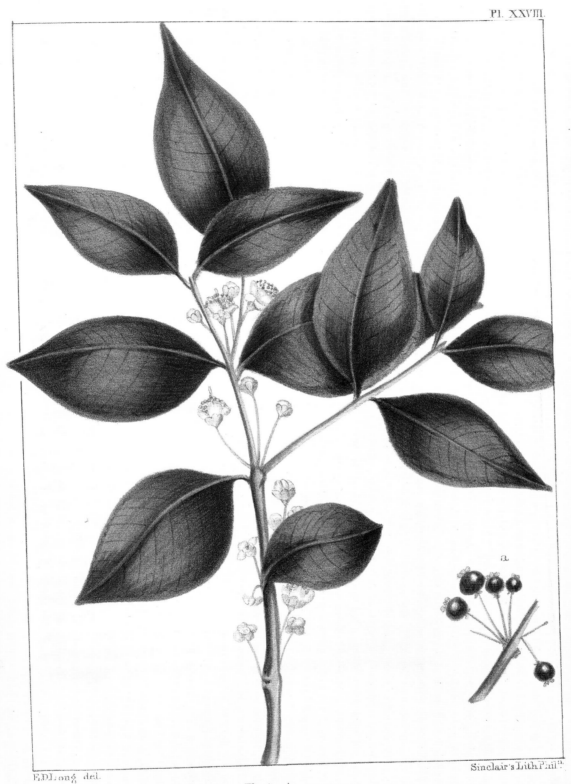

E.D.Long del.

Sinclair's Lith.Phil^a.

Eugenia procera.

Tall Eugenia.

Jambosier élevé.

Pl. 153. Red Stopper (*Eugenia rhombea* (O. Berg) Krug & Urb.) [173

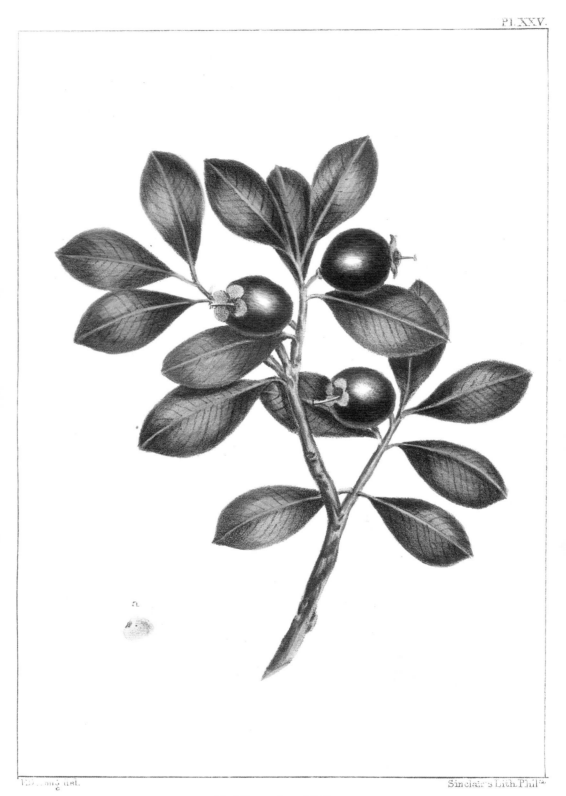

V.Withlong del.　　　　　　　　　　　　Sinclair's Lith.Phil.ᵃ

Florida Guava.　　P sidium buxifolium.　*Goyavier de la Floride.*

　　　　　Pl. 154. Florida Guava (*Psidium buxifolium* Nutt.)

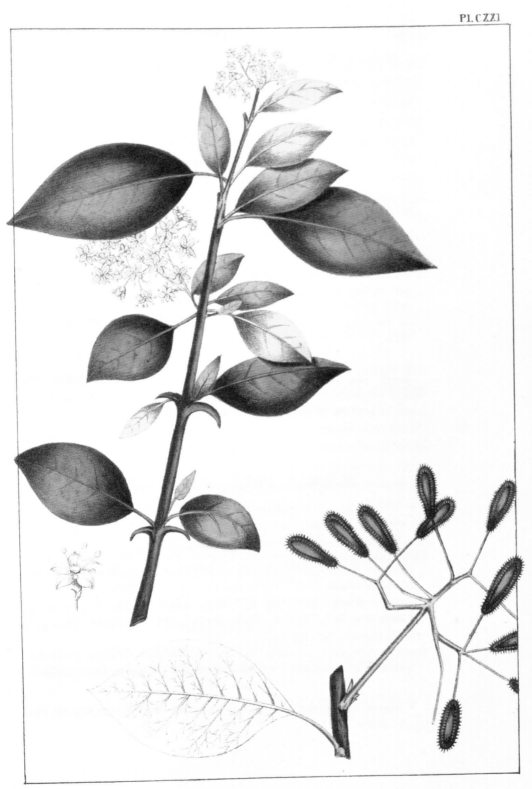

Pisonia Aculeata.

Prickly Pisonia. *Pisone épineuse*

Pl. 155. Devil's-claw, Pull-back-and-hold (*Pisonia aculeata* L.)

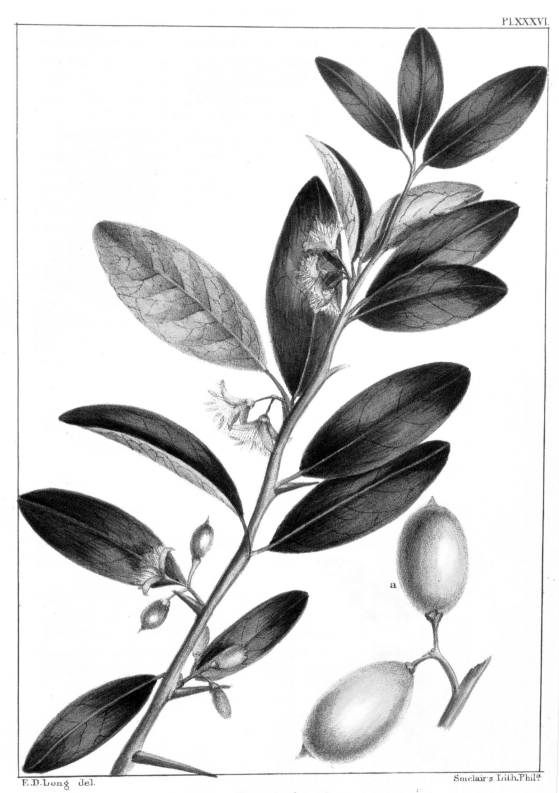

E.D.Long del.

Sinclair's Lith.Phil?

Mountain Plum. **Ximenia Americana.** *Ximenie Americaine.*

Pl. 156. Tallow Wood (*Ximenia americana* L.)

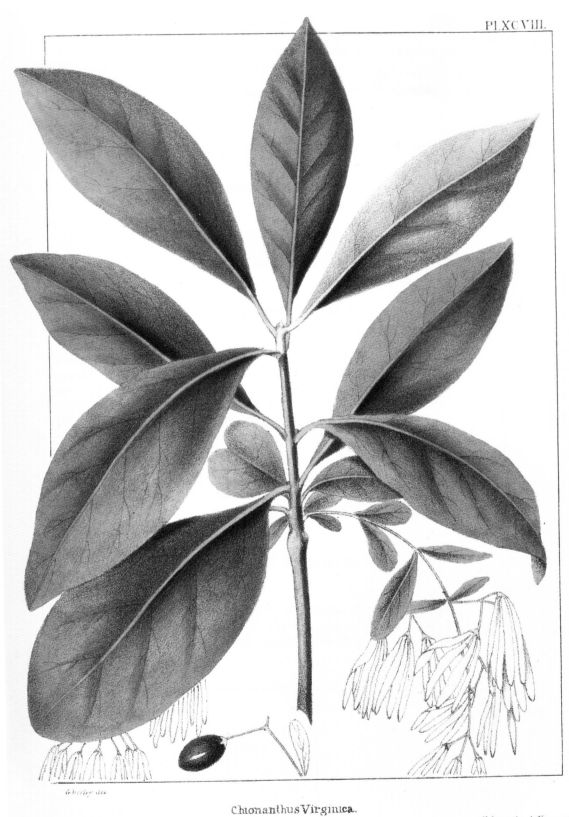

Geberlay del.

Chionanthus Virginica.

Fringe Tree

Chionanthe de Virginie

Pl. 157. Fringetree (*Chionanthus virginicus* L.)

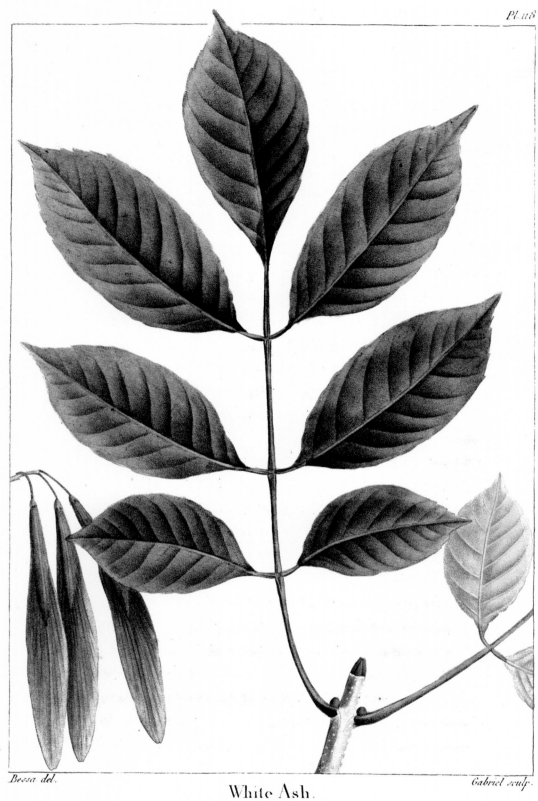

Pl. 118

Bessa del. *Gabriel sculp.*

White Ash.
Fraxinus americana.

Pl. 158. American Ash, White Ash (*Fraxinus americana* L.)

Pl. 121.

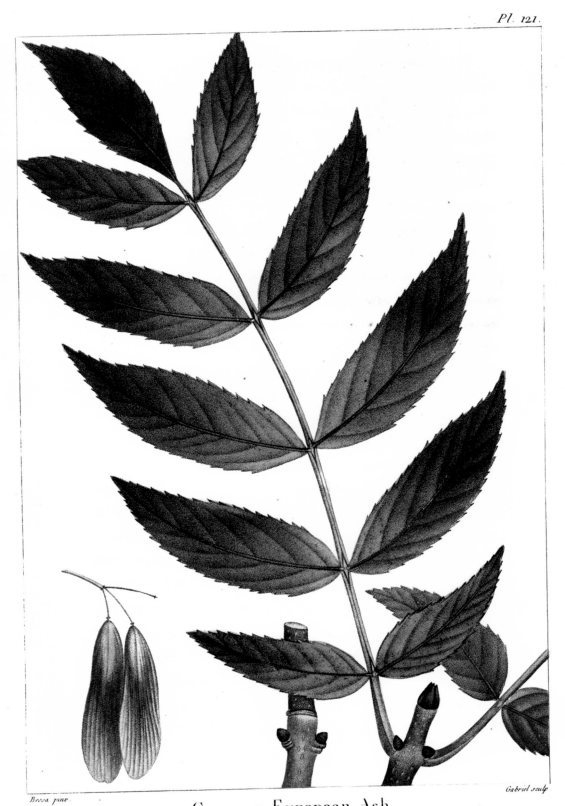

Bessa pinx.

Gabriel sculp.

Common European Ash.
Fraxinus excelsior.

Pl. 159. European Ash, English Ash (*Fraxinus excelsior* L.)

Pl. XCIX.

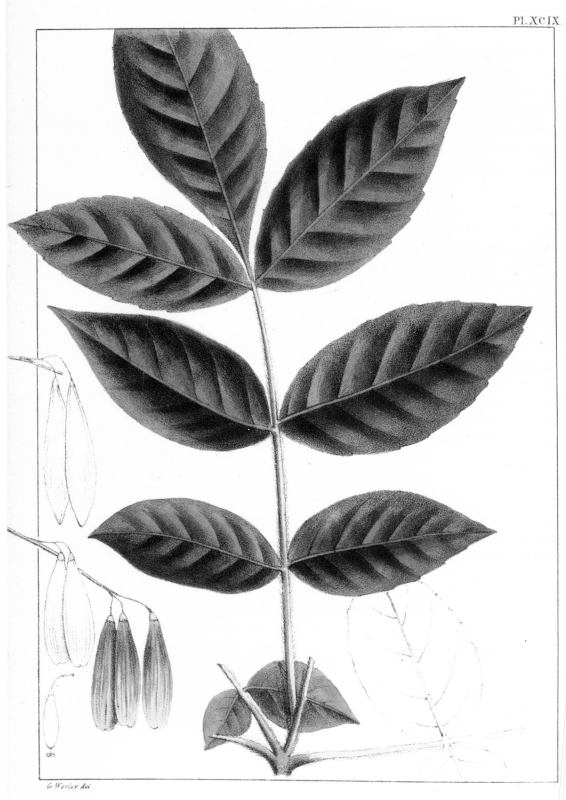

G. Werler del.

Fraxinus Oregona.

Oregon Black Ash

Frêne de l'Orégon

Pl. 160. Oregon Black Ash (*Fraxinus latifolia* Benth.)

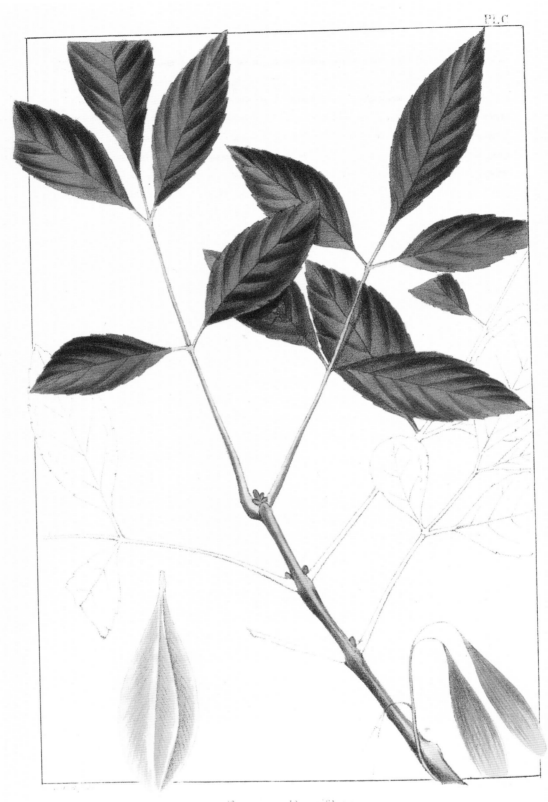

Fraxinus Pauciflora.

Smail leavid Ash

Frêne à petites Fleurs

Pl. 161. Swamp White Ash (*Fraxinus pauciflora* Nutt.)

Pl. 124.

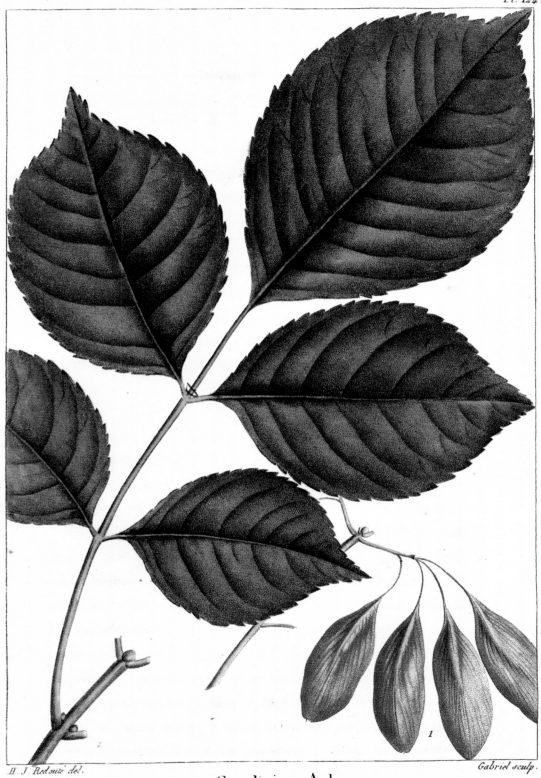

H. J. Redouté del.

Gabriel sculp.

Carolinian Ash.
Fraxinus platicarpa.

Pl. 162. Water Ash, Swamp Ash (*Fraxinus caroliniana* Mill.)

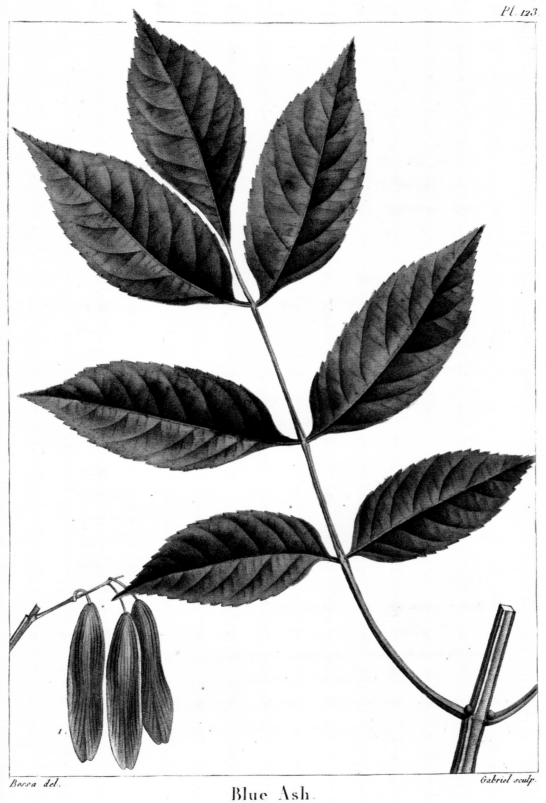

Pl. 123.

Bessa del.

Gabriel sculp.

Blue Ash.

Fraxinus quadrangulata.

Pl. 163. Blue Ash (*Fraxinus quadrangulata* Michx.)

[183

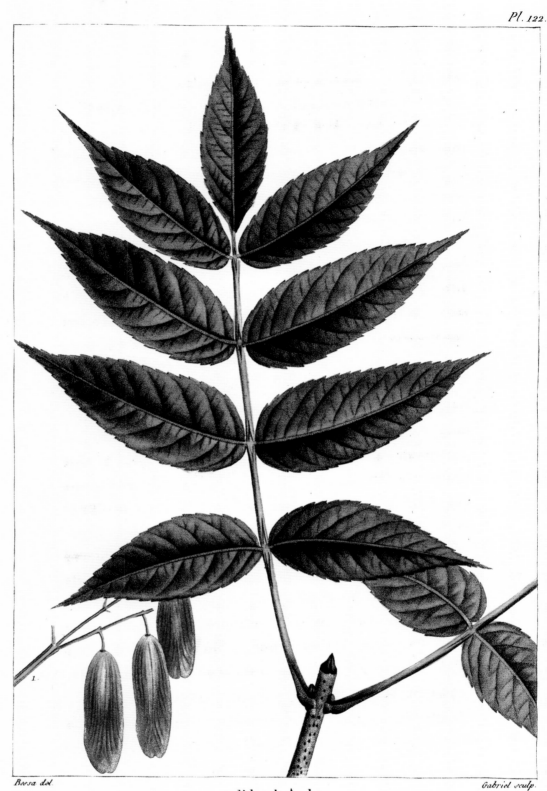

Pl. 122.

Bessa del.

Gabriel sculp.

Black Ash.

Fraxinus sambucifolia?

Pl. 164. Hoop Ash, Basket Ash (*Fraxinus nigra* Marshall)

Pl. 119.

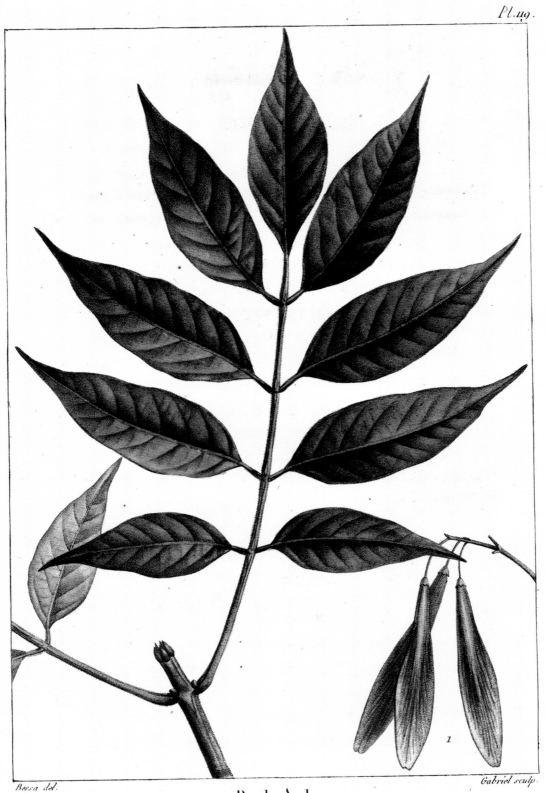

Bessa del.

Gabriel sculp.

I

Red Ash.

Fraxinus tomentosa.

Pl. 165. Pumpkin Ash, Swell-butt Ash (*Fraxinus profunda* (Bush) Bush)

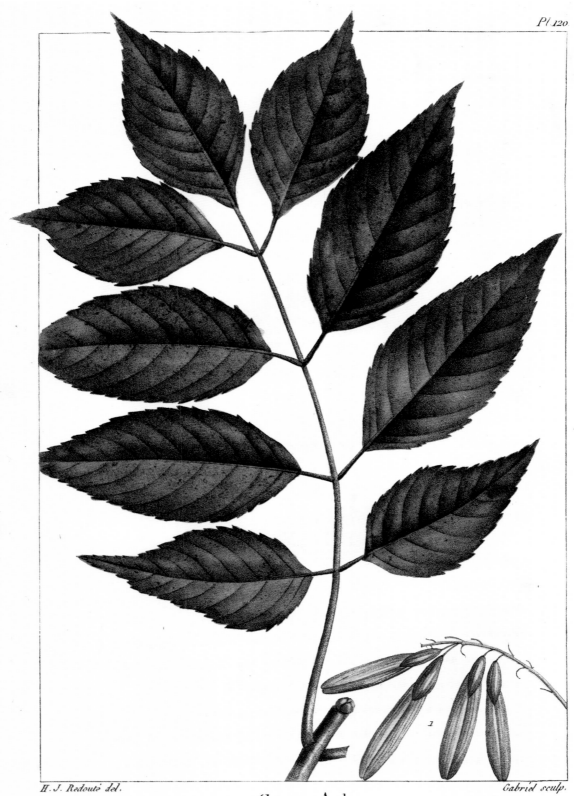

Pl. 120.

H. J. Redouté del.

Gabriel sculp.

Green Ash.

Fraxinus viridis.

186]

Pl. 166. Green Ash *(Fraxinus pennsylvanica* Marshall)

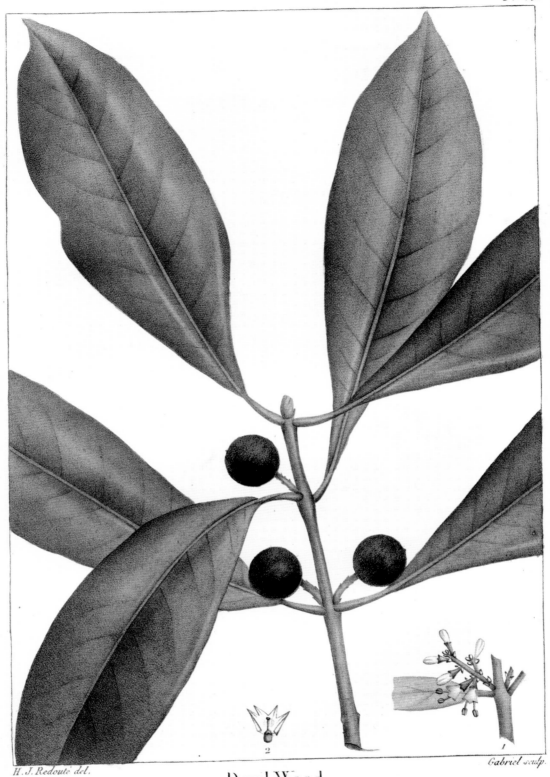

Pl. 167. Devilwood, Wild Olive
(*Osmanthus americanus* (L.) Benth. & Hook. f. ex A. Gray)



Devil Wood.

Olea americana.

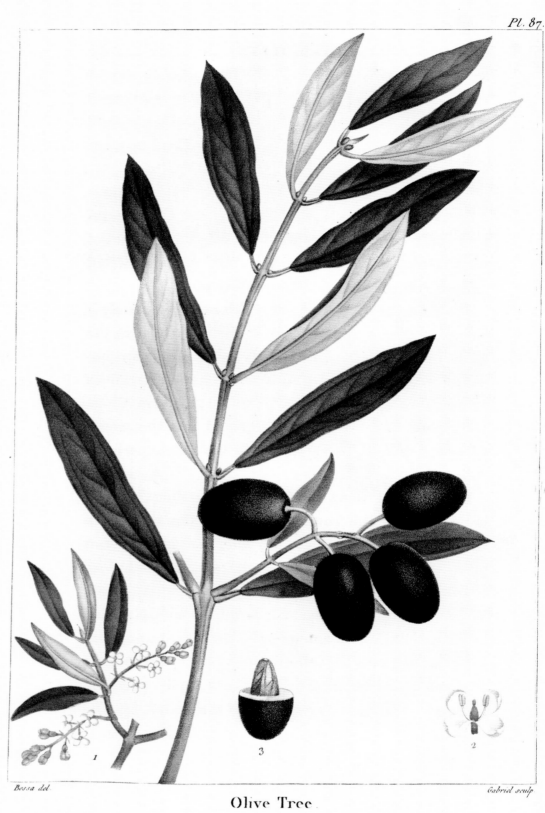

Pl. 87.

Bessa del.

Gabriel sculp.

1

3

2

Olive Tree

Olea Europæa.

Pl. 168. Common Olive, European Olive (*Olea europaea* L.)

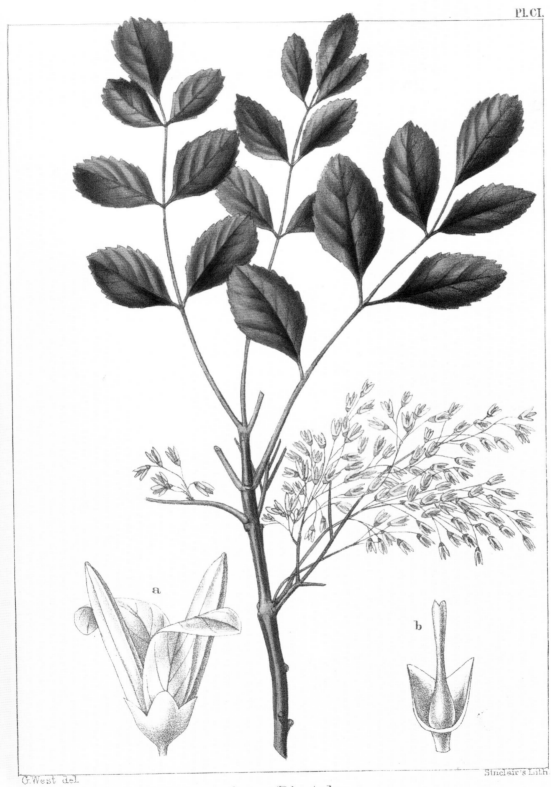

G.West del.

Sinclair's Lith.

Ornus Dipetala.

Californian Flowering Ash. *Le Frêne a fleurs de Californie.*

Pl. 169. California Ash (*Fraxinus dipetala* Hook. & Arn.)

Pl. 12.

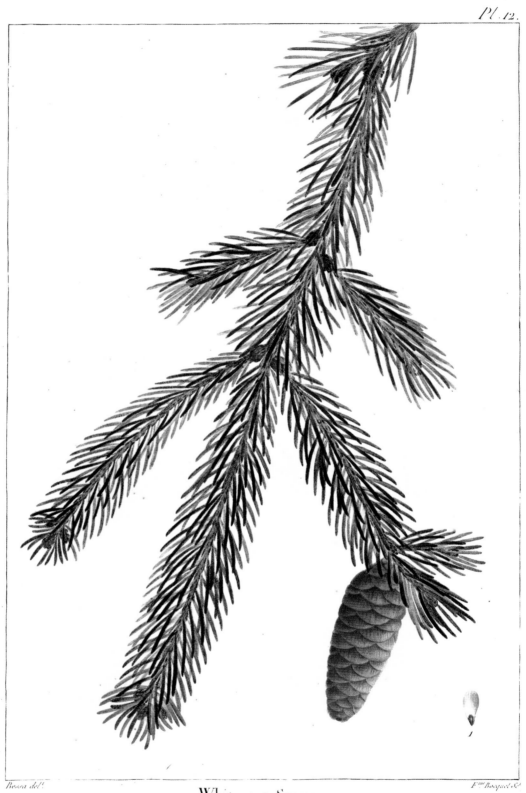

Bessa del. E.me Bocquet Sc.

White (single) Spruce.

Abies alba.

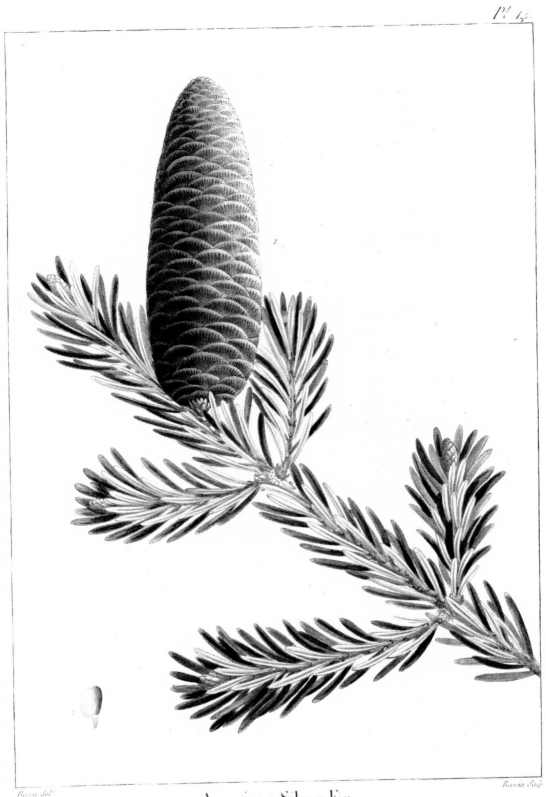

American Silver Fir.
or Balm of Gilead Fir.
Abies balsamifera.

Pl. 171. Balsam Fir (*Abies balsamea* (L.) Mill.)

[191

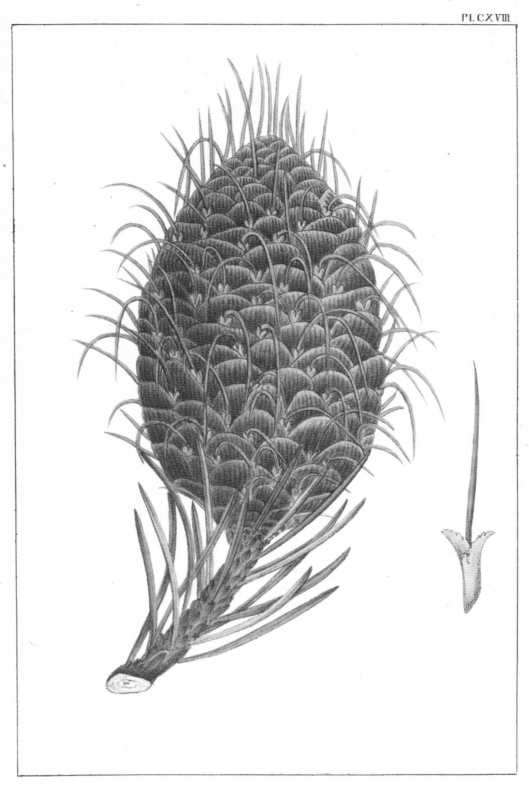

Abies Bracteata

Leafy coned Silver Fir. *Sapin bractée.*

 Pl. 172. Bristlecone Fir, Santa Lucia Fir (*Abies bracteata* (D. Don) Poit.)

Pl. 13.

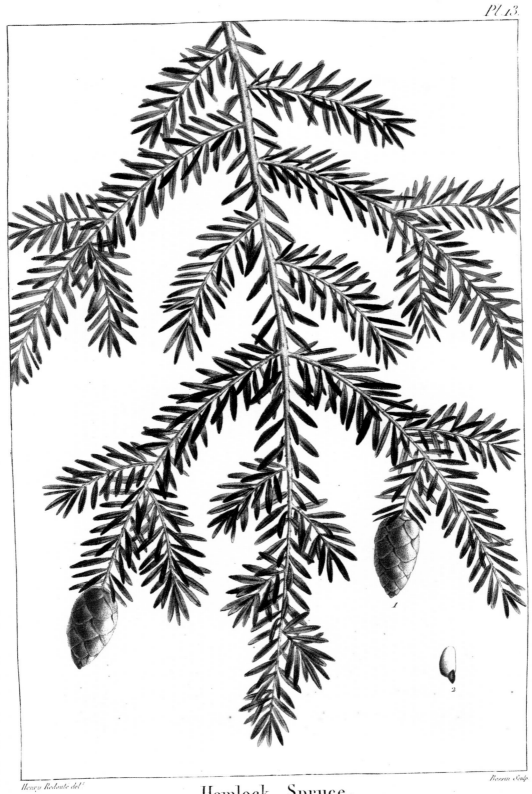

Henry Redouté del.

Besson Sculp.

Hemlock Spruce.
Abies canadensis.

Pl. 173. Eastern Hemlock (*Tsuga canadensis* (L.) Carrière)

Pl. CXV.

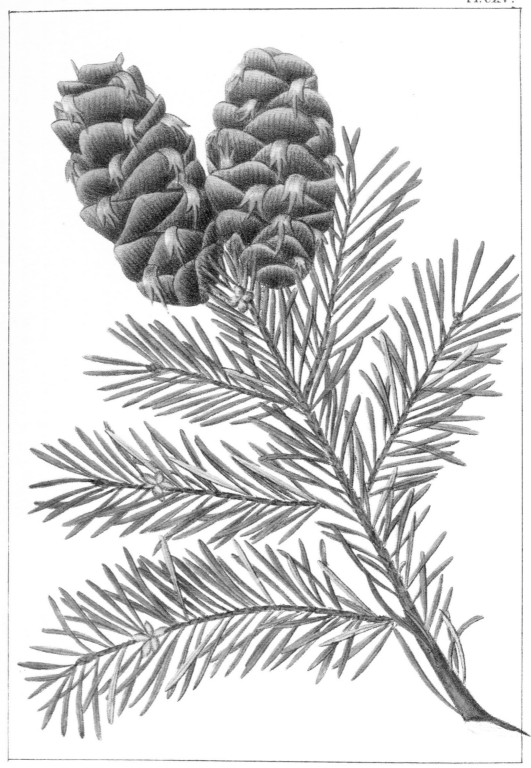

Abies Douglasii

Douglas's Fir *Sapin de Douglas*

Pl. 174. Douglas-fir (*Pseudotsuga menziesii* (Mirb.) Franco)

Pl. CXIX

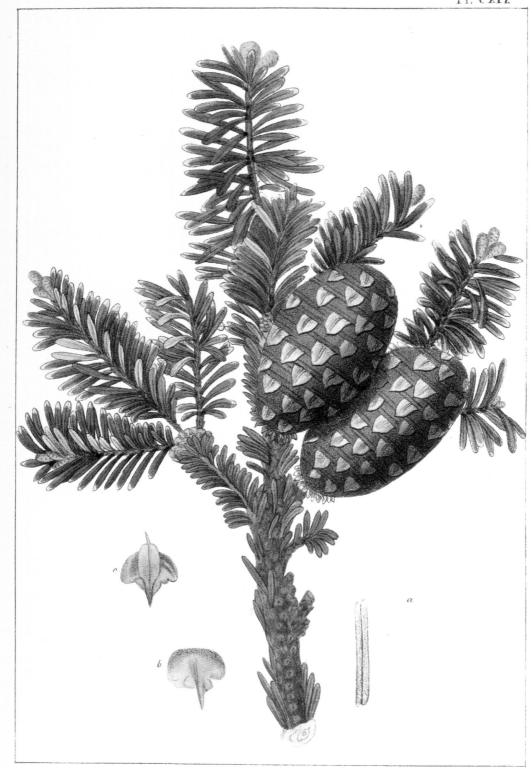

Abies Fraseri

Frasers Balsam Fir Sapin de Fraser.

Pl. 175. Fraser Fir (*Abies fraseri* (Pursh) Poir.)

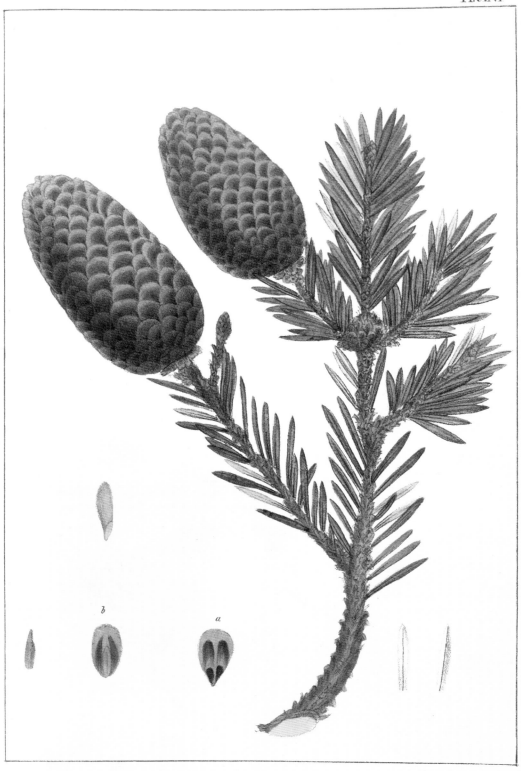

Abies Menziesii.

Menzies' Spruce Fir. *Sapin de Menzies.*

Pl. 176. Sitka Spruce (*Picea sitchensis* (Bong.) Carrière)

Pl. II.

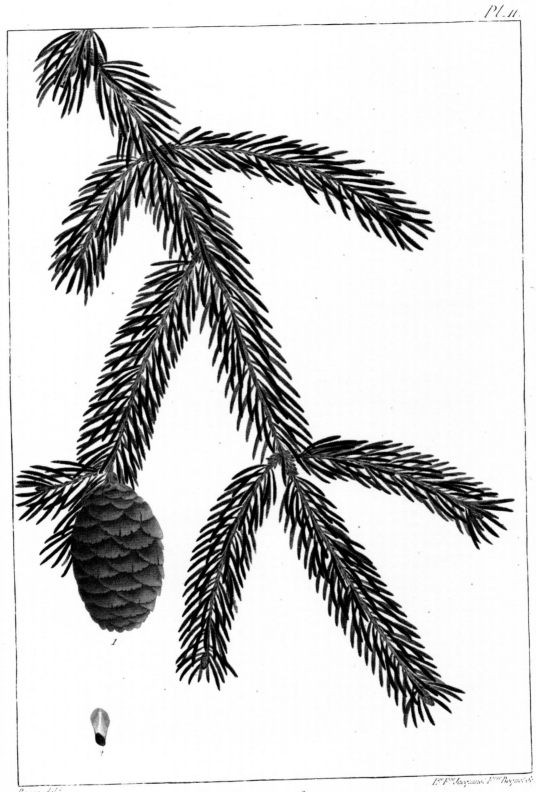

Bessa del.

1

2

Black (double) Spruce.
Abies nigra.

Pl. 177. Black Spruce
(*Picea mariana* (Mill.) Britton, Sterns & Poggenb.)

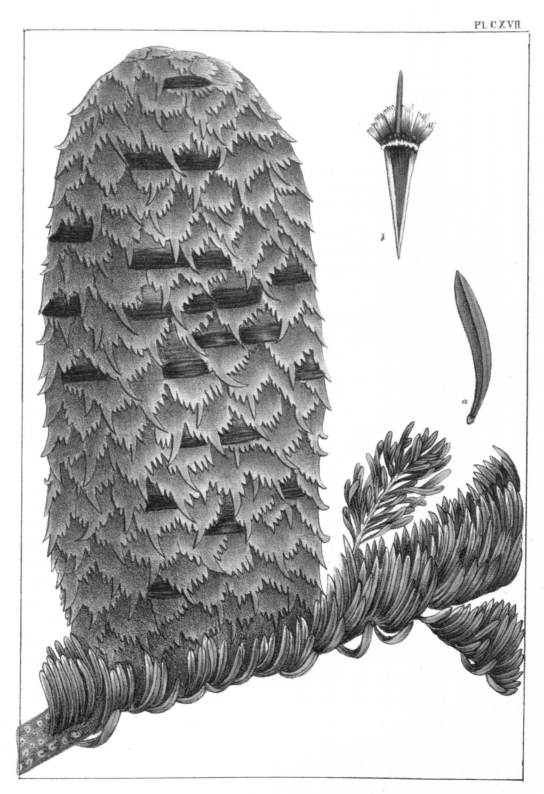

Abies Nobilis

Decorated Silver Fir. *Sapin noble.*

Pl. 178. Noble Fir (*Abies procera* Rehder)

Pl. 146.

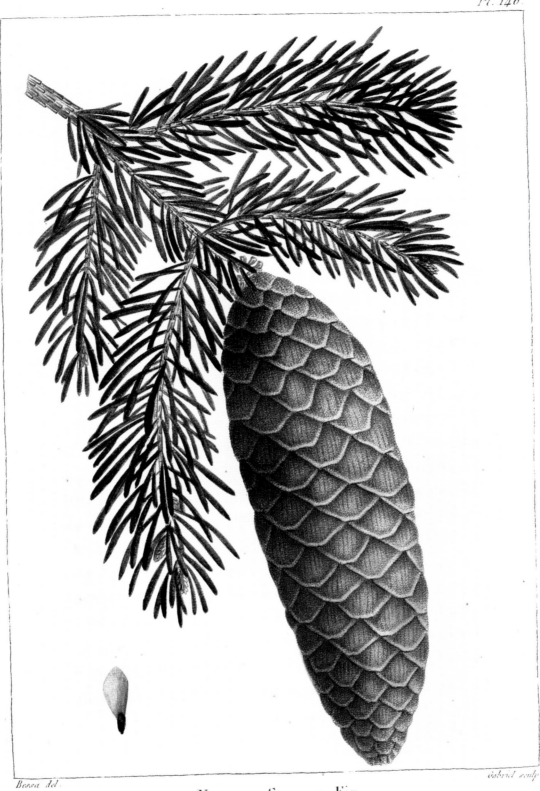

Bessa del.

Gabriel sculp.

Norway Spruce Fir.

Abies picea.

Pl. 179. Norway Spruce (*Picea abies* (L.) H. Karst.)

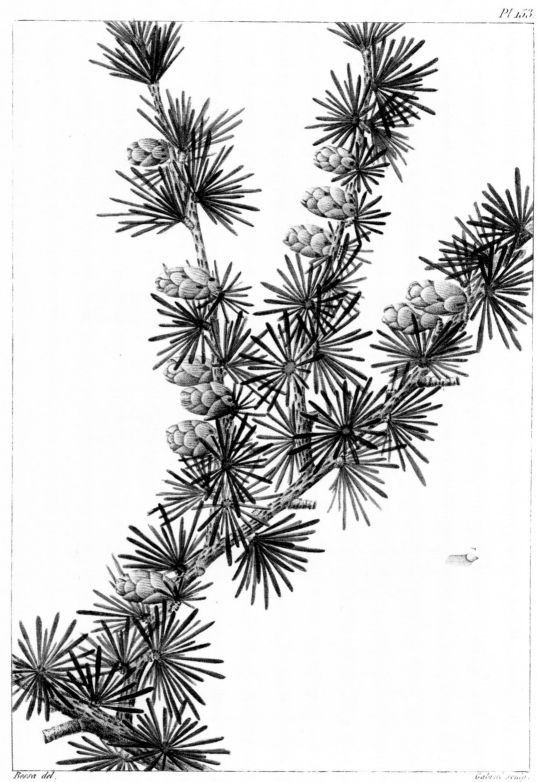

Pl. 153.

Bessa del.

Gabriel sculp.

American Larch.
Larix américana.

Pl. 180. Tamarack, Eastern Larch (*Larix laricina* (Du Roi) K. Koch)

Pl. 154

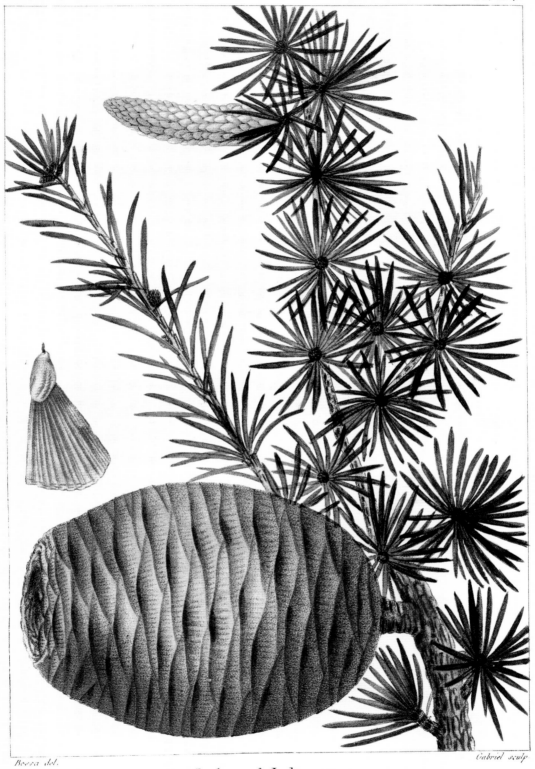

Bessa del.

Gabriel sculp.

Cedar of Lebanon.

Larix cedrus.

Pl. 181. Cedar of Lebanon (*Cedrus libani* A. Rich)

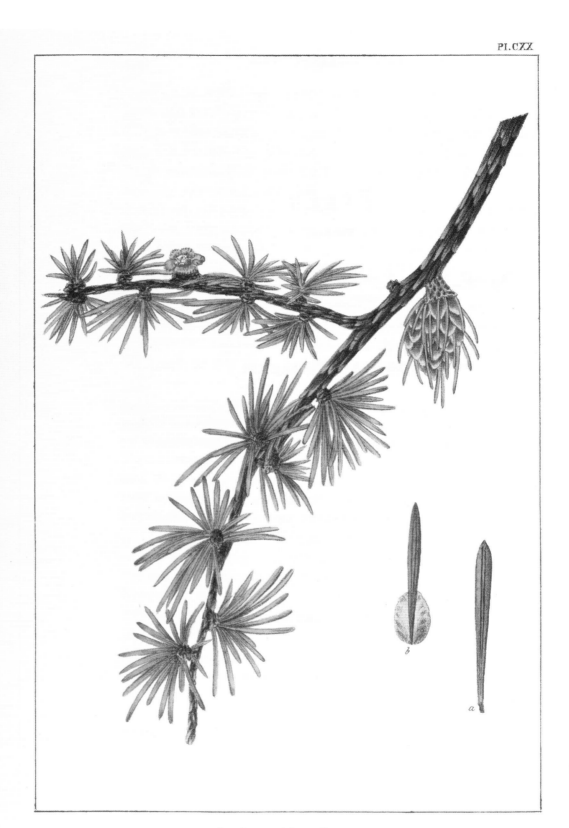

Larix occidentalis.

Western Larch. Sapin d' Occident

Pl. 182. Western Larch (*Larix occidentalis* Nutt.)

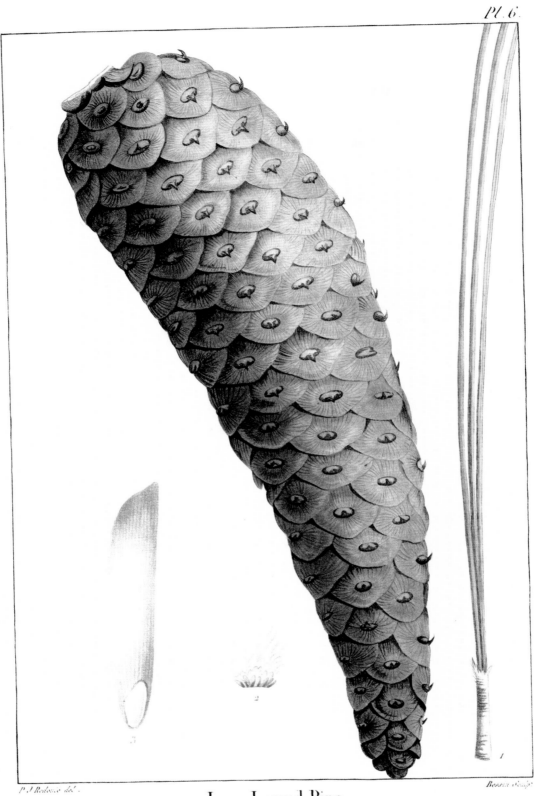

P. J. Redouté del.

Besson Sculp.

Pl. 6.

Long Leaved Pine.
Pinus Australis.

Pl. 183. Longleaf Pine (*Pinus palustris* Mill.)

[203

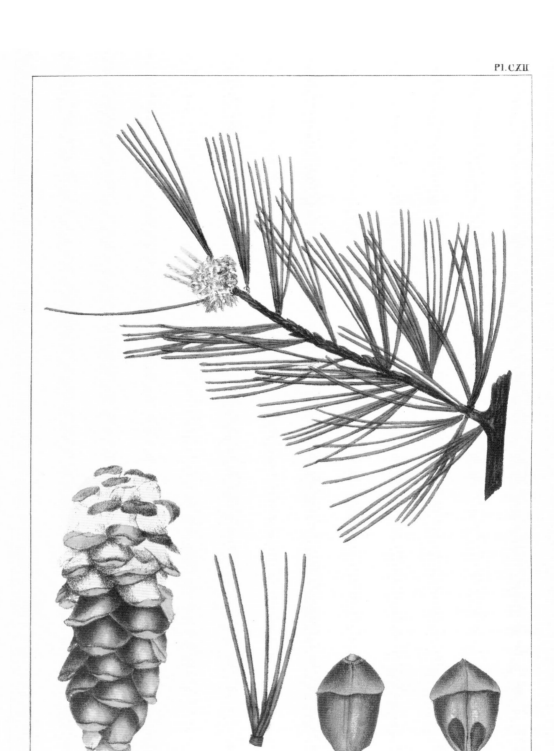

Pinus Flexilis.

American Timber Pine.　　　　　Pin occidental d'Amerique.

Pl. 184. Limber Pine (*Pinus flexilis* E. James)

Pl. 4.

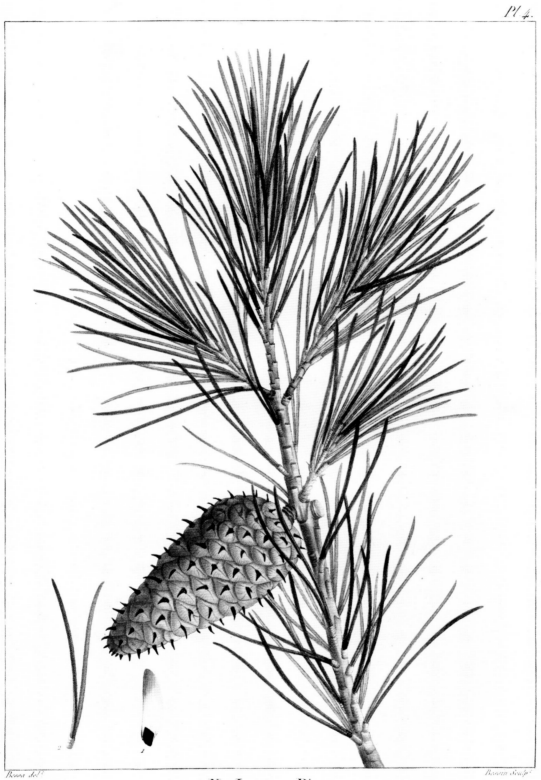

Bessa del. Bessin Sculp.

N . Jersey Pine.
Pinus inops.

Pl. 185. Virginia Pine (*Pinus virginiana* Mill.)

Pl. CXIV

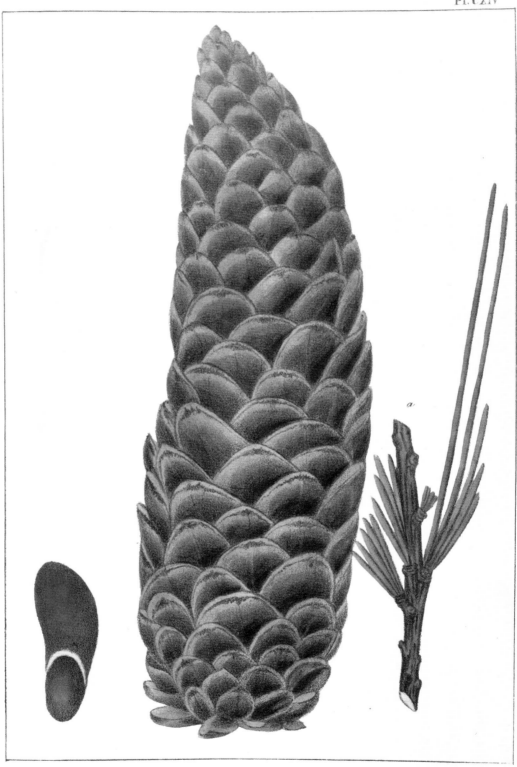

Pinus Lambertiana.

Gigantic Pine. *Pin gigantique de Lambert.*

Pl. 186. Sugar Pine (*Pinus lambertiana* Douglas)

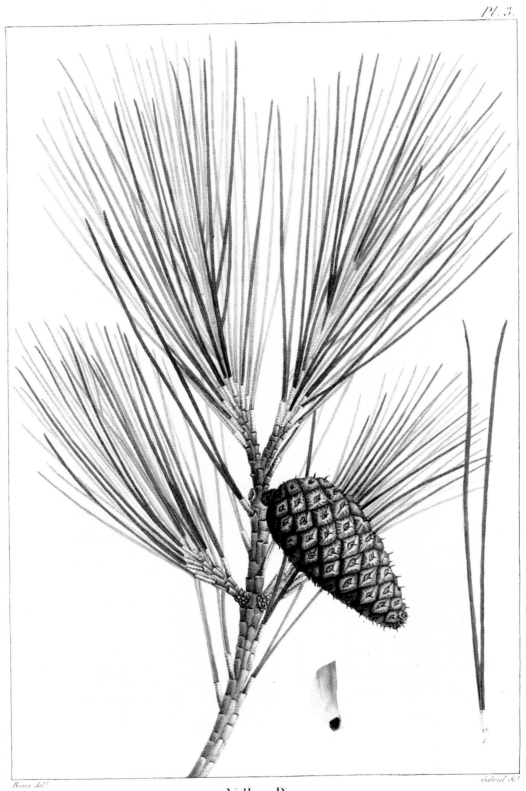

Pl. 3.

Yellow Pine.

Pinus mitis

Pl. 187. Shortleaf Pine (*Pinus echinata* Mill.)

[207

Pl. 135

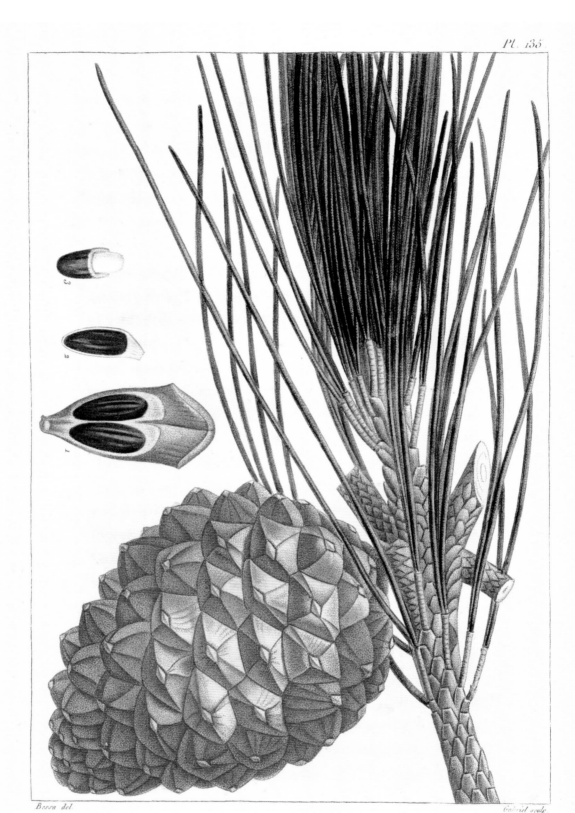

Bessa del.

Gabriel sculp.

Pinus Pinea.

Stone pine.

Pl. 188. Italian Stone Pine, Umbrella Pine (*Pinus pinea* L.)

Pl. 5.

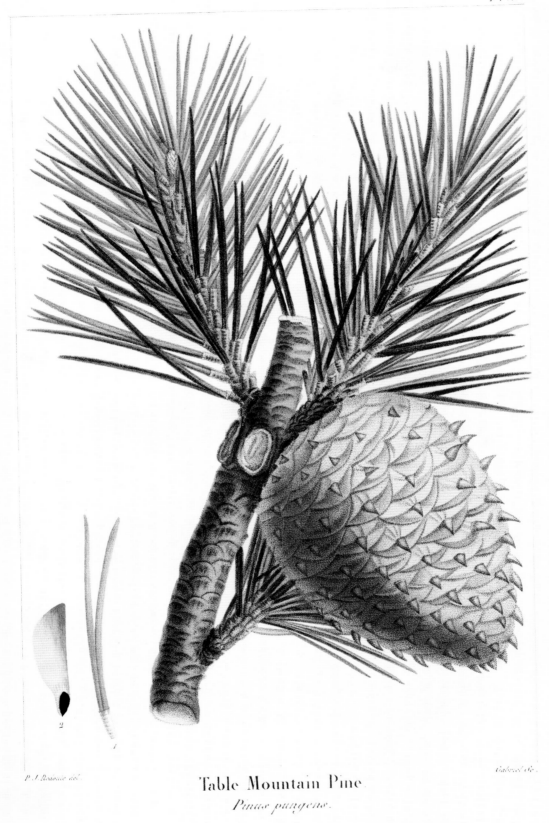

P.J. Redouté del. Gabriel Sc.

Table Mountain Pine.
Pinus pungens.

Pl. 189. Table Mountain Pine (*Pinus pungens* Lamb.)

Pl. 8.

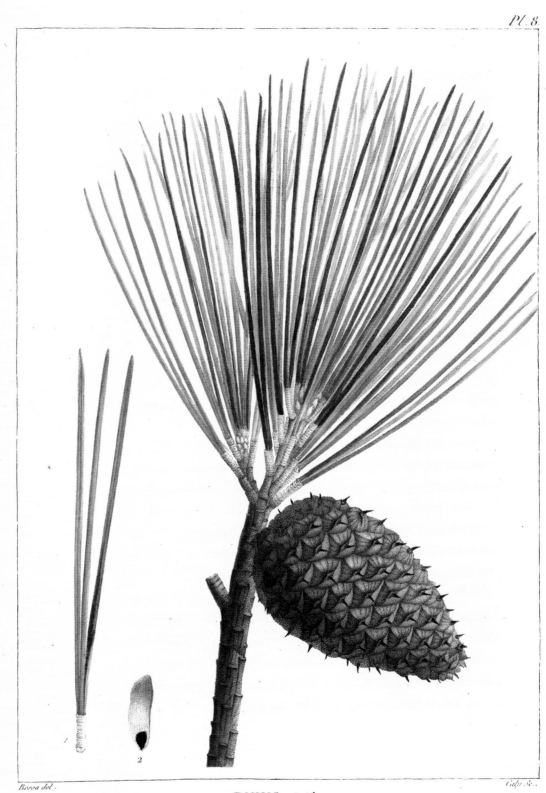

Bessa del.

Calp Sc.

PINUS rigida.

Pitch Pine.

Pl. 190. Pitch Pine (*Pinus rigida* Mill.)

Pl. I.re

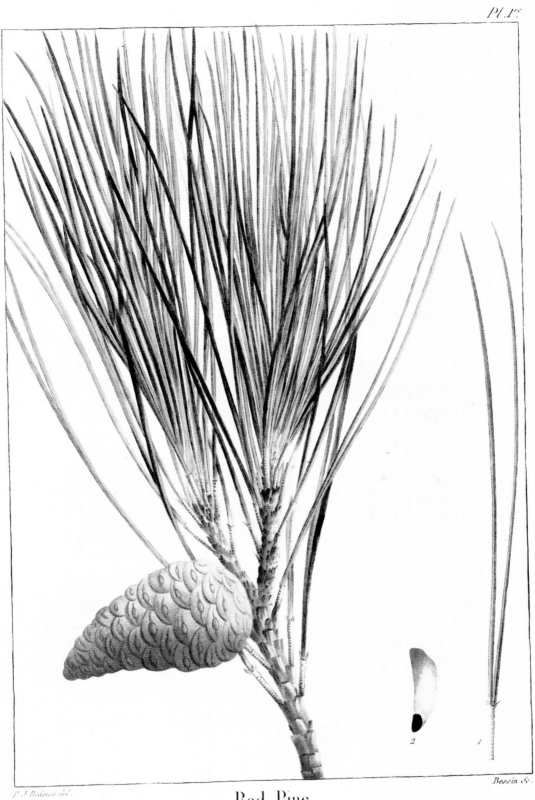

P. J. Redouté del.

Bessin Sc.

2 1

Red Pine.
Pinus rubra.

Pl. 191. Red Pine (*Pinus resinosa* Aiton)

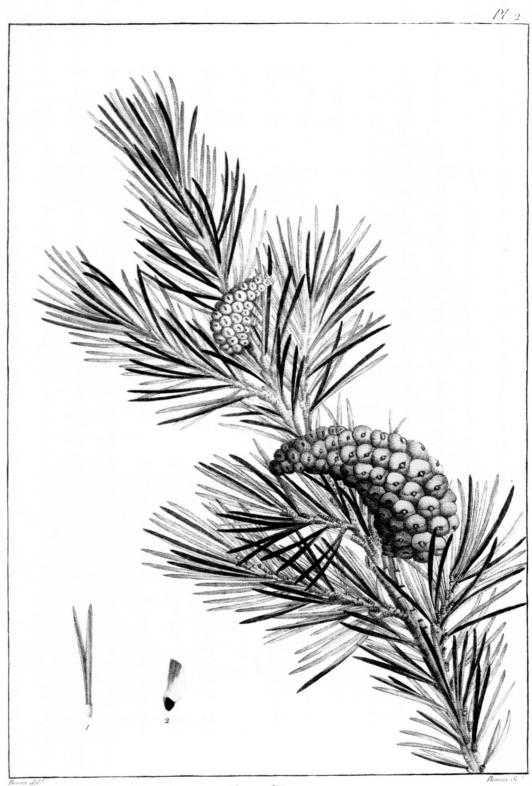

Pl. 2

Bessa del.

Bessa Sc.

Grey Pine.

Pinus rupestris.

1

2

Pl. 192. Jack Pine (*Pinus banksiana* Lamb.)

Pl. CXIII

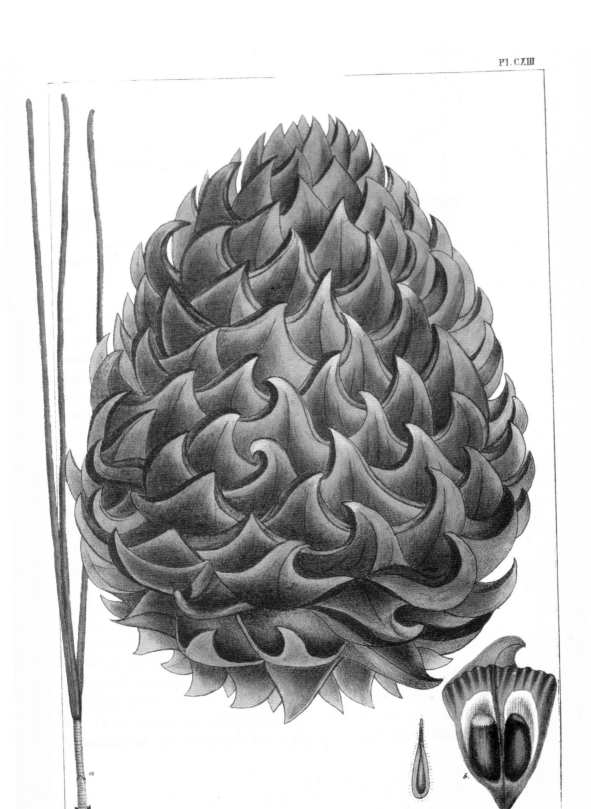

Pinus Sabiniana

Prickly coned Pine. Pin de Sabine à grands cônes épineux.

Pl. 193. California Foothill Pine (*Pinus sabiniana* Douglas) [213

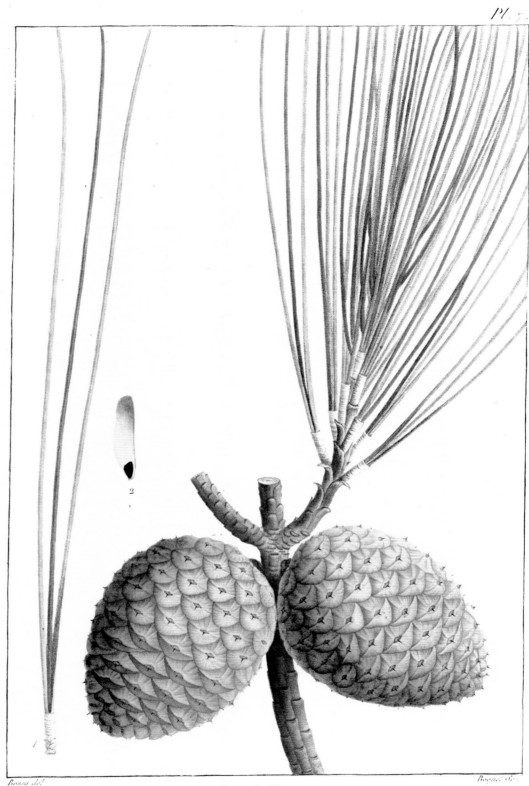

Pl. 7.

Pond Pine.

Pinus serotina.

Pl. 194. Pond Pine (*Pinus serotina* Michx.)

Pl. 10.

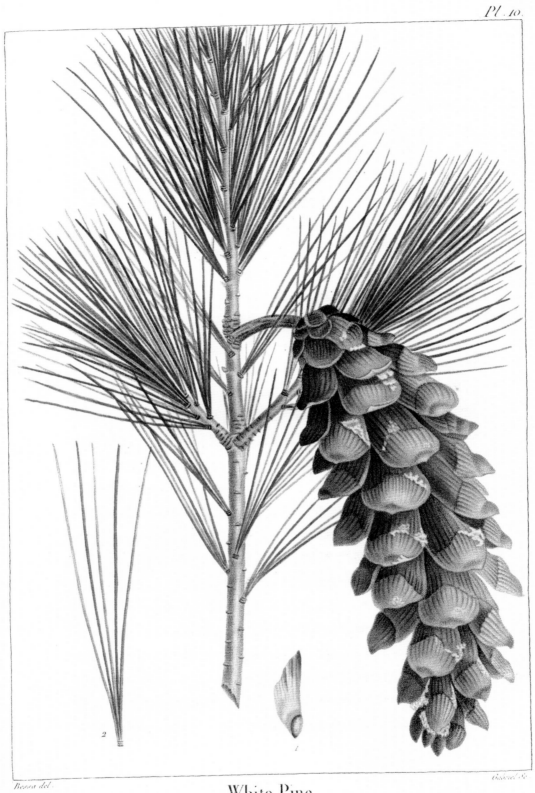

White Pine.
Pinus Strobus.

Bessa del.

Gabriel Sc.

Pl. 195. White Pine (*Pinus strobus* L.)

Pl. 138.

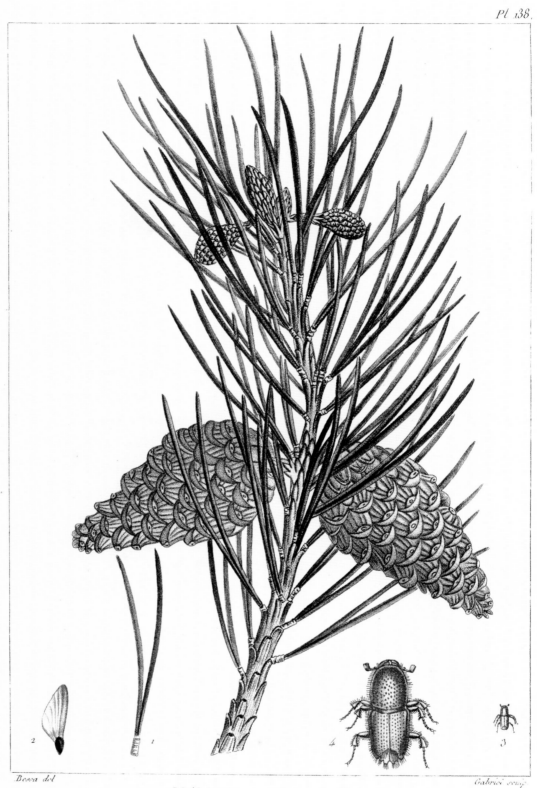

Wild Pine *or* Scotch Fir.

Pinus sylvestris.

Pl. 196. Scots Pine, Archangel-redwood (*Pinus sylvestris* L.)

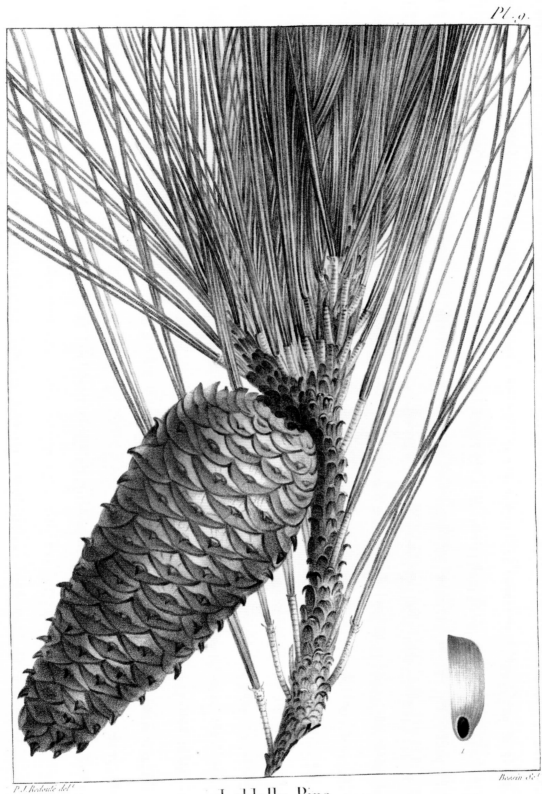

Pl. 9.

P.J. Redouté del.

Bessin Sc.

Loblolly Pine.

Pinus tæda.

Pl. 197. Loblolly Pine (*Pinus taeda* L.)

Pl. 68.

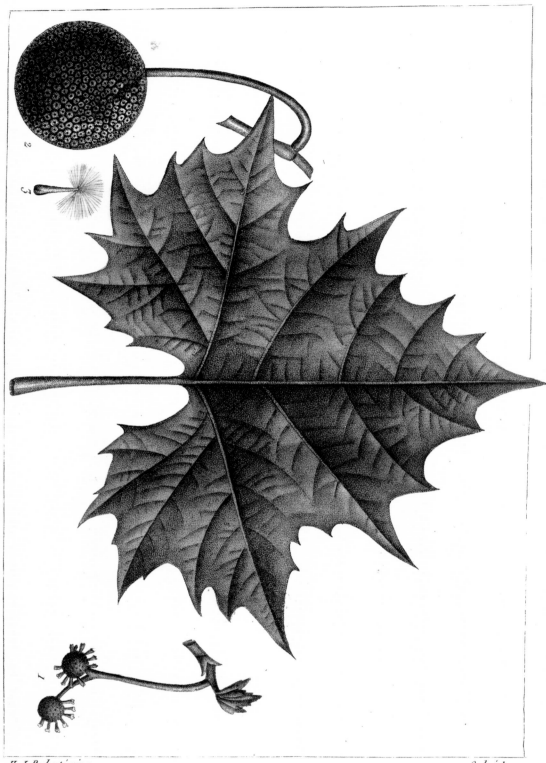

H. J. Redouté pinx.

Gabriel sc.

Button Wood.

Platanus occidentalis.

Pl. 198. American Sycamore, American Plane Tree (*Platanus occidentalis* L.)

Pl. XV.

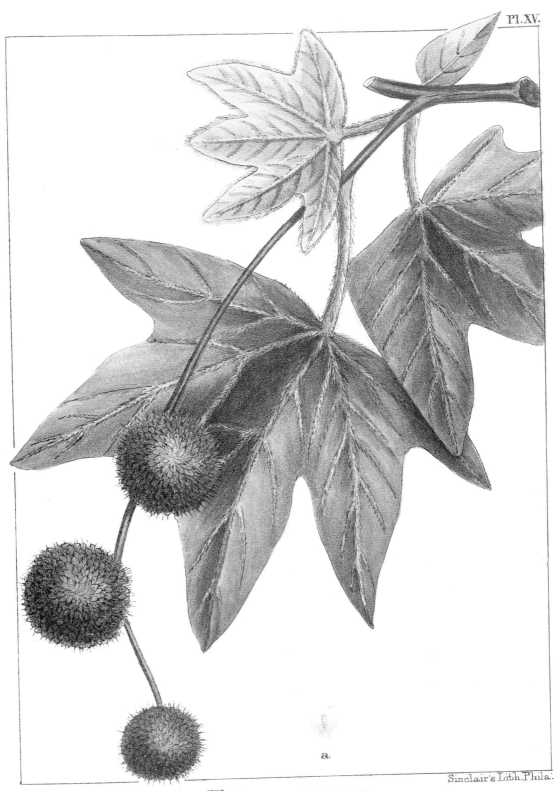

Sinclair's Lith.Phila.

Platanus racemosa.

California Buttonwood. *Platane de Californie.*

a

Pl. 199. California Sycamore (*Platanus racemosa* Nutt.)

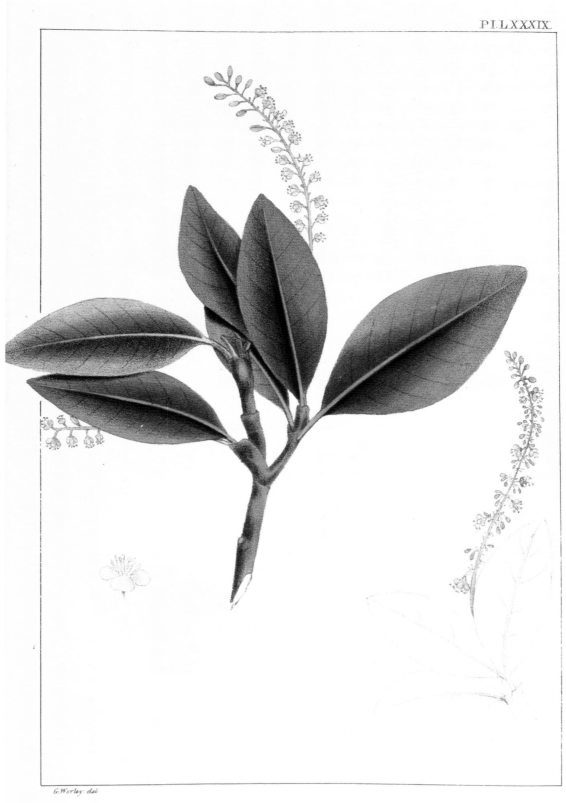

G.Worley. del.

Coccoloba parvifolia.

Small leaved Sea side Grape Raisinier à petites feuilles

220] Pl. 200. Sea Grape (*Coccoloba microstachya* Willd.)

Pl. LXXXVIII

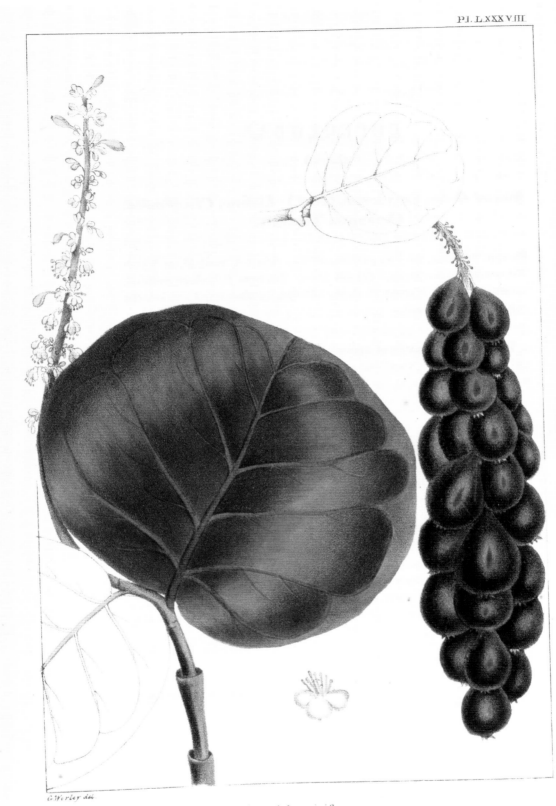

Coccoloba uvifera

Sea-Side Grape

Raisinier à Grappes

G. Worley del

Pl. 201. Seaside Grape (*Coccoloba uvifera* (L.) L.)

Ardisia Pickerinigia

Florida Ardisia

Troelier de Pickering

222] Pl. 202. Marlberry (*Ardisia escallonioides* Schltdl. & Cham.)

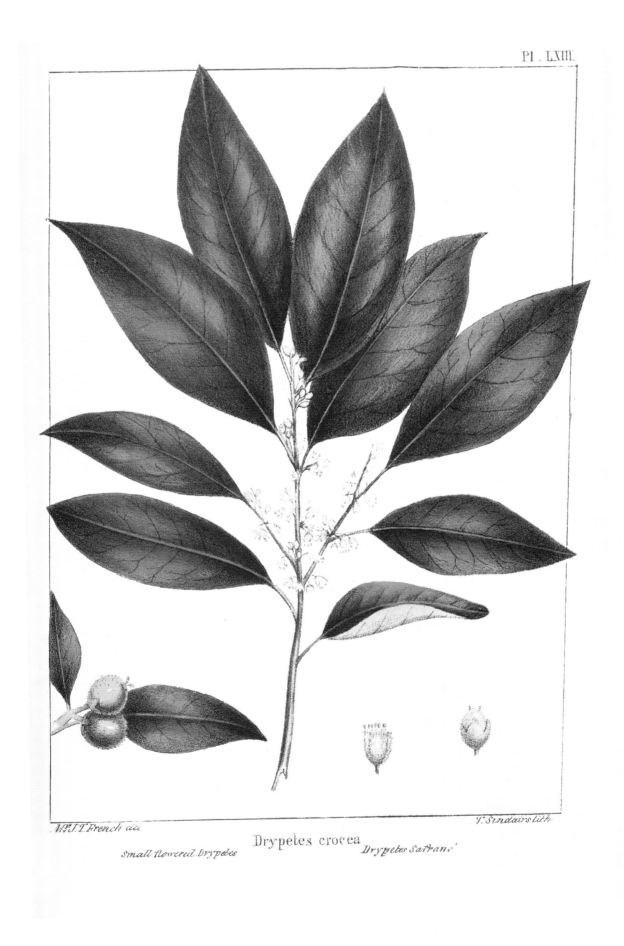

M?J.T. French ad.

T. Sinclairs lith.

Drypetes crocea

Small flowered Drypetes

Drypetes Safrane'

Pl. 203. Guiana Plum (*Drypetes lateriflora* (Sw.) Krug. & Urb.)

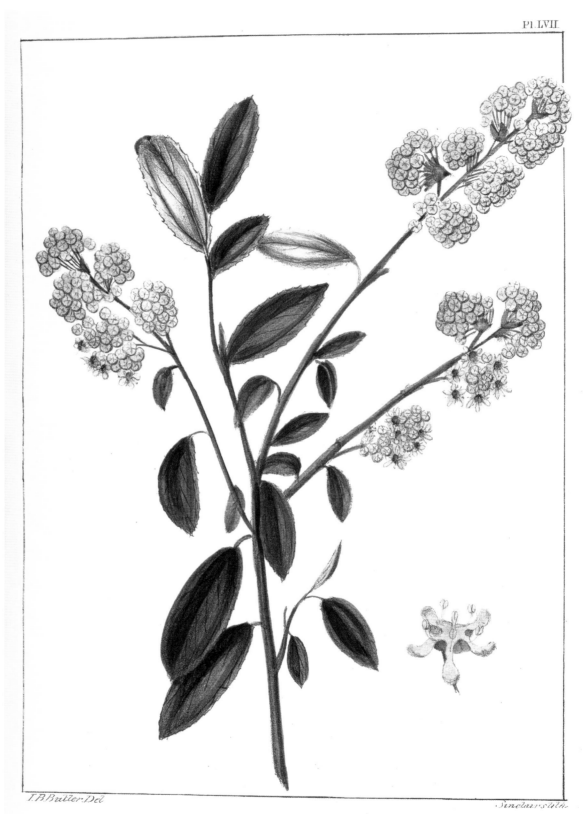

I.B.Butler.Del.

Sinclair.lith.

Ceanothus thyrsiflorus

Tree Ceanothus

Ceanothe thyrsiflore

Pl. 204. Blue Blossom, Tree Ceanothus (*Ceanothus thyrsiflorus* Eschsch.)

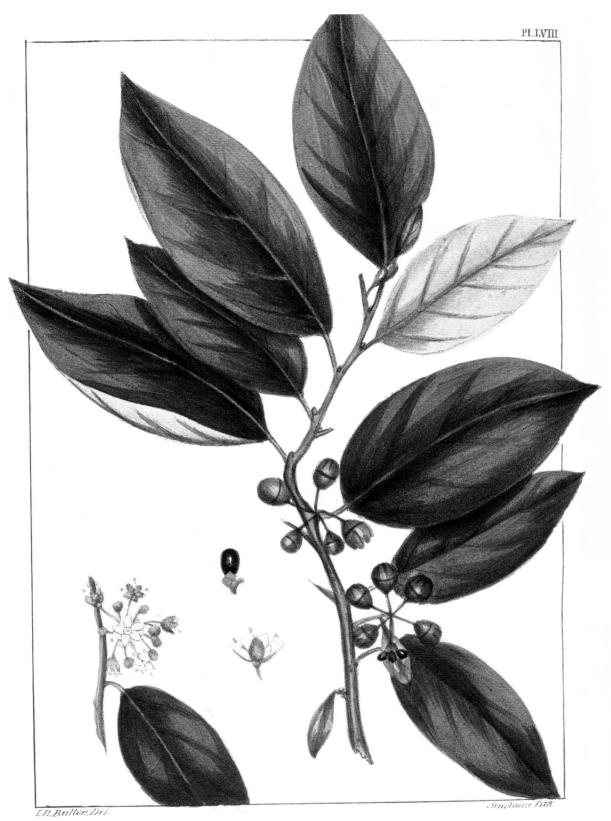

I.D.Buller.Del.

Sinclair:Lith.

Snake Wood

Colubrina Americana

Bois de Couleuvre

Pl. 205. Wild-coffee, Maubi, Snakebark (*Colubrina arborescens* (Mill.) Sarg.)

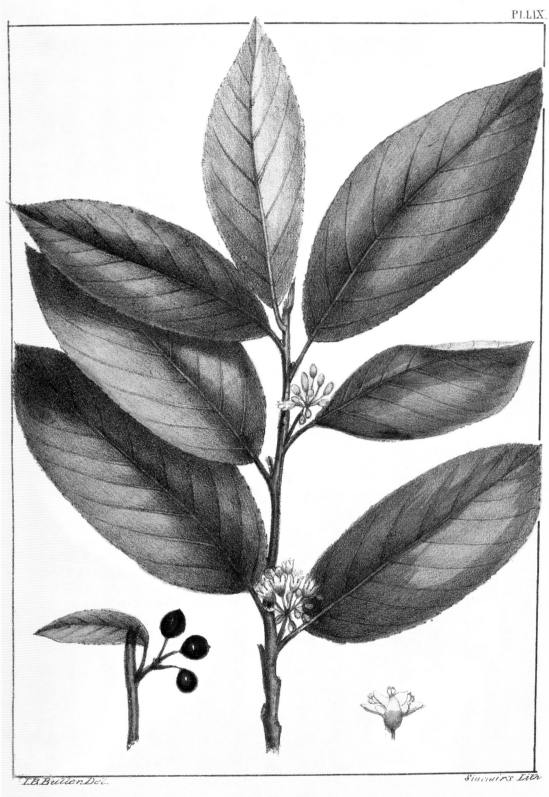

I.B.Bullen.Del.

Sincuir's Lith

Carolina Buckthorn

Rhamnus Carolinianus

Nerprun de la Caroline

Pl. 206. Carolina Buckthorn (*Frangula caroliniana* (Walter) A. Gray)

Pl. XXIV.

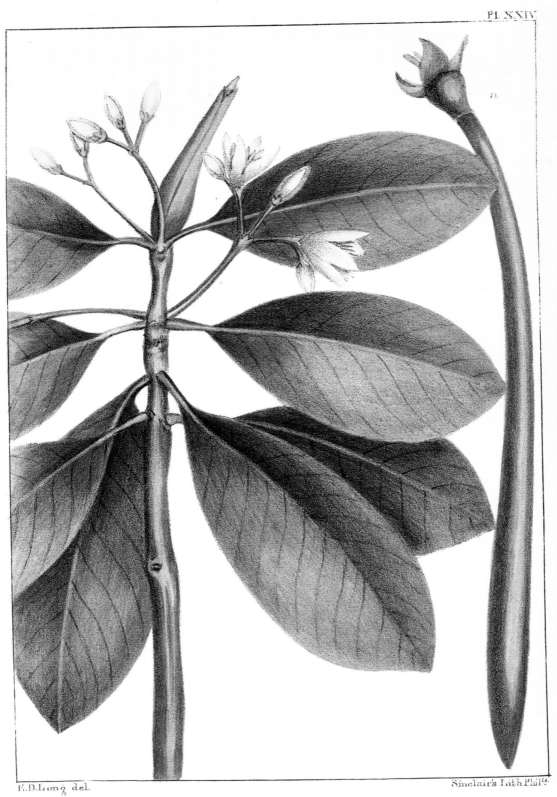

E.D.Long del.

Sinclair's Lith Phila

American Mangle. Rhizophora Americana. *Rhizophore d'Amerique.*

Pl. 207. Red Mangrove (*Rhizophora mangle* L.)

Pl. 90.

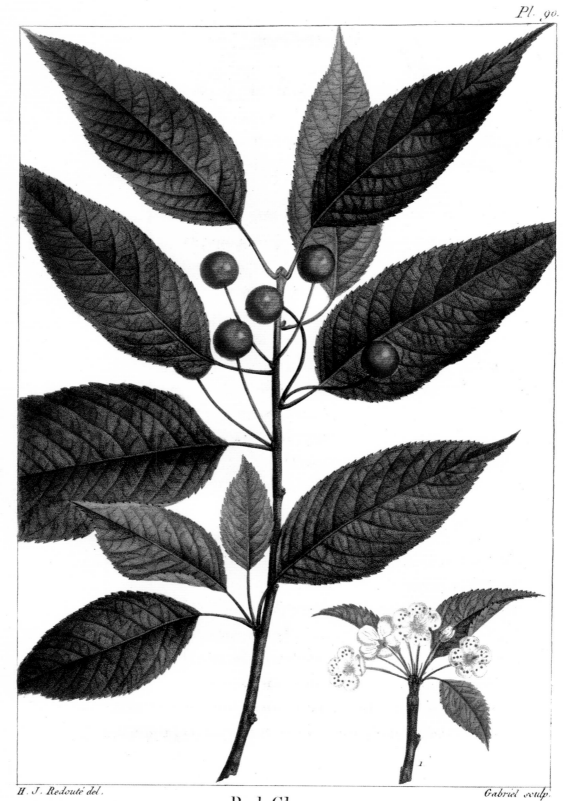

H. J. Redouté del. Gabriel sculp.

Red Cherry.

Cerasus borealis.

Pl. 89.

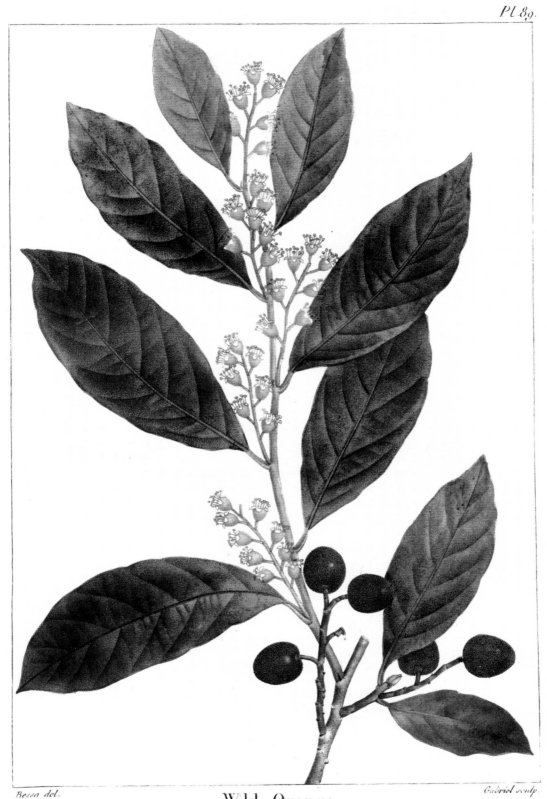

Bessa del.

Gabriel sculp.

Wild Orange.
Cerasus caroliniana.

Pl. 209. Carolina Cherry, Cherry Laurel, Mock Orange
(*Prunus caroliniana* (Mill.) Aiton)

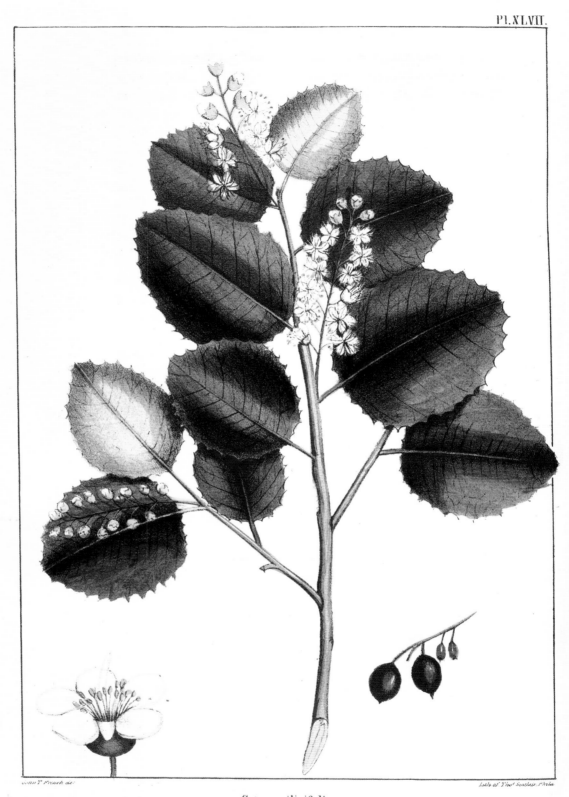

John T. French del.

Lith. of Tho.ª Sinclair, Phila.

Cerasus ilicifolia

Holly leaved Cherry

Cerisier à feuille de Houx

Pl. 210. Hollyleaf Cherry (*Prunus ilicifolia* (Nutt. ex Hook. & Arn.) D. Dietr.)

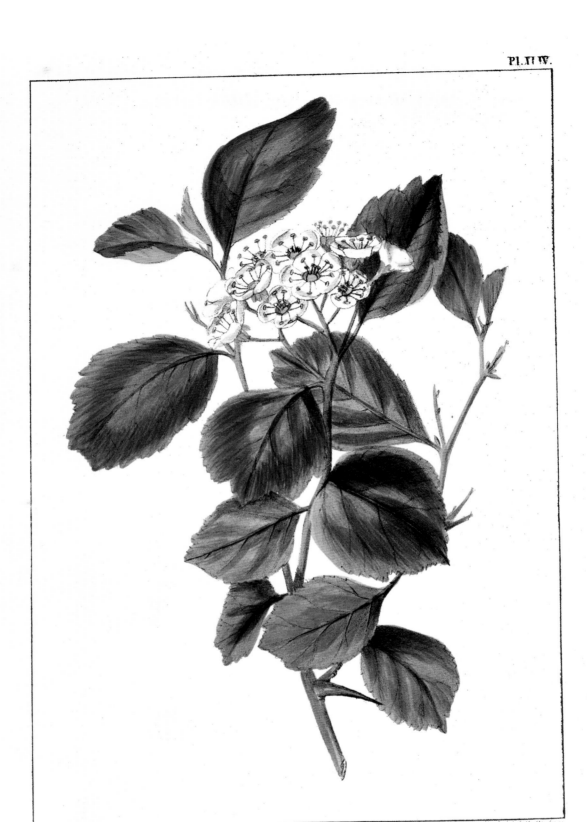

John T. French

Sinclair's Lith Publ.

Cratægus sanguineus.

Red Thorn

Alezier rouge

Pl. 215. Black Hawthorn (*Crataegus douglasii* Lindl.)

Pl. 65.

Becea del.

Gabriel sculp

Crab Apple.
Malus coronaria.

Pl. 216. Sweet Crabapple (*Malus coronaria* (L.) Mill.)

Pl. 66.

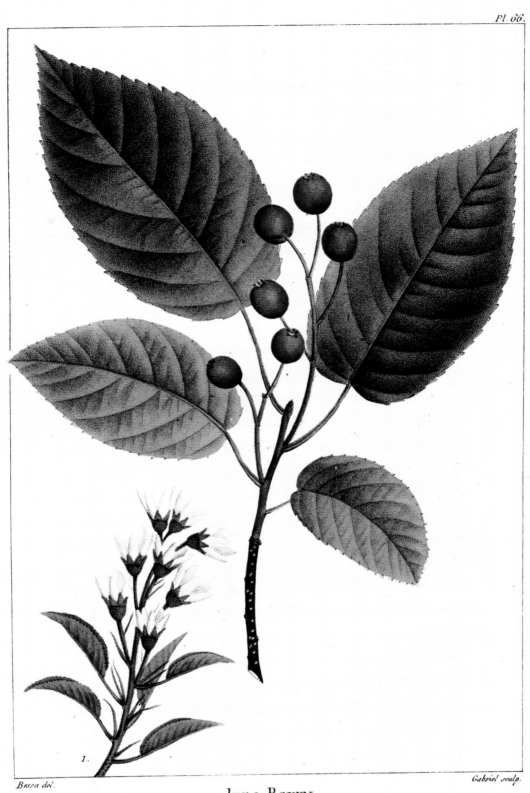

June Berry.
Mespilus arborea.

Pl. 217. Downy Serviceberry, Shadbush, Juneberry
(*Amelanchier arborea* (F. Michx.) Fernald)

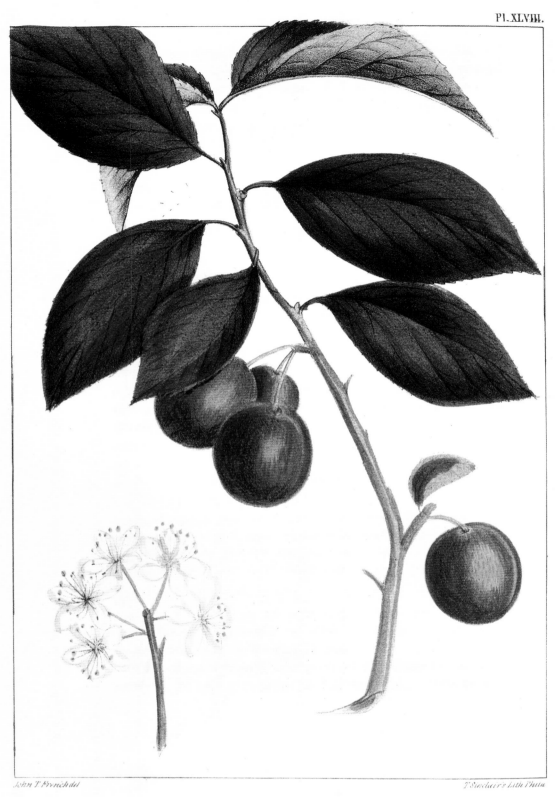

Pl. XLVIII.

John T. French del.

T. Sinclair's Lith Phila

Prunus Americana.

Wild Plum

Prunier d'Amerique

Pl. 218. Wild Plum (*Prunus americana* Marshall)

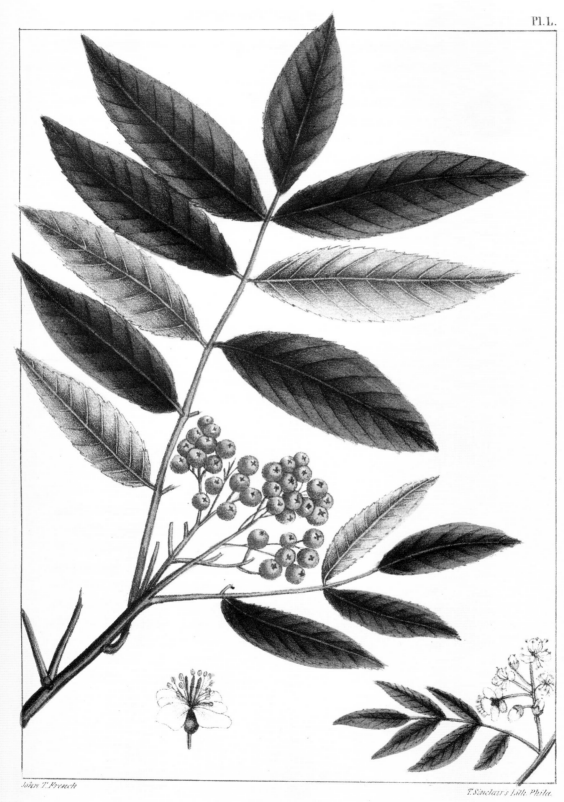

Pl. L.

John T. French

Pyrus Americana.

T. Sinclair's Lith. Phila.

American Mountain Ash

Sorbier d. Amérique.

Pl. 219. American Mountain Ash (*Sorbus americana* Marshall)

[239

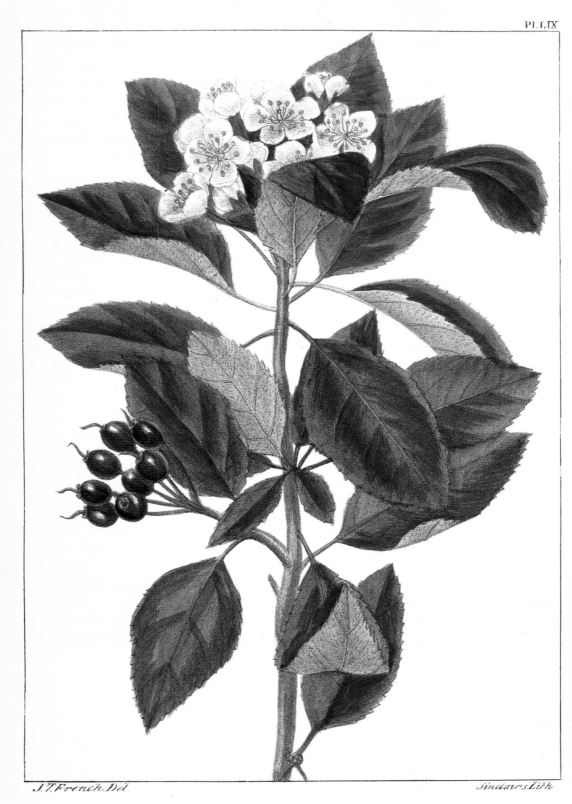

J.T.French.Del.

Sinclair's Lith.

Pyrus rivularis

River Crab.

Poirier rivulaire

Pl. 220. Oregon Crabapple (*Malus fusca* (Raf.) C. K. Schneid.)

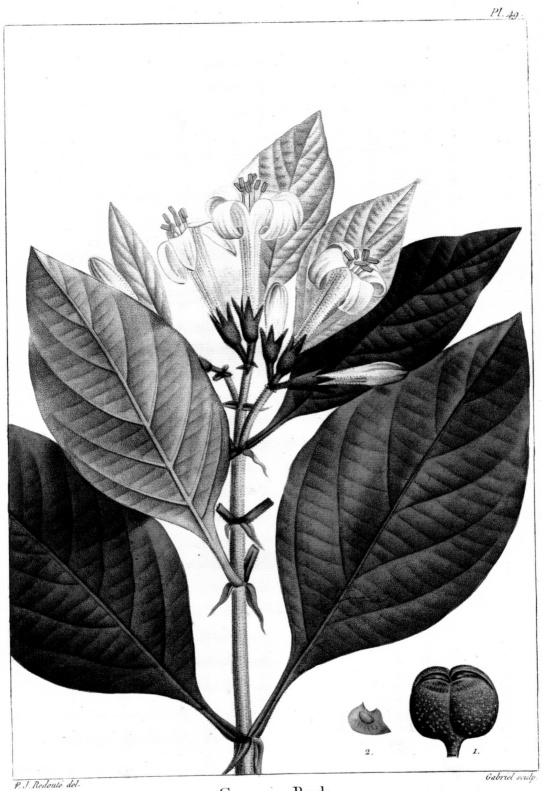

Pl. 49.

P.J. Redouté del.

Gabriel sculp.

2.　1.

Georgia Bark.
Pinckneya pubens.

Pl. 221. Fevertree (*Pinckneya bracteata* (W. Bartram) Raf.)

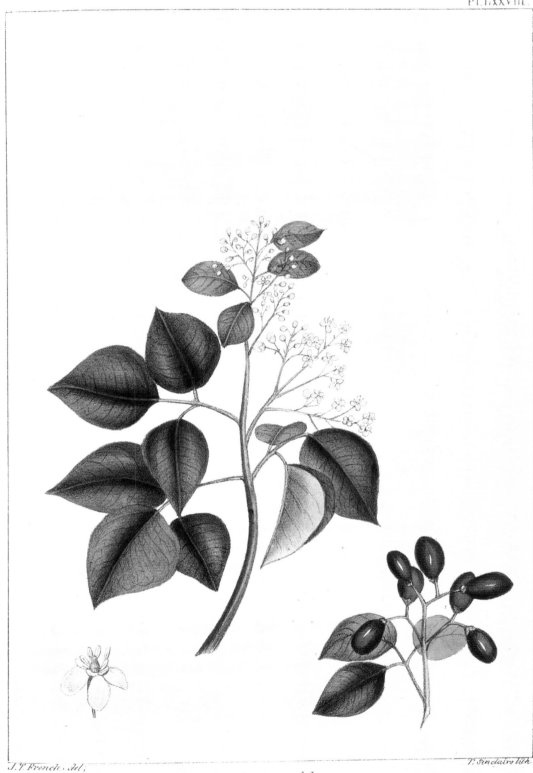

J.T. French del,

T. Sinclairs lith

Amyris Floridana

Florida Torch Wood.

Balsamier des Florides

Pl. 222. Torchwood (*Amyris elemifera* L.)

Pl LXXVI.

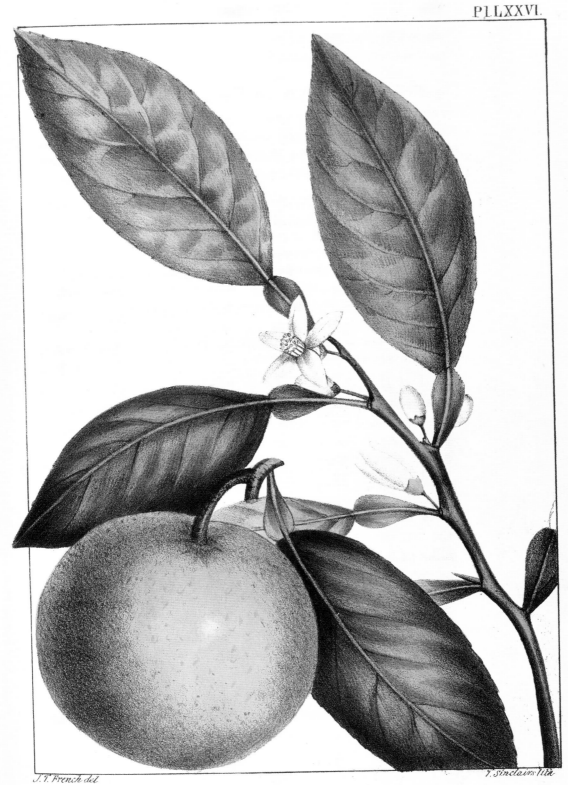

J.T. French del.

I. Sinclairs lith

Citrus vulgaris

Wild Orange Tree.

Oranger Sauvage.

Pl. 223. Bitter Orange (*Citrus* × *aurantium* L.)

Pl. LXXXIII.

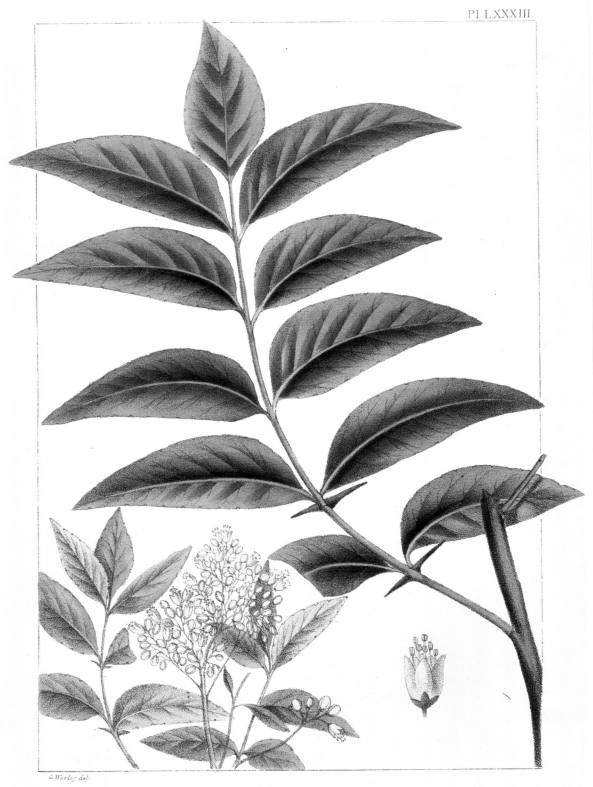

Xanthoxylum Carolinianum.

Carolina Prickly Ash. Clavalier de la Caroline.

Pl. 224. Southern Prickly Ash, Hercules' Club (*Zanthoxylum clava-herculis* L.)

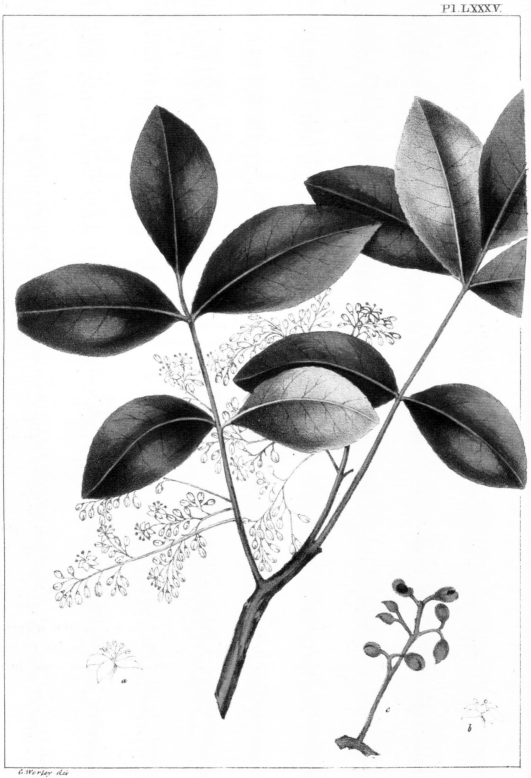

Pl. LXXXV.

Xanthoxylum Floridanum.

Florida Satin Wood

Claralier des Florides

G. Worley del.

a *b* *c*

Pl. 225. West Indian Satinwood (*Zanthoxylum flavum* Vahl.) [245

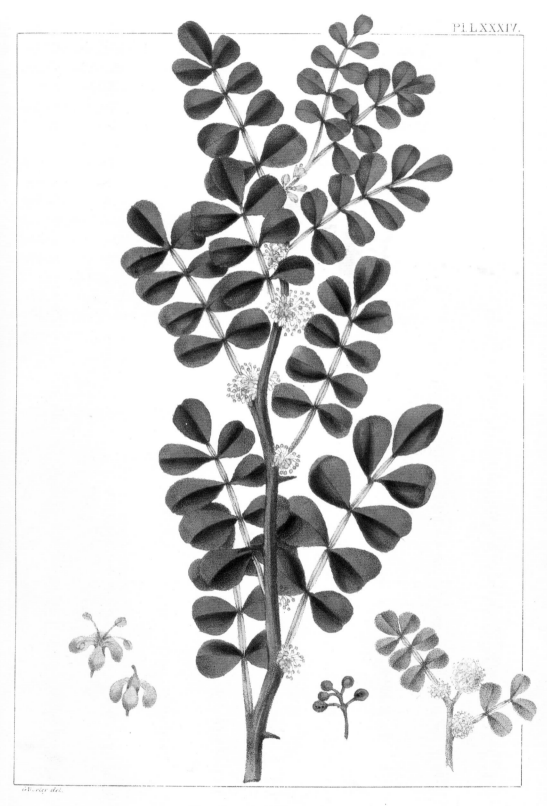

PL.LXXXIV.

Xanthoxylum Pterota.

Bastard Iron Weed. Clavalier Ailé.

Pl. 226. Lime Pricklyash (*Zanthoxylum fagara* (L.) Sarg.)

Pl. 94.

P. J. Redouté del.

Gabriel sculp.

2.

1.

Carolinian Poplar.

Populus Angulata.

Pl. 227. Eastern Cottonwood, Carolina Poplar (*Populus deltoides* Marshall) [247

Pl. XVI.

G.West del. Sinclairs Lith.Phila.

Populus Angustifolia.

Peuplier baumier a feuilles etroites. *NarrowLeaved Balsam Poplar.*

Pl. 228. Narrowleaf Cottonwood (*Populus angustifolia* E. James)

Bessa del . Cotton Tree . *Gabriel sculp.*

Populus argentea.

Pl. 229. Swamp Cottonwood (*Populus heterophylla* L.) [249

Pl.98.

Bessa pinx. Gabriel sculp.

1. Balsam Poplar. 2. Heart Leaved Balsam Poplar.
Populus Balsamifera *Populus candicans.*

Pl. 230 (1). Balsam Poplar (*Populus balsamifera* L.),
(2). Balm-of-Gilead (*Populus × jackii* Sargent)

Pl.95.

Bessa del.

Gabriel sculp.

Cotton Wood.
Populus Canadensis.

Pl. 231. Plains Cottonwood (*Populus deltoides* Marshall) [251

Pl. 160

Bessa del. Gabriel sculp

Common White *or* Grey Poplar.
Populus canescens.

Pl. 232. Gray poplar (*Populus* × *canescens* (Aiton) Sm.)

Pl. 99

Bessa pinx. Gabriel sculp.

1. American Aspen. 2. American Large Aspen.
Populus tremuloides. *Populus grandidentia.*

Pl. 233 (1). Quaking Aspen (*Populus tremuloides* Michx.),
(2). Bigtooth Aspen (*Populus grandidentata* Michx.)

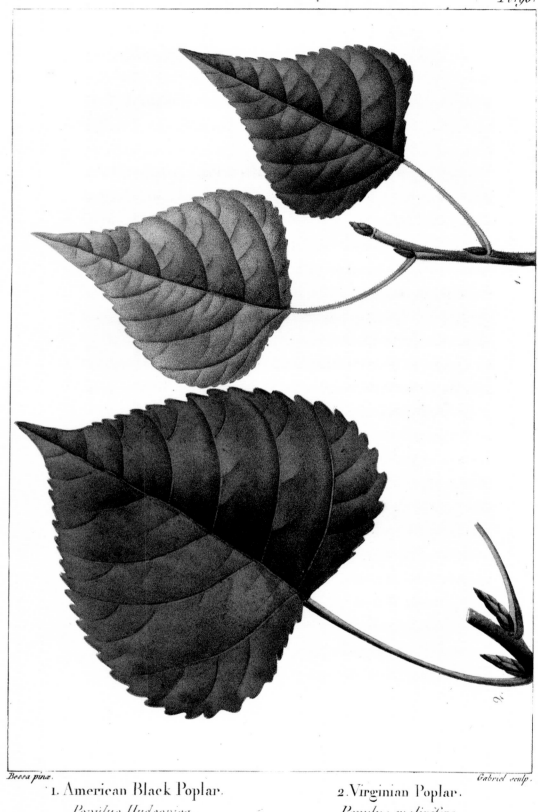

Pl. 96.

Bessa pinx.

Gabriel sculp.

1. American Black Poplar.
Populus Hudsonica

2. Virginian Poplar.
Populus molinifera

Pl. 234 (1). Lombardy Poplar, Black Poplar (*Populus nigra* L.),
(2). Carolina Poplar (*Populus* × canadensis Moench.)

b

a

E.D.Liong del.

Sinclair's lith.Phila

Silver-leaved Willow. **Salix argophylia.** *Saule à feuilles argentées.*

Pl. 235. Narrowleaf Willow (*Salix exigua* Nutt.)

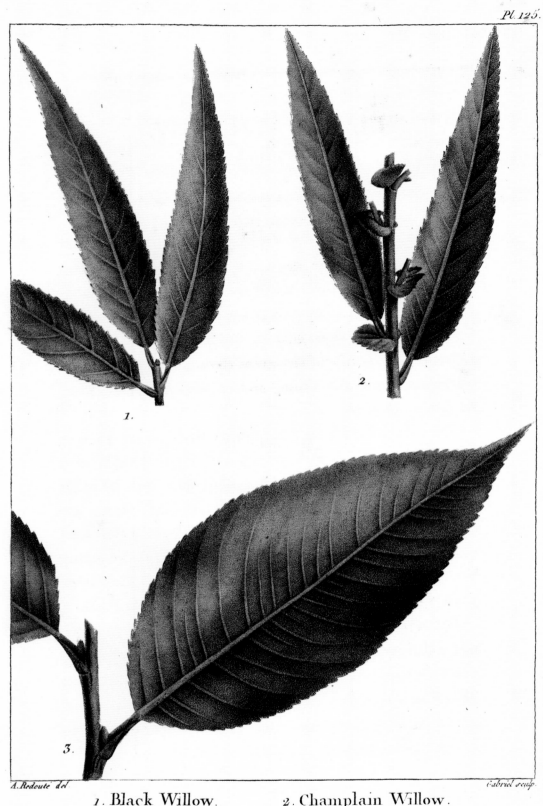

Pl. 125.

A. Redouté del.

Gabriel sculp.

1. **Black Willow.**
Salix nigra.

2. **Champlain Willow.**
Salix ligustrina.

3. **Shining Willow.**
Salix lucida.

Pl. 236 (1). Swamp Willow, Black Willow (*Salix nigra* Marshall), (2). Swamp Willow,
Black Willow (*Salix nigra* Marshall), (3). Shining Willow (*Salix lucida* Muhl.)

Pl. 237. Yellow Willow (*Salix lutea* Nutt.)

Pl. XXI.

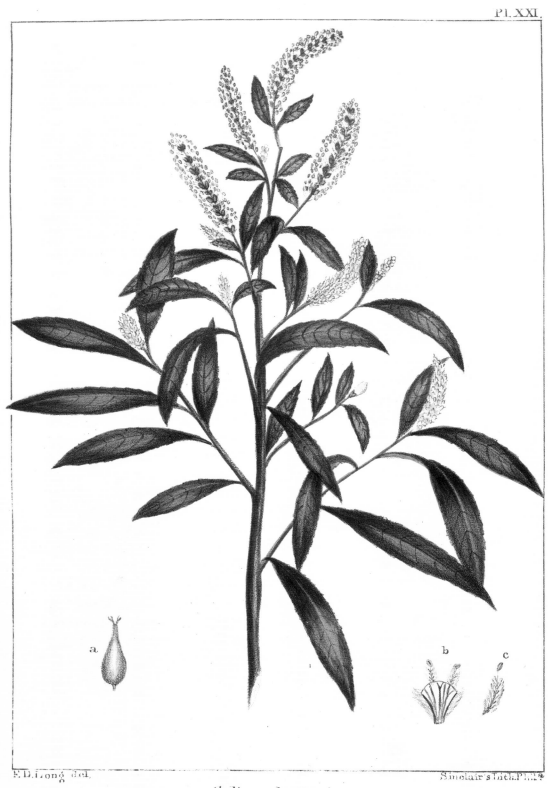

a

b c

E.D.Long del. Sinclair's Lith.Phila.

Dusky Willow. Salix melanopsis. *Saule noirâtre.*

Pl. 238. Dusky Willow (*Salix melanopsis* Nutt.)

Pl. XVIII.

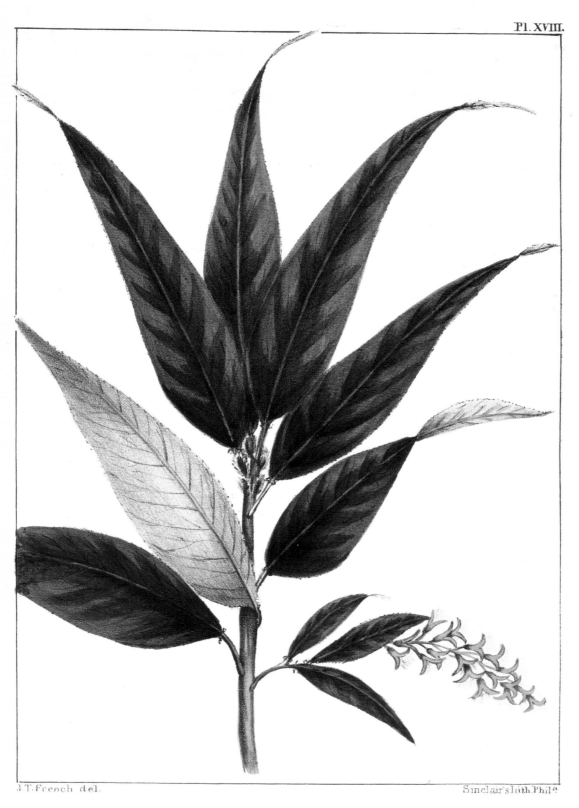

J.T.French del. Sinclair'sLith.Phil⁵

Long-leaved Bay Willow. **Salix pentandra**. Saule laurier.

Pl. 239. Greenleaf Willow (*Salix lasiandra* Benth. var. *caudata* (Nutt.) Sudw.)

Pl. XVII.

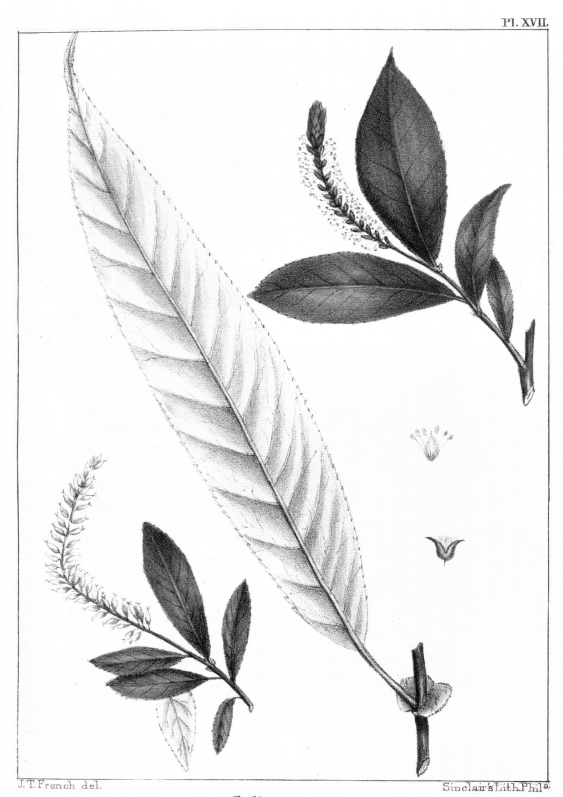

J.T.French del.

Sinclair's Lith.Phil^a

Salix speciosa.

Long-leaved Willow. *Saule gracieux.*

Pl. 240. Pacific Willow (*Salix lasiandra* Benth. var. *lasiandra*)

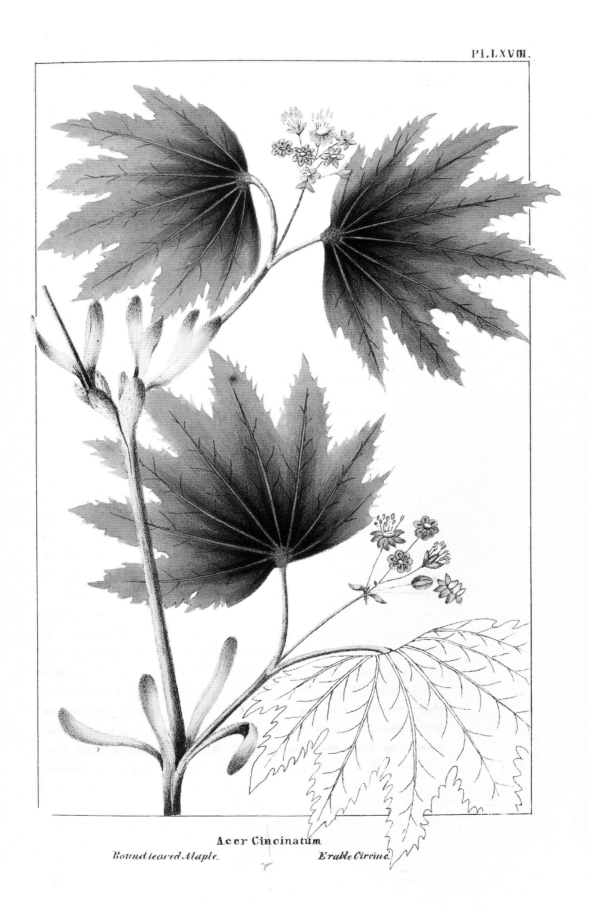

Acer Cincinatum

Round leared Maple. *Erable Circiné.*

Pl. 241. Vine Maple (*Acer circinatum* Pursh) [261

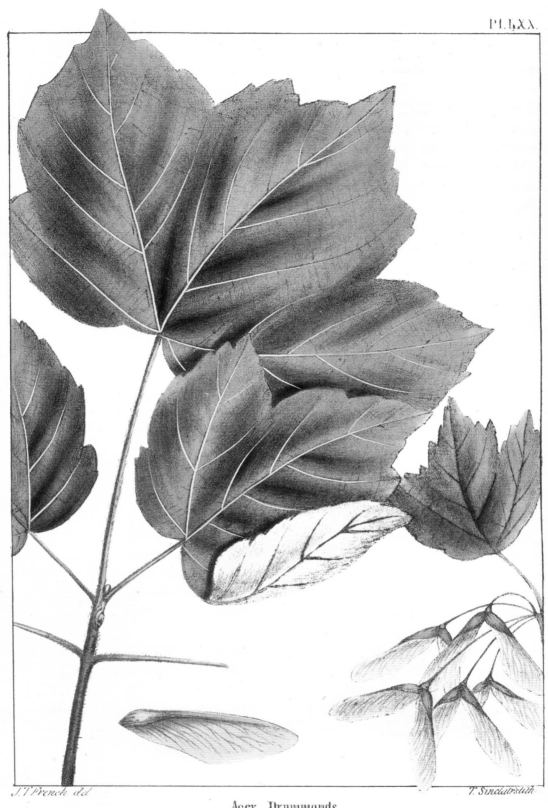

Pl. LXX.

Acer Drummonds.
Drummond's Maple Érable de Drummond

J.T.French del T. Sinclair lith

 Pl. 242. Drummond's Maple (*Acer rubrum* L. var. *drummondii* (Nutt.) Sarg.)

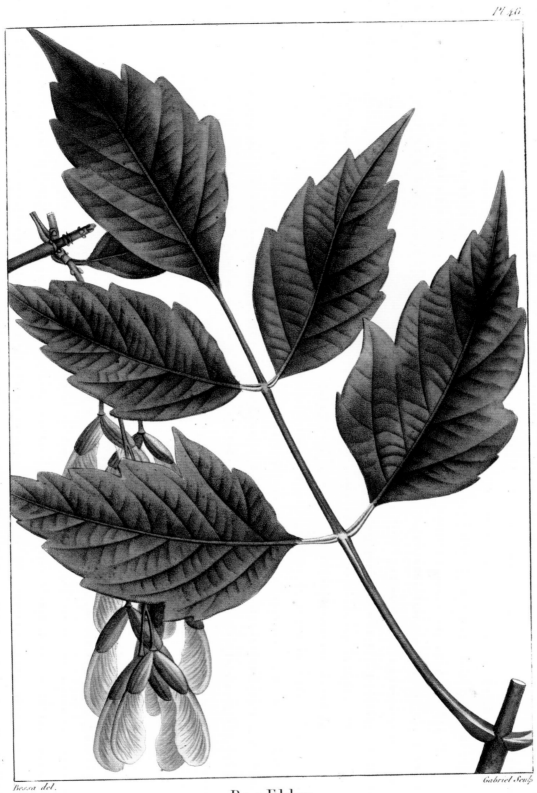

Box Elder.

Acer negundo.

Pl. 46

Bessa del.

Gabriel Sculp

Pl. 247. Boxelder, Ash Maple (*Acer negundo* L.)

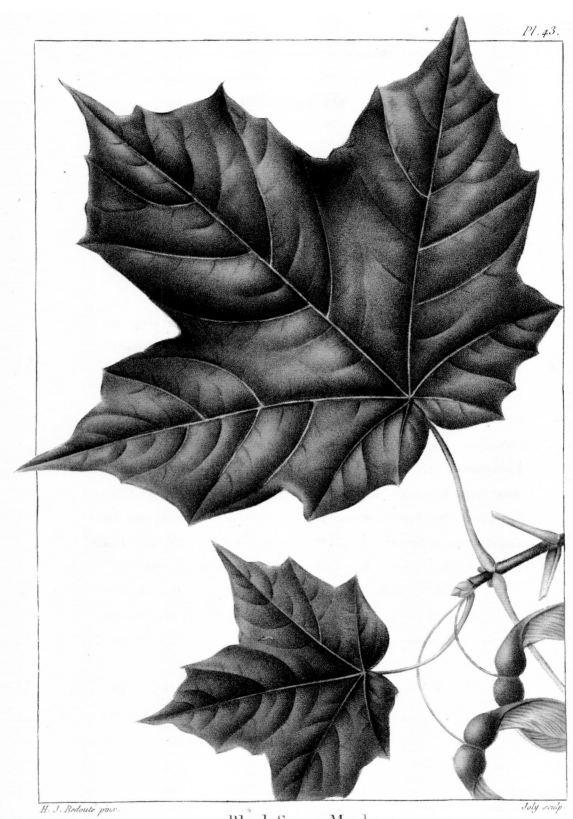

Pl. 43.

H. J. Redouté pinx.

Joly sculp.

Black Sugar Maple.
Acer nigrum.

Pl. 248. Black Maple
(*Acer saccharum* Marshall subsp. *nigrum* (F. Michx.) Desmarais)

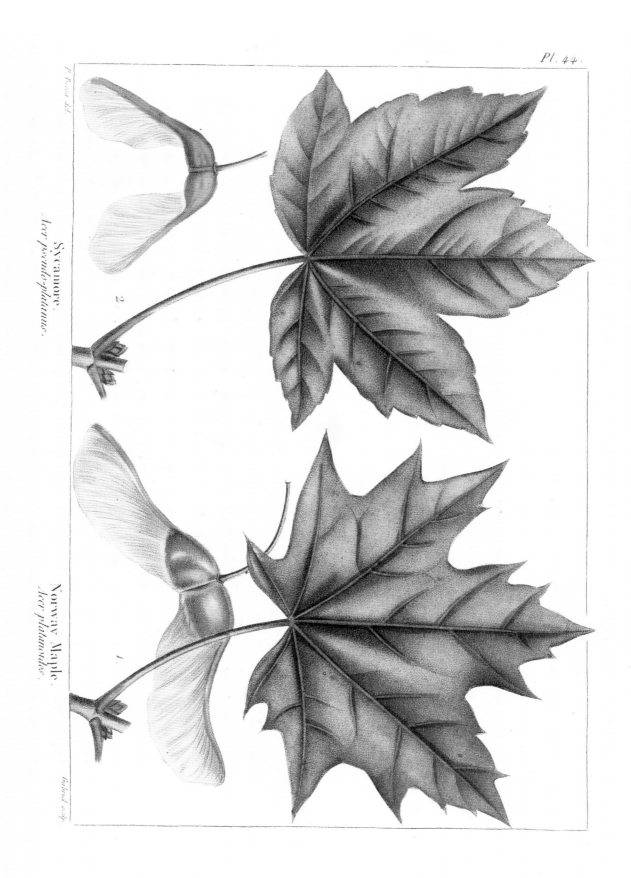

Pl. 44.

Sycamore.
Acer pseudo-platanus.

2

Norway Maple.
Acer platanoides.

1

P. Bessa del.

Gabriel sculp.

Pl. 249 (1). Norway Maple (*Acer platanoides* L.),
(2). Sycamore Maple, Planetree Maple (*Acer pseudoplatanus* L.)

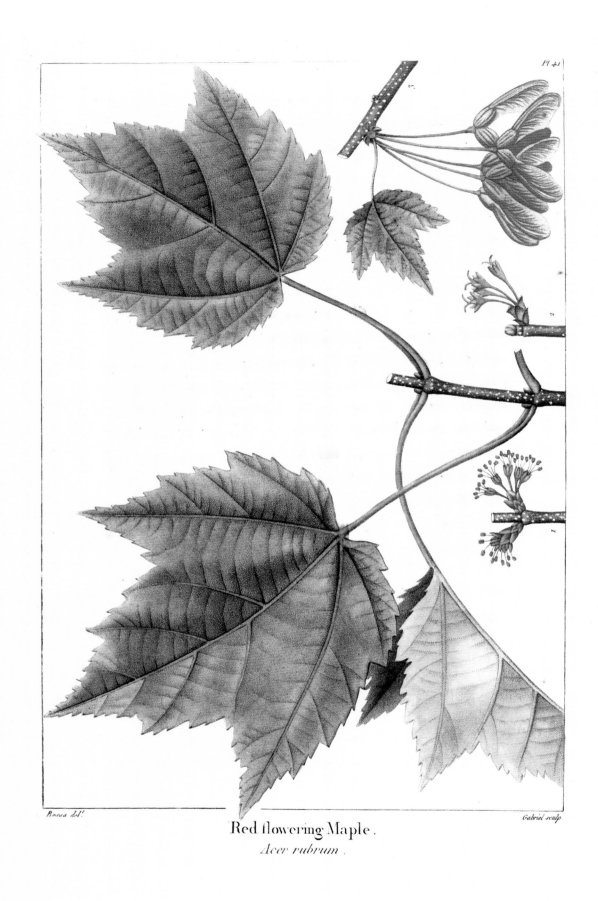

Red flowering Maple.

Acer rubrum.

Pl. 250. Red Maple, Scarlet Maple (*Acer rubrum* L.)

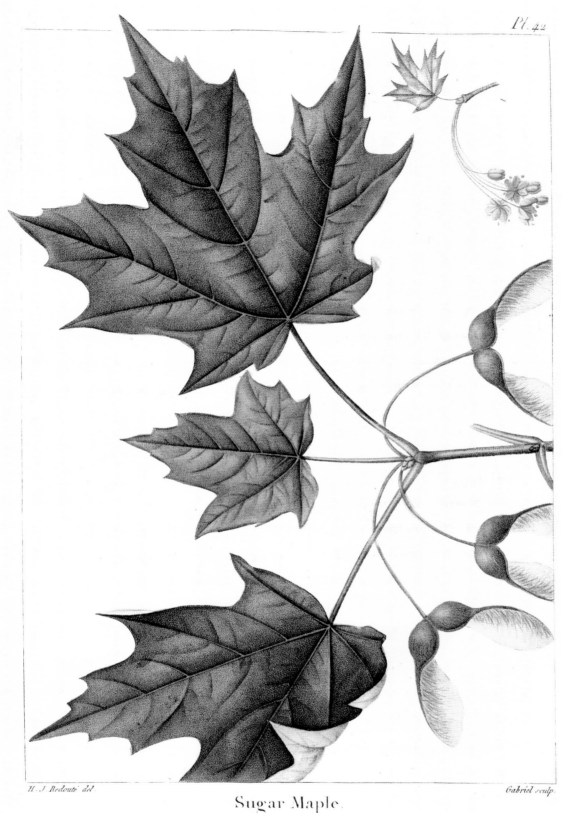

Pl. 42

H. J. Redouté del.

Gabriel sculp.

Sugar Maple.
Acer saccharinum.

Pl. 251. Sugar Maple, Rock Maple (*Acer saccharum* Marshall)

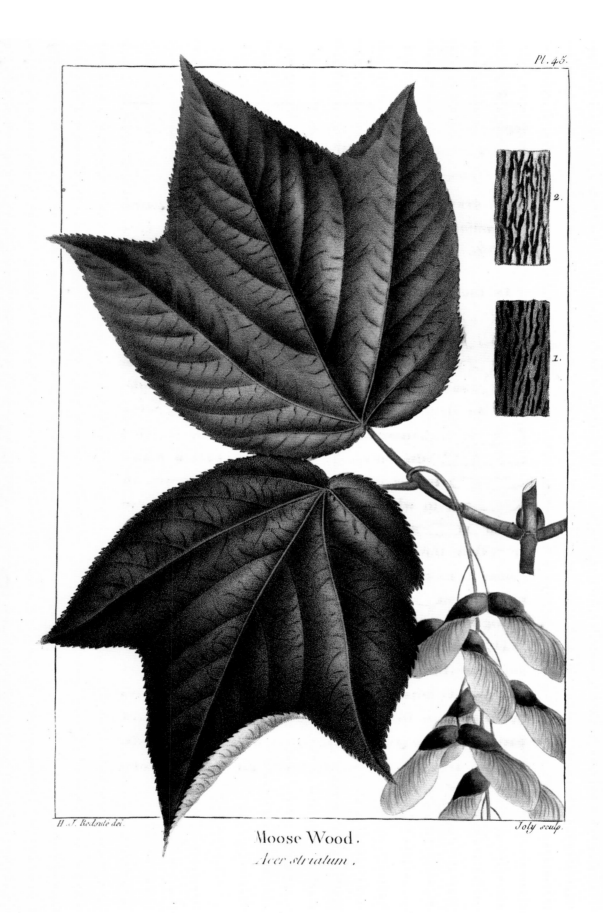

Pl. 45.

2.

1.

H. J. Redouté del.

Joly sculp.

Moose Wood.

Acer striatum.

Pl. 252. Moosewood, Striped Maple (*Acer pensylvanicum* L.)

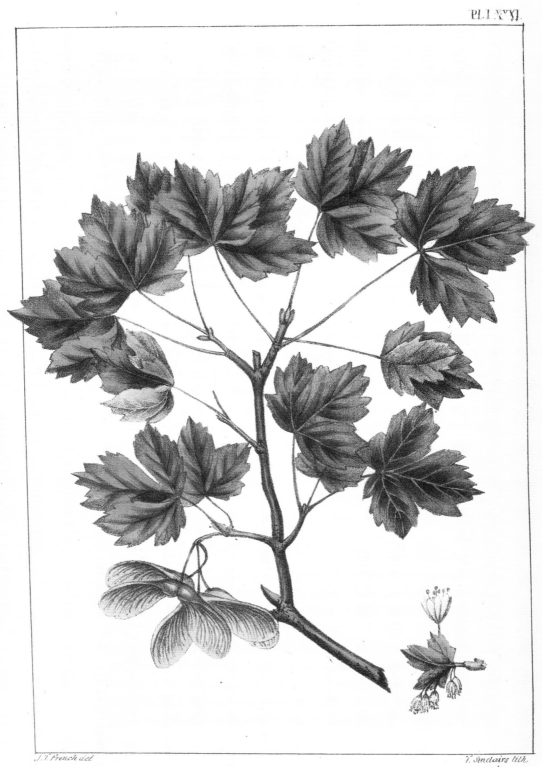

J.J. French del.

T. Sinclairs lith.

Acer tripartitum

Currant leaved Maple. *Érable triparti*

Pl. 253. Rocky Mountain Maple (*Acer glabrum* Torr.)

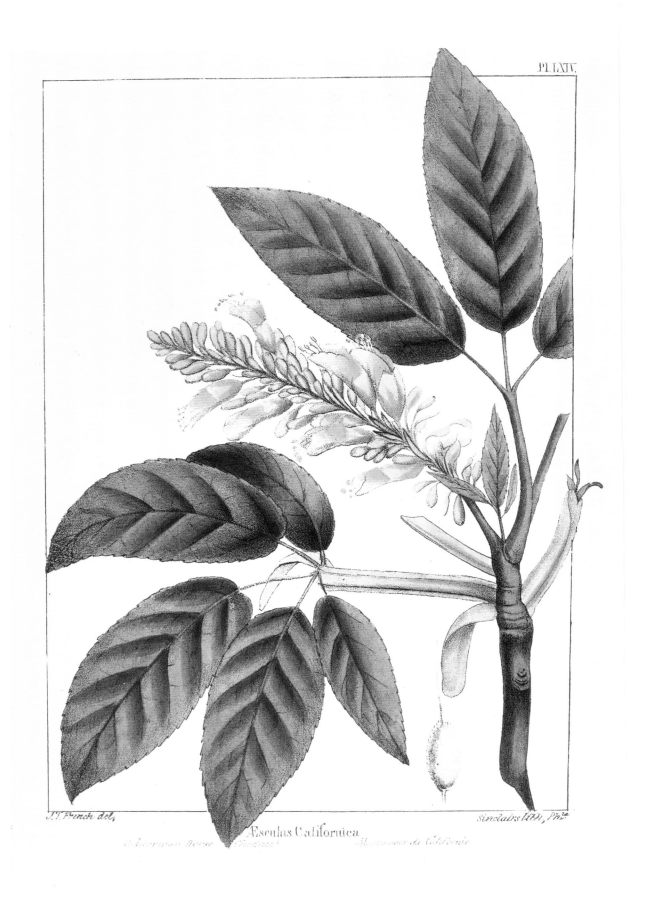

J.T. French del, Sinclairs lith, Ph.ia

Æsculus Californica

Pl. 254. California Buckeye, California Horse-chestnut
(*Aesculus californica* (Spach) Nutt.)

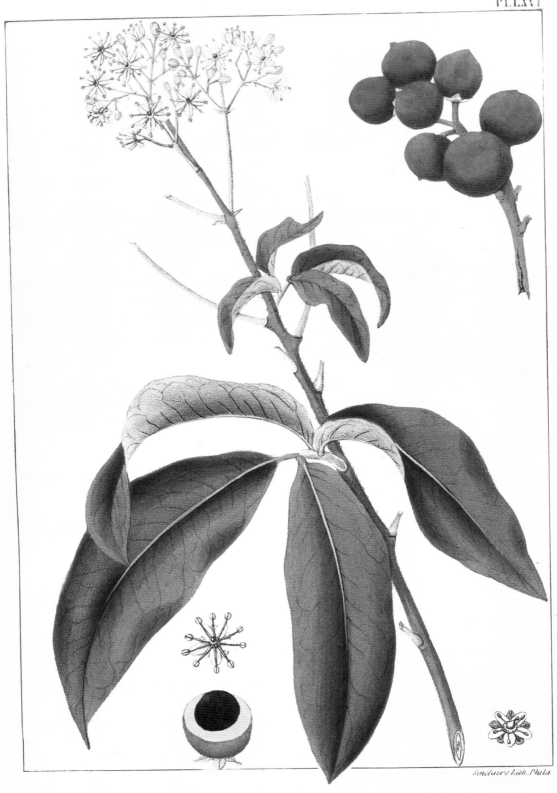

Pl.LXVI

Melicocca paniculata.

Round fruited honeyberry

Sinclair's Lith. Phila.

Knepier panicale

Pl. 255. Butter-bough, Inkwood (*Exothea paniculata* (Juss.) Radlk.)

[275

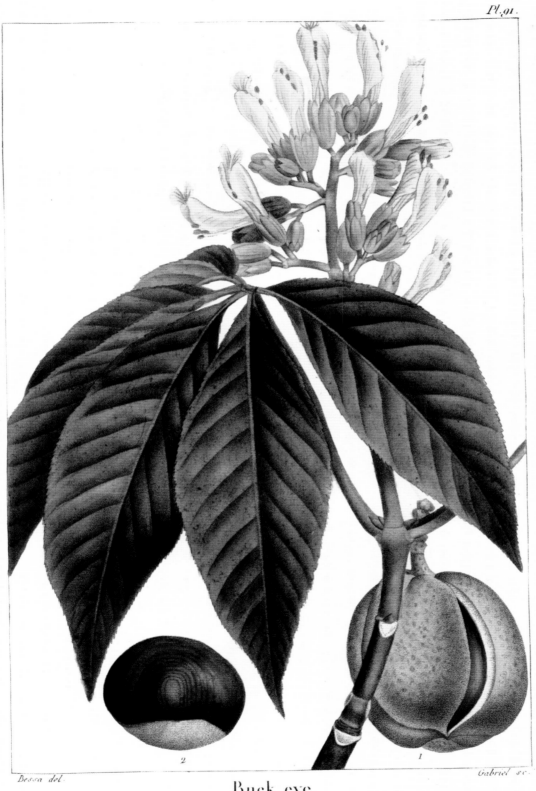

Pl. 91.

Bessa del.

Gabriel sc.

Buck eye.
Pavia lutea.

Pl. 257. Yellow Buckeye, Sweet Buckeye, Big Buckeye (*Aesculus flava* Sol.)

Pl. 92.

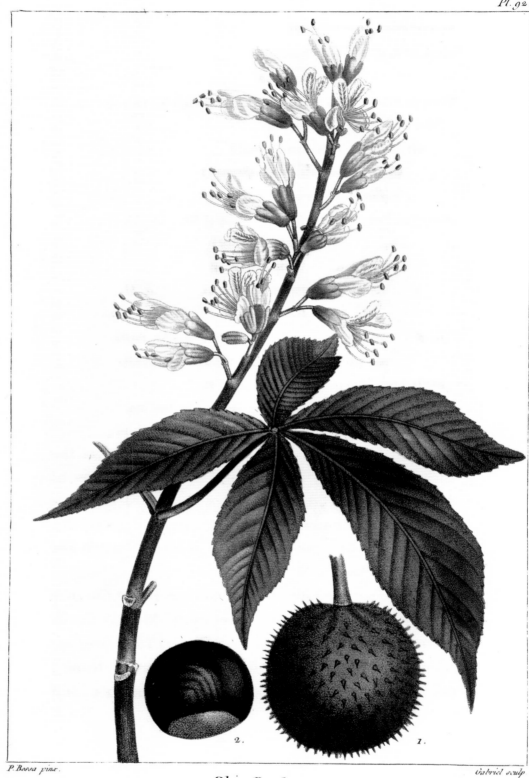

P. Bossa pinx.

Gabriel sculp.

2. 1.

Ohio Buck eye.
Pavia ohioensis.

Pl. 258. Ohio Buckeye, American Horse-chestnut (*Aesculus glabra* Willd.)

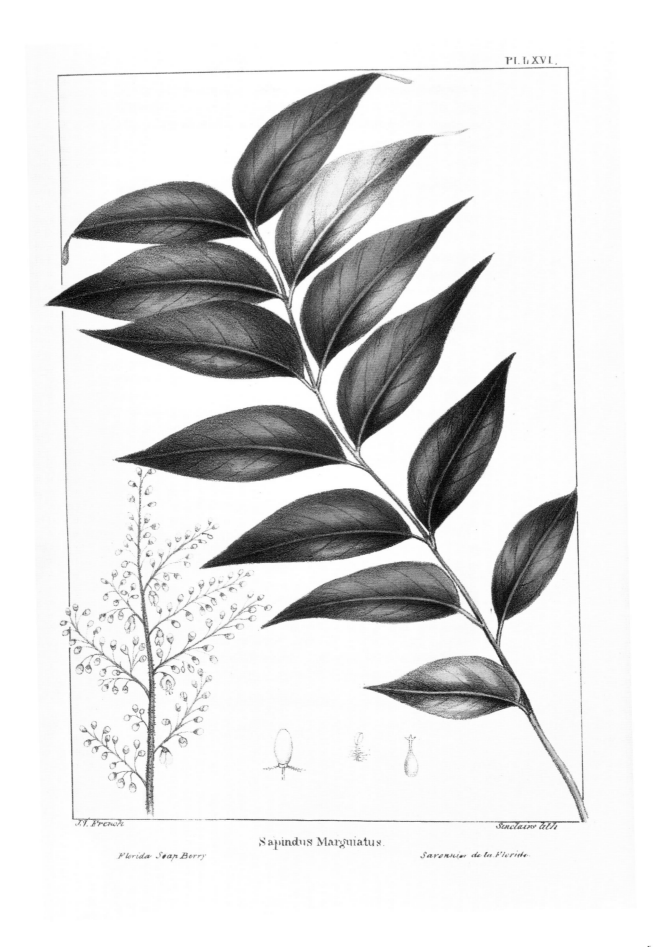

J.V. French

Sinclairs lith.

Sapindus Marginatus.

Florida Soap Berry

Savonnier de la Floride.

Pl. 259. Soapberry (*Sapindus saponaria* L.)

Pl XC.

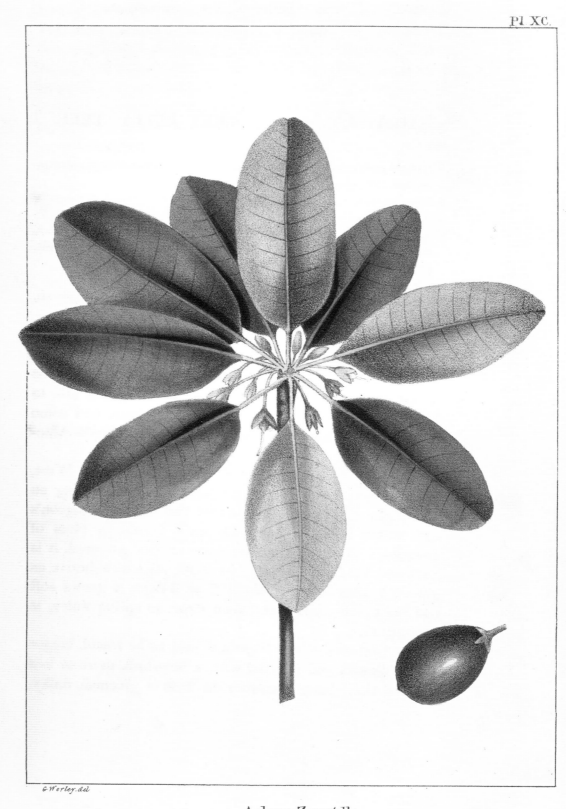

G. Worley. del.

Achras Zapotilla.

Small Sapodilla

Sapotillier Commun.

Pl. 260. Sapodilla (*Manilkara zapota* (L.) P. Royen)

Pl. XCIII

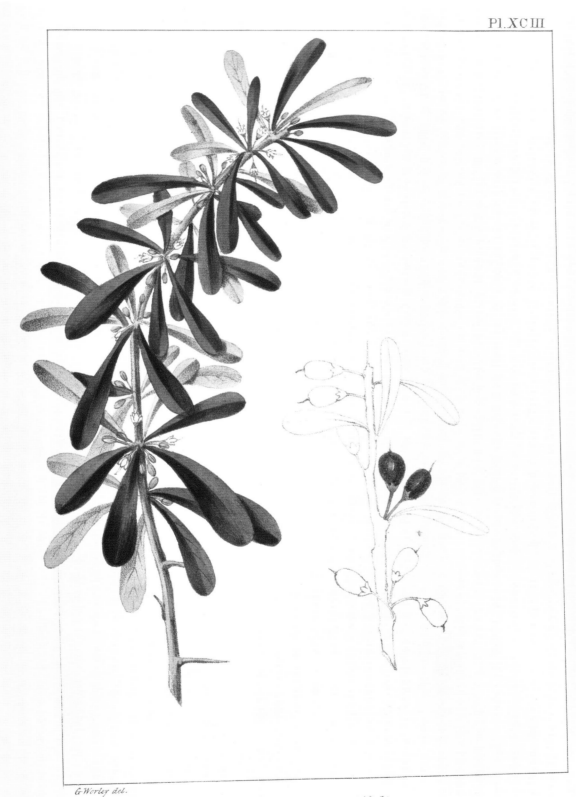

G. Worley del.

Bumelia angustifolia

Narrow-leaved Bumelia

Sapotillier à feuilles étroites

Pl. 261. Saffron Plum
(*Sideroxylon celastrinum* (Humb., Bonpl. & Kunth) T. D. Penn.)

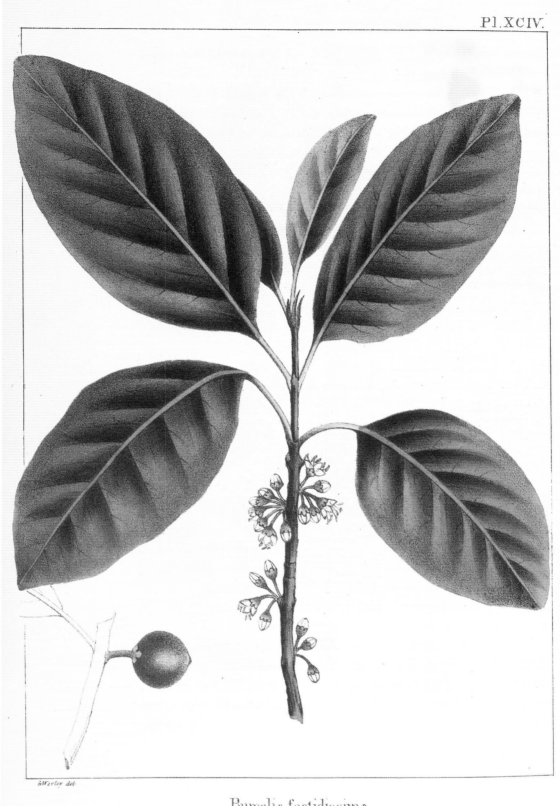

Pl. XCIV.

GWerter del.

Bumelia foetidissima.

Fetid Bumelia.

Sapotillier très fétide

Pl. 262. False Mastic (*Sideroxylon foetidissimum* Jacq.)

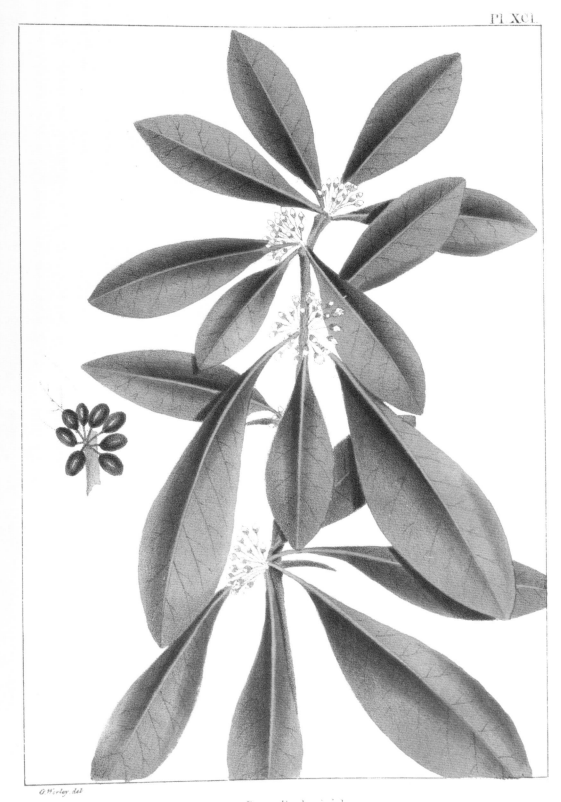

Pl XCI.

G. Worley del.

Bumelia lycioides

Smooth-leaved Bumelia

Sapotillier à feuilles de lycier

Pl. 263. Buckthorn Bully (*Sideroxylon lycioides* L.)

[283

Pl. XCII

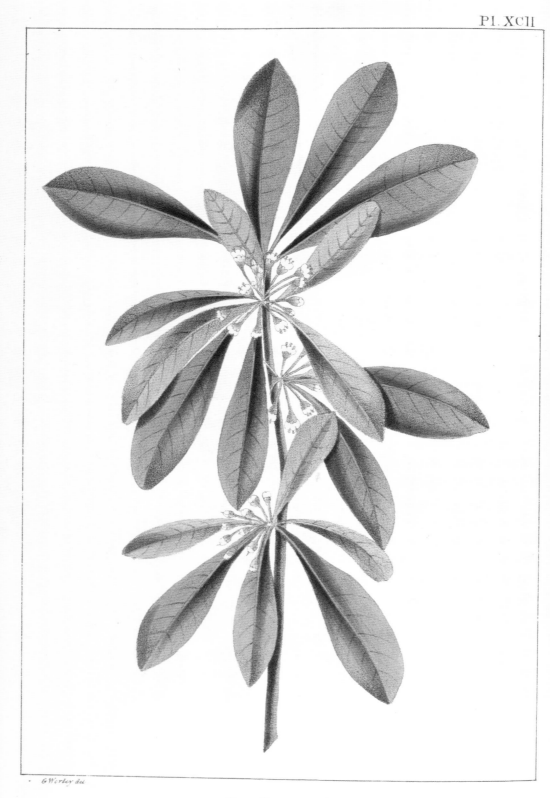

G Worley del

Bumelia tenax.

Silky-leaved Bumelia.

Sapotillier tenace

Pl. 264. Tough Buckthorn (*Sideroxylon tenax* L.)

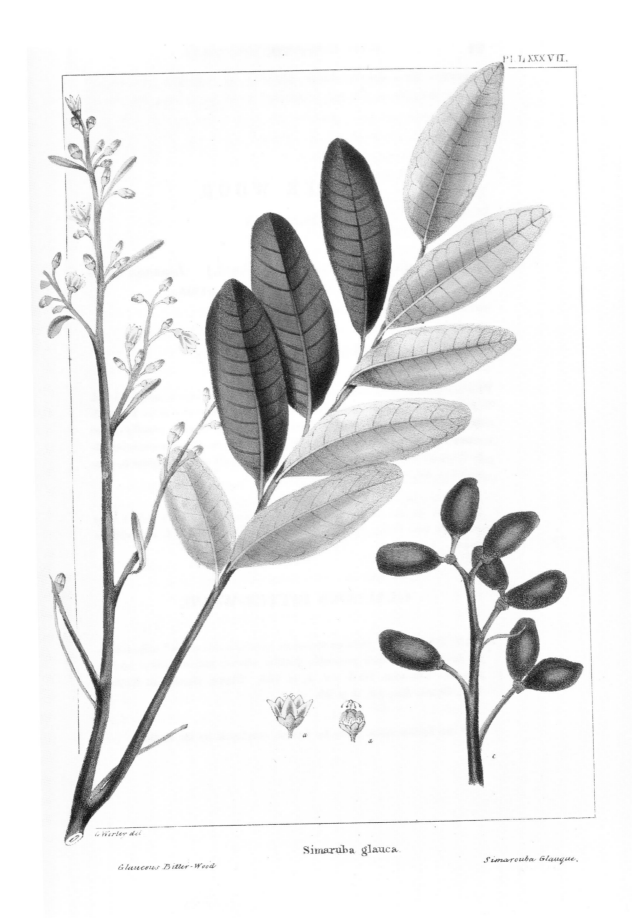

Pl. XXXVII.

Simaruba glauca.

Glaucous Bitter-Wood

Simarouba Glauque.

Pl. 265. Paradise Tree (*Simarouba glauca* DC.)

[285

Pl 117.

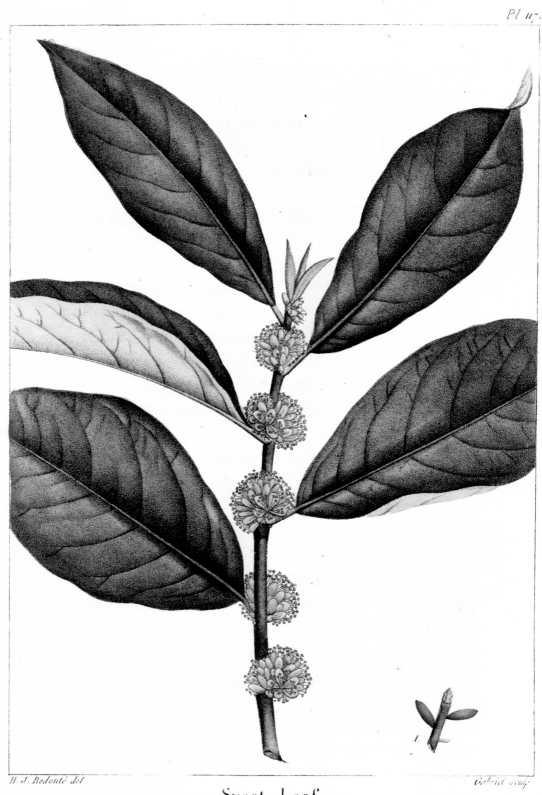

Sveet Leaf.
Hopea tinctoria.

H. J. Redouté del. Gabriel sculp

Pl. 266. Horse-sugar, Common Sweetleaf (*Symplocos tinctoria* (L.) L'Hér)

Pl. CVIII

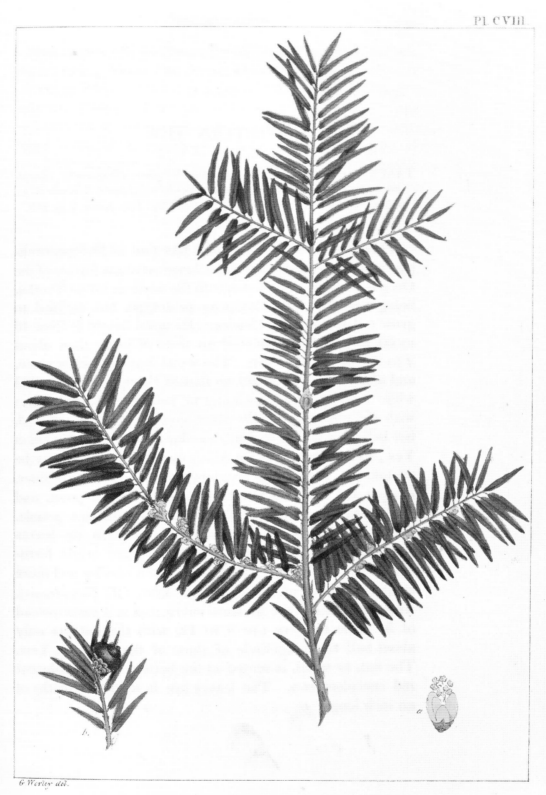

Taxus occidentalis.

Western Yew.

If d'Occident.

G Werier del.

Pl. 267. Western Yew (*Taxus brevifolia* Nutt.)

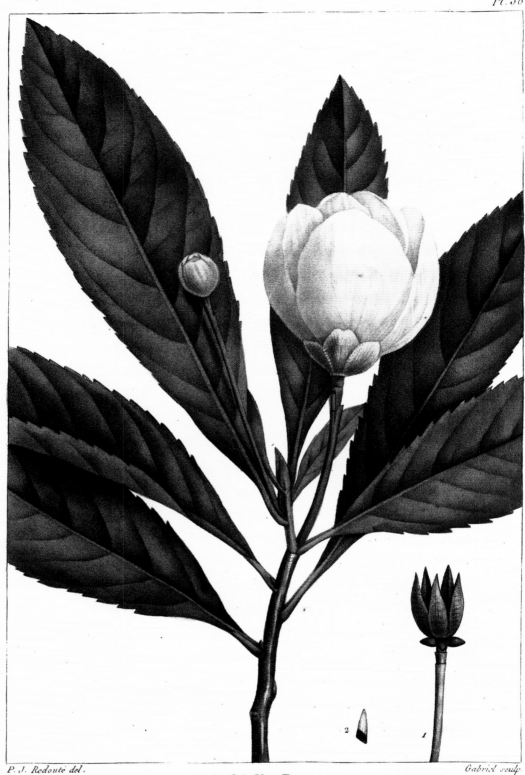

Pl. 58

P. J. Redouté del.

Gabriel sculp.

Loblolly Bay.
Gordonia lasyanthus.

Pl. 268. Loblolly Bay, Black Laurel (*Gordonia lasianthus* (L.) J. Ellis)

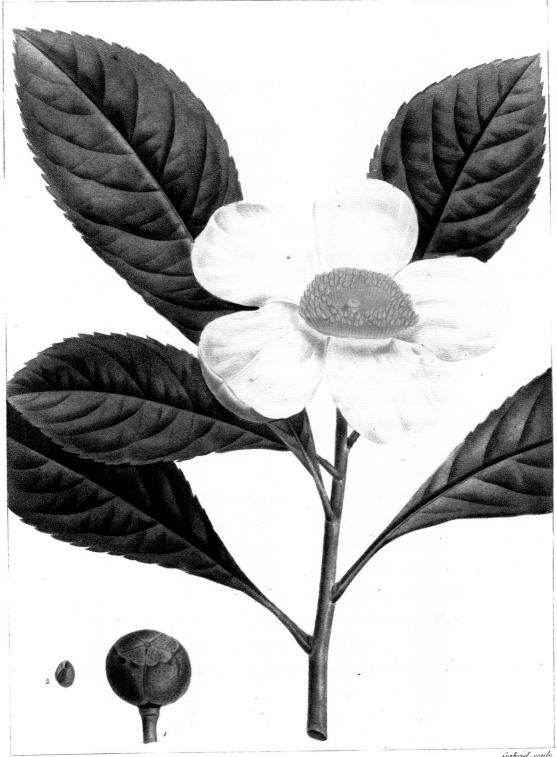

P. J. Redouté del. Gabriel sculp.

Franklinia.
Gordonia pubescens.

Pl. 269. Franklinia, Franklin Tree (*Franklinia alatamaha* Marshall)

[289

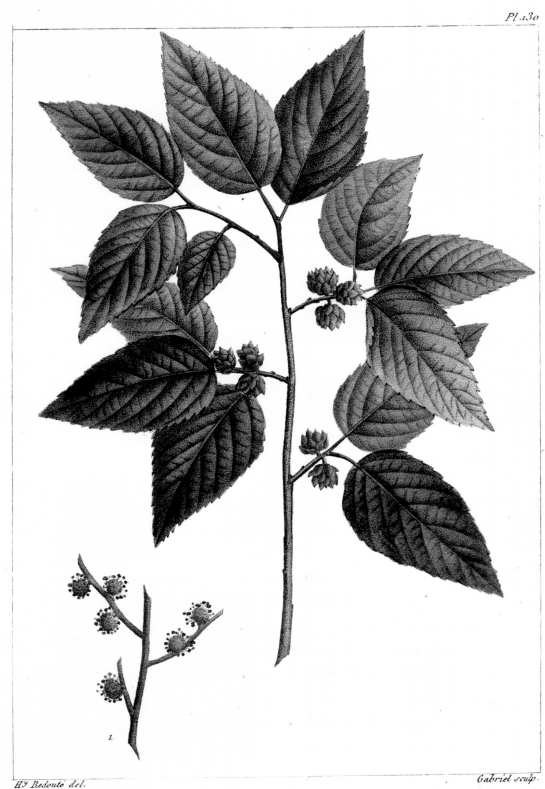

Pl.13o

H.J Redouté del.

Gabriel sculp.

Planer Tree.
Planera Ulmifolia.

290]

Pl. 270. Planertree, Water-elm (*Planera aquatica* J. F. Gmel.)

Pl. 127

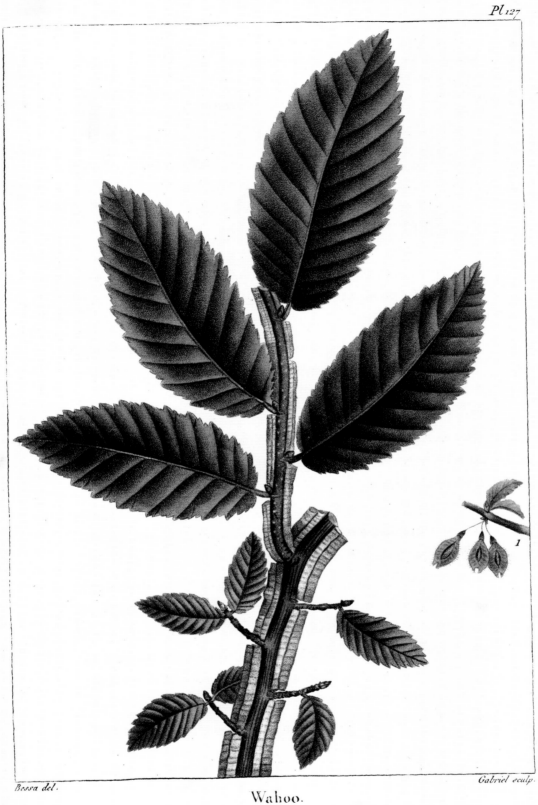

Bessa del.

Gabriel sculp.

Wahoo.
Ulmus Alata.

Pl. 271. Winged Elm, Wahoo (*Ulmus alata* Michx.)

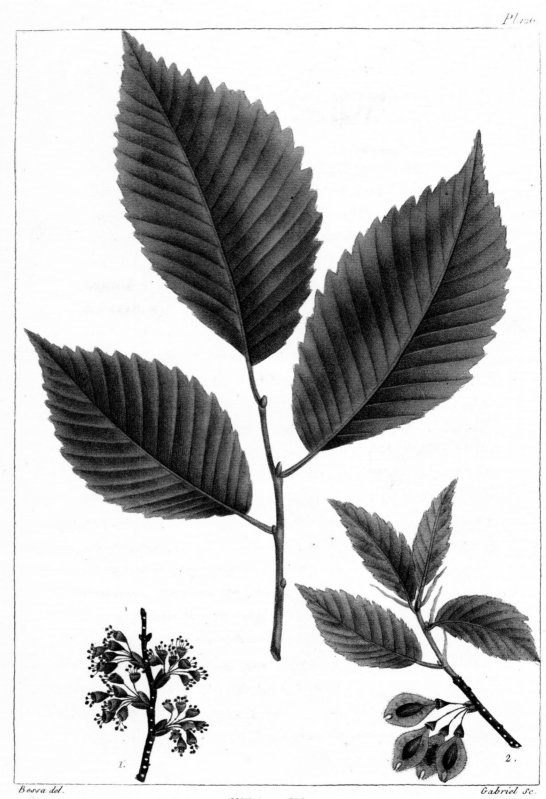

Pl. 126

Bessa del.

Gabriel Sc.

White Elm.
Ulmus Americana

Pl. 272. American Elm (*Ulmus americana* L.)

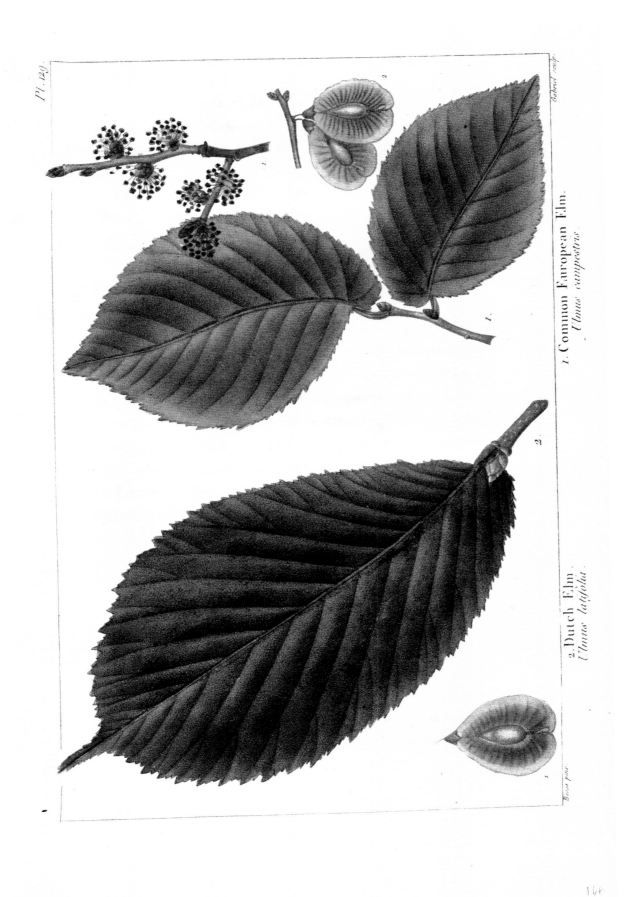

Gabriel sculp.

1. **Common European Elm.**
Ulmus campestris.

2. **Dutch Elm.**
Ulmus latifolia.

Bessa pinx.

Pl. 273 (1). Field Elm (*Ulmus minor* Mill.),
(2). Scots Elm, Wych Elm *(Ulmus glabra* Mill.)

[293

Pl. XI.

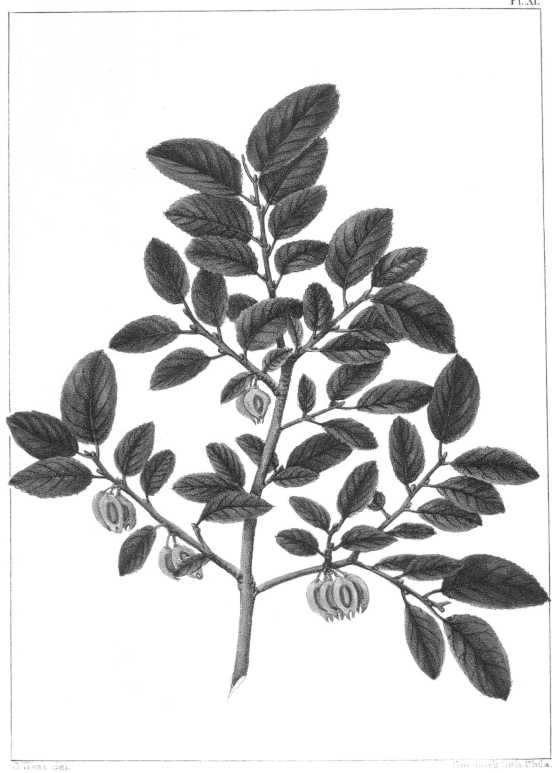

Ulmus opaca.

Opaque-leaved Elm. Orme opaque.

Pl. 274. Cedar Elm (*Ulmus crassifolia* Nutt.)

Pl. XII.

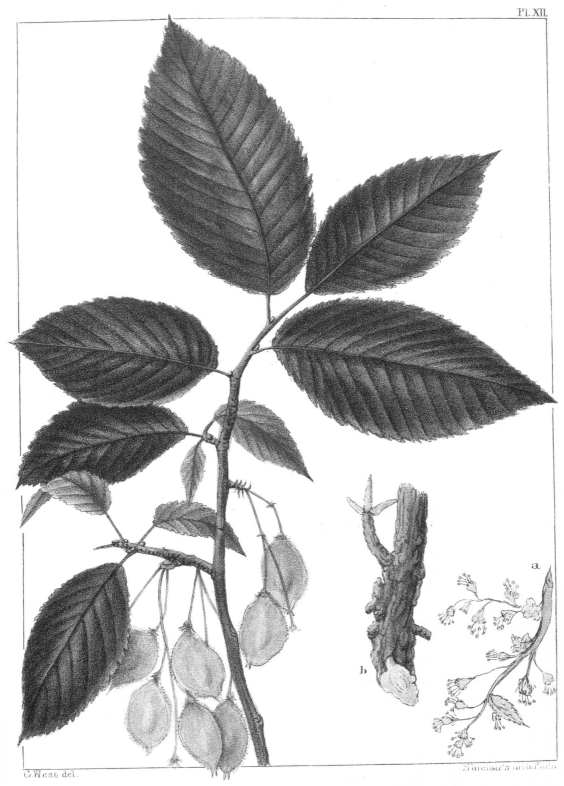

Ulmus racemosa.

Thomas's Elm. *Orme a' grappe.*

Pl. 275. Rock Elm, Cork Elm (*Ulmus thomasii* Sarg.)

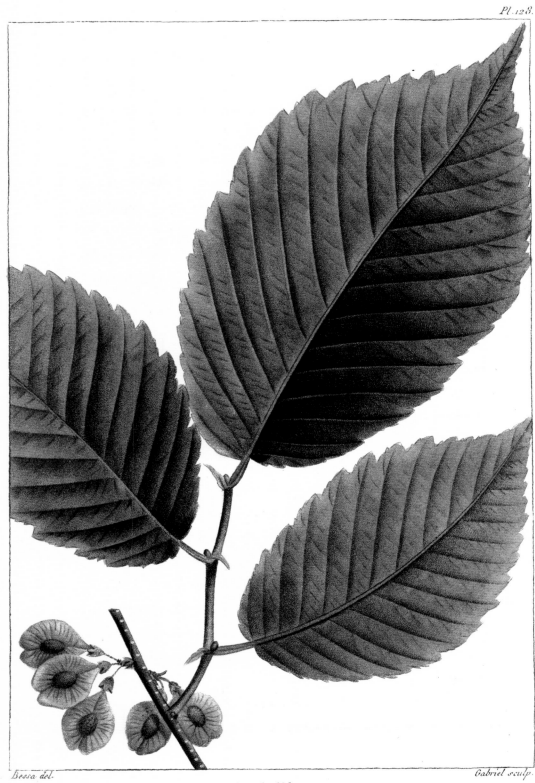

Pl. 128.

Bessa del.

Gabriel sculp.

Red Elm.

Ulmus Rubra.

Pl. 276. Slippery Elm, Red Elm (*Ulmus rubra* Muhl.)

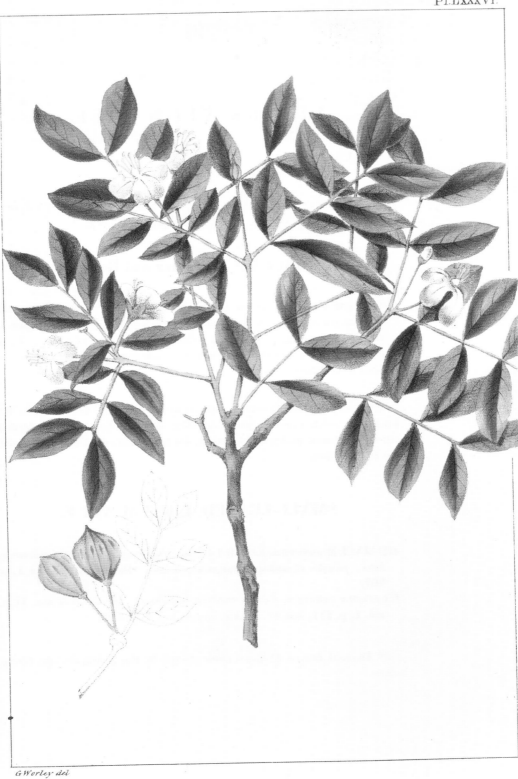

G.Worley del.

Guaiacum sanctum.

Small-leaved Lignum Vitæ

Gayac bois saint

Pl. 277. Holywood (*Guaiacum sanctum* L.)

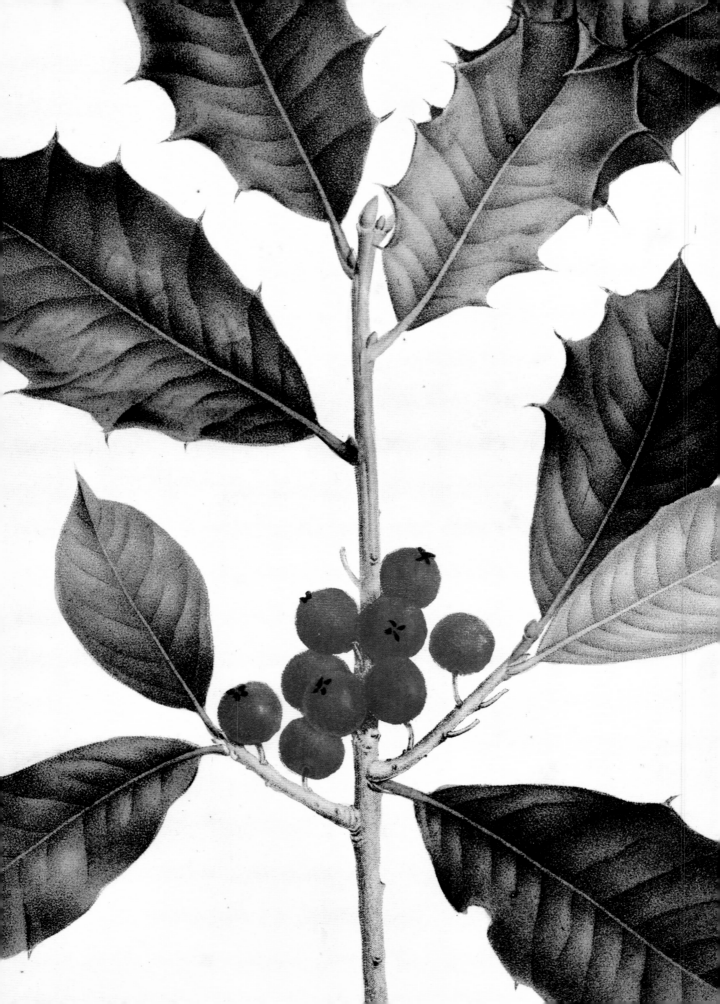

The Species

Legend

ILLUSTRATION BY DAVID ALLEN SIBLEY
(*Please note: not all treatments contain this element.*)

COMMON NAME
PER MICHAUX OR NUTTALL

COMMON NAME(S)
PER MODERN USAGE

SCIENTIFIC NAME
PER MICHAUX OR NUTTALL

Sweet Gum
(*Liquidambar styraciflua*)

PLATE NUMBER AS IT
APPEARS IN THIS BOOK

Pl. 2. Sweetgum, Redgum, Sapgum
(*Liquidambar styraciflua* L.)

AUTHOR(S) OF SCIENTIFIC NAME—PERSON(S)
WHO NAMED AND/OR REVISED THE SPECIES

ALTINGIACEAE

FAMILY NAME PER
CURRENT CLASSIFICATION

SCIENTIFIC NAME PER
CURRENT CLASSIFICATION

Native from the eastern U.S. and southwest into Texas,
Mexico, and Central America, sweetgum thrives in moist
woodlands. It is among the most beautiful trees in fall,
when star-shaped leaves turn breathtaking shades of
yellow, orange, red, and purple. Relatively slow growing,
an 80-foot tree can be more than 150 years old. Sweetgum
is named for its aromatic sap, which hardens into a resin
or gum when exposed to open air. This substance was used
by Native Americans to make chewing gum. (JLG)

INITIALS OF NYBG STAFF WHO
WROTE THE TREATMENT—SEE
ACKNOWLEDGMENTS FOR FULL NAME

Soft-leaved Avicennia
(*Avicennia tomentosa*)

Pl. 1. Black Mangrove
 (*Avicennia germinans* (L.) L.)

<div align="right">ACANTHACEAE</div>

Black mangrove is a tropical/subtropical tree that is often found growing with white and red mangroves. Reaching 50 feet tall, black mangrove forms virtually impenetrable dense thickets. The leaves are two to five inches long, green on top and silvery on bottom. They often have salt deposits on them from exuding salt absorbed in their preferred habitat. Propagules of black mangrove detach from parent when ripe and can float, rootless, indefinitely in salt water. They root when they land upon a suitable surface that allows protection from waves. The dense thickets of black mangroves provide a protected and safe environment for nesting birds and a nursery for hatching fish. (BPS)

Sweet Gum
(*Liquidambar styraciflua*)

Pl. 2. Sweetgum, Redgum, Sapgum
 (*Liquidambar styraciflua* L.)

<div align="right">ALTINGIACEAE</div>

Native from the eastern U.S. and southwest into Texas, Mexico, and Central America, sweetgum thrives in moist woodlands. It is among the most beautiful trees in fall, when star-shaped leaves turn breathtaking shades of yellow, orange, red, and purple. Relatively slow growing, an 80-foot tree can be more than 150 years old. Sweetgum is named for its aromatic sap, which hardens into a resin or gum when exposed to open air. This substance was used by Native Americans to make chewing gum. (JLG)

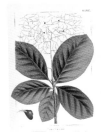

Large-leaved Cotinus
(*Cotinus americanus*)

Pl. 3. American Smokebush
 (*Cotinus obovatus* Raf.)

<div align="right">ANACARDIACEAE</div>

American smokebush is an outstanding small deciduous tree or large shrub native to parts of southern U.S. It is extremely tolerant of drought and wind as well as difficult sites, including wet and compacted soil, but prefers a high pH. Though a dull green during the growing season, American smokebush has vibrant red and orange fall leaf color. Six- to ten-inch panicles of tiny flowers that bloom in early summer give the tree a misty appearance inspiring its common name. The fruit that follow are enjoyed by native finches. Its wood was used to make yellow and orange dyes during the Civil War, when the tree was nearly harvested to the point of elimination. (KS)

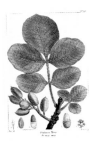

Pistacia Tree
(*Pistacia vera*)

Pl. 4. Pistacia Tree, Pistachio
 (*Pistacia vera* L.)

<div align="right">ANACARDIACEAE</div>

Pistacia tree furnishes the snack-time favorite, pistachio nuts, and assorted delectable treats made from them. Native to Asia Minor, this small tree thrives in hot, dry Mediterranean climates and a diversity of soil types. Michaux recommended *Pistacia vera* be imported to southern states for fruit production in the early 1800s. However, it was not until a century later that botanist William E. Whitehouse (b. 1893) journeyed to Persia (present-day Iran) to collect pistacia trees for cultivation. Today California, Arizona, and New Mexico are the top commercial producers. Pistacia tree is dioecious, meaning that male and female flowers grow on separate plants. (JAS)

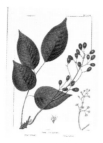

Coral Sumach
(*Rhus metopium*)

Pl. 5. Black Poisonwood
 (*Metopium brownei* (Jacq.) Urb.)

ANACARDIACEAE

Black poisonwood is a species in the Sumac family, growing in Central America, the Caribbean, and the Florida Keys. It has thick stems and large leaves with wavy margins. Black poisonwood produces small, bright coral-colored drupes, hence Nuttall's name coral sumach. Like its cousin, Florida native *Metopium toxiferum*, black poisonwood's highly toxic sap causes blistering red rashes that persist for weeks. Some people also have reactions to its toxic leaves and wood. The tree grows about 20 feet high. Its dense, hard wood, known as *chechem* in Latin America, boasts a beautiful grain striped with dark brown or black that is prized by woodworkers. (VBL)

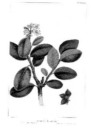

Entire-leaved Stryphonia
(*Stryphonia integrifolia*)

Pl. 6. Lemonade Sumac, Lemonadeberry
 (*Rhus integrifolia*
 (Nutt.) W. H. Brewer & S. Watson)

ANACARDIACEAE

Lemonade sumac is a shrub or small tree native to dry coastal areas of Southern California and the Baja California Peninsula. It has simple, small, leathery leaves. In spring tiny, fragrant, white to pink flowers give way to clusters of reddish-pink fruit. The coppery young bark becomes gray and scaly with age, giving the trunk an attractive gray and copper mottled appearance. Lemonade sumac requires full sun and free-draining soil. The nectar and fruit provide food for butterflies and birds. The dense resinous wood makes excellent kindling. Like many sumacs, the sap may cause irritation in sensitive individuals, but does not contain urushiol, the intensely irritating compound in the related poison ivy. (KS)

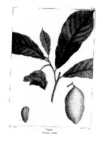

Papaw
(*Annona triloba*)

Pl. 7. Pawpaw, Custard Apple
 (*Asimina triloba* (L.) Dunal)

ANNONACEAE

Pawpaw is native to much of the eastern half of the U.S. It is a fairly small tree, especially in the Northeast, but can reach 30 to 40 feet high farther south. Its large leaves and unusual purple flowers appear almost tropical, but are not as notable as the long, yellow-green fruit that are among the largest found on trees native to North America. The fruit are edible, and the inner flesh is similar in flavor and texture to that of bananas, though its black seeds are poisonous to humans. This plant provided nourishment to explorers of the continent from Hernando de Soto (ca. 1496–1542) to Meriwether Lewis (1774–1809) and William Clark (1770–1838). (JLG)

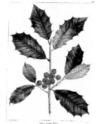

American Holly
(*Ilex opaca*)

Pl. 8. American Holly, Christmas Holly
 (*Ilex opaca* Aiton)

AQUIFOLIACEAE

American holly is a small tree or shrub with dark-green, leathery leaves with spiny margins. It ranges from central New Jersey south through the Atlantic Coastal Plain and Appalachian Mountains to eastern Texas. The foliage of American holly provides shelter for many songbirds and smaller mammals, as well as food for a variety of birds, including quail, grouse, wild turkeys, and songbirds. The fruit are mildly toxic if consumed by humans. Native Americans used the berries for buttons and trade. (RG)

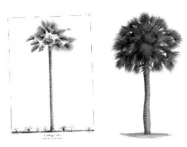

Cabbage Tree
(*Chamaerops palmetto*)

Pl. 9. Cabbage Palmetto
 (*Sabal palmetto*
 (Walter) Lodd. ex Schult. & Schult. f.)
 ARECACEAE

Michaux feared that the slow-growing cabbage palmetto, which he called cabbage tree, was in danger of extinction in his day. It was felled to build ships because it was less susceptible to shipyard pests, but the tree earned its name from the edible section at the base of the long leaves, which he noted was eaten with oil and vinegar. He writes lyrically of the loss of the tree: "...to destroy a vegetable which has been a century in growing, to obtain three or four ounces of a substance neither richly nutritious nor peculiarly agreeable to the palate, would be pardonable only in a desert which was destined to remain uninhabitable for ages." Fortunately, Michaux's predictions did not come to fruition, and today cabbage palmetto is among the most abundant palms native to North America. (JLG)

Common Alder
(*Alnus serrulata*)

Pl. 10 (1). Smooth Alder
 (*Alnus serrulata* (Aiton) Willd.)
 BETULACEAE

Like other alder species, smooth alder grows in wet soils such as swamps, streamsides, and bog margins, ranging from the Canadian Maritimes to Florida and Texas. It is often found with speckled alder, but can be distinguished from it by the finely serrate leaf margins with small, uniform teeth (*serrulate*) versus the coarsely serrate margins of the speckled alder with both large and small teeth. The interesting features of its wood were noted by Michaux, "the wood of the Common Alder, when first laid open, is white, and it becomes reddish by contact with the air." (CM)

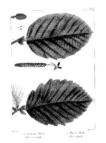

Black Alder
(*Alnus glauca*)

Pl. 10 (2). Speckled Alder
 (*Alnus incana* (L.) Moench
 subsp. *rugosa* (Du Roi) R. T. Clausen)
 BETULACEAE

Michaux called this tree "one of the most beautiful species of this genus." Speckled alder is a clonal shrub with crooked branches often forming dense colonies. On fertile sites it can reach 30 feet in height. Like other alders, it thrives on streambanks, lake shores, bog margins, wet roadsides, and wet woods with periodic flooding. It is often found growing with maples, willows, and spruce. The bark features prominent pale lenticels, giving the trunk a speckled appearance. (CM)

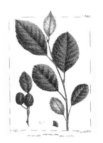

Sea-side Alder
(*Alnus maritima*)

Pl. 11. Seaside Alder
 (*Alnus maritima*
 (Marshall) Muhl. ex Nutt.)
 BETULACEAE

Seaside alder is the only North American representative of a distinctive group of fall-blooming alders, the others being two species found in Southeast Asia. It forms catkins during summer and flowers before the leaves are fully shed, as does native witch-hazel (*Hamamelis virginiana*). Its range is now two small disjointed areas, one along the coast of southern Delaware and the other in south-central Oklahoma, remnants of what may well have been a much wider range prior to the last glacial event. The shiny, minutely toothed dark-green leaves are also a unique trait, which according to Nuttall, "at first glance, look almost like the leaves of a Camellia." (MH)

Oregon Alder
(*Alnus oregona*)

Pl. 12. Red Alder
(*Alnus rubra* Bong.)

BETULACEAE

Red alder is a common tree of moist, rich soils throughout the Pacific Northwest, usually reaching 30 to 40 feet tall but potentially approaching heights of 65 to 75 feet. Taller trees approaching 100 feet are not unknown. Always found growing in association with water, it is a fast-growing pioneer tree. Like all alders, the roots have nodules containing nitrogen-fixing bacteria. Red alder provides shade for saplings, but eventually makes way for slower-growing conifers such as western red-cedar (*Thuja plicata*). The bark, especially of young trees, is a soft grayish-white becoming mottled with irregular blackish boles as it ages. Red alder's name is derived from the color of the inner bark and heartwood, which has been used in cabinetry and furniture making. (MH)

Thin-leaved Alder
(*Alnus tenuifolia*)

Pl. 13. Mountain Alder, Thinleaf Alder
(*Alnus incana* (L.) Moench
subsp. *tenuifolia* (Nutt.) Breitung)

BETULACEAE

Mountain alder is one of two North American subspecies of *Alnus incana*. This tree, as described by Nuttall, is *Alnus incana* subsp. *tenuifolia*, the subspecies found west of the Rocky Mountains. Typical of all alders, it prefers the moist soils of lakes and streams where it is usually a large shrub, often forming dense streamside thickets intermixed with willows. In the southern part of its range, where it grows at higher elevations, it can be found as a small slender tree, reaching 20 to 30 feet in height. A distinguishing feature is the very irregular, jagged margins of the leaves, often described as resembling raggedly torn paper. (MH)

Common European White Birch
(*Betula alba*)

Pl. 14. Downy Birch, European White Birch
(*Betula pubescens* Ehrh.)

BETULACEAE

This tree is often confused with silver birch, but it is distinguished by the silky, hairy texture of its twigs, which earned it the common name downy birch. The branches of younger specimens are a deep, glossy copper color while the bark of the trunk is dull brown or gray, and often peeling. In spring the tree produces yellow-brown catkins, which scatter seeds widely when they ripen. The finely toothed green leaves turn bright yellow in fall. (JLG)

Black Birch
(*Betula lenta*)

Pl. 15. Sweet Birch, Cherry Birch
(*Betula lenta* L.)

BETULACEAE

During fall, the heart-shaped leaves of sweet birch shine in bright-yellow tones. This tree was one of Michaux's favorites. "I shall terminate this description of one of my favorite trees, by recommending it to the lovers of foreign vegetables, as eminently adapted, by the beauty of its foliage and by the agreeable odour of its flowers, to figure in their parks and gardens." Scratching a small section of the bark on a twig fallen from this tree will reveal the sweet scent of wintergreen. Before the advent of artificial flavoring, black birch was harvested to produce oil of wintergreen, a popular flavoring for candy, chewing gum, medicines, and birch beer. (CM)

American Nettle Tree
(*Celtis occidentalis*)

Pl. 32. Northern Hackberry, Nettle Tree
 (*Celtis occidentalis* L.)

CANNABACEAE

Northern hackberry is an extremely variable species
tending to show some gradation from east to west, but
differentiating varieties based on leaf size is not possible.
The species ranges from New England to the Great Plains,
south to Alabama, Mississippi, and South Carolina, but
is absent from Florida. It is characterized by large leaves
that are evenly toothed along their entire margin, with
numerous secondary veins. (JLG)

Small-leaved Nettle Tree
(*Celtis reticulata*)

Pl. 33. Netleaf Hackberry
 (*Celtis reticulata* Torr.)

CANNABACEAE

Netleaf hackberry is a small deciduous tree or large shrub
native to the western U.S. and northern Mexico. Its leaves
are small, thick, and rough to the touch, adaptations that
allow it to survive the dry, windy conditions that dominate
much of its native range. The specific epithet, *reticulata*,
and the common name, netleaf, both refer to the promi-
nent network of veins that can be seen on the upper and
lower surfaces of its leaves. Netleaf hackberry produces
small, brownish-red berries that are eaten by a variety of
birds and animals. (TAF)

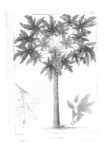

Papaw Tree
(*Papaya vulgaris*)

Pl. 34. Papaya
 (*Carica papaya* L.)

CARICACEAE

Native to Mexico and Central America, papaya has
become one of the most popular and widely grown
commercial fruit crops worldwide. Papaya grows easily
in fertile and well-drained soils, but is sensitive to frost.
Typically forming a single, non-woody stem, it can reach
up to 20 feet tall, terminating in a cluster of large dark-
green, deeply lobed leaves. The large fruit form directly
on the main trunk under the leaves. (BPS)

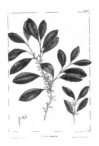

Jamaica Boxwood
(*Schaeffera buxifolia*)

Pl. 35. Florida Boxwood
 (*Schaefferia frutescens* Jacq.)

CELASTRACEAE

Contemporary botanists list Nuttall's *Schaeffera buxifolia*
as a synonym of *Schaefferia frutescens*, an evergreen shrub
or small tree native throughout tropical and subtropical
America. According to Charles Sprague Sargent (1841–
1927), Florida boxwood was introduced into cultivation
in England in 1793 by Captain William Bligh (1754–1817)
on his return from successfully introducing breadfruit
(*Artocarpus altilis*) into cultivation in the West Indies
on his second attempt. Bligh's first attempt to introduce
breadfruit from Tahiti into the New World was aborted
due to the mutiny of the crew he commanded on the
HMS *Bounty*. (TAF)

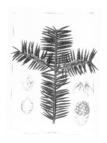

Yew-leaved Torreya
(*Torreya taxifolia*)

Pl. 36. Florida Nutmeg, Florida Torreya
(*Torreya taxifolia* Arn.)

CEPHALOTAXACEAE

Native to the southeastern U.S., Florida nutmeg is an evergreen conifer that can grow up to 40 feet and prefers shady, steep ravines. It is endemic to a very limited region along the eastern banks of the Apalachicola River in the panhandle of Florida and Georgia. Florida nutmeg is susceptible to a fungal disease of the trunk. Its small territory and the disease pressure make it the most endangered species of the genus *Torreya*, whose other species are found in Asia and California. Florida nutmeg is listed as Critically Endangered by the International Union for Conservation of Nature's Red List of Threatened Species and it is also listed as an endangered plant by the U.S. Fish and Wildlife Service. A few hundred specimens exist in the wild. Believed to be one of the oldest tree species, it is also one of the most threatened. Florida nutmeg was already in decline at the time it was described in 1838. (BPS)

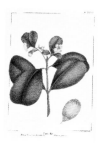

Yellow-flowered Balsam Tree
(*Clusia flava*)

Pl. 37. Monkey Tree
(*Clusia flava* Jacq.)

CLUSIACEAE

A broad-leaved evergreen native to Jamaica and elsewhere in the West Indies, monkey tree has not been documented as a wild plant in Florida since the 1800s. Some contemporary botanists believe that early explorers may have mistaken autograph-tree (*Clusia rosea* Jacq.), a large shrub or small tree native to southern Florida, for yellow-flowered balsam tree. Both species produce resinous sap and have shiny spatula-shaped, evergreen leaves that are broad at the top and narrow at the bottom. Some *Clusia* species are epiphytic and produce strangling roots similar to those of the strangler fig. (TAF)

Button Tree
(*Conocarpus erecta*)

Pl. 38. Buttonwood
(*Conocarpus erectus* L.)

COMBRETACEAE

Buttonwood grows in coastal habitats throughout southern Florida, the West Indies, the Gulf of Mexico, and northern South America. Often found just inland from mangrove swamps, buttonwood thrives in the dry, sandy soils of beaches and dunes. It is evergreen and extremely salt-tolerant. In protected sites, buttonwood will become a multi-stemmed tree with a spreading canopy. In sites battered by strong winds, its canopy will become contorted and picturesque. It has extremely hard, dense wood and is a preferred source of firewood. Buttonwood's common name is derived from its reddish-brown fruit clusters, which resemble old-fashioned leather buttons. (TAF)

White Mangrove
(*Laguncularia racemosa*)

Pl. 39. White Mangrove
(*Laguncularia racemosa* (L.) C. F. Gaertn.)

COMBRETACEAE

Along with red and black mangroves, white mangrove is an important component of mangrove swamps throughout southern Florida, the West Indies, Mexico, Central America, and northern South America. White mangrove is also native to the Atlantic coast of Africa. It is generally a large shrub, but can become a medium-size tree. It is easily distinguished from other mangroves by the prominent glands at the base of the stalks of its evergreen leaves. These glands produce nectar that attracts ants, which protect the plants from predation by other insects. White mangrove leaves are dotted with small pores that excrete salt taken up by the roots, an adaptation that allows the species to survive in brackish and salt water. (TAF)

Indian Almond
(*Terminalia catappa*)

Pl. 40. Indian-almond
(*Terminalia catappa* L.)

<div align="right">COMBRETACEAE</div>

Native to Malaysia, Indonesia, Australia, and the Pacific Islands, Indian-almond has been cultivated in subtropical and tropical regions of the world for centuries and has become naturalized throughout coastal areas of the New World tropics. Unlike many tropical trees, Indian-almond is deciduous, losing its leaves briefly during dry periods. It is long-lived and ultimately becomes a large shade tree with a broad canopy of distinctly tiered branches. Although not related to true almonds (*Prunus dulcis*), Indian-almond produces edible seeds that are an important source of food in Southeast Asia and India. (TAF)

Dogwood
(*Cornus florida*)

Pl. 41. Flowering Dogwood
(*Cornus florida* L.)

<div align="right">CORNACEAE</div>

Flowering dogwood is among the most beautiful and most popular of all eastern North American flowering trees. The tiny, greenish flowers of this species are surrounded by large white, petal-like bracts, which light up eastern woodlands just as the leaves emerge. Small red fruit, much loved by birds, follow the flowers, and the leaves turn shades of red in fall. This tree has dense, fine-grained wood that becomes smoother with use and is shock proof, making it well suited for the production of items such as spindles, knitting needles, and golf clubs. (RG)

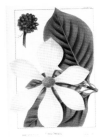

Large-flowered Dogwood
(*Cornus nuttallii*)

Pl. 42. Pacific Dogwood
(*Cornus nuttallii*
Audubon ex Torr. & A. Gray)

<div align="right">CORNACEAE</div>

This dogwood variety is native to the West Coast of North America, from British Columbia to San Francisco. It grows taller and more erect than the eastern flowering dogwood and typically has six large, white bracts instead of four. The wood has a finely grained texture and was used by Native Americans to make fishing harpoons, bows, arrows, tools, combs, and knitting needles. (RG)

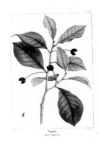

Tupelo
(*Nyssa aquatica*)

Pl. 43. Swamp Blackgum
(*Nyssa sylvatica* Marshall
var. *biflora* (Walter) Sarg.)

<div align="right">CORNACEAE</div>

Michaux identified two species of *Nyssa* native to the northeastern United States: tupelo and blackgum. He described tupelo as smaller in stature than blackgum and observed that it is found growing only in "wet grounds," as opposed to the "high and level grounds" occupied by blackgum. Contemporary botanists recognize two distinct varieties of *N. sylvatica* that roughly align with Michaux's two species. Swamp blackgum has a more southerly distribution and narrower leaves than black tupelo, and its female flowers are typically held in pairs, hence the epithet, *biflora*. (TAF)

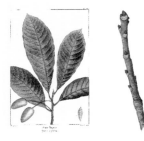
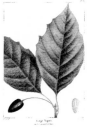

Sour Tupelo
(*Nyssa capitata*)

Pl. 44. Ogeechee Tupelo, Ogeechee-lime,
Sour Tupelo
(*Nyssa ogeche* Bartram ex Marshall)
CORNACEAE

Like water tupelo, Ogeechee tupelo grows in moist, even
flood-prone, soil. It is named for Georgia's Ogeechee
River, where it was first discovered by American botanist
William Bartram (1739–1823). The tree is also known by
the common name Ogeechee-lime because juice from
its fruit is sometimes used as a substitute for that of the
citrus. The fall foliage can be found in a variety of colors
ranging from yellow to red to nearly purple. (JLG)

Large Tupelo
(*Nyssa grandidentata*)

Pl. 45. Water Tupelo
(*Nyssa aquatica* L.)
CORNACEAE

Water tupelo grows in swamps and flood plains from east-
ern Texas and most of Louisiana, up the Mississippi River
to Illinois, across the Gulf Coast and Florida Panhandle,
then up the Atlantic coast to Virginia. The base of the
trunk is often swollen near the ground, which may aid in
its stability in waterlogged soils. Greenish-white spring
flowers may not appear until this tree is several decades
old. They are a favorite source of nectar for bees, and
tupelo honey is a prized delicacy in the South. (RG)

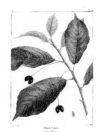

Black Gum
(*Nyssa sylvatica*)

Pl. 46. Black Tupelo, Blackgum, Sourgum
(*Nyssa sylvatica* Marshall)
CORNACEAE

Black tupelo is widely distributed throughout eastern
North America from western Maine to northern Florida.
Also known as blackgum, it thrives in swampy woodlands,
which surely inspired its botanical name *Nyssa* (home of
water nymphs in classical mythology) *sylvatica* (of the
forest). In spring deep-burgundy buds emerge, giving way
to thick, glossy-green leaves that turn rich red in fall. Blue
fruit are visible on female trees after the leaves have fallen.
High in fat, fiber, phosphorus, and calcium, the fruit are
a good source of food for many animals, which also use its
many cavities as dens. (RG)

Cypress
(*Cupressus disticha*)

Pl. 47. Bald-cypress
(*Taxodium distichum* (L.) Rich.)
CUPRESSACEAE

Bald-cypress is a majestic large tree of wetlands, river
basins, swamps, and bayous from southern New Jersey to
Texas. A deciduous conifer with soft, pale-green needles,
the alternately arranged feather-like leaves turn a range
of colors in fall, from rich, brick red to luminous golden
brown. Trees can easily reach 65 to 130 feet tall, especially
when growing in rich, swampy bottomlands. The wood
is soft, light, and durable and was used extensively in the
past for shingles, railroad ties, and construction. The
seeds are a food source for small mammals and birds, and
its top branches provide a nesting site for bald eagles,
ospreys, herons, and egrets. (MH)

White Cedar
(*Cupressus thyoides*)

Pl. 48. Atlantic White Cedar
(*Chamaecyparis thyoides*)
(L.) Britton, Sterns & Poggenb.)

CUPRESSACEAE

Atlantic white cedar is restricted in range to the narrow area of acidic freshwater swamps, bogs, and wet woodland along the Atlantic Coastal Plain from Maine to northern Florida, and the Gulf Coast to Louisiana. It is a medium-size, slow-growing tree with shaggy furrowed brown bark, usually only reaching 20 to 40 feet high. It forms an irregular, narrowly cylindrical, spire-like shape with the slender branches holding flat, finely textured, fan-shaped sprays of dark bluish-green scale-like leaves. The soft, light-brown wood is noted for its extreme resistance to decay and has been used since colonial times for making log cabins, roof shingles, and boats. The species is now rare or threatened throughout much of its range. (MH)

Rocky Mountain Juniper
(*Juniperus andina*)

Pl. 49. Western Juniper
(*Juniperus occidentalis* Hook.)

CUPRESSACEAE

Western juniper is an evergreen conifer found in the western U.S., from Washington to California. It is one of the dominant tree species in the foothills and mountain slopes of the Cascade and Sierra Nevada Ranges. Western juniper can withstand extremely dry situations and is tolerant of both the heat and the cold typical of the inter-mountain climates of the West. Mature specimens can reach 30 feet tall and, with the ability to live several centuries, develop a gnarled and rugged character, making it an iconic image of the Intermountain West. Western juniper provides food and nesting opportunities for birds. It has never been adapted to ornamental use, and therefore, is seen infrequently in cultivated landscapes. (BPS)

Red Cedar
(*Juniperus virginiana*)

Pl. 50. Eastern Red-cedar
(*Juniperus virginiana* L.)

CUPRESSACEAE

Eastern red-cedar is a tough, handsome evergreen tree that thrives where few other trees will grow. Throughout much of eastern and central North America, it can be seen in old fields, roadsides, and woodland edges. Growth habit is narrow and upright but becoming more open and loosely conical with age. Trees can reach 40 to 50 feet tall, usually shorter in most conditions. Eastern red-cedar is dioecious, with male trees producing tiny brown cones that release clouds of yellow pollen in spring, while the female trees bear ornamental clusters of tiny silver-blue, berry-like cones, a favorite food of many birds. The fragrant wood is used to make cedar chests and wooden pencils. (MH)

Gigantic Arbor Vitae
(*Thuja gigantea*)

Pl. 51. Western Red-cedar
(*Thuja plicata* Donn ex D. Don)

CUPRESSACEAE

A coniferous tree native to the Pacific Northwest, western red-cedar is adapted to a wide variety of growing conditions, although it prefers cool, moist environments. It was one of the most commonly used trees for totem poles by indigenous people in North America. Available in a wide variety of cultivars with a range of sizes and colors, western red-cedar is a valuable ornamental garden plant and is grown around the world in parks and gardens. It is the official tree of British Columbia. (BPS)

Arbor vitae or White cedar
(*Thuya occidentalis*)

Pl. 52. American Arborvitae
(*Thuja occidentalis* L.)

CUPRESSACEAE

A tree of the cooler, wetter parts of eastern North America from the Canadian Maritimes down through the higher elevations of the Appalachian Mountains, American arborvitae thrives in limestone soils, fens, and low swampy woods. In the wild American arborvitae is a broadly spreading, medium-size, pyramidal-shaped tree capable of reaching 40 feet in height with age. But the growth is usually dense and compact, with downward-sweeping branches well adapted to shedding a heavy snow load. The fragrant wood is a light yellowish-brown and, like many native cedars, prized for its resistance to rot. It is used for fence posts, shingles, and boat docks. (MH)

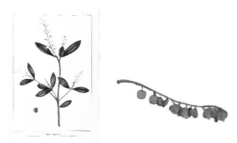

Buckwheat Tree
(*Cliftonia ligustrina*)

Pl. 53. Buckwheat Tree
(*Cliftonia monophylla*
(Lam.) Britton ex Sarg.)

CYRILLACEAE

Buckwheat tree is a small, multi-stemmed evergreen native to the southeastern U.S. Although a wetland species that grows in either sunny or partly shaded streamside locations with acidic soil, it can handle short periods of drought. Three-inch spires of fragrant white or light-pink flowers gracefully tip each branch in spring. Three- to four-winged yellowish fruit that follow are very similar in shape to buckwheat, giving rise to the common name. The flowers are an important food source for bees in its native range. (KS)

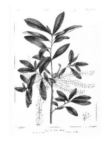

Carolina cyrilla
(*Cyrilla racemiflora*)

Pl. 54. White Titi
(*Cyrilla racemiflora* L.)

CYRILLACEAE

White titi is a spreading, multi-trunked small tree native to acidic swamps from Virginia to Florida that can make large colonies in moist, sunny sites. Its shiny, oval leaves are fully evergreen in the Deep South and deciduous in the northern end of its range, where its deciduous, older leaves show beautiful orange and scarlet fall color. In early summer, whorls of pendent racemes covered in small white flowers have a delightful fragrance. The heartwood, which is lovely rich red, is sometimes used in furniture making. The tree is high in tannins, which has given rise to its other uses. The pliable lower bark has been used as a styptic to stop bleeding. (KS)

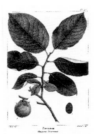

Persimon
(*Diospyros virginiana*)

Pl. 55. Common Persimmon, Possumwood
(*Diospyros virginiana* L.)

EBENACEAE

One of the most striking features of common persimmon is its bark, which is divided into raised square plates and is often compared to alligator hide. This deciduous tree is native to the eastern U.S. where it grows in fertile soils at low elevations. Common persimmon varies in size in different soils and climates, and sometimes can reach up to 75 feet in height and 18 or 20 inches in diameter. The fruit are green at first and ripen to a striking orange, but are not edible until after the first frost of autumn. They remain on the tree well into winter, creating the appearance of tiny holiday ornaments. (CM)

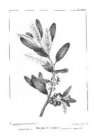

Rabbit Berry
(*Shepherdia argentea*)

Pl. 56. Silver Buffaloberry
(*Shepherdia argentea* (Pursh) Nutt.)
ELAEAGNACEAE

This thorny shrub is native to the Prairie Provinces in Canada and the northern Great Plains of the U.S., with small populations extending west to Southern California. It has many adaptations that allow it to thrive in difficult sites. Its long thorns protect it from grazing. Its silver foliage reduces water loss by reflecting intense summer sun. Its roots harbor nitrogen-fixing bacteria, which improve soil fertility. The fruit of silver buffaloberry are edible, albeit astringent, and extremely high in vitamin C. Native Americans used the fruit to treat a variety of ailments and as a flavoring for meats. (TAF)

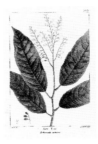

Sorel Tree
(*Andromeda arborea*)

Pl. 57. Sourwood, Sorreltree
(*Oxydendrum arboreum* (L.) DC.)
ERICACEAE

Sourwood grows from southwestern Pennsylvania along the Appalachian Mountains to Louisiana. The leaves are downy in spring, but become smooth and glabrous as they grow. The small white, bell-shaped flowers, which appear in late summer, are produced on slender racemes, clustered at the ends of the branches. It is named for the sour taste of the leaves. (CM)

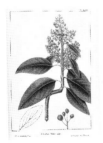

Menzies's Strawberry Tree
(*Arbutus menziesii*)

Pl. 58. Menzies's Strawberry Tree, Madroño,
(*Arbutus menziesii* Pursh)
ERICACEAE

Menzies's strawberry tree can be found along the coast of western North American from British Columbia to California. This tree is distinctive for the beauty of its orange-red bark, which peels and curls as it ages, contrasting with the green inner bark. Dependent on occasional fires to reduce competition and seed germination, it is declining throughout its natural range. (CM)

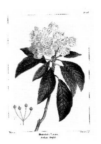

Mountain Laurel
(*Kalmia latifolia*)

Pl. 59. Mountain-laurel
(*Kalmia latifolia* L.)
ERICACEAE

Native across eastern North America from southern Canada to northern Florida and west to the Mississippi River, mountain-laurel is an evergreen shrub that thrives in cool, moist environments and acid soils. It is especially abundant in the Appalachian Mountains, where it often forms impenetrable thickets (known as "laurel hells") on mountain tops, in canopy gaps, and in forest understories. Mountain-laurel exhibits an unusual mechanism to ensure pollination of its abundant pinkish-white flowers, which open in late spring. The stamens arch backward from the center to the edge of the flower, where the anthers are wedged into small depressions. When an insect alights on the flower, the stamens spring forward and forcibly deposit pollen on its back. Mountain-laurel was named the state flower of Connecticut in 1907 and Pennsylvania in 1933. (TAF)

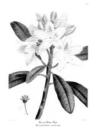

Dwarf Rose Bay
(*Rhododendron maximum*)

Pl. 60. Great Laurel, Great Rhododendron,
 Rosebay Rhododendron
 (*Rhododendron maximum* L.)

ERICACEAE

Great laurel is an evergreen shrub native to the
Appalachian Mountains from Nova Scotia to Alabama.
When the plant matures, its gnarled branches, covered
in deep-green leathery leaves, form a natural screen. Its
white or pink flowers attract bees, butterflies, and hum-
mingbirds. The evergreen leaves survive the winter by
curling inward when the temperature dips below freezing.
Also known as rosebay rhododendron, this tree grows in
woods, along streams, and on rocky slopes. (JLG)

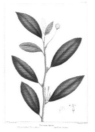

Shining-leaved Poison Wood
(*Excaecaria lucida*)

Pl. 61. Oysterwood
 (*Gymnanthes lucida* Sw.)

EUPHORBIACEAE

Oysterwood is a common tree of southern Florida, the
West Indies, Mexico, and Central America. Typically
growing to a 25-foot upright tree, it produces a "hard,
durable, and handsome wood" as described by Michaux.
The wood resembles an oyster shell when buffed, hence
the common name. The Greek word *Gymnanthes* (naked
flower) describes the inconspicuous yet interesting male
and female flowers on the same plant. The upper axis
contains numerous three-branched staminate flowers,
and the lower axils contain two or three long-stalked pistil-
late flowers. The shiny dark-green leaves are often spotted
with gray lichens. (JAS)

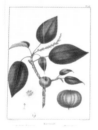

Manchineel
(*Hippomane mancinella*)

Pl. 62. Manchineel
 (*Hippomane mancinella* L.)

EUPHORBIACEAE

This poisonous tree, native to southern Florida, many
Caribbean Islands, Mexico, and Central America, grows
along the seashore and in brackish swamps. *Hippomane*
is derived from two Greek words, *hippo* (horse) and mane,
which is derived from *mania* (madness). Euphorbias
tend to be poisonous due to the presence of alkaloids,
cyanogenic glycosides, and tannins commonly present
in the plants' tissues and observed with the naked eye as
milky sap. Manchineel is from the Spanish word *manza-
nilla* (small apple), describing the bright-green fruit that
resemble crabapples turning yellow when ripe. (JAS)

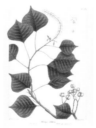

Tallow Tree
(*Stillingia sebifera*)

Pl. 63. Chinese Tallowtree
 (*Triadica sebifera* (L.) Small)

EUPHORBIACEAE

Native to eastern Asia, Chinese tallowtree is thought to
have been introduced into the U.S. by Benjamin Franklin
(1706–90) and is now considered an invasive species. It is
a medium-size tree that grows to 30 feet tall. The incon-
spicuous flowers give rise to a three-lobed brown capsule.
When mature the capsules split open to reveal three white
waxy seeds that resemble popcorn. Extremely prolific, a
mature tree can produce up to 100,000 seeds annually
that are dispersed mainly by birds and water. (JAS)

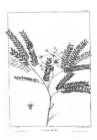

Broad-podded Acacia
(*Acacia latisiliqua*)

Pl. 64. False-tamarind
　　(*Lysiloma latisiliquum* (L.) Benth.)

FABACEAE

The feathery bi-pinnately compound leaves, spiky white flower clusters, and broad, flat seed pods of this leguminous tree native to subtropical and tropical regions of the Americas resemble those of acacias, to which it is closely related. False-tamarind is a popular choice for street tree plantings in southern Florida due to its broad-spreading canopy, showy white flowers, and durability. Its dense and decay-resistant wood is prized for outdoor furniture and flooring. (TAF)

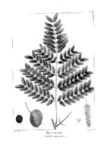

Water Locust
(*Gleditsia monosperma*)

Pl. 65. Water Locust
　　(*Gleditsia aquatica* Marshall)

FABACEAE

Like honey locust, water locust has thorns, though for this species these tend to be smaller in size and less abundant. Instead of long pods containing multiple seeds, the fruit contain a single seed. The natural range of water locust is more southerly than that of honey locust, and this tree prefers swampy surroundings, which makes it well suited as a planting to stabilize the banks of bodies of water. (JLG)

Sweet Locust
(*Gleditsia triacanthos*)

Pl. 66. Honey Locust
　　(*Gleditsia triacanthos* L.)　　**FABACEAE**

Honey locust is named for the sweet, gummy substance found in the brown seed pods that exceed 12 inches in length when they develop each summer. Michaux wrote that inhabitants of the western states used this substance to make beer, though he noted that other fruit, including apples, were replacing it. It is likely that the tree's long sharp thorns were a deterrent to its use. The specific epithet is derived from the Greek words *tri* (three) and *acanthi* (thorn), a reference to the triple-branched thorns. Today it is more likely that a thornless variety will be selected for use in the landscape. Honey locust is a woody legume, a tree-size relative of peas and beans. (JLG)

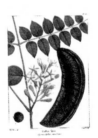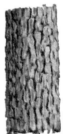

Coffee Tree
(*Gymnocladus canadensis*)

Pl. 67. Kentucky Coffee Tree
　　(*Gymnocladus dioicus* (L.) K. Koch)

FABACEAE

Kentucky coffee tree is a tall deciduous tree between 60 and 80 feet tall with scaly bark and large leaves. It grows in lowland areas, often near bodies of water. It is among the last trees to develop leaves in spring and loses leaves early each fall. Its genus name, from the Greek words *gymnos* (naked) and *cladus* (branch), is probably a reference to the long period each year during which this tree lacks foliage. It is likely that the seeds, which form in 10-inch-long reddish-brown pods in fall, were first roasted to make coffee by early settlers in Kentucky and Tennessee. (JLG)

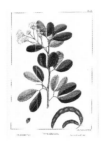

Guadaloupe Inga
(*Inga guadalupensis*)

Pl. 68. Florida Keys Blackbead
 (*Pithecellobium keyense* Britton)

FABACEAE

In his description, which he based on "numerous speci-
mens...from Florida," Nuttall acknowledged controversy
over the proper name for this plant, which Swiss botanist
Augustin de Candolle (1778–1841) believed might be a
thornless variety of cat's claw (*Pithecellobium unguis-
cati*). Nuttall's description and illustration strongly
resemble Florida Keys blackbead, a shrub or small tree
native to the Bahamas, southern Florida, Cuba, and the
Yucatan Peninsula. Florida Keys blackbead is similar to
cat's claw in many respects, but is a shrub rather than
a tree, lacks the prominent stipular spines, and has red
rather than white arils. (TAF)

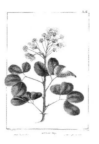

Blunt-leaved Inga
(*Inga unguis-cati*)

Pl. 69. Cat's Claw
 (*Pithecellobium unguis-cati* (L.) Benth.)

FABACEAE

Cat's claw is a small tree found primarily in coastal forests
from southern Florida through the West Indies into
northern South America. Its specific epithet and common
name refer to the small stipular spines found at the base
of its bi-pinnately compound leaves. These spines make
cat's claw a popular choice for living fences. It produces
spherical clusters of small greenish-yellow flowers and
twisted seed pods with five or six shiny black seeds, each
partially covered by a fleshy white aril. Nuttall noted that
a decoction of the bark is used to treat liver and kidney
ailments. (TAF)

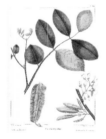

Jamaica Dogwood
(*Piscidia erythrina*)

Pl. 70. Jamaica-dogwood
 (*Piscidia piscipula* (L.) Sarg.)

FABACEAE

Jamaica-dogwood is a large tree native to southern
Florida, the West Indies, Central America, and northern
South America. Although its clusters of white flowers
resemble those of black locust (*Robinia pseudoacacia*) and
other tree legumes, it is easily identified by its fruit, which
are small four-winged pods. Jamaica-dogwood produces
some very potent chemical compounds. Extracts of the
bark, leaves, and young branches are used to poison fish, a
method of fishing practiced in many regions of the world.
The bark of the roots is used to treat pain and to induce
sleep. (TAF)

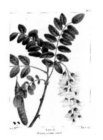

Locust
(*Robinia pseudo-acacia*)

Pl. 71. Black Locust
 (*Robinia pseudoacacia* L.)

FABACEAE

Locusts were among the first trees from North America
to be cultivated in Europe. The genus *Robinia*, named for
17th-century French botanist Jean Robin (1550–1629), is
especially prized for its white, drooping, fragrant spring
flowers. It can grow as a single-trunk columnar tree or as
a dense grove, and often its branches have spines greater
than one inch in length. The leaves appear to fold as dusk
falls, drooping on their stems during the night. (JLG)

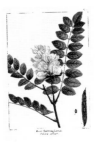

Rose-flowering Locust
(*Robinia viscosa*)

Pl. 72. Clammy Locust
(*Robinia viscosa* Vent.)

FABACEAE

Clammy locust may be most notable for its showy light-pink flowers that can appear more than once in a growing season. Michaux wrote that this tree "forms one of the most brilliant ornaments of the park and the garden." It was found by André Michaux (1746–1802) as well as by William Bartram (1739–1823), who wrote admiringly of the small-stature tree in his *Travels . . .* in 1791, " . . . there appears a singular pleasing wildness and freedom in its manner of growth." Its common name derives from the sticky secretions of the hairs on the twigs, leafstalks, and pods. Other than the twisted, spreading roots, which make it a useful tree to stabilize hillsides, the tree is mostly valued for its ornamental effect in the wild. (JLG)

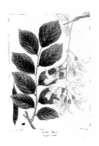

Yellow Wood
(*Virgilia lutea*)

Pl. 73. Yellowwood, American Yellowwood
(*Cladrastis kentukea* (Dum. Cours.) Rudd)

FABACEAE

Yellowwood was first described by Michaux, who noted that the center of the tree's trunk is a bright-yellow color, which was used as a dye by residents of the Appalachian Mountains, where the tree can be found growing naturally. He wrote that he discovered this when he felled several trees in order to harvest their seed pods so that he could send the seeds to Versailles, from where Marie-Antoinette (1755–93), then Queen of France, likely sent them to her father, Emperor of Austria. This tree is the only American species of a genus that is more commonly found in Asia. (JLG)

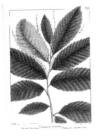

Dwarf Chestnut
(*Castanea alnifolia*)

Pl. 74. Chinquapin, Allegheny Chinquapin, Dwarf Chestnut
(*Castanea pumila* (L.) Mill.)

FAGACEAE

Chinquapin is a small, shrubby tree usually six to ten feet in height found in the sandy Pine Barrens and dry, rocky woodland from New Jersey south to central Florida, and west to eastern Texas. Nuttall first saw this plant near Charleston, South Carolina, and noted its small height, rarely more than two feet, and glossy leaves with fine hairy undersides. He thought it different enough to merit its own species, which he called *Castanea alnifolia*. (MH)

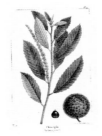

Chincapin
(*Castanea pumila*)

Pl. 75. Chinquapin, Allegheny Chinquapin, Dwarf Chestnut
(*Castanea pumila* (L.) Mill.)

FAGACEAE

Closely related to American chestnut, chinquapin can be distinguished by its diminutive stature, smaller leaves with fewer and less prominent teeth, and the smaller nuts. Like American chestnut, chinquapin is susceptible to chestnut blight. (RG)

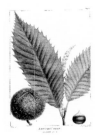

American Chestnut
(*Castanea vesca*)

Pl. 76. American Chestnut
 (*Castanea dentata* (Marshall) Borkh.)

FAGACEAE

American chestnut, identified by its glabrous leaves with large, widely spaced teeth on the edges, once numbered in the billions throughout its extensive range. But chestnut blight, *Cryphonectria parasitica*, a fungus from Asia discovered in 1904, spread quickly throughout the region and decimated the species. The American Chestnut Foundation estimates that four billion trees from Maine to Mississippi were ultimately destroyed by the fungus. As a foundational (or keystone) species, American chestnut's demise sent shock waves throughout the Appalachian region, affecting all forms of life, including the human inhabitants, who depended on the nuts, wood, and game. (RG)

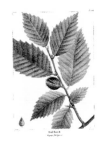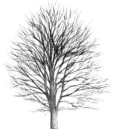

Red Beech
(*Fagus ferruginea*)

Pl. 77. American Beech
 (*Fagus grandifolia* Ehrh.)

FAGACEAE

American beech (sometimes also called red beech) is a large noble tree with a wide, drooping canopy. Glossy dark-green serrated foliage turns bronze in fall and will often remain on branches through winter. Small green flowers bloom mid-spring and develop into three-winged edible nuts that persist into winter and attract a variety of birds and woodland animals. Beechnuts are also edible to humans. One of the most identifiable features of American beech is its perfectly smooth, pale-gray bark. Unfortunately, trees in public spaces are often vandalized be people unable to resist carving their names into the bark. In the words of Roman poet Virgil (70–19 BC), translated from Latin by English poet John Dryden (1631–1700), "Or shall I rather the sad verse repeat, Which on the beech's bark, I lately writ?" (KLP)

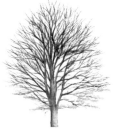

White Beech
(*Fagus sylvestris*)

Pl. 78. American Beech
 (*Fagus grandifolia* Ehrh.)

FAGACEAE

Michaux recognized two species of beech (red and white) native to eastern North America, which he distinguished by their geographic distribution, the color of their wood, and a few morphological characters. Contemporary botanists have combined these two species into one, American beech, which is an important forest tree across eastern North America from southern Ontario to northwestern Florida and west to the Mississippi River, with disjunct populations occurring in eastern Texas and northeastern Mexico. Extremely shade tolerant and long-lived, American beech is a keystone species in northern forests. Unlike European beech, which forms a single elephantine trunk, American beech produces root suckers that form groves of genetically identical trees. (TAF)

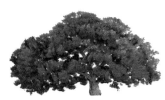

Holly-leaved Oak
(*Quercus agrifolia*)

Pl. 79. California Live Oak, Coast Live Oak
 (*Quercus agrifolia* Née)

FAGACEAE

California live oak grows only in coastal California, from Monterey and Santa Cruz in the north to the Baja California Peninsula in the south. Its leaves resemble holly: thick, leathery, and evergreen with spiny serrated edges. Although it can grow as a low shrub, California live oak is usually 40 to 50 feet tall and can reach heights of 100 feet. Deer and birds graze on its acorns. This is one of only a few oaks adapted to thrive in the coastal environment, tolerating wet winters, dry summers, and salty air. Because it forms hybrids with a number of other oak species, it can be tricky to identify. (VBL)

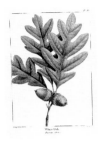

White Oak
(*Quercus alba*)

Pl. 80. White Oak
(*Quercus alba* L.)

FAGACEAE

Considered the stateliest of North American oak species, white oak grows slowly with a wide-spreading canopy that can reach more than 100 feet tall. It thrives in well-drained to dry soils from Maine to Florida and west to Minnesota and Texas. White oak's common name derives from its light-gray to nearly white bark. The thick deciduous leaves of this long-lived species turn wine-red in autumn. Historically, white oak produced the most highly prized oak lumber. Its strong and durable wood was important for shipbuilding and used to make furniture, flooring, tools, baskets, barrels, and carriages. (DFC)

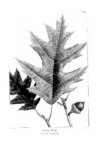

Gray Oak
(*Quercus ambigua*)

Pl. 81. Northern Red Oak
(*Quercus rubra* L.)

FAGACEAE

Northern red oak has a large native range that spans from Nova Scotia to Georgia, west to Minnesota and Oklahoma. It is found most commonly in well-drained upland areas. It transplants more readily than many other oaks and is frequently planted as an ornamental shade tree. Mature bark has wide, flat silvery-gray ridges separated by shallow fissures. An important timber species, red oak has been used for furniture, flooring, veneer, posts, crates, and a multitude of other products. (DFC)

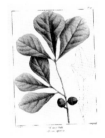

Water Oak
(*Quercus aquatica*)

Pl. 82. Water Oak
(*Quercus nigra* L.)

FAGACEAE

Water oak may be a misleading common name for this medium- to large-size oak species that grows in wet, poorly drained soils, but also thrives in drier, well-drained areas. Broadly adaptable, this oak has been commonly planted as a shade or street tree in Gulf Coast states. Its native range spreads from the southern tip of New Jersey to Florida, west to Missouri and Texas. *Quercus nigra* is fast grow-ing, weak-wooded, and not particularly long-lived when compared to other oaks. Semi-evergreen leaves are small and spatula-shaped, occasionally displaying three lobes and bristle tips. Dark brown to nearly black, half-inch-long acorns are borne abundantly on slender twigs. (DFC)

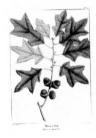 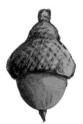

Bear's Oak
(*Quercus banisteri*)

Pl. 83. Bear Oak
(*Quercus ilicifolia* Wangenh.)

FAGACEAE

Bear oak is a thicket-forming shrub or small tree. This hardy species, which grows from Maine to North Carolina and west to Ontario, is among the first to colonize dry sites that have been cut or burned, making it a valuable early successional tree that stabilizes and shades bare soils. Glossy dark-green leaves are pale gray-green with tomentose hairs below and relatively small with three to seven acutely angled, bristle-tipped lobes separated by shallow sinuses. Oaks have separate male and female flowers on the same plant; the inconspicuous female flowers are represented here. Bear oak's small acorns are borne mostly in pairs and have downy cups that cover brown and black striped nuts. (DFC)

Barrens Scrub Oak
(*Quercus catesbaei*)

Pl. 84. American Turkey Oak
 (*Quercus laevis* Walter)

FAGACEAE

The common name differentiates this tree from the European species *Quercus cerris*, Turkey oak. This southeastern coastal plain species grows from Virginia to Florida, west to the edge of Louisiana. American turkey oak is a small- to medium-size, occasionally shrubby tree found most abundantly on high sandy bluffs near the Atlantic shore. Lustrous yellow-green leaves have a broad mid-vein and turn scarlet red in autumn. Typical leaves have a distinctly acute taper at the base, deep sinuses and three to seven wide-spreading lobes, each irregularly toothed and bristle-tipped. Short-stalked acorns are one inch long and rounded. (DFC)

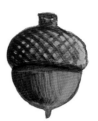

Upland Willow Oak
(*Quercus cinerea*)

Pl. 85. Bluejack Oak
 (*Quercus incana* W. Bartram)

FAGACEAE

Bluejack oak is a small, thicket-forming tree native to the Atlantic and Gulf Coastal Plains from southern Virginia to Florida, west to Arkansas and Texas. It is well adapted to fire in the sandy barrens, dunes, and upland ridges in which it grows. The name bluejack references its leaf shape's similarity to blackjack oak, *Quercus marilandica*, and to the blue-green color of its semi-evergreen leaves, which are mostly glossy above and densely tomentose below. Typical mature bluejack oak leaves are lobeless, narrow, and broadest toward the center with a prominent mid-vein. Juvenile leaves often display three shallow bristle-tipped lobes. (DFC)

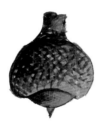

Scarlet Oak
(*Quercus coccinea*)

Pl. 86. Scarlet Oak
 (*Quercus coccinea* Münchh.)

FAGACEAE

Scarlet oak, though relatively adaptable, prefers the well-drained and occasionally dry soils where it grows from Maine to Georgia, west to Wisconsin and Alabama. In summer the leaves are glossy light green with five to nine lobes, bristle tips, and sinuses that seem to form a "C" shape. As the common name suggests, this oak's deciduous leaves turn a bright scarlet in autumn. For this reason, it is frequently planted as a large ornamental shade tree. The acorns are borne singularly or in pairs with large cups that cover roughly half the nut. (DFC)

Dense-flowered Oak
(*Quercus densiflora*)

Pl. 87. Tan Oak, Tanbark-oak
 (*Notholithocarpus densiflorus*
 (Hook. & Arn.) P. S. Manos,
 C. H. Cannon, & S. H. Oh)

FAGACEAE

First named *Quercus densiflora* by botanists William Jackson Hooker (1785–1865) and George A. Walker-Arnott (1799–1868) in 1840, this tree has been placed in a variety of genera and subgenera since. In 2008 botanists placed this plant in a new genus, *Notholithocarpus*. Tan oak grows as a shrub or medium-size tree, up to 80 feet tall, in a narrow range from southwestern Oregon through the Coast Ranges of California with scattered populations in the Sierra Nevada Range. The cups of its large acorns—up to four inches long—are first covered with thick brownish hairs but become smooth. (VBL)

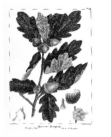
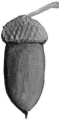

Douglas's Oak
(*Quercus douglasii*)

Pl. 88. Blue Oak
 (*Quercus douglasii* Hook. & Arn.)

FAGACEAE

Blue oak is very common within its small range in the Central Valley, Coast Ranges, and Sierra Nevada foothills of California. Nuttall had seen only a dried specimen when he described it. The medium-size blue oak may retain its bluish leaves year-round or may shed them after drought. It may have one trunk or several, short and straight from 20 to 65 feet tall. These trees grow solitary in the California savannah among chaparral shrubs, or in the understory of larger woodlands. (VBL)

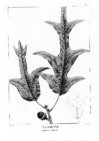

Spanish Oak
(*Quercus falcata*)

Pl. 89. Southern Red Oak
 (*Quercus falcata* Michx.)

FAGACEAE

A large tree, southern red oak grows tall in infertile soils. This drought- and heat-tolerant oak can be found along dry uplands and sandy lowlands from the southern edges of New York down to Florida, west to Missouri and Texas. This tree was formerly called Spanish oak, likely because its native range included early Spanish colonies. Leaves are variable in shape with three to seven bristle-tipped lobes that are notably slender and slightly curved. The center lobe is often elongated and the base is broad and rounded. Acorns are plentiful, globular, and small, about one-half inch long, with a saucer-shaped cup covering one-third to half the nut. (DFC)

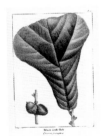
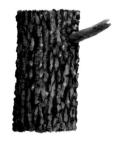

Black Jack Oak
(*Quercus ferruginea*)

Pl. 90. Blackjack Oak
 (*Quercus marilandica* Münchh.)

FAGACEAE

Blackjack oak is a small- to medium-size tree with contorted branches that forms an irregular silhouette. It grows from New York to Florida, west to Iowa and Texas. This oak's thick and lustrous leaves are extremely broad at the top and generally have three bristle-tipped shallow lobes or, occasionally, five. This wedge shape may be the reason for its sinister-sounding common name, resembling the form of a club-shaped weapon called a blackjack. Along with distinctive leaves, blackjack oak has distinctive bark, dark and blocky, resembling alligator hide. Acorns are rounded, small, and borne solitary or in pairs on short stalks. (DFC)

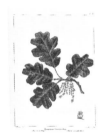

Western Oak
(*Quercus garryana*)

Pl. 91. Oregon White Oak, Garry's Oak
 (*Quercus garryana* Douglas ex Hook.)

FAGACEAE

Nuttall was surprised by the scarcity of oak trees west of the Mississippi, finding instead forests of pine and fir in the mountains. However, in Oregon he did encounter this deciduous oak, which is native to the Pacific region from British Columbia to Southern California. When solitary, *Quercus garryana* can reach majestic heights of 100 feet or more, with a broad, rounded crown, but when crowded, these oaks grow only 20 to 50 feet high with narrow habits. Its large, shiny dark-green leaves typically have five to nine rounded lobes and resemble the leaves of post oak (*Q. stellata*). Its whitish, scaled bark resembles that of white oak (*Q. alba*). (VBL)

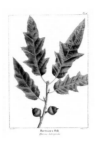

Bartram's Oak
(*Quercus heterophilla*)

Pl. 92. Bartram's Hybrid Oak
 (*Quercus × heterophylla* F. Michx.)

FAGACEAE

This large oak was originally considered its own species when first discovered growing in a field owned by botanist John Bartram (1699–1777) along the Schuylkill River near Philadelphia. Bartram was a prominent figure in the American botanical world— Swedish botanist Carl Linnaeus (1707–78) famously called him "the greatest natural botanist in the world." Eventually similar trees were found growing where the native ranges of the *Quercus rubra* and *Q. phellos* overlapped, and *Q. × heterophylla* was determined to be a naturally occurring hybrid between these two species. The leaves are narrow but variable, even within an individual tree. With leaves that may have one to four bristle-tipped lobes per side or none at all, Bartram's hybrid oaks are fast growing and display red to bronze autumn foliage. (DFC)

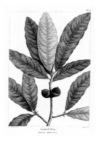
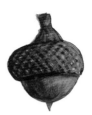

Laurel Oak
(*Quercus imbricaria*)

Pl. 93. Shingle Oak
 (*Quercus imbricaria* Michx.)

FAGACEAE

Shingle oak is found primarily inland on lowland slopes and river floodplains from Massachusetts to Georgia, west to Iowa and Oklahoma. An adaptable medium- to large-size tree, shingle oak will grow in acid to somewhat alkaline soils and in moist to dry conditions. The unlobed leaves are widest at the center and bristle-tipped at the apex. Smooth green above and covered with tiny hairs below, they may turn yellowish to russet-red in autumn with a strong propensity to retain browned winter leaves. Their acorns have downy-scaled cups and reddish-brown nuts. Shingle oak is so named for the historical use of its wood in making split shingles or shakes. (DFC)

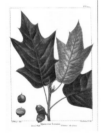

Lea's Oak
(*Quercus leana*)

Pl. 94. Lea Oak
 (*Quercus × leana* Nutt.)

FAGACEAE

Lea oak is a naturally occurring hybrid of shingle oak (*Quercus imbricaria*) and black oak (*Q. velutina*) found where its parent species coincide, from Missouri and Pennsylvania to North Carolina and Arkansas. Its pale-green, deeply lobed leaves with rust-colored ribs resemble those of shingle oak, and its rounded acorns those of the black oak. It is named in honor of its discoverer, American botanist Thomas G. Lea (1785–1844), with whom Nuttall corresponded. (VBL)

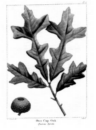

Over Cup Oak
(*Quercus lyrata*)

Pl. 95. Overcup Oak, Swamp Post Oak
 (*Quercus lyrata* Walter)

FAGACEAE

Overcup oak's common name describes this large deciduous tree's key feature, large acorns with nuts almost entirely enclosed by rough, scaly cups. The alternate common name, swamp post oak, indicates its ability to thrive in moist lowland soils and its cross-like leaf shape similarities with *Quercus stellata*. Primarily a southern oak, *Q. lyrata* grows from New Jersey to Florida, west to Illinois and Texas and is commonly found in river bottoms, where it can easily withstand short periods of flooding. Adaptable to a range of soils and fast growing with a uniform canopy, overcup oak is regularly planted as a shade tree. Michaux noted that he had found specimens along the Savannah River that were up to 12 feet in circumference and more than 80 feet tall. (DFC)

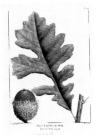

Over Cup White Oak
(*Quercus macrocarpa*)

Pl. 96. Bur Oak
 (*Quercus macrocarpa* Michx.)

FAGACEAE

Bur oak grows across a broad geographical range, from New Brunswick to Virginia, west to Saskatchewan and Texas, in a broad range of soils from droughty prairies to seasonally wet lowlands. Typically a large tree, bur oak takes on a shrubby form only in the most northwestern range. Its fringe-cupped acorns vary in size and shape and grow larger farther south. Bur oak leaves, though variable, have a characteristic fiddle shape pinched at the center by extremely deep sinuses. Its stout twigs often display corky ridges, or wings, and its thick bark is quite fire resistant. Bur oak produces some of the most durable and highly desirable oak lumber. Similar to *Quercus alba*, the wood has been used for shipbuilding, flooring, and furniture. (DFC)

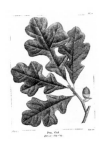

Post Oak
(*Quercus obtusiloba*)

Pl. 97. Post Oak, Turkey Oak
 (*Quercus stellata* Wangenh.)

FAGACEAE

The thick, leathery dark-green five- to seven-lobed leaves of post oak are distinctly shaped with large upper lobes and a strong symmetry down the mid-vein. Post oak grows in dry, gravelly, or sandy soils across a broad, mostly southern, range from Massachusetts to Florida, west to Iowa and Texas. Considered a smaller-stature oak, this species rarely reaches 50 feet high and frequently grows as shrub in both its coastal and southern limits. The heavy and durable wood from this oak was commonly used for fence posts, as the name suggests, as well as for railroad ties, construction, and fuel. Michaux noted that post oak's acorns attract squirrels and birds including turkeys, earning it another common name of turkey oak. (DFC)

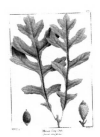

Mossy Cup Oak
(*Quercus olivaeformis*)

Pl. 98. Bur Oak
 (*Quercus macrocarpa* Michx.)

FAGACEAE

The deciduous leaves of bur oak are quite variable in shape, due, in part, to frequent hybridization with *Quercus bicolor*. They have five to nine lobes with wider upper lobes that are toothed along the margins and deep sinuses that nearly reach the mid-vein dividing the leaves at the center. Occasionally bur oak leaves display multiple deep sinuses along the mid-vein. The leaf undersides are whitish and felt-like to the touch, as are the scales on the acorn cups that enclose half to nearly the entire nut. The former common name, mossy oak, refers to the moss-like fringe that surrounds the edge of the acorn cup. This common name was reportedly coined by Michaux, who noted that he had only ever seen this tree growing along the Hudson River north of Albany, New York. (DFC)

Pin Oak
(*Quercus palustris*)

Pl. 99. Pin Oak, Swamp Oak
 (*Quercus palustris* Münchh.)

FAGACEAE

Pin oak's specific epithet, *palustris* (of the swamps), is likely in reference to its preferred habitat in poorly drained soils in lowland areas from Massachusetts to North Carolina, west to Iowa and Oklahoma. Because it can thrive in drier conditions, it is also frequently planted as a shade tree. This tall, straight-trunked oak has thin gray bark, descending lower branches, and a dense canopy. The common name relates to its heavy branching pattern, which gives it the appearance of being stuck all over with pins. Its lumber shows many pins or knots from the branches. Shiny bristle-tipped leaves have five to seven lobes with "U" shaped sinuses and often turn bold red in autumn. Pin oak acorns have thin, flat cups covering only one-quarter of the nut. (DFC)

Willow Oak
(*Quercus phellos*)

Pl. 100. Willow Oak
 (*Quercus phellos* L.)

FAGACEAE

Willow oak is named for its long, narrow willow-like leaves that are frequently clustered toward the ends of the branches. *Quercus phellos* grows as a large tree from southern New York to Florida, west to Oklahoma and Texas. Heat and drought tolerant once established, this large oak is a popular street or park tree in the Southeast. Its smooth green summer leaves turn shades of yellow and occasionally orange in autumn. Willow oak acorns are small with shallow saucer-shaped cups covering one-quarter to one-third of the nut, which often appears striped brown and black. (DFC)

Yellow Oak
(*Quercus prinus acuminata*)

Pl. 101. Chinkapin Oak
 (*Quercus muehlenbergii* Engelm.)

FAGACEAE

Chinkapin oak grows mainly inland on well-drained, often limestone soils in dry uplands and rich bottomlands from Vermont to Florida, west to Minnesota and New Mexico, and southward into Mexico. This round-headed, medium-size deciduous oak has glossy, coarsely toothed leaves with 9 to 16 teeth per margin. The leaves resemble those of chestnuts (*Castanea* spp.), as the common name, chinkapin oak, suggests. Chinkapin (or Chinquapin) is a name of Algonquin origin synonymous with chestnut trees and their fruit. Sometimes called yellow chestnut oak, chinkapin oak displays yellow to orange autumn foliage and acorns with light-brown nuts covered one-quarter to one-half by their cup. (DFC)

Small Chestnut Oak
(*Quercus prinus chincapin*)

Pl. 102. Dwarf Chinkapin Oak
 (*Quercus prinoides* Willd.)

FAGACEAE

Dwarf chinkapin oak forms thickets on rocky hillsides in dry shale or sandy soils from Ontario to South Carolina, west to Iowa and Oklahoma. This shrubby species has deep-green leaves with pale undersides that turn russet red in autumn. The small leaves have undulating margins of five to nine teeth, or shallow lobes, per side. Names for this oak are attributed to leaf similarities to chestnut oak, *Quercus montana*, and chinkapin oak, *Q. muehlenbergii*. Abundant acorns display cups that cover nearly half the nut and appear lighter due to a gray pubescence. This precocious oak can flower and bear fruit three to five years after planting. (DFC)

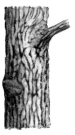

Swamp White Oak
(*Quercus prinus discolor*)

Pl. 103. Swamp White Oak, Swamp Oak
 (*Quercus bicolor* Willd.)

FAGACEAE

Aptly named, swamp white oak thrives in poorly drained soils, growing tall along stream borders and lake margins from Maine and Quebec to South Carolina, west to Minnesota and Missouri. Frequently planted as a park or street tree, *Quercus bicolor* is a large wide-spreading tree adaptable to range of soil conditions. The thick, dark-green lustrous leaves have velvety silver-green undersides that earn the tree the species name bicolor. Leaves are generally broader toward the top, though variable in shape due to common hybridization with *Q. macrocarpa*, where native populations overlap. Swamp white oak bark is reddish-brown and exfoliating in youth, developing deep fissures and flat gray ridges over time. (DFC)

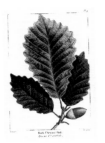

Rock Chestnut Oak
(*Quercus prinus monticola*)

Pl. 104. Chestnut Oak, Mountain Chestnut Oak,
Rock Oak
(*Quercus montana* Willd.)

FAGACEAE

Predominantly an inland species found in the
Appalachian Mountains, chestnut oak grows on dry
hillsides and rocky woodlands. Its native range extends
from Maine and Ontario to South Carolina, west to
Illinois to Mississippi. The thick bark of this oak is deeply
ridged and furrowed, appearing almost corky. Very high
in tannin content, the bark was historically used for
tanning leather. Chestnut oak wood is considered strong
and durable, often used for fencing, railway ties, and fuel.
(DFC)

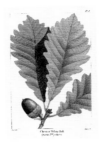

Chestnut White Oak
(*Quercus prinus palustris*)

Pl. 105. Chestnut Oak, Mountain Chestnut Oak,
Rock Oak
(*Quercus montana* Willd.)

FAGACEAE

This tall upland-slope and ridge-top forest species has
olive-green summer foliage that turns warm yellows in
autumn. Chestnut oak's leaves have a narrow base and
rounded teeth, with ten to sixteen along each side, and are
generally glabrous above and sometimes finely pubescent
below. The large acorns, which often grow at the end of
stalks, are lustrous reddish-brown and vary in shape.
These sweet acorns, like those of other oaks, provide food
to a wide array of wild birds and woodland animals, includ-
ing bears, deer, and squirrels. (DFC)

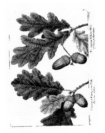
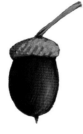

European White Oak
(*Quercus pedunculata*)

Pl. 106. English Oak, Common Oak
(*Quercus robur* L.)

FAGACEAE

The three- to seven-lobed leaves of *Quecus robur* often
display a blue-green hue and are similar in shape to the
North American species *Q. alba*, with rounded lobes and
smooth margins. English oak's distinguishing features
include heart-shaped (cordate) to earlobe-like (auriculate)
leaf bases and long stalk (peduncle) on which its elon-
gated acorns are frequently borne, either individually or
in multiples. This species is noted for its grand canopy
of wide-spreading limbs growing atop a study trunk, or,
alternately, the regal silhouette of its commonly planted
fastigiate forms. (DFC)

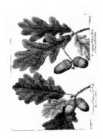

Common European Oak
(*Quercus robur*)

Pl. 106. Sessile Oak
(*Quercus petraea* (Matt.) Liebl.)

FAGACEAE

Sessile oak and English oak are the two most abundant
oaks across most of Europe. Once considered varieties of
the same species, they often grow in the same habitats
and hybridize freely. Michaux acknowledged the dif-
ficulty in telling the two species apart and stressed two
key differences between them. The acorns of sessile oak
are unstalked (or sessile), while those of English oak are
held on stalks up to four inches long. The leaves of sessile
oak have petioles of up to an inch long, whereas those of
English oak are generally less than a quarter inch in length.
To further the confusion, Michaux applied the name
Quercus robur to sessile oak, now known as *Q. petraea*,
and *Quercus pedunculata* to English oak, which is now
properly called *Q. robur*. Regardless of what they are called,
both species are ecologically and economically important
throughout their extensive native ranges. (TAF)

Running Oak
(*Quercus pumila*)

Pl. 107. Runner Oak
 (*Quercus pumila* Walter)

<div align="right">FAGACEAE</div>

A southern coastal species, runner oak grows from North Carolina to Florida, west to Alabama on dry sandy soils along low ridges, savannahs, and oak-pine scrub. This deciduous to semi-evergreen low-growing shrub typically only reaches three feet high. Its spreads, or runs, to form thickets. Its narrow leaves are unlobed with one bristle-tip at the apex and generally pubescent below. Runner oak has small acorns with thick cups. (DFC)

Red Oak
(*Quercus rubra*)

Pl. 108. Northern Red Oak
 (*Quercus rubra* L.)

<div align="right">FAGACEAE</div>

Northern red oak is one of the fastest-growing oaks, often reaching over 100 feet tall in the wild. Its thin, glossy-green leaves turn an attractive russet-red in the fall. These bristle-tipped leaves have five to eleven broad lobes. Oak leaves contain tannins, which make them leathery and slow their decomposition. Red oak acorns take two years to mature, like other bristle-tipped oak species, and vary in shape. They have thick cups that are frequently flat and saucer shaped, and occasionally woolly. The fruit are diet staples of wild turkeys, blue jays, squirrels, chipmunks, and other animals. (DFC)

Cork Oak
(*Quercus suber*)

Pl. 109. Cork Oak, Cork Tree
 (*Quercus suber* L.)

<div align="right">FAGACEAE</div>

This slow-growing, long-lived Mediterranean oak is found in open woodlands on lower slopes in generally acidic soils. While it is native to mostly coastal regions of southwest Europe and northwest Africa, cork oak grows best in climates with cool, moist winters and hot summers. It has evergreen leaves with spiny-ended lobes and margins that often curve downward. Its long acorns are borne in deep cups fringed with elongated scales. This medium-size oak has low, twisted branches and thick, corky bark that has been harvested for thousands of years. Ancient Romans used it for floating fishing buoys as well as for sandals. Today it is known more commonly for its commercial use in wine bottle stoppers and insulation. (DFC)

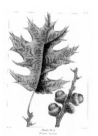

Black Oak
(*Quercus tinctoria*)

Pl. 110. Black Oak
 (*Quercus velutina* Lam.)

<div align="right">FAGACEAE</div>

Black oak's broad range spans Maine to Florida, west to Minnesota and Texas, and across Ontario, Canada. This tall oak is often found upslope and in dry sandy soils. Its dark-gray, nearly black bark is rich in tannins. Used in tanning leather, the bark itself was called quercitron from the Latin words *quercus* (oak) and *citron* (lemon). The bright-yellow inner bark was used to create a yellow dye by the same name. This deciduous oak's bristle-tipped leaves have five to nine lobes and vary in shape. Its clustered terminal buds are distinctive—notably wooly and four- or five-angled, in cross section. Acorn cup scales are also covered with velvety hairs. (DFC)

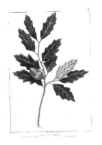

Rocky Mountain Oak
(*Quercus undulata*)

Pl. III. Gambel Oak
 (*Quercus gambelii* Nutt.)

FAGACEAE

Native to the southwestern states, Gambel oak is a shrubby tree with evergreen leaves that have pointed, toothed edges similar to holly. The bluish-green leaves are slightly wavy or crinkled with hairy undersides. The bark is rough and brownish gray. First discovered during the Long Expedition of 1819, led by Colonel James Long (1793–1822), it was drawn from nature by William Gambel (1823–49), for whom it was later named. (VBL)

Live Oak
(*Quercus virens*)

Pl. II2. Live Oak
 (*Quercus virginiana* Mill.)

FAGACEAE

Live oak may be the most iconic southern oak. Native to the Atlantic and Gulf Coastal Plains, live oaks grow in woodlands and scrublands from Virginia to Florida, west to Texas. Generally a large, wide-spreading tree, this species sometimes forms shrubby thicket-like growth. Leathery leaves are semi-evergreen, mostly glossy above, and typically gray-green and wooly below. The leaf shape is variable, with unlobed leaves sometimes displaying one to three toothy spines along each side. Acorn nuts appear elongated with distinctly thick, goblet-shaped cups. Historically this oak has been utilized heavily for a wide range of purposes, including timber processed for shipbuilding; acorns pressed for oil; and starchy swollen roots harvested and fried for food. (DFC)

Small-fruited Hickory
(*Carya microcarpa*)

Pl. II3. Broom Hickory, Pignut Hickory
 (*Carya glabra* (Mill.) Sweet)

JUGLANDACEAE

Nuttall recognized the similarity of this tree's smooth, serrated leaves to those of the pignut hickory (*Carya glabra*), but found its small, thin-shelled nuts to be more similar to those of common hickory (*C. tomentosa*) and classified this tree as its own species. Nuttall's tree is now considered a minor variant of pignut hickory. (VBL)

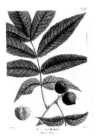

Bitter Nut Hickory
(*Juglans amara*)

Pl. II4. Bitternut Hickory
 (*Carya cordiformis* (Wangenh.) K. Koch)

JUGLANDACEAE

This hickory has a large range from southern Quebec and eastern Massachusetts, westward through Nebraska and eastern Texas, and south to Georgia and Louisiana. After its toothed green leaves turn yellow and fall, it is identifiable by its bright-yellow buds. As their name suggests, bitternuts are inedible to humans and unpalatable to animals. Early settlers used the nuts as a source of lamp oil. The wood, like other hickories, is strong and flexible, which once made it popular for wagon parts. (VBL)

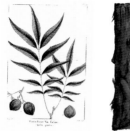

Water Bitter Nut Hickory
(*Juglans aquatica*)

Pl. 115. Water Hickory, Bitter Pecan
 (*Carya aquatica* (F. Michx.) Nutt.)
JUGLANDACEAE

This southeastern U.S. native was conflated with bitternut hickory (*Carya cordiformis*). Michaux recognized it as a separate species and proposed the name *Juglans aquatica*, though it has since been reclassified in the hickory genus, *Carya*. It is found most often in low, wet woodlands, but tolerates a range of soil conditions. Its round, reddish, flattened nuts are easily distinguished from other hickories. Its large, serrated leaflets are a beautiful green. The smooth gray bark of a young tree splits into shaggy scales in old age, similar to some other hickories. (VBL)

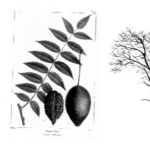

Butter Nut
(*Juglans cathartica*)

Pl. 116. Butternut
 (*Juglans cinerea* L.)
JUGLANDACEAE

Butternut, like black walnut, is native throughout the eastern U.S. and Canada. Michaux noted that black walnut and butternut resemble each other when young but are easily distinguishable in maturity, the butternut "forming a large and tufted head, which gives the tree a remarkable appearance." Its oily, oval nut is edible but quickly becomes rancid, and its wood is lighter and less strong than black walnut. Michaux argues against using the specific epithet *cinerea* (ashy), which refers to the smooth gray bark of butternut's secondary branches, in favor of *cathartica* (purging), which refers to the medicinal use of butternut bark extract as a painkiller and an emetic. (VBL)

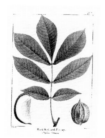

Thick Shell Bark Hickory
(*Juglans laciniosa*)

Pl. 117. Shellbark Hickory
 (*Carya laciniosa* (F. Michx.) Loudon)
JUGLANDACEAE

Michaux was first to identify this tree as a separate species from shagbark hickory. Shellbark hickory is similar in appearance to shagbark, but its bark flakes off in smaller, closer-fitting pieces for a neater appearance. The specific epithet, *laciniosa* (shredded), describes these long, narrow strips of exfoliating bark. Shellbark's whitish, egg-shaped nuts are the largest of all hickories. Shellbark hickory wood is especially hard and durable, and is used to make furniture, tool handles, and skis. (VBL)

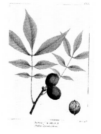

Nutmeg Hickory Nut
(*Juglans myristicaeformis*)

Pl. 118. Nutmeg Hickory, Swamp Hickory
 (*Carya myristiciformis* (Michx. f.) Nutt.)
JUGLANDACEAE

Nutmeg hickory is very rare, with a limited distribution in Mexico, near Monterrey, and in the southern U.S. between Arkansas and South Carolina. Michaux named the tree for its small brown nuts resembling those of nutmeg, *Myristica fragrans*. This handsome tree is unique among hickories for its metallic sheen: early spring shoots and golden buds are covered with shiny scales. Its leaves are scattered on top and bottom with silvery scales that change to gold or bronze. (VBL)

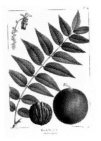

Black Walnut
(*Juglans nigra*)

Pl. 119. Eastern Black Walnut
 (*Juglans nigra* L.)

JUGLANDACEAE

Eastern black walnut is named for its dark, nearly black heartwood. It was once abundant in its native range throughout eastern North America but is now less common due to its long history as cabinet and furniture wood. Colonists began exporting the lumber to England from Virginia as early as 1610. Michaux noted its popular use in cabinets, gunstocks, coffins, and naval architecture. Black walnut has deeply furrowed, blackish bark and a similar sweet nut to the common walnut. This massive tree can reach 125 feet high and seven feet in diameter, with large aromatic leaves, making it a magnificent ornamental shade tree. (VBL)

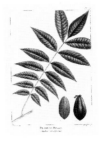

Pacanenut Hickory
(*Juglans olivae-formis*)

Pl. 120. Pecan
 (*Carya illinoinensis* (Wangenh.) K. Koch)

JUGLANDACEAE

The largest of the hickory trees, pecan has a straight trunk reaching up to 150 feet tall. Michaux was impressed by the abundance of the pecan's nuts, their thin shells, and their delicate flavor, which he considered superior to that of the European walnut. Pecan is native to the Midwest and southeastern U.S. but now grows throughout the East. Thomas Jefferson (1743–1826) planted pecans at Monticello and sent them to George Washington (1732–99), who followed suit at Mount Vernon and called them Illinois nuts. (VBL)

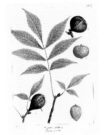

Pignut Hickory
(*Juglans porcina*)

Pl. 121. Broom Hickory, Pignut Hickory
 (*Carya glabra* (Mill.) Sweet)

JUGLANDACEAE

Broom hickory is native throughout the eastern and Midwest states, growing especially thickly in the Appalachian Mountains. In winter it can be identified by its small brown shoots and bare oval buds. This hickory boasts especially tough and heavy wood, which placed it in high demand throughout early American history. Settlers split strips of sapling wood into brooms, hence the name "broom hickory." Michaux called this species pignut hickory, another name derived from early British settlers, who fed these hard nuts to their hogs. (VBL)

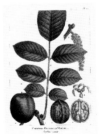

Common European Walnut
(*Juglans regia*)

Pl. 122. Persian Walnut, English Walnut
 (*Juglans regia* L.)

JUGLANDACEAE

Michaux called this walnut "one of the tallest and most beautiful among fruit trees ... remarkable for the amplitude of its summit, and the thickness of its shade." Though it is sometimes grown ornamentally, this is the walnut grown commercially in the U.S. and Europe for its nuts, which he described as "strongly odiferous" and "of a very agreeable taste." Traveling in Persia in the 1780s, he believed he had pinpointed the species' origin to the Gilan Province in present-day Iran, but it is native throughout Eastern Europe and Asia from the Balkans to the Himalayas. It was likely introduced to America by some of the earliest European settlers. (VBL)

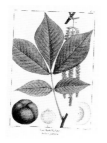

Shell Bark Hickory
(*Juglans squamosa*)

Pl. 123. Shagbark Hickory
 (*Carya ovata* (Mill.) K. Koch)

JUGLANDACEAE

Shagbark hickory is native through much of eastern
North America, from Quebec to Georgia and Texas. The
exfoliating bark for which it is named peels off in long,
narrow plates up to a foot long that curl away from the
trunk at each end. The trees have the rugged appearance
of wearing thick coats of armor. This shagginess develops
in comparatively young trees only seven or eight years old.
Shagbark hickory nuts are sweet and sometimes sold com-
mercially, though their shells are too hard to crack with
one's fingers. During the War of 1812, General Andrew
Jackson (1767–1845) was nicknamed "Old Hickory" after
this species. Six tall shagbark hickories are planted at
his gravesite at the Hermitage, his estate in Nashville,
Tennessee. (VBL)

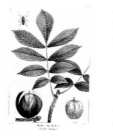

Mocker Nut Hickory
(*Juglans tomentosa*)

Pl. 124. Mockernut Hickory, White Hickory
 (*Carya tomentosa* (Poir.) Nutt.)

JUGLANDACEAE

This long-lived tree grows most abundantly in the
Mid-Atlantic states. It is called mockernut because its
nut, though edible and sweet, is tiny and very difficult to
extract from its extremely thick and hard shell. Mockernut
requires room to grow and can reach 120 feet high. Its
heavy foliage is fragrant with resin and turns bright yellow
in autumn before falling. The specific epithet, *tomentosa*
(with short hairs), describes the undersides of the toothed
leaflets. (VBL)

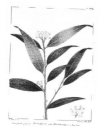

California Bay Tree
(*Drimophyllum pauciflorum*)

Pl. 125. California Bay, California Laurel
 (*Umbellularia californica*
 (Hook. & Arn.) Nutt.)

LAURACEAE

California bay is a large tree native to the coastal forests
of California and Oregon. It can reach nearly 100 feet tall
and three feet in diameter. It is one of the few members
of the Laurel family native to North America. Its long,
glossy leaves are intensely aromatic, similar to those of
the Mediterranean bay laurel. The small, yellow-green
flowers are produced in small umbels, hence the genus
name, *Umbellularia*. The fruit resemble small avocados,
to which they are closely related. Native Americans made
extensive use of the leaves and fruit. Even the seeds (pits)
were eaten. (RG)

Camphire Tree
(*Laurus camphora*)

Pl. 126. Camphortree, Camphor-laurel
 (*Cinnamomum camphora* (L.) J. Presl.)

LAURACEAE

Camphortree is native to China, Japan, and parts of
northern Vietnam. It was introduced in the late 19th
century to the southeastern U.S., where it thrives and
has become invasive. It is a large tree nearly 100 feet tall
with rough, gray bark. The leaves are glossy green and
aromatic. The small, white flowers produce globular,
black fruit less than one inch in diameter. Camphor oil
is distilled from the wood and used as a sedative and to
induce perspiration. The roots of young shoots are used to
make teas and leaves ground into spices. (RG)

Red Bay
(*Laurus caroliniensis*)

Pl. 127. Redbay
 (*Persea borbonia* (L.) Spreng.)
<div align="right">LAURACEAE</div>

Redbay is an evergreen tree or large shrub distributed
along the Atlantic Coastal Plain from southern Virginia,
throughout all of Florida and west to Louisiana and Texas.
It has reddish bark and leathery aromatic leaves. The
fruit are small drupes that turn blue-black when ripe. Its
fine-grained wood was used by early settlers as trimming
on boats and its leaves continue to provide flavoring to
authentic gumbos. (RG)

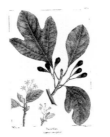

Sassafras
(*Laurus sassafras*)

Pl. 128. Sassafras, Cinnamon Wood, Ague Tree
 (*Sassafras albidum* (Nutt.) Nees)
<div align="right">LAURACEAE</div>

Sassafras is one of the last trees to produce leaves each
spring, but it is among the most beautiful sights in the
southern parts of the U.S. each fall. Its yellow, orange,
red, and even pink foliage is complemented by dark-blue
fruit. In the South sassafras can reach heights of 80 feet,
but as far north as New Hampshire it is a smaller tree.
Oil derived from the bark of the roots was long believed
to offer healing powers and used to flavor candy and
other sweet products. Michaux noted, "The Sassafras,
on account of its medicinal virtues, was among the first
trees of America which became known to the Europeans."
(JLG)

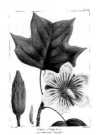

Poplar or Tulip Tree
(*Lyriodendrum tulipifera*)

Pl. 129. Tulip Tree, Yellow Poplar, Tulip Poplar
 (*Liriodendron tulipifera* L.)
<div align="right">MAGNOLIACEAE</div>

Tulip trees are among the tallest hardwood trees in
North America, and they grow along almost the entire
East Coast. Michaux called the tree "one of the most
magnificent vegetables of the temperate zones." It is
among the fastest growing of all native trees. Forest-grown
specimens have straight trunks free of branches for 60 feet
or more, which made them the preferred choice for Native
Americans to carve into dugout canoes. The four-lobed
leaves are unlike any other leaf. The common name refers
to the distinctive flowers, which emerge shortly after the
leaves in spring, stand upright, and are orange-yellow at
the base and light green-yellow at the ends of the petals.
Michaux wrote that New Yorkers gathered tulip tree flow-
ers and sold them in the markets of the city. The leaves
turn bright gold in fall and seed cones remain on the tree
throughout much of winter. (JLG)

Cucumber Tree
(*Magnolia acuminata*)

Pl. 130. Cucumber Tree, Mountain Magnolia
 (*Magnolia acuminata* (L.) L.)
<div align="right">MAGNOLIACEAE</div>

Following Europe's insatiable appetite for New World
plants, magnolias were some of Michaux's most sought-
after species in America. His discovery of cucumber tree
in Pennsylvania was well documented and celebrated.
Although its greenish-yellow, tulip-like flowers are less
showy than other *Magnolia* species, cucumber tree com-
pensates with its large foliage and attractive elongated
seed cones. The seeds turn bright red when ripe, but the
bitter, immature fruit were prized by early Americans as
flavoring for whisky and as well as for medicinal proper-
ties. (KLP)

Long-leaved Cucumber Tree
(*Magnolia auriculata*)

Pl. 131. Mountain Magnolia, Fraser Magnolia
(*Magnolia fraseri* Walter)

MAGNOLIACEAE

Naturalist William Bartram (1739–1823) was the first to describe this tree, which he encountered in spring 1776 while exploring the Appalachian Mountains. He was so enamored of the relatively small, multi-stemmed tree with the "very large rosaceous, perfectly white double or polypetalous flower, which is of a most fragrant scent," that he proclaimed the slope on which he found it "Mount Magnolia." Today this plant is known as mountain magnolia, as well as Fraser magnolia after Scottish botanist John Fraser (1750–1811), who introduced many North American plants to Europe. (JLG)

Heart-leaved Cucumber Tree
(*Magnolia cordata*)

Pl. 132. Cucumber Tree, Mountain Magnolia
(*Magnolia acuminata* var. *subcordata*
(Spach) Dandy)

MAGNOLIACEAE

Cucumber tree is one of the hardiest magnolias in North America, reaching over 100 feet tall and over six feet in diameter. Its native range extends from southern Canada through the Appalachian region to Louisiana. Michaux originally described this tree as two separate species that differed in stature, natural range, and size of foliage and flowers. It is understood today, however, that these are varieties of the same species. The long, cylindrical fruit, which are slightly curved and green in color, earn this tree its common name. (JLG)

Small Magnolia or White Bay
(*Magnolia glauca*)

Pl. 133. Sweetbay, Swamp Magnolia
(*Magnolia virginiana* L.)

MAGNOLIACEAE

Sweetbay is a popular ornamental tree that produces white, lemon-scented flowers in mid-spring. While the flowers are not as abundant as some of its relatives, the comparatively late bloom time of May into June protects the flowers from late frosts. Its aromatic dark-green leaves with silvery undersides can be evergreen in warmer areas of the tree's native range, which extends nearly the entire length of the East Coast. Many birds eat and disperse the red seeds, borne in cone-like structures in summer. (JLG)

Large Magnolia or Big Laurel
(*Magnolia grandiflora*)

Pl. 134. Southern Magnolia
(*Magnolia grandiflora* L.)

MAGNOLIACEAE

Southern magnolia is an evergreen tree with shiny, dark-green leaves. Its large, fragrant, white blossoms emerge in late spring, sometimes reaching diameters of 12 inches. The exceptionally large flowers earned this species its epithet, *grandiflora*. Although considered one of the iconic plants of the South, this tree can be found throughout its native range along the East Coast from Florida to Maryland. Today it is a popular ornamental tree in many parts of the world. (JLG)

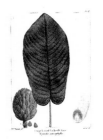
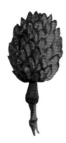
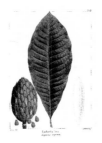

Large-leaved Umbrella Tree
(*Magnolia macrophylla*)

Pl. 135. Bigleaf Magnolia
(*Magnolia macrophylla* Michx.)
MAGNOLIACEAE

Bigleaf magnolia was first described by André Michaux after he spotted a specimen in full flower near Charlotte, North Carolina. Large white, sweetly fragrant spring flowers make this a popular landscape tree, but the enormous leaves that can extend three feet long and one foot wide earned this tree its common name. Bigleaf magnolia's leaves are the largest of any tree in all of temperate North America. The younger Michaux noted that bigleaf magnolia was prized as an exotic tree in Europe. He wrote that a specimen he brought to France bloomed in the garden of Joséphine Bonaparte (1783–1814). (JLG)

Umbrella Tree
(*Magnolia tripetala*)

Pl. 136. Umbrella Tree, Elkwood
(*Magnolia tripetala* (L.) L.)
MAGNOLIACEAE

Umbrella tree was first described by British naturalist Mark Catesby (1683–1749) in his *The Natural History of Carolina, Florida, and the Bahama Islands*.... It is a relatively small understory tree that is notable for its very large leaves that fan out at the end of branches to form an umbrella-like shape. Its large cream-colored flowers can range in size from six to ten inches and emit a strong fragrance that some find unpleasant but that attracts bees and beetles. The native range of umbrella tree extends from Pennsylvania to North Carolina, Tennessee, and Kentucky. Despite its wide geographic dispersal, Michaux noted that it was less commonly found than many other woodland species: "it is not met with at every step in the woods...it appears only in situations that are perfectly adapted to its growth." (JLG)

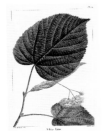

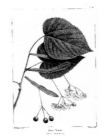

White Lime
(*Tilia alba*)

Pl. 137. White Basswood
(*Tilia americana* L.
var. *heterophylla* (Vent.) Loudon)
MALVACEAE

The range of white basswood extends through the Appalachian Mountains and the Piedmont westward, and as far south as Florida on well-drained, richly wooded slopes and along the banks of streams where it is often found growing with tulip tree, white ash, yellow buckeye, and hemlock. Michaux originally described the trees he saw growing on the along the banks of the Susquehanna and Ohio Rivers as *Tilia alba*. When Nuttall revised the text, he knew that this name was already in use for a European tree so he proposed to change the name to Michaux's Lime (*T. michauxii*), with the reservation that it may, upon further study, turn out to be only a variety of *T. heterophylla*. Modern taxonomy has gone further and subsumed them both as a single variety of *T. americana*, judging the differences as too subtle. (MH)

Bass Wood
(*Tilia americana*)

Pl. 138. American Basswood
(*Tilia americana* L. var. *americana*)
MALVACEAE

American basswood is an imposing medium- to large-size tree native to rich, fertile soils throughout eastern North America where it can be found growing with American elm, sugar maple, white oak, and hickory. Known for large, coarsely toothed, heart-shaped dark-green leaves with noticeably paler undersides, its drooping clusters of small, sweetly fragrant, creamy-white flowers become magnets for bees in summer. American basswood is an important timber tree; its relatively strong yet soft, very light wood is ideal for carving and has been used since colonial times for cabinet making, beehives, chicken coops, cheese boxes, and butter churns, as well as chair bottoms and dressmaker yardsticks. (MH)

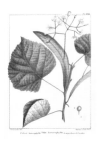

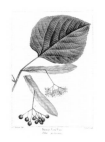

Large-leaved Linden
(*Tilia heterophylla*)

Pl. 139. White Basswood
 (*Tilia americana* L.
 var. *heterophylla* (Vent.) Loudon)
MALVACEAE

This botanical variety of American basswood is considered by some botanists to be a distinct species. White basswood is distinguished from American basswood by the undersides of its leaves, which are covered by fine silvery-white hairs, its larger flowers, and its more southerly native range, which extends from the mountains of southwestern Pennsylvania south to northern Florida and west to central Tennessee. It was first described by French botanist Étienne Pierre Ventenat (1757–1808) from specimens collected in South Carolina by André Michaux (1746–1802) and John Fraser (1750–1811). Like American basswood, the flowers of mountain basswood are an important source of nectar for native bees. (TAF)

Downy Lime Tree
(*Tilia pubescens*)

Pl. 140. Carolina Basswood
 (*Tilia americana* L.
 var. *caroliniana* (Mill.) Castigl.)
MALVACEAE

A small- to medium-size tree of 20 to 40 feet in height, Carolina basswood has a more southerly range than American basswood. It is a tree of moist woods, marshes, and riverbanks throughout the lowland and maritime parts of the southeast from North Carolina to Texas, where it is often the only basswood to be found. The winter buds, young twigs, flower bracts, ripe fruit, and newly emerging foliage are all densely covered with a fine downy pubescence. Like all of the former North American basswood species, Carolina basswood is now considered by most botanists to be a variety of American basswood though the flowers, much like the tree itself, are noticeably smaller. (MH)

Pride of India
(*Melia azedarach*)

Pl. 141. Chinaberry, Bead Tree, Pride of India
 (*Melia azedarach* L.)
MELIACEAE

Native to southern Asia and widely naturalized throughout tropical and subtropical regions, Chinaberry has been prized for the grace of its foliage and the beauty of its flowers, which are produced in pleasantly fragrant, light-purple clusters. According to Michaux, its fruit are sought by certain birds, particularly robins migrating south. The tree is no longer held in esteem in the U.S., where it is a troublesome invasive in the South. (CM)

Mahogany Tree
(*Swietenia mahogoni*)

Pl. 142. Mahogany Tree
 (*Swietenia mahagoni* (L.) Jacq.)
MELIACEAE

Mahogany tree, a stately specimen with elegant compound leaves, is native from southern Florida through the Caribbean Islands. It is very long-lived and can grow to 200 feet tall with a six-foot diameter trunk. Loose clusters of small, fragrant, near-white flowers appear in early spring, followed by prominent brown seed capsules. Perhaps best known for its very finely textured wood, which is equally beloved by cabinet makers and ship builders, mahogany is also currently showing promise in phytochemical studies as having analgesic, anti-inflammatory, anti-microbial, and cytotoxic properties with potential medical applications. Over-harvested for decades, wild mahogany specimens are now protected by international conservation laws. (KS)

Small-fruited Fig Tree
(*Ficus aurea*)

Pl. 143. Strangler Fig
 (*Ficus aurea* Nutt.)

MORACEAE

Strangler fig is named for its growth habit, which is
similar to its famous relative Banyan of India (*Ficus
benghalensis*). Its fruit are eaten by birds, which deposit
the seeds, along with a dose of guano as fertilizer, in beds
of organic material that has accumulated in the branches
of another tree. These seeds germinate and produce
fast-growing aerial roots that make their way down to the
ground. Once rooted in the ground, the growth of the fig
tree accelerates and it produces more roots. Over time,
these roots thicken and coalesce with others to completely
engulf or "strangle" the tree in which the seed germi-
nated. (TAF)

Short-leaved Fig Tree
(*Ficus brevifolia*)

Pl. 144. Shortleaf Fig
 (*Ficus citrifolia* Mill.)

MORACEAE

According to Charles Sprague Sargent (1841–1927) in his
Silva of North America, published from 1891 to 1902, this
and the following entry both describe shortleaf fig, which
is one of two *Ficus* native to southern Florida. Nuttall
described *F. brevifolia* based on a single specimen col-
lected by Dr. John Loomis Blodgett (1809–53), a physician
who lived on Key West from 1838 to 1851. For many years,
Blodgett was the only person collecting plants in southern
Florida, including the Keys, and many of his collections
represented species botanists had never seen. Blodgett
sent his specimens to John Torrey (1796–1873) in New
York for identification. Torrey shared Blodgett's Florida
specimens with Nuttall, leading to the publication of
many new species in *The North American Sylva*. (TAF)

Cherry Fig Tree
(*Ficus pedunculata*)

Pl. 145. Shortleaf Fig
 (*Ficus citrifolia* Mill.)

MORACEAE

Shortleaf fig shares an unusual pollination strategy
with other members of its genus. Tiny male and female
flowers are held within small fleshy sacs that are sealed
off by scales. Female wasps burrow through the scales
and lay their eggs into the female flowers within the sacs,
depositing pollen as they move from flower to flower.
After some time, the wasp eggs hatch to produce a new
generation of male and female wasps. The wingless male
wasps never leave the developing fig. After they impreg-
nate the females, they chew holes in the flesh of the fruit,
providing the females with the means of escape. The
impregnated females then fly to another fig to begin the
process again. (TAF)

Osage Orange
(*Maclura aurantiaca*)

Pl. 146. Osage-orange
 (*Maclura pomifera* (Raf.) C. K. Schneid.)

MORACEAE

Best known for its odd-looking knobby fruit, Osage-
orange is neither an orange, nor related. A member of
the Mulberry or Fig family, its common name is derived
from the citrusy scent of its large fruit (actually a mass of
individual fruit) and orange-colored bark and wood. The
choice wood of archers because of its toughness and rot
resistance, it was particularly favored by the Osage Native
American tribe for constructing hunting bows. It was also
used for dyes and was the source of khaki-colored military
uniforms during World War I. Urban folklore frequently
purports its effectiveness as an insect repellant, but this
has not yet been proven by scientific research. (KLP)

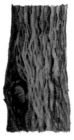

Osage Orange
(*Maclura aurantiaca*)

Pl. 147. Osage-orange
 (*Maclura pomifera* (Raf.) C. K. Schneid.)
 MORACEAE

Osage-orange can be instantly recognized by its unusual fruit, which are bright yellow-green, warty, and about the size of a small grapefruit. It is native to a relatively small range in Texas, Oklahoma, and southern Arkansas, but was widely planted by early settlers throughout the Midwest as a living fence because of its dense growth habit and sharp thorns. Native Americans used its strong and flexible wood to make bows. Although the fruit are inedible to humans and rarely eaten by livestock or wild animals, some scientists speculate that Osage-orange was dispersed by a now extinct member of the Pleistocene megafauna. (TAF)

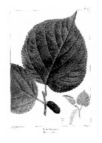

Red Mulberry
(*Morus rubra*)

Pl. 148. Red Mulberry
 (*Morus rubra* L.)
 MORACEAE

Red mulberry is a deciduous tree native to a wide range across eastern North America. It is most abundant in the Ohio River Valley, where it grows in floodplain forests and other fertile sites. Its edible fruit are relished by people and wildlife alike. Native Americans used red mulberry sap to treat ringworm and a tea made from its leaves to treat dysentery. Throughout its native range, red mulberry hybridizes freely with two introduced mulberry species: white mulberry (*Morus alba*) from China and black mulberry (*M. nigra*) from western Asia. (TAF)

Inodorous Candle Tree
(*Myrica inodora*)

Pl. 149. Wax Tree
 (*Myrica inodora* W. Bartram)
 MYRICACEAE

Wax tree is a large evergreen shrub native to the swamps of the Florida Panhandle, Alabama, and Mississippi. It was first described and named by naturalist William Bartram (1739–1823), who encountered it during his travels through the American South in the late 18th century. Bartram's brief description mentioned that French settlers near Mobile believed that candles made from wax produced by this tree were superior to candles made from beeswax. He also noted that, unlike the closely related wax myrtle (*Morella cerifera*), no part of wax tree is fragrant, hence the specific epithet, *inodora*. (TAF)

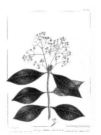

Forked Calyptranthes
(*Calyptranthes chytraculia*)

Pl. 150. Forked Calyptranthes
 (*Calyptranthes chytraculia* (L.) Sw.)
 MYRICACEAE

It is unclear from Nuttall's description exactly which species of *Calyptranthes* is illustrated and described. Forked calyptranthes is native to the Yucatan and Central America, not Florida, yet Nuttall wrote that the species he described was found in the Florida Keys and the Caribbean. Modern botanists recognize two species of *Calyptranthes* native to Florida: pale lidflower (*C. pallens*) and myrtle-of-the-river (*C. zuzygium*). All *Calyptranthes* have unusual flowers that are completely enclosed within cup-like buds covered by "lids" that pop off suddenly to allow the stamens and pistils to emerge. (TAF)

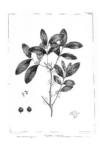

Box-leaved Eugenia
(*Eugenia buxifolia*)

Pl. 151. Spanish Stopper
(*Eugenia foetida* Pers.)

MYRTACEAE

Another multi-stemmed shrub or small tree in the Myrtle family, Spanish stopper is native to coastal areas from southern Florida to northern South America. Ethnobotanists speculate that the common name is derived from its fruit, which were traditionally used as a remedy for diarrhea. Spanish stopper's small evergreen leaves, slow growth rate, and dense habit make it well suited for use as a hedge. Although quite small compared to those of other *Eugenia* species native to Florida, its fruit are an important source of food for birds. (TAF)

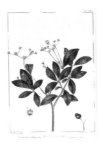

Small-leaved Eugenia
(*Eugenia dichotoma*)

Pl. 152. Twinberry
(*Myrcianthes fragrans* (Sw.) McVaugh)

MYRTACEAE

Twinberry is a large shrub or small tree native from northern South America through the West Indies and into southern Florida, where it grows in the Keys and in the understory of forests on both the East and West Coasts. Gardeners plant twinberry for its showy and fragrant flowers, attractive bark, tidy habit, evergreen leaves, and its fleshy fruit, which attract birds and other wildlife. It grows equally well in full sun or part shade, can be pruned into a hedge, and requires little maintenance once established. (TAF)

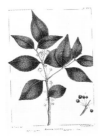

Tall Eugenia
(*Eugenia procera*)

Pl. 153. Red Stopper
(*Eugenia rhombea* (O. Berg) Krug & Urb.)

MYRTACEAE

Red stopper is native from the Florida Keys south through the West Indies to Mexico and northern South America. Endangered in Florida, it is found exclusively in the Keys as an understory shrub or small tree on hammocks, which are small forests established on raised ground surrounded by wetlands or water. Like other members of the Myrtle family, its leaves are aromatic when crushed and its flowers have clusters of showy white stamens. Red stopper fruit are a valuable source of food for birds and other wildlife. (TAF)

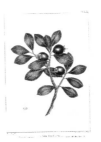

Florida Guava
(*Psidium buxifolium*)

Pl. 154. Florida Guava
(*Psidium buxifolium* Nutt.)

MYRTACEAE

As is often the case with historic scientific works, some mystery surrounds the appropriate name for this plant, which Nuttall described based on only a single specimen collected by Dr. William Baldwin (1779–1819) along the St. Johns River in eastern Florida. Contemporary botanists have identified three species of *Psidium* naturalized in Florida (none is native to the state): strawberry guava (*P. cattleianum*—native to Brazil); guava (*P. guajava*—native to the West Indies); and Guinea guava (*P. guineense*—native to South and Central America). The plant Nuttall illustrated most closely resembles the strawberry guava, which was not introduced into Florida until nearly 50 years after Nuttall wrote his description. (TAF)

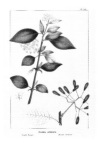

Prickly Pisonia
(*Pisonia aculeata*)

Pl. 155. Devil's-claw, Pull-back-and-hold
 (*Pisonia aculeata* L.)

NYCTAGINACEAE

Described by Nuttall as an "inelegant, but curious trailing branched tree," Devil's-claw is a fast-growing woody vine with a broad distribution through the tropical regions of the world. It is armed with hooked thorns that grow from the axils of its leaves and its fruit are coated with a sticky substance that firmly adheres them to passers-by. In spite of these troublesome qualities, Devil's-claw is an important medicinal plant in Brazil, where its roots are used as a purgative and an infusion of its leaves and bark is used as an anti-inflammatory. (TAF)

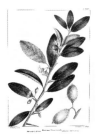

Mountain Plum
(*Ximenia americana*)

Pl. 156. Tallow Wood
 (*Ximenia americana* L.)

OLACACEAE

Although Swedish botanist Carl Linnaeus (1707–78) gave tallow wood the specific epithet *americana* (native to the Americas), the native range of this medium-size tree is a subject of debate among botanists. It grows in tropical America, Africa, and Asia. Wherever it grows, it is cherished for its edible fruit, which is slightly acidic and similar in flavor to the plum, and for its seeds, which are used to produce oil. Tallow wood has a wide variety of medicinal uses, which vary throughout its native range. It is used in Africa as an analgesic and to treat malaria and in Brazil as a purgative. (TAF)

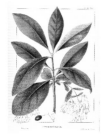

Fringe Tree
(*Chionanthus virginica*)

Pl. 157. Fringetree
 (*Chionanthus virginicus* L.)

OLEACEAE

A deciduous tree native to the eastern U.S., fringetree is well known for its gorgeous spring display of white, tassel-like slightly fragrant flowers. These airy flowers give the tree its fringe-like appearance in full bloom. It name is derived from the Greek words *chioni* (snow) and *anthus* (flower). Bluish-black, olive-like edible fruit are formed in fall and are a favorite of birds. The bark has a rough exfoliating quality that adds interest year-round, especially in winter. A valuable ornamental addition to a garden or landscape, fringetree has nice fall interest, when the yellow leaves appear with the blue fruit. It is tolerant of air pollution, which makes it suitable for urban settings. A rounded habit makes it an excellent specimen tree in a lawn, mixed into a woodland edge, or planted near ponds or streams or other wet conditions. (BPS)

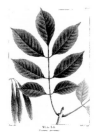

White Ash
(*Fraxinus americana*)

Pl. 158. American Ash, White Ash
 (*Fraxinus americana* L.)

OLEACEAE

White ash grows from Nova Scotia to Minnesota, south to Texas and central Florida. The leaf segment undersides are coated with a white wax, hence the common name. Ash wood is very strong, shock resistant, and heavy. It is used for flooring, tool handles, and sporting equipment, particularly baseball bats. White ash, like most or all North American ash trees, faces near total demise because of the imported emerald ash borer (EAB) discovered near Detroit in 2002 and spreading throughout the country. The wooden baseball bat industry's response to the threat posed by EAB has been to switch to maple bats, which are denser and harder. (JLG)

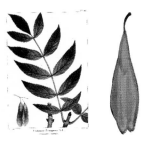

Common European Ash
(*Fraxinus excelsior*)

Pl. 159. European Ash, English Ash
 (*Fraxinus excelsior* L.)

<div align="right">OLEACEAE</div>

European ash is one of the largest, tallest, and most common deciduous trees across Europe. It is a hardy tree that grows in a variety of soil types. The leaves, bark, and seeds have been used for a variety of medicinal purposes as an astringent, mild diuretic, purgative, and it has been used to treat fevers. Known as the "tree of life" in Scandinavian mythology, it is believed to have mystical healing powers. (RG)

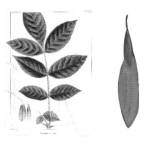

Oregon Black Ash
(*Fraxinus oregona*)

Pl. 160. Oregon Black Ash
 (*Fraxinus latifolia* Benth.)

<div align="right">OLEACEAE</div>

Oregon black ash is the only ash species native to the Pacific Northwest. It occurs exclusively on the west side of the Cascade Range from British Columbia to Oregon and the Sierra Nevada Range in California. It is commonly found in riparian habitats and valleys where it has access to a steady supply of water in an otherwise arid environment. It grows in heavy, poorly drained soils and can tolerate occasional flooding. Oregon black ash's symmetrical habit and quick rate of growth make it an appealing ornamental tree in gardens in both the U.S. and Europe. In addition, its overall hardiness leads to its use as a city street tree. As is typical of many species of ash trees, Oregon black ash is dioecious, with the male and female flowers occurring on separate trees. (BPS)

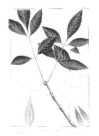

Small-leaved Ash
(*Fraxinus pauciflora*)

Pl. 161. Swamp White Ash
 (*Fraxinus pauciflora* Nutt.)

<div align="right">OLEACEAE</div>

One of a group of *Fraxinus* called water ashes, swamp white ash is native to the swampy ravines of northern Florida and southeastern Georgia. This small deciduous tree can grow up to 20 feet and often grows with its roots submerged in standing water. Swamp white ash has the pinnately compound leaf characteristic of other ash species but distinctly whitened undersides, a feature shared only with white ash (*F. americana*). In describing the species, Nuttall wrote, "Collected in Georgia in the neighborhood of 'Trader's Hill,' by the late indefatigable and excellent botanist, Dr. Baldwyn." (BPS)

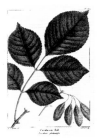

Carolinian Ash
(*Fraxinus platicarpa*)

Pl. 162. Water Ash, Swamp Ash
 (*Fraxinus caroliniana* Mill.)

<div align="right">OLEACEAE</div>

Water ash is native to swamps and floodplains along the Atlantic and Gulf Coasts from southern Virginia west to Texas, where it grows alongside bald-cypress, red maple, tupelo, and other species adapted to regular inundation. Unlike other ashes, which are important timber trees, water ash has comparatively soft and weak wood used only occasionally as firewood or to produce pulp for paper. The Miccosukee Native American tribe from Florida used water ash to make bows and arrows. (TAF)

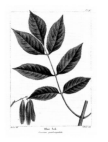

Blue Ash
(*Fraxinus quadrangulata*)

Pl. 163. Blue Ash
 (*Fraxinus quadrangulata* Michx.)
<div align="right">OLEACEAE</div>

First described by André Michaux (1746–1802) in *Flora Boreali-Americana* based on trees he encountered during his ill-fated western expedition of 1793, blue ash is a tall forest tree native to fertile, high pH soils from southern Michigan to Arkansas and Tennessee. Its common name is derived from the use of its macerated bark to produce blue dye. Its specific epithet, *quadrangulata*, refers to its prominently four-angled, winged twigs. In his description, François-André Michaux wrote "Milk in which the leaves have been boiled is said to be an unfailing remedy for the bite of the rattlesnake: we may be allowed, however, to doubt its efficacy till it has been attested by enlightened physicians." (TAF)

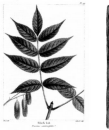

Black Ash
(*Fraxinus sambucifolia*)

Pl. 164. Hoop Ash, Basket Ash
 (*Fraxinus nigra* Marshall)
<div align="right">OLEACEAE</div>

Hoop ash is a deciduous tree growing 80 feet high in a variety of loamy and clay-based soils in swamps and wet woods. The species ranges from Newfoundland west to Manitoba and south along the line traced by the last glacial maximum across southern New York, Pennsylvania, Ohio, and west to Wisconsin and Iowa. It is distinguished from other native ash trees by unstalked (sessile) leaflets. The wood splits readily into long strips and is a preferred basket material for Native Americans throughout its range. (RG)

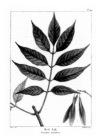

Red Ash
(*Fraxinus tomentosa*)

Pl. 165. Pumpkin Ash, Swell-butt Ash
 (*Fraxinus profunda* (Bush) Bush)
<div align="right">OLEACEAE</div>

Pumpkin ash grows in swamps and low-lying wet woodlands in very discontinuous populations from southern New York to Texas, but is most abundant along the Mississippi River and the Mid-Atlantic Coastal Plain. When found in standing water the tree develops an enlarged pumpkin-like base similar to tupelo. (RG)

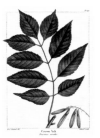

Green Ash
(*Fraxinus viridis*)

Pl. 166. Green Ash
 (*Fraxinus pennsylvanica* Marshall)
<div align="right">OLEACEAE</div>

Green ash is the most widely distributed North American ash. It can be found from Nova Scotia to Florida and as far west as Texas and Montana. It thrives in moist soil and quickly grows to heights exceeding 50 feet. At one time this tree was commonly planted as a shade tree, and ashes often lined city streets. However, the emerald ash borer, a pest native to Asia, first detected in North America near Detroit in 2002, has led to a serious decline in ash trees in the Midwest. Green ash is no longer planted widely because of this threat. (JLG)

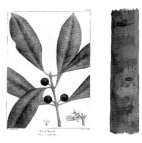
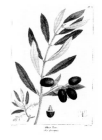

Devil Wood
(*Olea americana*)

Pl. 167. Devilwood, Wild Olive
 (*Osmanthus americanus*
 (L.) Benth. & Hook. f. ex A. Gray)

OLEACEAE

Devilwood is a small evergreen tree native to the Coastal
Plain, from southeastern Virginia, Florida, and west to
Louisiana. The wood of this tree is finely textured with
a compact grain, and when dry is very hard and difficult
to cut, earning the common name devilwood. The tree
bears small blue fruit that provide food to various species
of wildlife. It is often used as a hedge because of its pest
resistance and growth rate, and it is cultivated as an
ornamental plant for its fragrant flowers. (RG)

Olive Tree
(*Olea europaea*)

Pl. 168. Common Olive, European Olive
 (*Olea europaea* L.)

OLEACEAE

Common olive is a small evergreen tree native to the
Mediterranean region, Middle East, and Asia Minor, and
east to China. It has been grown for thousands of years
for its edible fruit and the valuable oil. A small tree with
gray-green leathery leaves, common olive has a smooth
bark when young that becomes gnarled with age. Olive
trees often live for hundreds of years, and some have been
documented at more than a thousand years old. Olive oil is
a staple of Mediterranean cuisine and is used for making
soaps and skin care creams. (JLG)

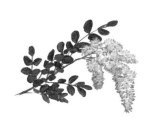
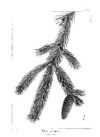
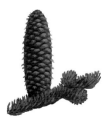

Californian Flowering Ash
(*Ornus dipetala*)

Pl. 169. California Ash
 (*Fraxinus dipetala* Hook. & Arn.)

OLEACEAE

With a range that includes California, Arizona, Nevada,
and northern Baja California, California ash occurs in
the chaparral and foothill woodland plant communities,
which are adapted to long, dry summers. Able to with-
stand drought conditions when established, California
ash drops leaves in summer in defense of the heat of its
native interior regions. It leafs out again following the
return of the winter rains. Unlike many ashes, it bears
both female and male flowers on the same plant, and the
flowers are sweetly fragrant, suggesting insect or animal
pollination. (BPS)

White (single) Spruce
(*Abies alba*)

Pl. 170. Silver Fir
 (*Abies alba* Mill.)

PINACEAE

The most widespread species of fir in Europe, silver fir has
beautiful long, downward-sweeping branches. Despite
this, it is uncommon in cultivation. It is native to central
and southern Europe, where it mostly thrives in moun-
tainous areas. In Great Britain, it has been cultivated for
so long that it is often thought of as native there. Flat,
glossy dark-green leaves have white stomatal stripes on
the lower surface, creating an almost metallic sheen. The
bark is also silvery-gray and smooth. Young shoots are
gray and visibly furry. One of the tallest firs, it usually has
a very straight trunk and is self-pruning so that the lower
trunk is branchless. (KLP)

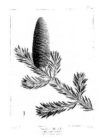

American Silver Fir or Balm of Gilead Fir
(*Abies balsamifera*)

Pl. 171. Balsam Fir
 (*Abies balsamea* (L.) Mill.)

PINACEAE

The botanical and common names for balsam fir both refer to its fragrant liquid resin, which is made into Canada balsam, a type of turpentine. The resin is extracted from raised blisters on otherwise smooth bark. This resin has numerous uses, including cough syrup, oil painting, and glue for scientific optical lenses. The resin's light-refracting property is equivalent to glass. Medicinal usage has included antiseptic salve, which explorers Meriwether Lewis (1774–1809) and William Clark (1770–1838) kept in their first aid kit. The most widespread fir species in North America, this slow-growing tree has been cultivated since 1696. It can live up to 200 years in the wild but is usually short-lived in cultivation. Lustrous dark-green needles and a symmetrically pyramidal form have established this extremely shade-tolerant evergreen's popularity as a Christmas tree. In the North Woods, balsam fir's bark provides the major food supply for moose in winter. (KLP)

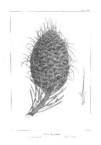
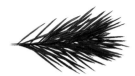

Leafy-coned Silver Fir
(*Abies bracteata*)

Pl. 172. Bristlecone Fir, Santa Lucia Fir
 (*Abies bracteata* (D. Don) Poit.)

PINACEAE

Extraordinarily long, needle-like bract blades protruding from egg-shaped seed cones are what give bristlecone fir both its common and botanical names. The purple-brown cones are extremely striking, standing upright above branches, with three to four inch bracts cascading in all directions. Restricted to the Santa Lucia Mountains of California, it is one of the rarest firs in the world, both in the wild and in cultivation. Another common name is Santa Lucia fir. It is also one of the few firs with sharply pointed needles and the only *Abies* species with glabrous cone scales. Because of its rarity it is valued as an ornamental tree rather than for its timber. (KLP)

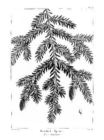

Hemlock Spruce
(*Abies canadensis*)

Pl. 173. Eastern Hemlock
 (*Tsuga canadensis* (L.) Carrière)

PINACEAE

Long-lived and slow growing, eastern hemlock is a graceful native evergreen that thrives in the cool temperate forests of eastern Canada and the U.S., from Nova Scotia to Alabama. Tall and mostly triangular in habit, they often have a drooping top, atypical of conifers. Slender horizontal branches have dark-green needle-like leaves that are flattened and rather short, just one-half inch long and with solitary seed cones borne at the tips. Cones are numerous, have woody scales, and add ornamental value. Cold loving and shade tolerant, this quintessential American tree was immortalized in "The Hemlock," a poem by Emily Dickinson (1830–86). Native Americans and early European settlers made a tea of the leaves, which is high in vitamin C. The bark has a high tannin content and was once heavily used for tanning hides. Unfortunately, today eastern hemlock is seriously threatened by an introduced pest, the hemlock woolly adelgid. (KLP)

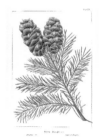

Douglas's Fir
(*Abies douglasii*)

Pl. 174. Douglas-fir
 (*Pseudotsuga menziesii* (Mirb.) Franco)

PINACEAE

Taxonomically complex, Douglas-fir has been variously classified as a spruce, a pine, and a fir, though it is none of those. It is now placed in a separate genus, *Pseudotsuga* (false hemlock). A noble forest tree native to western North America and central Mexico, Douglas-fir is one of the world's most important timber trees. Fortunately, this fast-growing conifer regenerates quickly. It is the most common material used for plywood and has been historically used for ship masts, including that of the USS *Constitution*. The specific epithet honors Archibald Menzies (1754–1842), who discovered it, and the common name honors David Douglas (1799–1834), who introduced it to cultivation in 1827. One of the most notable features is its cones, which have very prominent trident-shaped bracts extruding from the scales. (KLP)

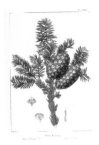

Fraser's Balsam Fir
(*Abies fraseri*)

Pl. 175. Fraser Fir
(*Abies fraseri* (Pursh) Poir.)

PINACEAE

Native to a limited area of the U.S., where it occurs only in Virginia, North Carolina, and Tennessee, Fraser fir is the only fir endemic to the southern Appalachian Mountains. Named for John Fraser (1750–1811), a Scottish botanist who explored the American South in the late 18th century, Fraser fir was also discovered by him. A rival of Michaux, Fraser had been traveling with him though they eventually parted ways. Soon after, Fraser discovered this previously unknown species in North Carolina. Fraser fir grows at high elevations and is highly valued for its scenic attraction and also for protecting mountain watersheds. Because of its beautiful form, blue-green foliage, exceptional needle retention and fragrance, Fraser fir is a popular selection for Christmas decorations. (KLP)

Menzies' Spruce Fir
(*Abies menziesii*)

Pl. 176. Sitka Spruce
(*Picea sitchensis* (Bong.) Carrière)

PINACEAE

The largest spruce species and one of the largest conifers in the world, Sitka spruce gets its name from Sitka Island in Alaska, although its range extends along the foggy coastlines of the Pacific Northwest, south to California. Sitka Island is where it was first spotted by European explorers. Introduced to Great Britain by David Douglas (1799–1834) in 1831, it is now a common reforestation species there and the most frequently planted conifer. Nearly every part of the tree is desirable for some purpose. The wood is extremely versatile and used for papermaking, the construction of buildings, boats and aircraft. It has one of the best strength-to-weight ratios of any wood. With extra-long fibers and fine grain, it is considered to have some of the best acoustic qualities and is therefore used in making musical instruments, particularly for guitar soundboards. Sitka spruce is easily recognized by its flared, buttress-like base. (KLP)

Black (double) Spruce
(*Abies nigra*)

Pl. 177. Black Spruce
(*Picea mariana* (Mill.)
Britton, Sterns & Poggenb.)

PINACEAE

Primarily a northern species, black spruce is a very upright, narrow, spire-like tree, small and slow growing. It is one of the most widely distributed conifers in North America, with the bulk of its range in Canada. It is one of the smallest spruces, with correspondingly small seed cones. Though used for pulpwood, black spruce has limited commercial value because of its diminutive size. The common name is derived from the dark blue-green hue of its foliage, so dark that it is nearly black. Needles, as with all spruces, are borne on woody pegs. At one time two popular products made from black spruce were chewing gum and spruce beer, the latter having a high vitamin C content. (KLP)

Decorated Silver Fir
(*Abies nobilis*)

Pl. 178. Noble Fir
(*Abies procera* Rehder)

PINACEAE

The largest native fir in North America, noble fir also has the largest seed cones, sometimes breaking branches under their own weight. Hailing from the Pacific Northwest, it was introduced to England by David Douglas (1799–1834) in 1830 and is now planted there in great quantities. Requiring high rainfall, this large conifer is equally suited for the similar climate of its native land. Noble fir is a hardy and highly ornamental tree, with a massive straight trunk, conical crown and attractive barrel-shaped cones that are red, purple, or green and overlaid with yellowish bracts. It yields high quality timber because it is both strong and light. (KLP)

Norway Spruce Fir
(*Abies picea*)

Pl. 179. Norway Spruce
(*Picea abies* (L.) H. Karst.)

PINACEAE

Native to Norway, as its name implies, Norway spruce's native range includes much of the rest of Europe as well. Now widely naturalized, it was introduced to the U.S. as an ornamental landscape plant. It is known for being especially easy to transplant, even when mature. Horticulturally, it is the most widely used spruce in North America. One of the tallest species in Europe and one of the fastest growing, Norway spruce is easily identified by its long, cylindrical cigar-like cones, perfectly pyramidal habit, and pendulous branchlets. The wood has many purposes but is frequently used by luthiers for musical instruments. Antonio Stradivari (1644–1737) allegedly used it in the construction of his famous violins. (KLP)

American Larch
(*Larix americana*)

Pl. 180. Tamarack, Eastern Larch
(*Larix laricina* (Du Roi) K. Koch)

PINACEAE

Unlike most conifers, tamarack is a deciduous tree. Before falling to the ground, its leaves turn a brilliant golden yellow to yellow-orange, creating a spectacular display of fall color. In spring new leaves are bright apple green. Soft tufts of needles give the tree a fuzzy appearance from a distance. Needles are arranged in clusters of 10 to 20 on short spurs and whorled along slender branches. Small cones are bright purple before ripening, making this a colorful tree. One of the most cold-hardy native trees, tamarack is frequently found growing in swamps and bogs. Another common name, eastern larch, does not take into account that its range covers northern North America from Newfoundland to Alaska. The wood has little commercial value and is used mostly for pulp products such as the transparent paper windows on mailing envelopes. Tamarack is an important food source for snowshoe hares, porcupines, and red squirrels. (KLP)

Cedar of Lebanon
(*Larix cedrus*)

Pl. 181. Cedar of Lebanon
(*Cedrus libani* A. Rich)

PINACEAE

Cedar of Lebanon is a majestic tree with tiered, wide-sweeping, often horizontal branches bearing dark-green foliage. Soft tufts of needles on short spurs are widely spaced and whorled around branches. Its ornamental value is outstanding. Large, egg-shaped cones stand upright above the leaves. It is native to not just Lebanon, where it is prominently featured on the nation's flag, but also throughout Asia Minor and along the Mediterranean coast. This mountainous species is not named for the country, but for Mount Lebanon in Syria. More than any other tree, it is frequently cited in mythology and religious texts. This symbolic evergreen is one of the oldest cedars in cultivation. For thousands of years it has been prized for its timber, oils and resins, which have medicinal, insect-repelling, and decay-resisting properties. Ancient Egyptians used the resin for preparing mummies and built temples with its wood. (KLP)

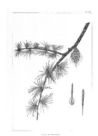

Western Larch
(*Larix occidentalis*)

Pl. 182. Western Larch
(*Larix occidentalis* Nutt.)

PINACEAE

First recognized as a distinct species by Nuttall in 1849, western larch is unusual in that it is a deciduous conifer and sheds its leaves each year. The specific epithet, *occidentalis* (from the west), refers to its nativity to western North America, where it grows in mountainous areas and is one of the most valued timber species. In spring short bright-green, needle-like leaves emerge in crowded clusters on woody peg-like spurs along its branches. In fall they turn a stunning golden yellow before abscising. New cones are bright red, rounding this out to a very colorful tree. (KLP)

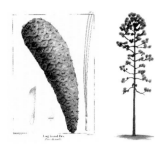

Long-leaved Pine
(*Pinus australis*)

Pl. 183. Longleaf Pine
　　　(*Pinus palustris* Mill.)

<div align="right">PINACEAE</div>

As its common name suggests, longleaf pine has the longest needles of any North American pine species, growing to a length of 15 inches. It also has the largest cones of all southern pines. This tall southern yellow pine is native to the coastal plain of the eastern U.S., from Virginia to central Florida and East Texas. Longleaf pine is unique for its "grass stage," which seedlings pass through for its first five or six years, giving it a tufted, grass-like appearance. During this phase, most of the tree grows underground at a very slow rate while developing thick bark, making it one of the most fire-resistant pine species. It produces some of the finest timber and is abundant in oleoresin, making it one of the most economically important southern pines. (KLP)

American Cembra Pine
(*Pinus flexilis*)

Pl. 184. Limber Pine
　　　(*Pinus flexilis* E. James)

<div align="right">PINACEAE</div>

Limber pine, as both its common and botanical names infer, has extremely flexible twigs. A popular trick to demonstrate this trait is to try to tie them in knots, but many trees have been injured in doing so. Its flexibility, however, gives it a great advantage in withstanding high winds and heavy snows. Native to western Canada and the U.S., it is primarily found in the Rocky Mountains. Cold-hardy and tolerant of harsh conditions, limber pine is often multi-stemmed with an uneven crown, and with needles in bundles of five and cones in pairs or whorls of three or four. Limber pine is extremely long-lived and specimens have been known to live as long as 2,000 years, making it useful for studying changes in climate. Despite its longevity, limber pine tends to remain short, often developing a thick trunk and twisted form. (KLP)

[New] Jersey Pine
(*Pinus inops*)

Pl. 185. Virginia Pine
　　　(*Pinus virginiana* Mill.)

<div align="right">PINACEAE</div>

Once considered a weed tree, Virginia pine is a pioneer tree that is able to flourish in the harshest conditions. Inhabiting dry rocky places and adapting to poor sites and soils earned another of its many descriptive common names, poverty pine. Because of this, it has been used to reclaim abandoned land and strip mine sites. It is also called scrub pine for its signature ragged, scrubby appearance. Despite this irregular habit, it can be easily pruned into shape, even for bonsai. This small, slow-growing and short-lived tree is native from New York to Georgia, west to Missouri and Mississippi, is also distinguished by its numerous cones, which can persist for several years. Otherwise pest-resistant, older wood can be softened by fungal decay, providing excellent nesting sites for woodpeckers. (KLP)

Gigantic Pine
(*Pinus lambertiana*)

Pl. 186. Sugar Pine
　　　(*Pinus lambertiana* Douglas)

<div align="right">PINACEAE</div>

One of the tallest and largest of pine species, with the longest cones of any conifer (up to 30 inches), sugar pine was discovered in 1827 by plant explorer David Douglas (1799–1834), who named this majestic tree for Aylmer Bourke Lambert (1761–1842), British botanist, author of an early monograph on the genus *Pinus*, and founding fellow of the Linnean Society. Native to the mountains of the western U.S., this long-lived pine became more valuable as the California Gold Rush created an influx of settlers, who needed timber to construct mines and homes. The smooth grain of its wood makes it a good material for pipe organs, including the famous Wanamaker organ. With a remarkably straight trunk, it self-prunes so that the crown towers above the mostly branchless column-like tree. The heartwood exudes a sugary sap when wounded, giving it its common name. Naturalist John Muir (1838–1914) claimed it tasted better than maple sugar. (KLP)

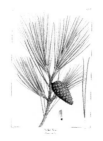

Yellow Pine
(*Pinus mitis*)

Pl. 187. Shortleaf Pine
(*Pinus echinata* Mill.)

PINACEAE

As the common name implies, shortleaf pine has the shortest needles of any southern yellow pine, with leaves three to five inches long, occurring in bundles of two and three on the same tree. Identified and named by English botanist Philip Miller (1691–1771) in 1768, the specific epithet is derived from the Latin word *echinus* (hedgehog), referring to the prickly tips of the cone scales, which have diamond-shaped protuberances with small prickles. Occurring in 22 states from southern Pennsylvania to eastern Texas, shortleaf pine has the widest geographic range of any pine in southeastern U.S. This wide range indicates shortleaf pine's ability to adapt to a wide range of climate, site, and soil conditions. It is fairly drought resistant and requires little in the way of nutrients. This lowland pine is important in the South and valued for its timber and provides precious habitat for the endangered red-cockaded woodpecker. (KLP)

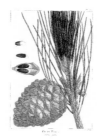

Stone Pine
(*Pinus pinea*)

Pl. 188. Italian Stone Pine, Umbrella Pine
(*Pinus pinea* L.)

PINACEAE

Planted for centuries throughout the Mediterranean, Italian stone pine is highly valued for the edible cone seeds, known as pine nuts or *pignolia*, a traditional ingredient in Italian cuisine. The seeds can be eaten raw or cooked and are often added to pesto. Italian stone pine thrives in dry climates like the Mediterranean and develops thick, fire-resistant bark. Cones open and release their seeds in response to heat. Another common name, umbrella pine, refers to the tree's habit with its lanky trunk, radiating branches, and unusual round top. Unfortunately, demand for Italian stone pine and other pine species heavily harvested for their nuts has led to deforestation and pest problems, resulting in a decline in population. (KLP)

Table Mountain Pine
(*Pinus pungens*)

Pl. 189. Table Mountain Pine
(*Pinus pungens* Lamb.)

PINACEAE

Characterized by its cones with extremely sharp hooked prickles, this Appalachian native was named for this trait as its specific epithet, pungens (sharply pointed, spiny), indicates. The cones are attached directly to branches and usually in clusters, becoming quite ornamental. Some claim that the common name refers to Table Rock, a mountain in North Carolina, although its range extends from Pennsylvania to Georgia. More likely, it is named for a generic landform, rather than a specific mountain. Often having a crooked trunk, it tends to be short and squat, with many arching branches and a rounded form. The timber is low grade (too small and knotty), but table mountain pine has excellent landscape value for its visual appeal, including the cones as well as eye-catching peeling red bark. (KLP)

Pitch Pine
(*Pinus rigida*)

Pl. 190. Pitch Pine
(*Pinus rigida* Mill.)

PINACEAE

The dominant tree of the Pine Barrens in New Jersey, pitch pine grows where few others can—on dry, windswept slopes with shallow, rocky soil. The common name alludes to the high resin content and as a result, the tree has been used in the production of turpentine, rosin, and the pine tar used by baseball hitters to improve their grip. Pitch pine comes in extremely variable forms but is easily recognized for its irregular habit, contorted branches and adventitious sprouts growing from the trunk. The specific epithet, *rigida* (rigid), refers to the stiffness of the needles and branching habit. One of the most fire-resistant eastern conifers, it is also decay resistant due to the high resin content. (KLP)

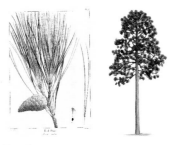

Red Pine
(*Pinus rubra*)

Pl. 191. Red Pine
(*Pinus resinosa* Aiton)

PINACEAE

Bright red-brown, plated bark on this large tree gives it its common name, red pine. Lustrous dark-green needles are formed in pairs and seed cones are short, about two inches long. It is misleadingly also nicknamed Norway pine, despite the fact that it is native to northeastern U.S. and Canada. Known for its lack of genetic variation, it is one of the most important timber trees in the Great Lakes region and is one of the few New World hard pines. It is popular for forest plantings because of its relative pest resistance. In the 1930s, millions were planted by the Civilian Conservation Corps. The majority of telephone poles in the Great Lakes region were formerly made of red pine and it is also frequently used in log cabin construction. (KLP)

Grey Pine
(*Pinus rupestris*)

Pl. 192. Jack Pine
(*Pinus banksiana* Lamb.)

PINACEAE

Named for Joseph Banks (1743–1820), British botanist, explorer, plant collector, and first director of the Royal Botanic Gardens, Kew, jack pine is the most northerly of North American pines. It thrives in soil conditions so poor that little else will grow around it. Because of this, it was once much maligned and shrouded in superstition. This two-needled pine has unusually short needles and oddly shaped curved cones. Stubborn cone scales remain closed for years, releasing seeds only when exposed to fire, further lending to some superstitious beliefs. This rather short, cold-hardy tree with pale green needles tends to yield knotty lumber that is good for little more than levers (or "jacks") but provides essential shelter for one of North America's most endangered species, Kirtland's warbler, which will only nest in jack pines. (KLP)

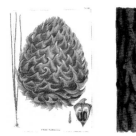
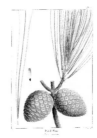

Prickly-coned Pine
(*Pinus sabiniana*)

Pl. 193. California Foothill Pine
(*Pinus sabiniana* Douglas)

PINACEAE

In 1894 naturalist John Muir (1838–1914) described California foothill pine as "remarkable for its airy, widespread tropical appearance, which suggests a region of palms rather than cool pine woods," probably after its noticeably sparse crown, long dropping gray needles, and massive pine cones. The gray coloring is so prominent that trees can be identified in Google Earth images. The crown is so thin that it is sometimes called see-through pine. Named by Scottish plant collector David Douglas (1799–1834), the California foothill pine's botanical name honors Joseph Sabine (1770–1837), secretary of the Horticultural Society of London (now the Royal Horticultural Society) between 1810 and 1830. Its specific epithet is sometimes spelled *sabineana* and there is much debate over the orthographic correctness. The large cones yield large edible pine nuts with an almond-like flavor. (KLP)

Pond Pine
(*Pinus serotina*)

Pl. 194. Pond Pine
(*Pinus serotina* Michx.)

PINACEAE

Closely related to *Pinus rigida* and sharing many of the same characteristics, pond pine is classified by some botanists as a subspecies of it, *Pinus rigida* subsp. *serotina*. Found in bogs, swamps, marshes, and seasonally flooded sites, it is an important wetland species as well as a valuable understory tree. Another common name for this gnarled tree with twisted branches is pocosin pine, from an Eastern Algonquian word for swamp. The specific epithet, *serotina* (late), refers to the cones that are late to open, sometimes taking as long as three years to mature yet the seeds remaining completely viable, and frequently not opening until exposed to fire. (KLP)

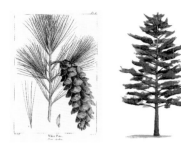

White Pine
(*Pinus strobus*)

Pl. 195. White Pine
 (*Pinus strobus* L.)

PINACEAE

The largest conifer in the Northeast, white pine is one of the tallest trees in all of North America. Native to the eastern U.S., it has been liberally planted as a landscape plant here and in the United Kingdom, where it is known as the Weymouth pine. Despite having brittle branches that easily break, white pine's timber is considered superior and has been historically significant. It molded much of the manmade landscape of the early British colonies, from homes to covered bridges. Prized by the British navy in the 18th and early 19th centuries for ship masts, it was also legally protected to reserve it for this purpose. (KLP)

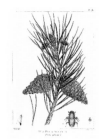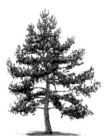

Wild Pine or Scotch Fir
(*Pinus sylvestris*)

Pl. 196. Scots Pine, Archangel-redwood
 (*Pinus sylvestris* L.)

PINACEAE

Introduced as an ornamental tree around 1752, Scots pine is the most widely planted pine in the U.S. and one of the most widely cultivated conifers. The only pine native to Great Britain, it is now naturalized in parts of the U.S. The common name Scots pine is not completely accurate as it is actually native throughout most of northern Europe and Asia, reaching as far south as Spain and Turkey. Despite its huge range, Scots pine is remarkably uniform in its morphology. The specific epithet, *sylvestris* (of the forest), refers to its natural habitat. It is a distinctive tree and easy to identify because of its short, twisted blue-green needles borne in pairs, scaly orange-red bark and asymmetrical form. Its smooth wood makes it a premium timber tree and lends another common name, archangel-redwood. (KLP)

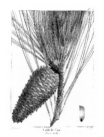

Loblolly Pine
(*Pinus taeda*)

Pl. 197. Loblolly Pine
 (*Pinus taeda* L.)

PINACEAE

An important timber species in the southern U.S. and commercially the most important southern pine, loblolly pine is commonly used for pulp and paper products such as kraft paper. It is also one of the fastest growing southern pines. Although considered a "southern pine," the natural range of this tall tree is concentrated across much of southeastern U.S., but extends north to New Jersey. The common name comes from a vernacular term for mud puddle, referring to the tree's tendency to grow in swampy areas, though is does not grow exclusively in this habitat. Sometimes called rosemary pine because it is aromatic, loblolly pine has long needles in clusters of two or three, large cones, and adapts to a wide range of soils and tends to grow in pure stands. Swedish botanist Carl Linnaeus (1707-78) named this pine for the ancient Roman word for torch, owing to the tree's extremely resinous quality. (KLP)

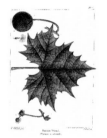

Button Wood
(*Platanus occidentalis*)

Pl. 198. American Sycamore, American Plane Tree
 (*Platanus occidentalis* L.)

PLATANACEAE

Michaux wrote that he and a traveling companion measured a button wood growing on an island in the Ohio River as having a 47-foot circumference. Today button wood is known as American sycamore, and is part of the family with the largest girth of any deciduous tree in North America. The great size, sometimes even reaching heights of 150 feet tall, and mottled gray, green, and nearly white exfoliating bark make them distinctive. Sycamores are most commonly found in lowlands in the eastern half of North America, and reach their greatest size in moist areas. The wood has been used for butcher blocks, containers, and cabinets. (JLG)

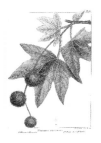

California Buttonwood
(*Platanus racemosa*)

Pl. 199. California Sycamore
 (*Platanus racemosa* Nutt.) PLATANACEAE

California sycamore ranges from central California down into Baja California, where it can be found singly or in small groves growing along stream banks, floodplains, and in deep canyons. A rapidly growing, medium to tall tree with an open spreading crown, it is adaptable to a range of soils as long the moisture level is high. While the mottled, exfoliating bark appears very similar to its eastern relatives, the distinctive deeply lobed, five-pointed leaves are quite different, resembling those of a giant sweetgum. The fruit are also different. Rather than a single, pendulous rounded cluster, the long drooping stalks hold multiple hanging fruit in a zigzag arrangement. (MH)

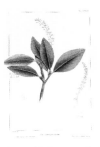

Small-leaved Sea-side Grape
(*Coccoloba parvifolia*)

Pl. 200. Sea Grape
 (*Coccoloba microstachya* Willd.)
 POLYGONACEAE

Sea grape is a common plant in its limited native range of the Caribbean islands of Puerto Rico, the Virgin Islands, and Hispaniola. Depending on its growing environment, it can be either a multi-trunked shrub or a small tree between 12 and 40 feet tall with numerous small branches of light gray bark. Three-inch light-green leaves are either deciduous or semi-deciduous. In summer and fall, sea grape bears tiny greenish-white flowers arranged at the tips of the stems in racemes that slightly curve down at the tip. It prefers moist soils and can be found growing in the wild in the islands' wet forests or as specimens in gardens and cultivated landscapes. (BPS)

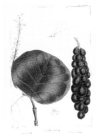

Sea-side Grape
(*Coccoloba uvifera*)

Pl. 201. Seaside Grape
 (*Coccoloba uvifera* (L.) L.)
 POLYGONACEAE

Seaside grape is a tropical plant whose native region extends from coastal Florida into South America. It is highly tolerant of seaside conditions, including salt spray, salty soils, wind and sun. In sandy areas nearer the beach, it has a sprawling shrub-like habit. Inland, away from the coast, it has the opportunity to develop a single trunk and can form an attractive small tree to about 50 feet tall. Leaves are heart-shaped and glossy dark green, and the flowers are small, white, and fragrant. These diverse habits and tolerance of tough conditions make seaside grape a valuable plant in the coastal regions of the tropics and one of the most commonly used landscape plants in tropical regions. (BPS)

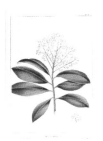

Florida Ardisia
(*Ardisia pickeringia*)

Pl. 202. Marlberry
 (*Ardisia escallonioides* Schltdl. & Cham.)
 PRIMULACEAE

In *The North American Sylva*, Nuttall described marlberry as a beautiful evergreen tree with leaves that resemble laurel. Its fragrant flowers and glossy-green, three- to six-inch leaves are among the attributes that make marlberry a valuable ornamental shrub for tropical gardens. Typically growing upright from eight to 15 feet, this elegant evergreen shrub is either always in flower or bearing fruit, often at the same time. It prefers moist, well-drained soils, and is tolerant of salt spray. It is a versatile plant and can be grown as a specimen or massed for a screening effect. (BPS)

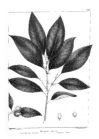

Small-flowered Drypetes
(*Drypetes crocea*)

Pl. 203. Guiana Plum
 (*Drypetes lateriflora* (Sw.) Krug. & Urb.)
 PUTRANJIVACEAE

Guiana plum is a 20- to 30-foot-tall understory tree that thrives in the calcareous soils of south Florida hammocks. This dioecious tree produces inconspicuous white flowers in spring and summer that give rise to bright-red drupes eaten by birds. The bark can be red to light gray and contrasts with the shiny dark-green leaves. (JAS)

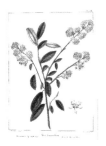

Tree Ceanothus
(*Ceanothus thyrsiflorus*)

Pl. 204. Blue Blossom, Tree Ceanothus
 (*Ceanothus thyrsiflorus* Eschsch.)
 RHAMNACEAE

Blue blossom is a beautiful California native shrub to small tree that can grow 25 feet tall. In spring the plants are adorned with eight-inch-long, light- to deep-blue inflorescences that resemble lilac flowers. This drought-tolerant and largest-growing *Ceanothus* species forms dense thickets after logging or fires. Blue blossom provides food and cover to a diverse group of native wildlife. Pollinators and butterflies frequent the flowers; butterflies and moths use it as a larval food source, and birds eat the seeds. (JAS)

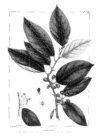

Snake-Wood
(*Colubrina americana*)

Pl. 205. Wild-coffee, Maubi, Snakebark
 (*Colubrina arborescens* (Mill.) Sarg.)
 RHAMNACEAE

Native to the coastal uplands of south Florida, this small tree to large shrub grows to 20 feet tall. Flowering throughout the year, the inconspicuous yellow flowers give rise to explosive dehiscent fruit that pop open when ripe and fling the black seeds a short distance. Wild-coffee is commonly used as a hedge or screen planting and in ecological restoration of the unique rockland hammock communities of south Florida that consist of sandy alkaline soils. (JAS)

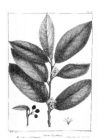

Carolina Buckthorn
(*Rhamnus carolinianus*)

Pl. 206. Carolina Buckthorn
 (*Frangula caroliniana* (Walter) A. Gray)
 RHAMNACEAE

Discovered in South Carolina, Carolina buckthorn has a wide distribution in the eastern half of the U.S., typically found in alkaline soils along woodland streams, open woodlands, upland ridges, and thickets. The most notable characteristics of Carolina buckthorn are the up to five-inch-long leaves and the berry-like drupes that turn from ornamental red to black when ripe. Creamy-green, inconspicuous spring flowers give rise to fruit that are consumed by songbirds and other wildlife in the fall. The large dark-green leaves also produce fall color in shades of yellows and oranges. (JAS)

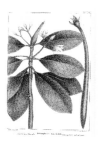

American Mangle
(*Rhizophora americana*)

Pl. 207. Red Mangrove
 (*Rhizophora mangle* L.)

RHIZOPHORACEAE

In the U.S., red mangrove is native to warm coastal areas from southern North Carolina south around coastal Florida and along the Gulf of Mexico from Alabama to Texas. It also grows throughout the Caribbean and in northern South America. Throughout its native range, red mangrove joins other mangrove species to form extensive thickets, known as mangrove swamps, in calm, shallow brackish or salt water. Mangrove swamps provide essential habitat for a wide variety of wildlife, including herons and other wading birds, sea turtles, crocodiles, many fish species, and an incredible array of invertebrates. Mangroves are threatened in many places by coastal development. (TAF)

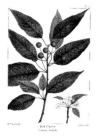

Red Cherry
(*Cerasus borealis*)

Pl. 208. Pin Cherry
 (*Prunus pensylvanica* L. f.)

ROSACEAE

Pin cherry is native to the boreal region of North America from the Canadian Maritimes to British Columbia, south through the Great Lakes region and the higher elevations of the Appalachian Mountains to Georgia. There is an outlaying population, sometimes classified as a subspecies, occurring in British Columbia, Alberta, Montana, Wyoming, and Colorado. Pin cherry is a characteristic short-lived, early successional tree or shrub, rarely reaching 50 feet tall and 20 inches in diameter. It grows quickly and the abundant red fruit are eaten by birds. The seeds are long-lived in the seed bank and germinate quickly after disturbances such as landslides, fire, and windstorms. (CM)

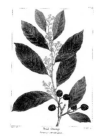

Wild Orange
(*Cerasus caroliniana*)

Pl. 209. Carolina Cherry, Cherry Laurel,
 Mock Orange
 (*Prunus caroliniana* (Mill.) Aiton)

ROSACEAE

Carolina cherry is indeed native to the Carolinas, ranging from North Carolina south along the Atlantic Coastal Plain to Louisiana and Texas. It is a dense shrub or small tree with evergreen glossy leaves. Michaux remarked, "the only merit of this tree is its brilliant vegetation, which renders it, when in bloom, one of the most beautiful productions of the southern part of the United States." Today the species is widely cultivated for its dense foliage and deer resistance. Its fruit persist into the winter, providing an important source of food for birds when insects and other fruit are scarce. (CM)

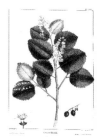

Holly-leaved Cherry
(*Cerasus ilicifolia*)

Pl. 210. Hollyleaf Cherry
 (*Prunus ilicifolia*
 (Nutt. ex Hook. & Arn.) D. Dietr.)

ROSACEAE

Hollyleaf cherry is a small evergreen tree native to western California from the hills of Napa south to the Baja California Peninsula. Its common name and specific epithet refer to its spiny evergreen leaves, which are similar in appearance to the leaves of holly (*Ilex* spp.). These spines are an adaptation to the dry climate of its native habitat: they protect the leaves from browsing by animals. The seeds of hollyleaf cherry were an important source of food for Native Americans, who ground them into flour used to make small cakes. The flour had to be rinsed in water repeatedly to remove toxins before it was consumed. (TAF)

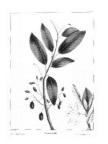

Soft-leaved Cherry
(*Cerasus mollis*)

Pl. 211. Bitter Cherry
(*Prunus emarginata*
(Douglas ex Hook.) Eaton)

ROSACEAE

Bitter cherry is a highly variable shrub or small tree native to the Pacific Northwest. In northern limits of its range and at higher elevations, the leaves, shoots, and inflorescences tend to be softly hairy. In the southern portions of its range and at lower elevations, the leaves, shoots, and inflorescences tend to be glabrous. The hairy-leaved form was first described and named *Cerasus mollis* by Scottish plant explorer David Douglas (1799–1834), who traveled throughout the Pacific Northwest in the 1820s and 1830s. Douglas introduced many plant species from western North America into cultivation before his untimely death in Hawaii. (TAF)

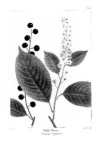

Wild Cherry
(*Cerasus virginiana*)

Pl. 212. Chokecherry
(*Prunus virginiana* L.)

ROSACEAE

Chokecherry is a thicket-forming shrub or occasionally a small tree, common across the northern half of North America, with isolated populations across the southern half of the continent from California, Texas, Tennessee, and North Carolina. It grows to 20 feet tall and has elliptical leaves somewhat wider than the closely related black cherry. The marginal leaf teeth are curved inward in chokecherry and are straight or curved outward in black cherry. Chokecherry is so named for the astringent or bitter immature fruit. When dried, the fruit are palatable and formed a significant part of the Native American diet throughout its wide range. (CM)

Feather Bush
(*Cercocarpus ledifolius*)

Pl. 213. Curl-leaf Mountain-mahogany
(*Cercocarpus ledifolius* Nutt.)

ROSACEAE

Nuttall described curl-leaf mountain-mahogany based on plants he observed while exploring the American West in 1834. It is a large shrub or small tree native to high elevations throughout the Great Basin from the western slopes of the Rocky Mountains to eastern California. Curl-leaf mountain-mahogany can be distinguished from other mountain-mahoganies by its thick, evergreen leaves, which curl downward along the margins. The leaves are resinous and aromatic, with a scent that reminded Nuttall of birch trees. The tiny fruit of curl-leaf mountain-mahogany are adorned with long feathery "tails" that catch the wind and aid in seed dispersal. (TAF)

Lance-leaved Hawthorn
(*Crataegus arborescens*)

Pl. 214. Green Hawthorn
(*Crataegus viridis* L.)

ROSACEAE

Native to the southeastern U.S., green hawthorn, particularly the cultivar 'Winter King', is an excellent small flowering tree for gardens. It is somewhat resistant to scab and rust, fungal diseases that plague other hawthorns in American gardens. It has brilliant-white flowers followed by orange-red fruit that mature in late summer that persist well into winter. In the wild, green hawthorn grows in dense thickets in old fields and along forest edges where it provides food and nesting habitat for a variety of birds. (TAF)

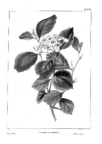

Red Thorn
(*Crataegus sanguinea*)

Pl. 215. Black Hawthorn
 (*Crataegus douglasii* Lindl.)

ROSACEAE

Black hawthorn is native to a wide swath of the northern U.S. and southern Canada from coastal Alaska south to Northern California, east through the northern Rockies to southwestern Quebec. It is most abundant in the Pacific Northwest. Its edible fruit are quite small yet nutritious. They were cherished by Lewis and Clark Expedition members, who had little access to fresh fruit during long portions of their journey. A voucher of black hawthorn made by members of the Expedition on April 29, 1806, was deposited in the herbarium at the Academy of Natural Sciences in Philadelphia. (TAF)

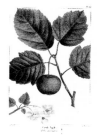

Crab Apple
(*Malus coronaria*)

Pl. 216. Sweet Crabapple
 (*Malus coronaria* (L.) Mill.)

ROSACEAE

One of North America's few native members of the genus *Malus*, sweet crabapple has a native range that includes the Great Lakes region, Midwest, and Appalachian Mountains. It is a shrub or small tree with short, contorted branches, reddish bark and white to pink fragrant flowers. Despite its common name, this tree's small, yellow-green fruit are sour and generally preferred by birds and other wildlife. The common name more likely refers to the sweet, violet-like scent of its flowers. Michaux notes the tree is "highly agreeable for the beauty of its flowers and for the sweetness of its perfume." (CM)

June Berry
(*Mespilus arborea*)

Pl. 217. Downy Serviceberry, Shadbush, Juneberry
 (*Amelanchier arborea* (F. Michx.) Fernald)

ROSACEAE

Downy serviceberry grows throughout the eastern U.S. and Canada, with the exception of the southeastern Atlantic Coastal Plain. Usually a small tree with a slender trunk, large individuals can reach 60 feet in height and 15 inches in diameter. The species' common name derives from the spring foliage that is clothed in soft white hairs, distinguishing it from other serviceberries, which have glabrous spring foliage. The large white flowers are produced as the leaves unfold, "when the shad run," as the saying goes, and are followed by racemes of sweet purple fruit typically ripening in June, suggesting another common name for these trees, juneberry. (CM)

Wild Plum
(*Prunus americana*)

Pl. 218. Wild Plum
 (*Prunus americana* Marshall)

ROSACEAE

This relative of cultivated plum (*Prunus domestica*) has an extensive native range across North America from the Intermountain West to the Atlantic coast from Florida to the Maritime Provinces. It is a densely branched shrub or small tree that produces clusters of white flowers with five petals in spring, which are followed in summer by small yellow to reddish-purple plums. The flesh of the fruit is sweet and wild plums were considered a delicacy by Native Americans across the continent. Pomologists have selected and named numerous varieties with attributes that make them more suitable for cultivation. (TAF)

American Mountain Ash
(*Pyrus americana*)

Pl. 219. American Mountain Ash
(*Sorbus americana* Marshall)

ROSACEAE

American mountain ash is a large shrub or small decidu-
ous tree that thrives in the cool climate of high latitudes
or high elevations in eastern and mid-western North
America. Its leaves are pinnately compound and turn
orange-yellow in fall. It has dense inflorescences of small,
fragrant, white flowers that open in late spring and are
followed by flat clusters of small orange-red fruit. The fruit
ripen in late summer and often persist until well after the
leaves drop in autumn. American mountain ash is often
browsed by deer or moose. (TAF)

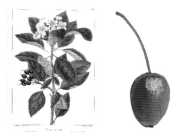

River Crab [Apple]
(*Pyrus rivularis*)

Pl. 220. Oregon Crabapple
(*Malus fusca* (Raf.) C. K. Schneid.)

ROSACEAE

Oregon crabapple grows in moist, fertile soils in forest
gaps, floodplains, and other open areas near the coast
from southern Alaska south to Northern California.
According to botanists, it is more closely related to Asian
crabapples than it is to crabapple species native to eastern
North America. Its flowers are white and its fruit are
small, usually about a half-inch in diameter, with a sweet
and slightly acid flavor. According to Nuttall, Native
Americans used the fruit as "they do many more berries of
the country, for food...." (TAF)

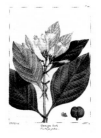

Georgia Bark
(*Pinckneya pubens*)

Pl. 221. Fevertree
(*Pinckneya bracteata* (W. Bartram) Raf.)

RUBIACEAE

Michaux reportedly successfully transplanted speci-
mens of what he called Georgia bark to his garden near
Charleston, South Carolina. He so named the tree,
comparing it to the Peruvian bark of *Cinchona*, because
he observed the inner bark being used medicinally. Known
today as fevertree, *Pinckneya bracteata* is a large shrub
or small tree 10 to 30 feet tall. Though native to South
Carolina, Georgia, and Florida, it is no longer common,
and is endangered in Florida. In the wild, fevertree thrives
in moist soil near streams and swamps. Its small yellow-
green flowers are surrounded by white or pink sepals that
contrast with the dark-green foliage. The flowers are most
abundant when grown in full sun. (JLG)

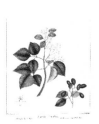

Florida Torch Wood
(*Amyris floridana*)

Pl. 222. Torchwood
(*Amyris elemifera* L.)

RUTACEAE

Torchwood is a small tree or large shrub native to coastal
hammocks in eastern Florida and the Keys, many
Caribbean Islands and Central America. It has opposite,
evergreen, compound leaves with three shiny leaflets.
Small white flowers become hanging black fruit that are
consumed by many species of birds, small mammals, and
humans. Leaves, fruit, and twigs all have a citrusy scent
when crushed. Notably, torchwood is the host species for
several swallowtail butterflies, including the endangered
Schaus' swallowtail. The specific epithet, *elemifera* (bear-
ing resin), gives rise to its common name as the wood can
be used as a torch. (KS)

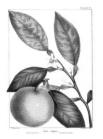

Wild Orange Tree
(*Citrus vulgaris*)

Pl. 223. Bitter Orange
(*Citrus × aurantium* L.)

RUTACEAE

Naturalist William Bartram (1739–1823) reported encountering vast groves of this relative of the sweet orange growing along the banks of the St. Johns River during his 1774 travels through Florida. Nuttall assumed that bitter orange was native "like banana and some other tropical productions" to Florida based on Bartram's observations and the reports of other botanists who had explored the area. He was mistaken; bitter orange had been introduced to the New World by early Spanish explorers centuries before Bartram's expedition. Although its flesh and juice are quite sour, bitter orange is consumed raw and used to produce marmalade, essential oils, and perfume. (TAF)

Carolina Prickly Ash
(*Xanthoxylum carolinianum*)

Pl. 224. Southern Prickly Ash, Hercules' Club
(*Zanthoxylum clava-herculis* L.)

RUTACEAE

This small tree native to the southeastern U.S. is named for its spiny trunk and branches. The slender trunk, about six inches in diameter, is scattered with distinctive spine-tipped, conical, corky bumps, while the twigs sport narrower thorns. A member of the Citrus family, its serrated leaves and clustered fruit are dotted with resin glands that impart a smell similar to orange. Hercules' club is also sometimes called "toothache tree" because chewing the bitter bark or leaves has a numbing effect and is a home remedy for toothache. (KS)

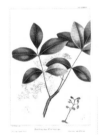

Florida Satin Wood
(*Xanthoxylum floridanum*)

Pl. 225. West Indian Satinwood
(*Zanthoxylum flavum* Vahl.)

RUTACEAE

West Indian satinwood is a slow-growing shrub or small tree native to thickets and woodland on rocky limestone in Florida and throughout the Caribbean. It prefers a sunny site with good drainage and is very drought tolerant once established. Panicles of small near-white highly fragrant flowers are a food source for bees. Large specimens of West Indian satinwood are rare as the species has been over-harvested for its lovely wood that is popular for decorative woodworking. (KS)

Bastard Iron Wood
(*Xanthoxylum pterota*)

Pl. 226. Lime Pricklyash
(*Zanthoxylum fagara* (L.) Sarg.)

RUTACEAE

Lime pricklyash is a small- to medium-size tree or large shrub native to hammocks from Florida and Texas south through the Americas. Branches bear recurved thorns and feature bright-red fruit contrasting sharply against its evergreen, compound foliage that smells of limes when crushed. Lime pricklyash flowers are yellow-green and inconspicuous though very fragrant, and male and female flowers occur on separate plants. It provides food for a wide range of creatures including deer, birds, and butterflies. Powdered lime pricklyash leaves are used as a condiment and furniture is made from its wood. (KS)

Carolinian Poplar
(*Populus angulata*)

Pl. 227. Eastern Cottonwood, Carolina Poplar
 (*Populus deltoides* Marshall)

SALICACEAE

Eastern cottonwood is a fast-growing tree that colonizes open habitats, particularly gravelly sites with abundant moisture. It can become quite large, often reaching 130 feet tall and nearly six feet in diameter. The large leaves are triangular in outline (*deltoid*) with numerous rounded teeth along the margins. Like the related quaking aspen (*Populus tremuloides*), cottonwoods have flattened petioles, which permit the leaves to flutter at the slightest breeze. It is named colloquially for the cotton-like fluff attached to the seeds produced in great abundance just after the leaves unfold. (JLG)

Narrow-leaved Balsam Poplar
(*Populus angustifolia*)

Pl. 228. Narrowleaf Cottonwood
 (*Populus angustifolia* E. James)

SALICACEAE

From the Sonora Desert of Mexico to the mountains of southern Alberta, narrowleaf cottonwood is a distinctive, familiar riparian species of gravelly stream banks and moist sandy soils throughout its range. It gets its common name from its unmistakable, narrow willow-like leaves. Grouped with other balsam poplars, the buds and young leaves are noticeably coated with a pleasantly fragrant gummy resin. In 1805 Meriwether Lewis (1774–1809) and William Clark (1770–1838) recorded seeing this tree on the upper Missouri River with leaves "like that of the wild cherry," and noted that beavers preferred this species because of its "deeper and soft bark." (MH)

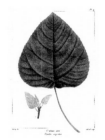

Cotton Tree
(*Populus argentea*)

Pl. 229. Swamp Cottonwood
 (*Populus heterophylla* L.)

SALICACEAE

Swamp cottonwood is a large tree native to the eastern U.S. from Massachusetts and Michigan south to Louisiana and Georgia. It grows in swamps and wet woods, and is neither common nor abundant. It is endangered in six northeastern states. Preeminent Swedish botanist Carl Linnaeus (1707–78) called it *heterophylla* because the leaves are quite unlike any other member of the genus. Its large oval leaves are rounded to heat-shaped at the base, blunt-tipped, and have dark upper surfaces and lighter undersurfaces. The wood is lightweight and has been used to make boxes, crates, and paper. (JLG)

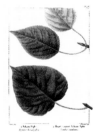

Balsam Poplar
(*Populus balsamifera*)

Pl. 230 (1). Balsam Poplar
 (*Populus balsamifera* L.)

SALICACEAE

Balsam poplar is a large tree native to the boreal zone of North America from Newfoundland, Hudson Bay, and west to the Arctic Circle in Alaska. Is is the northernmost hardwood species in North America. Like other members of the genus, it is a short-lived pioneer speices, germinating in open, freshly disturbed sites. It is a medium- to large-size tree with gray, furrowed bark and leathery, ovate, or heart-shaped leaves that are a distinctive bronze color underneath. The winter buds may be two inches long and produce a fragrant resin, long appreciated for medicinal and aromatic properties. (JLG)

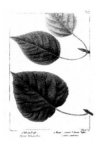

Heart-leaved Balsam Poplar
(*Populus candicans*)

Pl. 230 (2). Balm-of-Gilead
　　　　(*Populus × jackii* Sargent)

SALICACEAE

André Michaux (1746–1802) found this tree growing "before the houses" in New Hampshire, Massachusetts, and Rhode Island, adding that that "I have never found it in the forests of these states, where, if it exists, it must be exceedingly rare." And indeed it is. The species is actually a hybrid between common cottonwood (*Populus deltoides*) and balsam poplar (*P. balsamifera*). Natural hybrids are everywhere the parental species overlap. It is grown primarily as a shade tree, as in Michaux's day, with several cultivars available. (JLG)

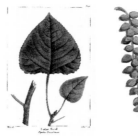

Cotton Wood
(*Populus canadensis*)

Pl. 231. Plains Cottonwood
　　　　(*Populus deltoides* Marshall)

SALICACEAE

Cottonwoods tend to follow human disturbance, particularly along rivers and lake margins, and it is this tendency to grow "among the people" that gives them their genus name, *Populus*. In describing this species, Michaux relies almost exclusively on the information of Mr. De Foucault, who he says, " . . . has long cultivated this tree and studied it with more minute attention than myself." It is reported to be a tree with "trowel-shaped" or triangular leaves, flattened petioles and pendulous female catkins, six to eight inches long. This description and the accompanying figure are all consistent with the common cottonwood tree that is widespread and variable in North America. (JLG)

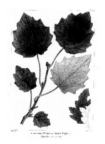

Common White or Grey Poplar
(*Populus canescens*)

Pl. 232. Gray Poplar
　　　　(*Populus × canescens* (Aiton) Sm.)

SALICACEAE

Michaux noted that gray poplar was one of the tallest trees in its family. He recalled an allée of the trees that grew near his childhood home near Versailles, which had reached nearly 100 feet in height before they were cut down. Gray poplar is adaptable to a variety of conditions, but grows more quickly in moist soil. The leaves are smoother on older specimens, and tend to have more fine hairs on specimens that are found in swampier conditions. (JLG)

American Aspen
(*Populus tremuloides*)

Pl. 233 (1). Quaking Aspen
　　　　(*Populus tremuloides* Michx.)

SALICACEAE

First described by André Michaux in the 1803 edition of *Flora Boreali-Americana*, quaking aspen is a boreal and montane species with one of the widest ranges of any North American tree, extending from Canada and Alaska, through the Rocky Mountains into Mexico. It forms extensive clonal stands that persist and expand for centuries. In fact, the world's largest living organism (and perhaps its oldest) is a stand of quaking aspen in south-central Utah known as Pando. In fall the leaves turn a brilliant yellow and contrast beautifully with the white bark and cobalt-blue skies common throughout its range. (JLG)

American Large Aspen
(*Populus grandidentata*)

Pl. 233 (2). Bigtooth Aspen
 (*Populus grandidentata* Michx.)

SALICACEAE

André Michaux was the first to describe this species
in *Flora Boreali-Americana*. His son noted in the text
of *The North American Sylva* that this species was
often confused with *Populus tremuloides*, but he drew
a distinction between these two related plants, noting
that *P. grandidentata* grew taller. The specific epithet,
grandidentata (large teeth), refers to the leaves, which
are a distinguishing feature of the foliage. Bigtooth aspen
is native to North America from Nova Scotia south to
Virginia and west to Missouri. It is often found growing
near quaking aspen, and is among the first plants to
colonize heavily forested or burned land. (JLG)

American Black Poplar
(*Populus hudsonica*)

Pl. 234 (1). Lombardy Poplar, Black Poplar
 (*Populus nigra* L.)

SALICACEAE

Michaux wrote that he had only ever seen this tree
growing on along the Hudson River north of Albany, New
York, and he believed it was native to northern parts of the
U.S. and Canada. It is more likely that it was introduced
to the U.S. from Europe, where today it is an endangered
species. (JLG)

Virginian Poplar
(*Populus monilifera*)

Pl. 234 (2). Carolina Poplar
 (*Populus* × *canadensis* Moench.)

SALICACEAE

François-André Michaux claimed that despite their
extensive travels, neither he nor his father, André, had
ever seen Virginian poplar, but he felt certain it must
exist in some obscure, unexplored corner of the country.
Nevertheless, he described it as a large tree 60 to 70
feet tall, with a cylindrical, smooth trunk with blackish
markings. The leaves, he said, are nearly as long as wide
with compressed apices and obtusely "denticulated" on
long petioles and that the tree is grown extensively in
Europe, particularly in Switzerland. It is believed that the
tree described and illustrated is in fact a hybrid between
European black poplar (*Populus nigra*) and American
cottonwood (*P. deltoides*). (JLG)

Silver-leaved Willow
(*Salix argophylla*)

Pl. 235. Narrowleaf Willow
 (*Salix exigua* Nutt.)

SALICACEAE

Like many western willows, narrowleaf willow can be
variously found as a spreading clonal shrub or a small tree
from 20 to 35 feet in height. As Nuttall noted, a distin-
guishing feature are the dense silky-white hairs that cover
the undersides of the narrow, lance-shaped, finely toothed
blue-green leaves, giving an overall silvery appearance
to the foliage. Narrowleaf willow has a wide distribution
throughout the Rocky Mountains at lower elevations
east of the Cascade Range, from British Columbia to the
Mexican State of Chihuahua. A pioneer species, it typi-
cally colonizes in narrow bands along rocky, gravelly, and
sandy stream edges that are prone to flooding. (MH)

Black Willow
(*Salix nigra*)

Pl. 236 (1). Swamp Willow, Black Willow
 (*Salix nigra* Marshall)

<div align="right">SALICACEAE</div>

Swamp or black willow, which is named for its very dark bark, grows throughout much of the eastern half of North America. It grows best along shorelines, riverbanks, and in wetlands. In these settings it is often used for restoration. This tree was used to create charcoal for gunpowder during the American Revolution, and has been used to make wicker furniture and baskets (JLG)

Champlain Willow
(*Salix ligustrina*)

Pl. 236 (2). Swamp Willow, Black Willow
 (*Salix nigra* Marshall)

<div align="right">SALICACEAE</div>

A large and common tree of stream and river bottomlands, black or swamp willow has little lumber value due to its weak wood. However, as with other species in this genus, it is a natural source of salicylic acid, a chemical compound similar to aspirin. The anti-inflammatory properties of this plant hormone make it popular for ethnobotanical uses and as an ingredient in modern skincare products. An important wildlife tree, it is one of the first plants to flower in spring. It provides nectar and pollen for bees, and the bark is consumed by beavers and other mammals. (KLP)

Shining Willow
(*Salix lucida*)

Pl. 236 (3). Shining Willow
 (*Salix lucida* Muhl.)

<div align="right">SALICACEAE</div>

A large shrub or small tree with an extensive native range across most of northern North America, shining willow is named for its lustrous dark-green leaves. Like most willows, it grows primarily along riverbanks and in other wetland habitats. Some botanists split the species into three subspecies (ssp. *lucida*, ssp. *lasiandra*, ssp. *caudata*), which are distinguished by their geographic distributions. While Michaux felt that shining willow has "no property that recommends it to attention," Charles Sprague Sargent (1841–1927) felt that its shiny leaves and showy catkins "make it a desirable garden plant." (TAF)

Western Yellow Willow
(*Salix lutea*)

Pl. 237. Yellow Willow
 (*Salix lutea* Nutt.)

<div align="right">SALICACEAE</div>

Yellow willow is generally a shrubby pioneer species found along stream banks prone to periodic flooding throughout the western mountains of North America from Alberta to New Mexico. As Nuttall noted in his original observations, it is widespread but uncommon throughout its range. A relatively small species, yellow willow rarely reaches upward of 20 feet in height but is capable of forming a substantial thicket, making it a good candidate for erosion control or stabilization projects in riparian areas. Its common name comes from the slender, yellowish-green color of the new growth. (MH)

Dusky Willow
(*Salix melanopsis*)

Pl. 238. Dusky Willow
(*Salix melanopsis* Nutt.)

SALICACEAE

Nuttall found dusky willow growing at Fort Hall on the banks of the Snake River in what is now southeast Idaho. He noted it growing not in masses, but scattered over the banks of the river in elevated situations, "and when in flower forming a very elegant object." Dusky willow is found almost exclusively in riparian habitats, occupying banks of rivers and streams, marshes, lakes, and ponds—anywhere subjected to periodic flooding and rocky, sandy deposits from British Columbia to California. Nuttall gave it the name dusky willow from the dark appearance of his collected specimens once dried. (MH)

Long-leaved Bay Willow
(*Salix pentandra*)

Pl. 239. Greenleaf Willow
(*Salix lasiandra* Benth.
var. *caudata* (Nutt.) Sudw.)

SALICACEAE

It was with some surprise that Nuttall encountered "this species, hitherto wholly European, in the very centre of the North American Continent...." While he acknowledged that this was indeed a "remarkable" variety, he still grouped it in with European willows. Modern taxonomy now classifies the specimens he saw growing along streams in the Rocky Mountains as a variety of Pacific willow native to the interior and mountainous areas of western North America. Greenleaf willow differs from its European relatives in that it lacks the notable silvery undersides of the former. (MH)

Long-leaved Willow
(*Salix speciosa*)

Pl. 240. Pacific Willow
(*Salix lasiandra* Benth. var. *lasiandra*)

SALICACEAE

Pacific willow grows all along the coast from western Alaska to Southern California. Nuttall was much taken with "this noble species," which he saw growing along the banks of the Columbia and Willamette Rivers, "at every instance when touched by the breeze, displaying the contrasted surface of their leaves, above of a deep and lucid green, beneath the bluish-white of silver: the whole scene, reflected by the water and in constant motion, presented a silent picture of exquisite beauty." (MH)

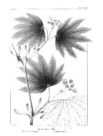

Round-leaved Maple
(*Acer circinatum*)

Pl. 241. Vine Maple
(*Acer circinatum* Pursh)

SAPINDACEAE

Vine maple's native range is along the coast of Washington, Oregon, and Northern California, but it is cultivated as an ornamental tree elsewhere. Closely related to Japanese and Korean maples, this tree grows like a vine with multiple trunks conjoined at the root, clustered in entangled groups of four or five to form a densely shaded grove. It is a short tree with a smooth narrow trunk up to 20 feet high. Nuttall compared its delicate, many-lobed leaves to outspread fans. Its small flowers and widespread samara are deep red and its leaves turn bright yellow and crimson in autumn. (VBL)

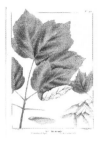

Drummond's Maple
(*Acer drummonds*)

Pl. 242. Drummond's Maple
 (*Acer rubrum* L.
 var. *drummondii* (Nutt.) Sarg.)

SAPINDACEAE

The range of Drummond's maple is more southerly than the species, with a slightly warmer zone and wetter habitat. Although similar to red maple, it is visually distinct by the densely pubescent undersides of its leaves, which are also much lighter in color. Drummond's maple is one of the first trees to signal the change in seasons, with bright-red flowers from late winter to early spring. In fall the leaves turn reliably scarlet, adding to this commonly occurring tree's popularity and desirability in designed gardens and landscapes. (KLP)

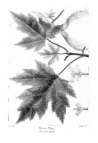 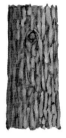

White Maple
(*Acer eriocarpum*)

Pl. 243. Silver Maple, Soft Maple, River Maple
 (*Acer saccharinum* L.)

SAPINDACEAE

This fast-growing maple is native throughout the East, growing up to 80 feet tall on stream banks and lake edges. It is especially common on the banks of the Ohio River, where it grows alone and in stands mixed with willow. Silver maple's two-inch winged seed pods are the largest of any maple. Its large, bright-green foliage is silvery white underneath. In fall these leaves turn pale yellow, retaining their silvery undersides. Silver maple has been planted beyond its native range throughout the U.S., and Michaux noted that it had been propagated in the gardens of Europe by the 18th century. The specific epithet, *saccharinum* (sugary), refers to its sweet sap. (VBL)

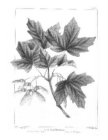

Mountain Sugar Maple
(*Acer grandidentatum*)

Pl. 244. Bigtooth Maple
 (*Acer grandidentatum* Nutt.)

SAPINDACEAE

This species grows in the mountainous interior West, from Idaho through Utah, Colorado, Arizona, and New Mexico, and parts of Mexico, Oklahoma, and Texas. Whereas sugar maple (*Acer saccharum*) can reach more than 100 feet tall, this small tree attains heights of about 40 or 50 feet at best and more often only 10 to 15 feet. Its trunk is narrower and its thick, large-lobed leaves smaller than sugar maple, but it offers the same beautiful fall color, turning red and gold. (VBL)

Large-leaved Maple
(*Acer macrophyllum*)

Pl. 245. Bigleaf Maple, Large-leaved Maple,
 Broadleaf Maple
 (*Acer macrophyllum* Pursh)

SAPINDACEAE

Bigleaf maple is true to its common name, usually bearing leaves up to 12 inches across. Exceptionally large leaves of 24 inches have been observed. Native to the Pacific Northwest, it makes an excellent shade tree as well as a commercial hardwood tree species whose lumber is used for furniture such as piano frames. The sap can be made into maple syrup. The familiar winged maple fruit are covered in dense or hispid hairs and distinct for this maple species. (JAS)

Mountain Maple
(*Acer montanum*)

Pl. 246. Mountain Maple
(*Acer spicatum* Lam.)

SAPINDACEAE

In the Great Smoky Mountains in Tennessee and North Carolina, mountain maple can grow as a bushy tree up to 30 feet tall, but it usually grows in the form of a six- to eight-foot shrub in dense thickets in the understory across the eastern U.S. It has unevenly colored dark-green leaves with a hairy underside and small greenish flowers on a graceful spike. Its seed pods' wings turn brighter when mature for vibrant fall color. (VBL)

Box Elder
(*Acer negundo*)

Pl. 247. Boxelder, Ash Maple
(*Acer negundo* L.)

SAPINDACEAE

Michaux described this American species' popularity in Europe, where it was featured along the Rue de Buffon in Paris and in pleasure gardens in Germany and England. The small tree is short-lived but fast growing and able to endure a great variety of climates and soil conditions. Unlike most American maples, boxelder has compound leaves with three to five leaflets. Its seed pods are eaten by winter birds such as grosbeaks. (VBL)

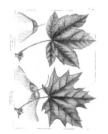

Black Sugar Maple
(*Acer nigrum*)

Pl. 248. Black Maple
(*Acer saccharum* Marshall
subsp. *nigrum* (F. Michx.) Desmarais)

SAPINDACEAE

Michaux classified this tree as its own species, but it was later reclassified as a subspecies of sugar maple. Black maple has darker bark and leaves than sugar maple, and its leaves have only three lobes to sugar maple's five. Its sap can likewise be used to make maple syrup. (VBL)

Norway Maple
(*Acer platanoides*)

Pl. 249 (1). Norway Maple
(*Acer platanoides* L.)

SAPINDACEAE

This European maple is native to Europe and Asia from France to Russia and along the Black Sea and Caucasus to Iran. Despite its specific epithet, *platanoides* (resembling *platanus*/sycamore), its leaves more closely resemble those of the sugar maple (*Acer saccharum*). Norway maple can be distinguished from sugar maple by its milky sap and dark, tightly furrowed bark. It is an invasive species throughout much of the eastern U.S. It produces dense shade and allelopathic chemicals that inhibit the growth of competitors, including native plants. (VBL)

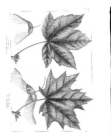

Sycamore
(*Acer pseudo-platanus*)

Pl. 249 (2). Sycamore Maple, Planetree Maple
 (*Acer pseudoplatanus* L.)

<div align="right">

SAPINDACEAE

</div>

Another non-native species, sycamore maple is native to central Europe and western Asia. It is named for the superficial resemblance of its leaves to those of the sycamore or plane tree in the genus *Platanus*. Its small greenish flowers and seed pods form in large pendent panicles. Its fine-grained wood can attain a high polish and Michaux noted its popularity with turners and musical instrument makers. (VBL)

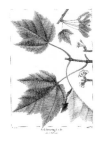

Red-flowering Maple
(*Acer rubrum*)

Pl. 250. Red Maple, Scarlet Maple
 (*Acer rubrum* L.)

<div align="right">

SAPINDACEAE

</div>

As Michaux's common name suggests, red maple boasts red flowers, but its leaf stalks, winter buds, and fall foliage are all red as well. Its crimson flowers are some of the first flowers of spring, and though small they stand out strikingly against bare white branches before the tree's first leaves appear. Its tall, columnar trunk has rough gray bark somewhat similar to sugar maple. Red maple typically grows about 60 feet tall, but with room to grow and in swampy conditions, it can reach up to 120 feet with a diamond-shaped habit, narrower at its crown and base. It makes a good street or lawn tree. (VBL)

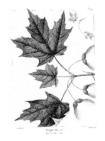

Sugar Maple
(*Acer saccharinum*)

Pl. 251. Sugar Maple, Rock Maple
 (*Acer saccharum* Marshall)

<div align="right">

SAPINDACEAE

</div>

Sugar maple is ubiquitous throughout the East and especially in New England, where its sap is harvested each spring to make maple syrup. Michaux described the process of obtaining maple sugar, which is largely unchanged to this day. In February or March, sap is drawn from an auger driven a half-inch into the wood; full troughs of collected sap are boiled down into maple sugar. Aside from their utility as a sugar source, sugar maples are beautiful, white-barked trees with excellent autumn yellow-orange foliage, one of the main players in a New England forest's fall color show. (VBL)

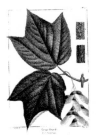
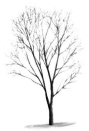

Moose Wood
(*Acer striatum*)

Pl. 252. Moosewood, Striped Maple
 (*Acer pensylvanicum* L.)

<div align="right">

SAPINDACEAE

</div>

Early American settlers called this small understory tree moosewood because they noticed that moose subsisted on its bark and young twigs in winter and spring. The other common name describes these bright white-and-green striped twigs. Striped maples have yellow-green flowers that open in late May or early June. Their fruit mature in late summer and are notable for a small cavity on one side of the samara. Moosewood's autumn leaves do not have the rich-red color of sugar maple, but turn pale and clear yellow through which sunlight passes. Michaux noted that this species had been cultivated in Europe for its handsome, veiny trunk. (VBL)

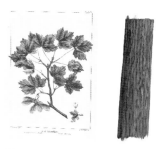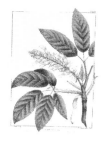

Currant-leaved Maple
(*Acer tripartitum*)

Pl. 253. Rocky Mountain Maple
(*Acer glabrum* Torr.)

SAPINDACEAE

This small western tree or shrub grows in rocky areas from Alaska to Southern California and east to Nebraska and Montana. Its red bark and light-green leaves that turn red in fall give it a striking appearance. Big game such as moose and deer eat its leaves and twigs throughout the year. Nuttall gave this species the epithet *tripartitum* for its three-lobed, serrated leaves, which are sometimes so deeply lobed that they are divided into three distinct leaflets. The accepted epithet selected by John Torrey (1796–1873) is *glabrum* (smooth or hairless), again describing the tree's leaves. (VBL)

Californian Horse Chestnut
(*Aesculus californica*)

Pl. 254. California Buckeye,
California Horse-chestnut
(*Aesculus californica* (Spach) Nutt.)

SAPINDACEAE

Endemic to California, California buckeye grows during the wet winter and spring months, often defoliating and entering dormancy in hot, drier climates in July. In spring sweetly fragrant pale-pink to white flowers attract native bees, butterflies, and hummingbirds. The flowers give rise to pear-shaped gray, dehiscent fruit that opens to a single shiny-brown seed or "buckeye." During dry summers, California buckeye often drops its leaves prematurely and appears dead, but leafs out again when rain returns. (JAS)

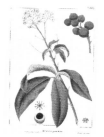

Round-fruited Honeyberry, Genip Tree
(*Melicocca paniculata*)

Pl. 255. Butter-bough, Inkwood
(*Exothea paniculata* (Juss.) Radlk.)

SAPINDACEAE

Butter-bough is a medium-size tree typically growing 30 feet tall with thin, reddish-brown exfoliating bark and shiny, dark-green leaves that measure up to five inches. The flowers are borne on showy panicles, creamy white, disk-shaped, and fragrant. The fruit are berries, orange-brown that ripen to dark purple, and are eaten by birds. (JAS)

Californian Box Elder
(*Negundo californicum*)

Pl. 256. California Boxelder
(*Acer negundo* L. var. *californicum* (Torr. & A. Gray) Sarg.)

SAPINDACEAE

California boxelder is a large deciduous tree of most variable shape native to California and Arizona that thrives in many different difficult locations. It will tolerate wetland conditions and very dry conditions. It is different from most maples in that it has compound leaves that can vary from three to seven leaflets. California boxelder is distinguished from other boxelders in that its leaves are larger and have a more velvety texture. Boxelder sap is often used by indigenous people as a sweetener and its wood is sometimes burned in religious ceremonies. (KS)

Buckeye
(*Pavia lutea*)

Pl. 257. Yellow Buckeye, Sweet Buckeye,
 Big Buckeye
 (*Aesculus flava* Sol.)

SAPINDACEAE

Yellow buckeye is a large tree native to the Ohio Valley
and Appalachian Mountains. It thrives in rich moist
woods and floodplains and can reach 100 feet tall.
Cultivated since the 18th century, it is best known for its
vivid display of yellow flowers and the large, palmately
compound leaves that turn orange in fall. Yellow buckeye
is distinguished from other buckeyes by the smooth outer
covering of the fruit. (CM)

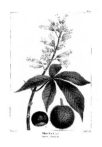

Ohio Buckeye
(*Pavia ohioensis*)

Pl. 258. Ohio Buckeye, American Horse-chestnut
 (*Aesculus glabra* Willd.)

SAPINDACEAE

Michaux found this tree growing on the banks of the
Ohio River, between Pittsburgh and Marietta. He called
it Ohio buckeye, but also referred to it as American
horse-chestnut, an alternate name that is still used today
because its prickly fruit resemble that of horse chestnut.
Striking clusters of white blossoms in spring are followed
by the spiky fruit. (CM)

Florida Soap Berry
(*Sapindus marginatus*)

Pl. 259. Soapberry
 (*Sapindus saponaria* L.)

SAPINDACEAE

Soapberry is native to the southeastern U.S. and grows
to a height of 30 and sometimes 40 feet. The pinnately
compound, evergreen leaves that are 12 inches long and
the symmetrical crown give this tree an elegant form.
The panicles of small white flowers are large, dense, and
terminal. This panicle inflorescence produces berry fruit
the size of a cherry with "saponaceous pulp" that lather
when mixed with water, giving rise to the common name,
soapberry. (JAS)

Small Sapodilla
(*Achras zapotilla*)

Pl. 260. Sapodilla
 (*Manilkara zapota* (L.) P. Royen)

SAPOTACEAE

Sapodilla, native to the Yucatan, including Mexico,
Guatemala, and Belize, is cultivated in many regions
across the tropics. Capable of reaching 60 feet in the open
and up to 100 feet when competing in a forest, sapodilla
is supported by an extensive root system that provides
strength and stability in wind. Glossy leaves are carried
in clusters at the tip of branches, and the small cream-
colored flowers are pollinated by bats. Sapodilla's soft and
juicy fruit are a favorite of people and wildlife. The most
notable feature of this tropical tree is *chicle*, a gummy
white substance that is harvested from the tree by slashing
the bark and collecting the exudate. *Chicle*, developed
by the Mayans, is transformed into a chewable material
that inspired the worldwide obsession with chewing gum.
(BPS)

Narrow-leaved Bumelia
(*Bumelia angustifolia*)

Pl. 261. Saffron Plum
 (*Sideroxylon celastrinum*
 (Humb., Bonpl. & Kunth) T. D. Penn.)

<div style="text-align: right">SAPOTACEAE</div>

Saffron plum is a tropical evergreen native to coastal
Florida. Growing up to 30 feet, this tree forms dense
growth and can become a thicket. It has small leaves that
are held in pairs on the upright side of the branches, while
the fragrant white flowers, arranged in tight clusters,
are formed on all sides of the branches, creating a showy
appearance. Small dark-purple fruit, which are attractive
to wildlife, ripen close to the branches. As with many
other species in the genus, saffron plum bears thorns
along the branches. Its thicket-like growth, thorny
branches, and attractive edible fruit create a desirable
refuge for nesting birds and other animals. This coastal
tree demonstrates good resistance against high winds,
which makes it a valuable addition for tropical landscapes
in hurricane zones. (BPS)

Foetid Bumelia
(*Bumelia foetidissima*)

Pl. 262. False Mastic
 (*Sideroxylon foetidissimum* Jacq.)

<div style="text-align: right">SAPOTACEAE</div>

False mastic is native to Florida, the Caribbean, and
Central America. Growing up to 50 feet tall, it often forms
the upper canopy of its community. False mastic's specific
epithet, *foetidissimum* (stinky), refers to the rather
unpleasant smell of its inconspicuous yellow flowers. The
yellow-orange one-inch fruit, however, are very attractive
to birds. It thrives in a variety of soils and full sun, becom-
ing quite tolerant of drought conditions as it matures. Its
size, wind resistance, and beauty lead false mastic to be
used frequently as a shade tree and along streets in coastal
tropical climates. (BPS)

Smooth-leaved Bumelia
(*Bumelia lycicoides*)

Pl. 263. Buckthorn Bully
 (*Sideroxylon lycioides* L.)

<div style="text-align: right">SAPOTACEAE</div>

Buckthorn bully is native to the southeastern U.S., from
Texas to Virginia. It can reach up to 30 feet and, unlike
the tropical species of the genus, is deciduous. It is quite
tolerant of wet soils, found in flood plain forests and
edges of swamps. *Sideroxylon* is derived from the Greek
words *sidero* (iron) and *xylon* (wood). It is named for
the hardness of the wood of all the species in the genus.
In addition to being hard, the wood of buckthorn bully
is beautifully colored and the rough bark of the mature
trees exfoliates to reveal the red color underneath. Small
white flowers are borne in summer in clusters along
the branches. Small dark-purple berries follow in fall.
One-inch thorns occur along the branches with the leaves,
earning it the common name buckthorn bully. (BPS)

Silky-leaved Bumelia
(*Bumelia tenax*)

Pl. 264. Tough Buckthorn
 (*Sideroxylon tenax* L.)

<div style="text-align: right">SAPOTACEAE</div>

Tough buckthorn is a subtropical 30-foot-tall evergreen
tree native to the southeastern coastal U.S. from Florida
to North Carolina. It thrives in dry sandy soils and has a
high salt tolerance. Once established, it can withstand
very dry conditions. *Sideroxylon* is named for the
hardness of the wood of all the species in the genus. In
particular, tough buckthorn has very hard branches, as
reinforced by its specific epithet, *tenax* (strong). Clusters
of white flowers, fragrant in the evening, form with thorns
along the branches. Dark-purple fruit follow in fall, and
the bark reddens as it matures. (BPS)

Glaucus Bitter-wood
(*Simaruba glauca*)

Pl. 265. Paradise Tree
 (*Simarouba glauca* DC.)

SIMAROUBACEAE

Native to Florida, Mexico, and Central America, paradise tree is an evergreen with glossy 16-inch, pinnate leaves with individual leaflets of up to three inches. New foliage emerges red. This upright tropical tree can reach 50 feet tall with a round canopy. Paradise tree bears small yellow flowers in large numbers in summer. The flowers and coarse texture of the leaves provide an overall interesting appearance. The flowers are followed by small purplish fruit. Paradise tree grows in a wide range of soils, as long as they are well drained. This frost-sensitive tree is popular in tropical gardens as a specimen shade tree. (BPS)

Sweet Leaf
(*Hopea tinctoria*)

Pl. 266. Horse-sugar, Common Sweetleaf
 (*Symplocos tinctoria* (L.) L'Hér)

SYMPLOCACEAE

Horse-sugar earned its common name because its thick oval-shaped leaves were fed to horses and cows, who relished the sugary taste. According to Michaux, this tree varies in size depending on where it grows, noting "on the banks of the Savannah and on the borders of large swamps, where the soil is deep, loose and fertile, I have seen it 25 or 30 feet high and 7 or 8 inches in diameter at the high of 5 feet. Commonly it does not exceed half these dimensions, and in the *pine-barrens*, where it is profusely multiplied, it is sometimes only 3 or 4 feet height." (CM)

Western Yew
(*Taxus occidentalis*)

Pl. 267. Western Yew
 (*Taxus brevifolia* Nutt.)

TAXACEAE

Western yew is an evergreen conifer native to the Pacific Northwest. Its range includes Alaska to Northern California and disjunct in the Rocky Mountains from British Columbia to central Idaho. Depending on its environment, it may develop into an upright tree of 45 feet or a 15-foot shrub with multiple contorted stems. The bark and needles of western yew is a natural source of Taxol, a chemotherapeutic cancer medication used to treat a variety of cancers, including breast cancer and lung cancer. (BPS)

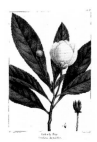

Loblolly Bay
(*Gordonia lasyanthus*)

Pl. 268. Loblolly Bay, Black Laurel
 (*Gordonia lasianthus* (L.) J. Ellis)

THEACEAE

Loblolly bay inhabits southern bogs, wet flatlands, and hardwood swamps on the Atlantic and Gulf Coastal Plains from North Carolina to Louisiana. This evergreen tree has five- to six-inch leaves with serrated edges. Loblolly bay can grow up to 60 feet in height with a pyramidal crown. The two- to three-inch, white saucer-like flowers are very showy, but not abundant. Michaux noted that the tree "affords turpentine in abundance." (RG)

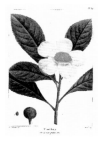

Franklinia
(*Gordonia pubescens*)

Pl. 269. Franklinia, Franklin Tree
 (*Franklinia alatamaha* Marshall)
 THEACEAE

Franklinia, named after Benjamin Franklin (1706–90), was first discovered growing along the banks of the Altamaha River in Georgia in 1770 by John Bartram (1699–1777) and his son William Bartram (1739–1823). Considered extinct in the wild since 1803, all cultivated Franklinias are derived from the seeds collected by William Bartram when he returned to the site in 1773. Franklinia can withstand cold temperatures, cultivated as far north as Boston. It has attractive saucer-like white flowers and dark-green leaves that turn purple, red, and orange in fall. (RG)

Planer Tree
(*Planera ulmifolia*)

Pl. 270. Planertree, Water-elm
 (*Planera aquatica* J. F. Gmel.)
 ULMACEAE

Planertree is a small deciduous tree endemic to the southeastern U.S. from the Carolina coast through Georgia and across to Louisiana, east Texas, and up the Mississippi River to Cairo, Illinois, and its confluence with the Ohio River. Unlike true elms, whose seeds are enclosed within a papery wing, planertree's seeds are surrounded by a soft, prickly nut-like structure. The unique fruit are the defining characteristic of the genus, which contains only one species. (CM)

Wahoo
(*Ulmus alata*)

Pl. 271. Winged Elm, Wahoo
 (*Ulmus alata* Michx.)
 ULMACEAE

Winged elm is a small tree rarely reaching 30 or 40 feet tall with a slender trunk and short branches. The leaves are narrow, oblong and smaller than most other Elm species. Michaux aptly bestowed the specific epithet *alata* for this small tree in reference to the twigs and branches that are often flanked by broad, corky wings nearly an inch broad. The species has a wide range through the Southeast from Virginia to Texas and up to Missouri. He described this range precisely, a remarkable achievement considering the vastness of the area and the limited resources he had available. (CM)

White Elm
(*Ulmus americana*)

Pl. 272. American Elm
 (*Ulmus americana* L.)
 ULMACEAE

American elm is one of the most elegant of all trees. The substantial fluted trunk is supported on a flaring pedestal of roots, balanced perfectly by the soaring canopy, whose strong limbs arch gracefully in a wide circle, which in fine specimens reaches all the way to the ground. Michaux was so impressed with it he declared it "the most magnificent vegetable of the temperate zone." The species has a wide distribution throughout the entire eastern half of North America. More than two centuries ago, he reported that American elm grew no farther north than the St. John River in Canada, which is still the northern limit of the species. (CM)

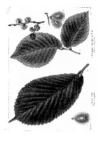

Common European Elm
(*Ulmus campestris*)

Pl. 273 (1). Field Elm
 (*Ulmus minor* Mill.)

ULMACEAE

As described by Michaux, field elm is a large, upright
columnar tree reaching nearly 100 feet tall with rough
bark forming rectangular blocks with age. The branches
are sometimes corky winged as in winged elm. The
leaves are elliptic with evenly serrate margins, gradually
narrowed toward the tip. The smooth upper surfaces
distinguish this species from wych elm, with rough leaves.
Field elm is predominately southern in distribution (as
opposed to the northern distribution of wych elm), rang-
ing from Ireland, through southern Europe, North Africa,
and Asia Minor. (CM)

Dutch Elm
(*Ulmus latifolia*)

Pl. 273 (2). Scots Elm, Wych Elm
 (*Ulmus glabra* Mill.)

ULMACEAE

Scots elm is a large tree with a short trunk, relatively
smooth bark, and a rounded crown with drooping
branches. Its large leaves are widest above the middle with
jaggedly serrate margins and a long, slender tip, occasion-
ally flanked by two shorter lobes. The fruit are smooth, for
which it is given the specific epithet, *glabra*. Its natural
range extends from Ireland through northern Europe to
Iran and Russia. Scots elm is believed to be the only elm
native to the British Isles. Its other common name, wych
elm, is derived from the Old English or Gallic word "wic,"
meaning flexible. (CM)

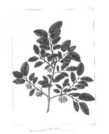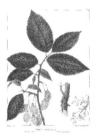

Opaque-leaved Elm
(*Ulmus opaca*)

Pl. 274. Cedar Elm
 (*Ulmus crassifolia* Nutt.)

ULMACEAE

In summer 1818 Nuttall observed this tree at the conflu-
ence of the Red and Kiamichi Rivers in what is now
southeastern Oklahoma. He ended his fond description of
this "densely-verdant" and "majestic and spreading forest
tree" with a quote from the *Georgics* of Roman poet Virgil
(70–19 BC). This was a clever allusion to the botanical
name he had chosen for this tree, as the words *Ulmus
opaca* are themselves part of a famous quotation from the
Aeneid, another epic poem written by Virgil, translated
from Latin by English poet John Dryden (1631–1700),

 "Full in the midst of this infernal road,
 An elm displays her dusky arms abroad:
 The God of Sleep there hides his heavy head,
 And empty dreams on ev'ry leaf are spread." (MH)

Thomas's Elm
(*Ulmus racemosa*)

Pl. 275. Rock Elm, Cork Elm
 (*Ulmus thomasii* Sarg.)

ULMACEAE

The first scientific description of rock elm was in 1830 of a
tree found growing in Cayuga County, New York, by David
Thomas (1776–1859), a former engineer on the Erie Canal.
Charles Sprague Sargent (1841–1927) noted in the appen-
dix of his *Silva of North America* that the name *Ulmus
racemosa* had already been used to describe a European
species. He proposed a new name in honor of its original
author, which is still the current botanical name for this
tree. Rock elm is a large tree often reaching 100 feet in
height that occurs mainly on the deep, moist, sandy loams
of the northern Midwest and Great Lakes region from
Michigan and Wisconsin eastward as far as Vermont. It
rarely forms pure stands and is often found growing with
other hardwoods such as sugar maple, red maple, yellow
birch, and American beech. It is sometimes referred to as
cork elm because of the broad, irregular corky wings seen
on the older branches. (MH)

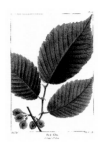

Red Elm
(*Ulmas rubra*)

Pl. 276. Slippery Elm, Red Elm
 (*Ulmus rubra* Muhl.)

ULMACEAE

Slippery elm, or red elm, is a North American elm native throughout much of the eastern U.S., but is nearly absent from the Gulf Coastal Plain except for a narrow band east of Pensacola, Florida. It is a medium- to large-size tree with fissured bark and ovate leaves that are very rough on the upper surface. Although morphologically very similar to American elm, only smaller, it is more closely related to wych elm, yielding an abundant mucilage when the twigs are macerated in water, hence the common name slippery elm. (CM)

Small-leaved Lignum Vitae
(*Guaiacum sanctum*)

Pl. 277. Holywood
 (*Guaiacum sanctum* L.)

ZYGOPHYLLACEAE

Holywood, the national tree of the Bahamas, is an evergreen, medium-size tree native to dry coastal areas from Florida through the Caribbean and Mexico, south to Panama. Shiny compound leaves are accompanied by lovely small blue flowers on branch tips throughout the year but most heavily in the spring. The seed is an important food source for many species of birds, including the Bahama parrot. The self-lubricating wood is so dense that it sinks in water. It is the traditional material for croquet mallets and cricket balls. (KS)

The North American Sylva and the Art of Botanical Illustration

David Allen Sibley

FRANÇOIS-ANDRÉ MICHAUX AND THOMAS NUTTALL's book on North American trees stands as one of the landmarks in the early study of natural history of this continent. It came at a time when three significant and complementary trends converged. The period is generally acknowledged to be the golden age of botanical illustration, and the undisputed master of the genre—Pierre-Joseph Redouté (1759–1840)—contributed many of the images in these volumes. It was also near the pinnacle of copper plate engravings when these works were still hand-colored, and just as the printing process transitioned to less-expensive methods such as lithography. And, finally, it was a time when the people of Britain and Europe had a nearly unquenchable desire for knowledge of the New World. It was that widespread and passionate curiosity that stimulated interest in funding in these publications, allowing the naturalists, artists, and engravers to embark on such a magnificent project as *The North American Sylva*. Although the intentions and style of botanical illustration vary across time and from illustrator to illustrator, I admire the work of Redouté and others in the volumes of Michaux and Nuttall, and it informs my approach as an artist.

I think there is more than a little bit of poetry in botanical illustration. Poetry uses a few words to re-create a scene or an emotion, to elicit a sense of recognition in the reader, and to highlight some aspect of an experience—to make the poem seem "real." When it is successful, a poem is much more than the sum of its words, but that success depends on carefully chosen words. When I create an illustration, my intent is to use light and shade to focus on the key features to elicit recognition in the viewer.

Both art forms—poetry and illustration—require a delicate balancing act. Too little information will fail to evoke a connection, but too much information will distract or divert the reader and viewer. My goal as an illustrator is to convey a technically accurate image as simply as possible, to strip away the extraneous information and expose the very essence of the thing. As an illustrator, I might be working with the pattern of veins on a leaf, or the shapes of a flower, but much of the philosophy guiding the process is the same as the poet's.

Similarly, in both poetry and illustration, an approach that is too technical or too direct will fail to move the reader and viewer. Balancing the

Pierre-Joseph Redouté

artistic and the technical requires a deep understanding of the subject and the medium. A carefully measured and technically perfect drawing can be lifeless, but adding the artistic embellishments that suggest life and movement, while maintaining accuracy and precision, is very difficult. In my work, conveying a sense of life, of reality, and the beauty that is inherent in all of the details of structure and pattern in living things requires a certain amount of artistic freedom, to use some emotion and lyricism to bring the work to life.

 The subtle balance of precision and artistry that I aspire to is exemplified by Pierre-Joseph Redouté's illustration of Bur Oak (plate 96). The artist shows us a beautifully sculpted, three-dimensional leaf. Its shape is irregular, asymmetrical, with a few large lobes on the left side and much smaller lobes on the right. Some lobes are pointed and some are rounded, and the major leaf veins all curve in different directions. And yet, with all of these imperfections, the leaf still looks perfectly natural. In fact, it looks more natural because of the imperfections, but only because these imperfections stay within the narrow limits of the natural structure of a leaf.

 Redouté is justifiably recognized as one of the greatest botanical artists of all time. Born in Luxembourg, he trained as a painter and made his way to Paris at age 23 intending to join his older brother, Antoine-Ferdinand

(1756–1809), designing and painting sets for the theater. While there he met a wealthy and influential botanist, Charles Louis L'Hértier de Brutelle (1746–1800), who hired him to produce large paintings for publication of new species of plants. He was later appointed draughtsman to the Cabinet of Marie-Antoinette, then Queen of France.

Studying with botanists at the Jardin des Plantes gave Redouté the scientific background needed for his work, provided connections to the royal court, and afforded the opportunity to learn from a preeminent botanical artist, Gerard van Spaendonck (1746–1822). During this period, many artists had been using gouache (opaque watercolor paint) for their botanical paintings, but van Spaendonck had recently perfected new techniques for illustrating flowers with transparent watercolor on vellum. Redouté learned and adapted this new method, and the precision and artistry of his illustrations soon exceeded those of his teacher.

He went on to produce more than 2,000 botanical paintings in his lifetime. The beautifully hand-colored images in the first three volumes of Michaux's *The North American Sylva* include 156 finely executed stipple-point engravings by Redouté, his brothers, Antoine-Ferdinand and Henri-Joseph Redouté (1766–1852), Adèle Riché (1791–1887), and by Pierre-Joseph Redouté's most accomplished pupil, Pancrace Bessa (1772–1846).

Bessa and Redouté jointly illustrated several publications, including Michaux's *Histoire des Arbres Forestiers de l'Amérique Septentrionale* (Paris, 1810–1813), the first edition of *The North American Sylva* in which Bessa provided 75 of the illustrations. By the time that publication was produced, the art of engraving had advanced in many ways. One such advance, which is used in *The North American Sylva*, is a technique called stipple-point engraving. Stippling is a common technique in pen-and-ink drawing, in which tiny dots of ink are used to create areas of shading and gradual tonal change across an image. When viewed quickly or at a distance the tiny dots blur together into shades of gray. More dots in an area appear darker, fewer dots appear lighter. To create a stipple engraving, the engraver would simply scratch out small dots in the plate, so that the metal acquired a pattern of tiny pits that could hold ink for printing. The resulting dots on the printed sheet produced the same effect as stippling with a pen.

Many editions of *The North American Sylva* contained color engravings although some editions were issued with the traditional (and much simpler) black ink print. The production of a multicolor print essentially involves coloring the plate before printing—wiping different colored inks onto each part of the copper plate. This produces a more subtle coloring in the finished print and avoids the harsh edges that would be created with black ink. It allows the stippling to blend with the watercolor added later, but it greatly increases the complexity of the printing process. Each color has to be added to the correct parts of the plate without missing any part. Another challenge of the medium is that the engraver needs to copy all of the shapes and details of the original art as a mirror image, so that a sheet of paper pressed against the plate will pick up an image that matches the original. Any words or numbers, such as the artist's signature, must be written backwards on the engraving.

After that painstaking process—engraving and printing—the product is a

sheet of paper with a somewhat skeletal framework of nuanced lines and dots. The final stage involved hand-coloring each print. Skilled colorists, referring to the original painting, would add transparent washes of watercolor paint to fill in the shapes of leaves, twigs, flowers, etc. Many details and subtleties were added at this stage, but the stippling of the print always showed through the watercolor wash and provided the basis of the outlines and shading.

I imagine it must have been difficult for artists to turn over their work to engravers, who—no matter how skilled or knowledgeable about the subject— might lose the subtle shadings and curves of the original. Inevitably, engravers would introduce their own style and interpretation to the artists' work.

The medium of engraving has limitations that watercolor paint and brushes do not, and has a sort of filtering effect that leads to a consistency in appearance and a uniformity not seen in the original paintings. The printing process adds another interpretation and can obscure some of the artist's personal vision. Imagine the songs of multiple guitarists, all being performed by some very talented harpists. That is essentially what we have in this book. The end results are beautiful, and the prints are true works of art on their own, but they are different from the originals.

Appreciating the art of engraving, it is fascinating to look at the details of these prints. The Red Maple (plate 250) clearly shows the different printed colors in the samaras (winged fruit). One edge is reddish while the other is pale green. Looking carefully at other prints will reveal many different colors of stippling.

The image of the fruit of Eastern Black Walnut (plate 119) uses stippling around the edge of the spherical fruit to suggest the coarse texture of the surface. By making the outline stippled, rather than a solid line, and then coloring the fruit up to, but not including, the outermost stipples, the artists left a finely textured outline visible.

Or look carefully at the nut of Butternut (plate 116) in which the printed ink in jagged shapes is used to indicate the dark furrows, and to suggest the rough edges on the outline, while a simple wash of one brownish color, skillfully applied to grade from dark to light on different parts of the nut, ties the whole object together. At first glance it looks very detailed and intricately rendered, but a close inspection reveals only two colors, and some artistic shortcuts to suggest texture and form.

By 1842, when Thomas Nuttall was ready to publish the first part of his three-volume supplement to the first American edition of *The North American Sylva,* Philadelphia was a hotbed of the publishing and printing industries. Nuttall, who had worked as an apprentice in his uncle's printing shop in England before coming to America, was familiar with printing techniques. The images in his work were drawn by several artists and prepared for publication using lithography as a means of printing. Lithographic printing used polished stones instead of copper plates from which to transfer the image to paper. The lithographer would re-draw the original drawing or watercolor onto a flat stone using an oil-based crayon and apply color to the greased areas. It was an effective means of creating multiple prints. Multiple stones were used for different colors, and like the copperplate engravings, these lithographic prints were also often touched by hand. Both processes of converting a single

illustration into a printed page required days of meticulous work by a team of highly skilled artists.

Botanical illustrations (and in fact all natural history illustrations) were extremely popular throughout the 1800s. Their value was not only aesthetic; they also provided scientific documentation to preserve the appearance of delicate structures such as flowers and other perishable three-dimensional objects such as fruit. In the twenty-first century, we are all accustomed to seeing photographs, which are often reproduced in stunning detail with enhanced color. When looking at these illustrations from two centuries ago, however, it is important to remember the context. Color engravings such as the prints made for *The North American Sylva* were available only to the privileged.

Although travel was expensive and difficult, it was not an impediment to the growth and dissemination of scientific knowledge. Fascination with the new United States was especially intense in Europe. As the entire New World was being explored, illustration served as a compelling source for revealing all kinds of exotic, never-before-seen plants and animals. Until the advent of photography, illustrated books provided a captivating means for explorers such as Michaux and Nuttall and artists such as Redouté and Bessa to document and share these wonders.

Concordance

The following lists relate the plate numbers in this book, in which the plates are arranged alphabetically by family and then by the genus and species as identified by François-André Michaux or Thomas Nuttall, to the plates as they are numbered in the original volumes of *The North American Sylva* by Michaux (1–3) and the later compendium volumes by Nuttall (1–3, identified below as 4–6). Editions vary.

Abbeville Edition = Michaux and Nuttall Editions

ABBEVILLE PLATE NUMBER	VOLUME	ORIGINAL PLATE NUMBER	ABBEVILLE PLATE NUMBER	VOLUME	ORIGINAL PLATE NUMBER	ABBEVILLE PLATE NUMBER	VOLUME	ORIGINAL PLATE NUMBER
1	6	CV	42	6	XCVII	83	1	21
2	2	62	43	3	111	84	1	22
3	6	LXXXI	44	3	113	85	1	16
4	3	103	45	3	112	86	1	25
5	5	LXXX	46	3	110	87	4	V
6	6	LXXXII	47	3	151	88	4	IV
7	2	60	48	3	152	89	1	23
8	2	84	49	6	CX	90	1	20
9	3	101	50	3	155	91	4	I
10	2	75	51	6	CXI	92	1	18
11	4	Xbis	52	3	156	93	1	15
12	4	IX	53	5	LXXIII	94	4	Vbis
13	4	X	54	5	LXXIV	95	1	4
14	2	70	55	2	93	96	1	6
15	2	74	56	4	XXXV	97	1	5
16	2	73	57	2	85	98	1	3
17	4	VII	58	6	XCV	99	1	27
18	2	69	59	2	68	100	1	14
19	2	71	60	2	67	101	1	10
20	4	VIII	61	5	LXI	102	1	11
21	2	72	62	5	LX	103	1	7
22	3	108	63	5	LXII	104	1	9
23	3	109	64	5	LIII	105	1	8
24	2	64	65	2	80	106	1	2
25	6	CIII	66	2	79	107	1	17
26	6	CIV	67	1	50	108	1	28
27	6	CVII	68	5	LV	109	1	13
28	6	CVI	69	5	LIV	110	1	24
29	5	LXXIX	70	5	LII	111	4	III
30	3	115	71	2	76	112	1	12
31	4	XL	72	2	77	113	4	XIII
32	3	114	73	2	78	114	1	33
33	4	XXXIX	74	4	VI	115	1	34
34	6	XCVI	75	3	105	116	1	31
35	5	LVI	76	3	104	117	1	37
36	6	CIX	77	3	106	118	1	39
37	5	LXXVII	78	3	107	119	1	30
38	4	XXXIII	79	4	II	120	1	32
39	4	XXXIV	80	1	1	121	1	38
40	4	XXXII	81	1	26	122	1	29
41	1	48	82	1	19	123	1	36

ABBEVILLE PLATE NUMBER	VOLUME	ORIGINAL PLATE NUMBER	ABBEVILLE PLATE NUMBER	VOLUME	ORIGINAL PLATE NUMBER	ABBEVILLE PLATE NUMBER	VOLUME	ORIGINAL PLATE NUMBER
124	1	35	176	6	CXVI	228	4	XVI
125	4	XXII	177	3	11 [147]	229	2	97
126	2	83	178	6	CXVII	230	2	98
127	2	82	179	3	146	231	2	95
128	2	81	180	3	153	232	2	100
129	2	61	181	3	154	233	2	99
130	2	53	182	6	CXX	234	2	96
131	2	56	183	3	6 [141]	235	4	XX
132	2	54	184	6	CXII	236	3	125
133	2	52	185	3	4 [139]	237	4	XIX
134	2	51	186	6	CXIV	238	4	XXI
135	2	57	187	3	3 [137]	239	4	XVIII
136	2	55	188	3	135	240	4	XVII
137	3	132	189	3	5 [140]	241	5	LXVIII
138	3	131	190	3	8 [143]	242	5	LXX
139	4	XXIII	191	3	Ire 134	243	1	40
140	3	133	192	3	2 [136]	244	5	LXIX
141	3	102	193	6	CXIII	245	5	LXVII
142	5	LXXV	194	3	7 [142]	246	1	47
143	5	XLIII	195	3	10 [145]	247	1	46
144	5	XLII	196	3	138	248	1	43
145	5	XLI	197	3	9 [144]	249	1	44
146	4	XXXVII	198	2	63	250	1	41
147	4	XXXVIII	199	4	XV	251	1	42
148	3	116	200	6	LXXXIX	252	1	45
149	4	XIV	201	6	LXXXVIII	253	5	LXXI
150	4	XXVI	202	6	CII	254	5	LXIV
151	4	XXIX	203	5	LXIII	255	5	LXV
152	4	XXVII	204	5	LVII	256	5	LXXII
153	4	XXVIII	205	5	LVIII	257	2	91
154	4	XXV	206	5	LIX	258	2	92
155	6	CXXI	207	4	XXIV	259	5	LXVI
156	4	XXXVI	208	2	90	260	6	XC
157	6	XCVIII	209	2	89	261	6	XCIII
158	3	118	210	5	XLVII	262	6	XCIV
159	3	121	211	5	XLVI	263	6	XCI
160	6	XCIX	212	2	88	264	6	XCII
161	6	C	213	5	LI	265	6	LXXXVII
162	3	124	214	5	XLV	266	3	117
163	3	123	215	5	XLIV	267	6	CVIII
164	3	122	216	2	65	268	2	58
165	3	119	217	2	66	269	2	59
166	3	120	218	5	XLVIII	270	3	130
167	2	86	219	5	L	271	3	127
168	2	87	220	5	XLIX	272	3	126
169	6	CI	221	1	49	273	3	129
170	3	12 [148]	222	5	LXXVIII	274	4	XI
171	3	14 [150]	223	5	LXXVI	275	4	XII
172	6	CXVIII	224	6	LXXXIII	276	3	128
173	3	13 [149]	225	6	LXXXV	277	6	LXXXVI
174	6	CXV	226	6	XXXIV			
175	6	CXIX	227	2	94			

Michaux and Nuttall Editions = Abbeville Edition

VOLUME	ORIGINAL PLATE NUMBER	ABBEVILLE PLATE NUMBER	VOLUME	ORIGINAL PLATE NUMBER	ABBEVILLE PLATE NUMBER	VOLUME	ORIGINAL PLATE NUMBER	ABBEVILLE PLATE NUMBER
1	1	80	2	51	134	3	101	9
1	2	106	2	52	133	3	102	141
1	3	98	2	53	130	3	103	4
1	6	96	2	54	132	3	104	76
1	5	97	2	55	136	3	105	75
1	4	95	2	56	131	3	106	77
1	7	103	2	57	135	3	107	78
1	8	105	2	58	268	3	108	22
1	9	104	2	59	269	3	109	23
1	10	101	2	60	7	3	110	46
1	11	102	2	61	129	3	111	43
1	12	112	2	62	2	3	112	45
1	13	109	2	63	198	3	113	44
1	14	100	2	64	24	3	114	32
1	15	93	2	65	216	3	115	3
1	16	85	2	66	217	3	116	148
1	17	107	2	67	60	3	117	266
1	18	92	2	68	59	3	118	158
1	19	82	2	69	18	3	119	165
1	20	9	2	70	14	3	120	166
1	21	83	2	71	19	3	121	159
1	22	84	2	72	21	3	122	164
1	23	89	2	73	16	3	123	163
1	24	110	2	74	15	3	124	162
1	25	86	2	75	10	3	125	236
1	26	81	2	76	71	3	126	272
1	27	99	2	77	72	3	127	271
1	28	108	2	78	73	3	128	276
1	29	122	2	79	66	3	129	273
1	30	119	2	80	65	3	130	270
1	31	116	2	81	128	3	131	138
1	32	120	2	82	127	3	132	137
1	33	114	2	83	126	3	133	140
1	34	115	2	84	8	3	Ire [134]	191
1	35	124	2	85	57	3	135	188
1	36	123	2	86	167	3	2 [136]	192
1	37	117	2	87	168	3	3 [137]	187
1	38	121	2	88	212	3	138	196
1	39	118	2	89	209	3	4 [139]	185
1	40	243	2	90	208	3	5 [140]	189
1	41	250	2	91	257	3	6 [141]	183
1	42	251	2	92	258	3	7 [142]	194
1	43	248	2	93	55	3	8 [143]	190
1	44	249	2	94	227	3	9 [144]	197
1	45	252	2	95	231	3	10 [145]	195
1	46	247	2	96	234	3	146	179
1	47	246	2	97	229	3	11 [147]	177
1	48	41	2	98	230	3	12 [148]	170
1	49	221	2	99	233	3	13 [149]	173
1	50	67	2	100	232	3	14 [150]	171

VOLUME	ORIGINAL PLATE NUMBER	ABBEVILLE PLATE NUMBER	VOLUME	ORIGINAL PLATE NUMBER	ABBEVILLE PLATE NUMBER	VOLUME	ORIGINAL PLATE NUMBER	ABBEVILLE PLATE NUMBER
3	151	47	4	XXXVIII	147	6	LXXXI	3
3	152	48	4	XXXIX	33	6	LXXXII	6
3	153	180	4	XL	31	6	LXXXIII	224
3	154	181	5	XLI	145	6	XXXIV	226
3	155	50	5	XLII	144	6	LXXXV	225
3	156	52	5	XLIII	143	6	LXXXVI	277
4	I	91	5	XLIV	215	6	LXXXVII	265
4	II	79	5	XLV	214	6	LXXXVIII	201
4	III	111	5	XLVI	211	6	LXXXIX	200
4	IV	88	5	XLVII	210	6	XC	260
4	V	87	5	XLVIII	218	6	XCI	263
4	Vbis	94	5	XLIX	220	6	XCII	264
4	VI	74	5	L	219	6	XCIII	261
4	VII	17	5	LI	213	6	XCIV	262
4	VIII	2	5	LII	7	6	XCV	58
4	IX	12	5	LIII	64	6	XCVI	34
4	X	13	5	LIV	69	6	XCVII	42
4	Xbis	11	5	LV	68	6	XCVIII	157
4	XI	274	5	LVI	35	6	XCIX	160
4	XII	275	5	LVII	204	6	C	161
4	XIII	113	5	LVIII	205	6	CI	169
4	XIV	149	5	LIX	206	6	CII	202
4	XV	199	5	LX	62	6	CIII	25
4	XVI	228	5	LXI	61	6	CIV	26
4	XVII	240	5	LXII	63	6	CV	1
4	XVIII	239	5	LXIII	203	6	CVI	28
4	XIX	237	5	LXIV	254	6	CVII	27
4	XX	235	5	LXVI	259	6	CVIII	267
4	XXI	238	5	LXV	255	6	CIX	36
4	XXII	125	5	LXVII	245	6	CX	49
4	XXIII	139	5	LXVIII	241	6	CXI	51
4	XXIV	207	5	LXIX	244	6	CXII	184
4	XXV	154	5	LXX	242	6	CXIII	193
4	XXVI	150	5	LXXI	253	6	CXIV	186
4	XXVII	152	5	LXXII	256	6	CXV	174
4	XXVIII	153	5	LXXIII	53	6	CXVI	176
4	XXIX	151	5	LXXIV	54	6	CXVII	178
4	XXXII	4	5	LXXV	142	6	CXVIII	172
4	XXXIII	38	5	LXXVI	223	6	CXIX	175
4	XXXIV	39	5	LXXVII	37	6	CXX	182
4	XXXV	56	5	LXXVIII	222	6	CXXI	155
4	XXXVI	156	5	LXXIX	29			
4	XXXVII	146	5	LXXX	5			

Selected Bibliography

"American Conifer Society—Evergreen Plants for Year-round Interest."
American Conifer Society. Accessed May 5, 2016.
http://conifersociety.org/.

Auders, Aris G., and Derek P. Spicer. *Royal Horticultural Society Encyclopedia of Conifers: A Comprehensive Guide to Cultivars and Species.* London: Royal Horticultural Society, 2012.

Beidleman, Richard G. *California's Frontier Naturalists.* Berkeley, University of California Press, 2006.

"Biodiversity Heritage Library." Biodiversity Heritage Library. Accessed April/May, 2016. http://www.biodiversitylibrary.org/.

Bradbury, John. *Travels in the Interior of America, in the Years 1809, 1810, and 1811.* London: Sherwood, 1817.

Brummitt, R.K., and C.E. Powell, eds. *Authors of plant names: a list of authors of scientific names of plants with recommended standard forms of their names including abbreviations.* London: Royal Botanic Gardens, Kew, 1992.

Chinard, Gilbert. "André and François André Michaux, An Essay on Early Botanical Exchanges between America and France." *Proceedings of the American Philosophical Society,* 101, no. 4. August, 1957.

Eckenwalder, James E. *Conifers of the World: The Complete Reference.* Portland: Timber Press, 2009.

Ewan, Joseph, ed. *A Short History of Botany in the United States.* New York: Hafner Publishing Company, 1969.

Deleuze, J.P.F. *The Annotated Memoirs of the Life and Botanical Travels of André Michaux.* Athens, Ga.: Fevertree Press, 2011.

Durand, Elias. "Biographical Memoir of the Late François André Michaux," *The Transactions of the American Philosophical Society,* XI, December 5, 1856.

Eastman, John (John Andrew). *The Book of Forest and Thicket: Trees, Shrubs, and Wildflowers of Eastern North America* / illustrated by Amelia Hansen. Harrisburg, Pa.: Stackpole Books, 1992.

Flowers by Redouté: Artist for an Empire. Bronx: The New York Botanical Garden, 2005.

Graustein, Jeannette E. *Thomas Nuttall Naturalist.* Cambridge, Mass.: Harvard University Press, 1967.

"The International Plant Names Index - Home Page." The International Plant Names Index - Home Page. Accessed June 28, 2016. http://www.ipni.org/.

Lottinville, Savoie, ed. Introduction to new edition of Nuttall's *Journal of Travels into the Arkansas Territory during the year 1819.* Norman, Okla.: University of Oklahoma Press, 1980.

MacPhail, Ian. *André & François-André Michaux*. The Sterling Morton Library Bibliographies in Botany and Horticulture. The Morton Arboretum, 1981.

——. *Thomas Nuttall*. The Sterling Morton Library Bibliographies in Botany and Horticulture. The Morton Arboretum, 1983.

Michaux, François-André. *The North American Sylva: or, A Description of the Forest Trees of the United States, Canada and Nova Scotia, Considered Particularly with Respect to their Use in the Arts and their Introduction into Commerce;...* Philadelphia: Sold by Thomas Dobson [and] Solomon Conrad, (Paris: Printed by C. d'Hautel), 1817–1819.

Michaux, François-André. *The North American Sylva: Or, A Description of the Forest Trees of the United States, Canada and Nova Scotia: Considered Particularly with Respect to Their Use in the Arts, and Their Introduction into Commerce: To Which Is Added a Description of the Most Useful of the European Forest Trees*. New Harmony, Ind.: W. Amphlett, 1841.

Nuttall, Thomas, F. L. S. *Journal of Travels into the Arkansas Territory During the Year 1819*. Philadelphia: Thos. H. Palmer, 1821.

——. *The North American Sylva; or A Description of the Forest Trees of the United States, Canada and Nova Scotia not Described in the Work of F. Andrew Michaux and Containing all the Forest Trees Discovered in the Rocky Mountains, the Territory of Oregon, Down to the Shores of the Pacific, and into the Confines of California, as Well as in the Various Parts of the United States*. Philadelphia: Smith & Wistar, 1849.

Peattie, Donald Culross. *A Natural History of Trees of Eastern and Central North America*. Boston: Houghton Mifflin, 2007.

"The Plant List—A Working List for All Plant Species." Home. Accessed May 5, 2016. http://www.theplantlist.org/.

Raphael, Sandra. *An Oak Spring Sylva: A Selection of the Rare Books on Trees in the Oak Spring Garden Library*. Upperville, Va.: Oak Spring Garden Library (distributed by Yale University Press), 1989.

Sargent, Charles Sprague, 1841–1927. *The Silva of North America; a Description of the Trees Which Grow Naturally in North America Exclusive of Mexico,...* Boston: Houghton, Mifflin and company, 1891–1902.

Savage, Henry, Jr. and Elizabeth J. *André and François André Michaux*. Charlottesville, Va.: University of Virginia Press, 1986.

Sibley, David Allen. *The Sibley Guide to Trees*. New York: Alfred A. Knopf, 2009.

Stafleu, Frans A., and Richard S. Cowan. *Taxonomic Literature: A Selective Guide to Botanical Publications and Collections with Dates, Commentaries and Types*, 2nd ed. Utrecht: Bohn, Scheltema and Holkema, 1976–1988.

Tomlinson, Philip Barry. *The Biology of Trees Native to Tropical Florida*. Allston, Mass.: Harvard Printing and Publications Services, 2001.

"Welcome to the PLANTS Database | USDA PLANTS." Welcome to the PLANTS Database | USDA PLANTS. Accessed May 5, 2016. http://plants.usda.gov/.

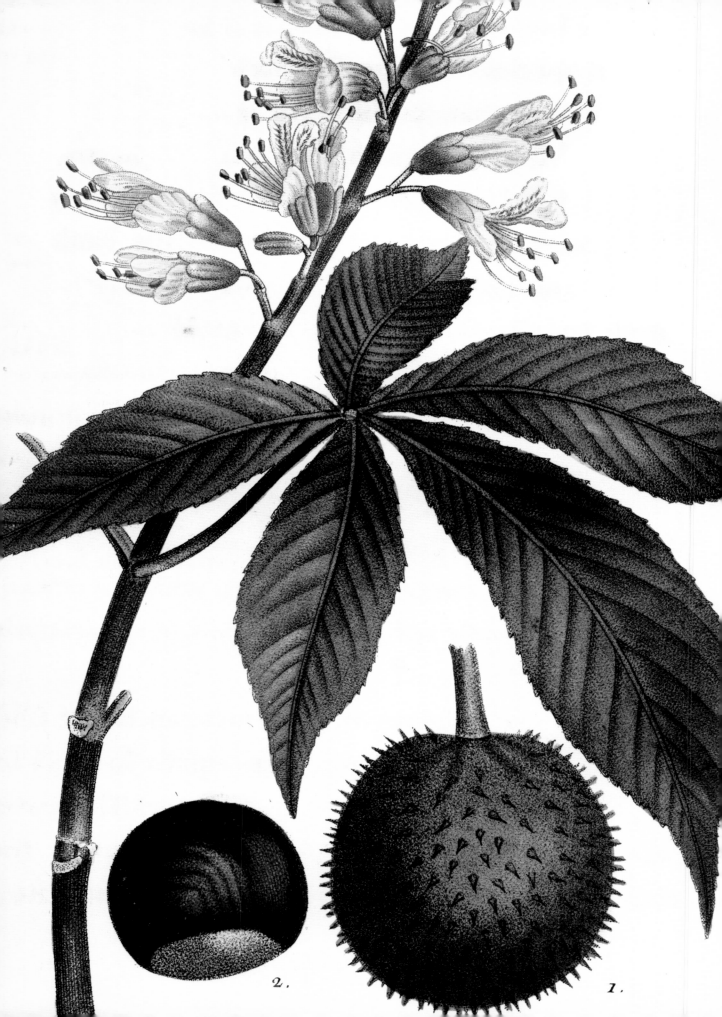

2. 1.

Contributors

Gregory Long is Chief Executive Officer and The William C. Steere Sr. President of The New York Botanical Garden.

Susan M. Fraser is Vice President and Director of the LuEsther T. Mertz Library at The New York Botanical Garden.

Marta McDowell is a gardener, lecturer, and horticultural writer. Her books include *All the Presidents' Gardens* (2016) and *Beatrix Potter's Gardening Life* (2013), winner of the Gold Award from the Garden Writers Association.

David Allen Sibley is one of the world's best-known natural history illustrators and the author of acclaimed field guides, including *The Sibley Guide to Trees*, which have sold more than one million copies.

Acknowledgments

The volume editors thank their dedicated colleagues at The New York Botanical Garden who provided insight and expertise that greatly assisted this project.

Horticulture staff who wrote the species treatments: Arthur Ross Vice President for Horticulture and Living Collections Todd A. Forrest (TAF), Deanna F. Curtis (DFC), Joanna L. Groarke (JLG), Rachel Guardiola (RG), Michael Hagen (MH), Victoria B. Lewis (VBL), Claudia Mora (CM), Kristine L. Paulus (KLP), Kristin Schleiter (KS), Jessica Arcate Schuler (JAS), and Brian P. Sullivan (BPS)

Mertz Library staff who helped prepare spreadsheets, research current taxonomy, and digitize the plates from the original published works: Gina Baldwin, Samantha D'Acunto, Linda DeVito, Esther Jackson, Eric Lieberman, Susan Lynch, Stephen Sinon, and Andrew Tschinkel

Science staff who reviewed and verified current taxonomy: Daniel Atha and Michael Nee, Ph.D.; and who provided assistance with particular species questions: Richard Abbott, Ph.D., and Robert F. C. Naczi, Ph.D.